The Art of iPhone Photography

Bob Weil • Nicki Fitz-Gerald

The Art of iPhone Photography

Creating Great Photos and Art on Your iPhone

Editor: Joan Dixon
Copyeditor: Jeanne Hansen
Layout: Petra Strauch
Cover Design: Helmut Kraus, www.exclam.de
Front cover image: Nicki Fitz-Gerald
Printer: Friesens Corp.
Printed in Canada

ISBN 978-1-937538-18-7

1st Edition 2013
© Bob Weil and Nicki Fitz-Gerald

Rocky Nook, Inc.
802 E. Cota Street, 3rd Floor
Santa Barbara, CA 93103

www.rockynook.com

Library of Congress Cataloging-in-Publication Data

Weil, Bob.
 The art of iPhone photography : creating great photos and art on your
iPhone / by Bob Weil and Nicki Fitz-Gerald. -- 1st edition.
 pages cm
 ISBN 978-1-937538-18-7 (softcover : alk. paper)
 1. iPhone (Smartphone) 2. Photography, Artistic. 3. Photography--Digital
techniques. I. Fitz-Gerald, Nicki. II. Title.
 TR263.I64W45 2013
 778.80285'53--dc23
 2013010939

Distributed by O'Reilly Media
1005 Gravenstein Highway North
Sebastopol, CA 95472

I dedicate this book to my beautiful wife, friend, and life and faith companion, Marya, and my talented and charming son, Jon, for their boundless patience and loving support of my iPhoneography habit and the seemingly never-ending process of writing this book.

Bob Weil

This book is dedicated to my wonderfully supportive partner, Bob, my beautiful son, Lewis, and my fabulous mum and dad for their endless love, support, and patience throughout the creation of this book and my iPhoneography obsession.

Nicki Fitz-Gerald

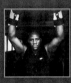
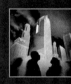

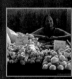

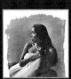

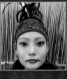

Tutorials • Part 2: Illustration and Fine Art

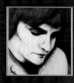
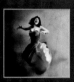
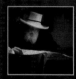
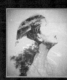

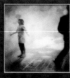
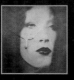
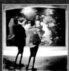

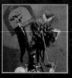

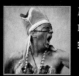

FOREWORD

by Daria Polichetti
Cofounder of iPhoneArt.com,
LA Mobile Arts Festival, and The iPrints Store

iPhone Art: The Collision of Art and Technology

In the brief span of a decade, mobile digital photography has collided with the birth of social networks. It has transformed the way we view and understand art on a global scale. But many still struggle with the question, is it ok for me to like it?

Classical definitions of *fine arts* refer to painting, sculpture, architecture, music, and poetry. Today fine arts finally includes "newer" art forms such as installation art and photography, which, although they have been around for a long time, are good examples of how innovations often struggle to gain acceptance in the world of fine art.

During the Renaissance early photographic devices gained popularity and allowed many noted artists to study light, lines, and images on a two-dimensional surface in ways that had never before been possible. Yet photography did not gain real acceptance as its own art form for hundreds of years.

The daguerreotype, invented in France in the mid-1800s, was the first process to capture a true likeness, and it led to a love affair with landscape and portrait photography. In America, photographers carted innovative portable darkrooms across Civil War battlefields, and Farm Security Administration photographers, such as Walker Evans and Dorothea Lange, documented the Great Depression—they all showed the world what was really going on. This history was paralleled around the world and transformed the way people understood their surroundings—in much the same way mobile digital devices are doing today. And yet, through it all, photography was disparaged as an art form.

"It's not real art." "The camera's doing all the work." "You're just clicking a button." "Anyone can do it." Such critiques were commonplace until the mid-20th century, when photography finally came into its own, due, in large part, to a small group of pioneers such as Ansel Adams, Edward Weston, and Imogen Cunningham—key members of Group f/64 who spent their lives exploring and advocating this new medium.

The debate didn't stop there. Indeed, every time there is a technological advance, the same arguments arise. When editing programs such as Adobe Photoshop came on the scene, for example, those who were used to shooting on chromes and having to get it right in-camera thought the art of the photograph was being lost. The same thing happened when digital cameras started replacing film. It seems that each time advances in technology make the ability to create art more accessible, it stirs the technology argument all over again. And what technological advance in photography has been more widespread and visible than the iPhone? It's an entirely new kind of device that gives everyone the ability to carry around a handheld digital camera and post-production system—with camera, darkroom, software applications, and delivery system all included.

Today's explosion of social networks, such as Facebook, Flickr, and Instagram,

are a key factor in the popularity of mobile art. At the same time, they are the reason many people are turned off to it. It is so easy to look at the millions of online snaps of your friends' feet or breakfast and just tune out.

But that is not the real story. A dynamic underground art community is inventing new methods and exploring the possibilities of this new medium in much the same way the founding fathers of photography once did. This movement congregates in global communities such as iPhoneArt.com and iPhoneographyCentral.com. These and other online art colonies should not be confused with the explosion of social networking. But they live and thrive side by side.

Ultimately, mobile art is not about process or equipment. As is true of any art form, it's about the artist's vision. But mobile devices do bring many new possibilities to the table.

The iPhone is discrete. It allows you to capture candid moments that may otherwise have been disrupted by the presence of a bulky, intrusive camera setup, and it allows you to capture shots you could not have otherwise obtained.

The iPhone is powerful. It triggers enormous creative energy for the artist, with its easily accessible, extensive, yet inexpensive library of apps for post-processing. But a simple click of a button does not do all the work for you—quite the opposite. Many dedicated mobile artists use 2 or 5 or 10 apps to process a single image. They study the different capabilities of each app and then design their own combinations, tricks, and innovations to create a unique vision and voice.

The iPhone is ever-present. The cover photo for the November 12, 2012 issue of *Time* magazine, which featured Hurricane Sandy, was shot with an iPhone. A *New York Times* photographer shot an award-winning war photo with an iPhone app. National Geographic, which produces some of the best photos in the world, offers online tips on capturing worthy moments on your phone and has produced a coffee table book in Germany featuring only mobile photographers. In the past these moments might otherwise have been lost. But today our mobile devices are always with us, so we are always ready to capture the fleeting moments of life.

The iPhone is immediate. As many artists have observed, one of the most revolutionary aspects of mobile devices is that they give you the ability not just to shoot an image on location, but to process, tweak, refine, and finish it there, too. As Nicki Fitz-Gerald recently noted, the iPhone gives her the ability to post-process "on the spot where I took the shot—still surrounded by the smells, the sounds, the cold, the warmth—the whole environment," not unlike the experience of creating a plein air painting. Until now, if you shot a picture out in the world you had to wait until you were back at home with your computer before you could finish the image. But the iPhone allows you to bring your darkroom with you, and for many that immediacy allows the full inspiration of the moment to be present from the beginning through the end of the creative process.

The iPhone is collaborative. Not only are our camera and darkroom now in the palm of our hand, but our social networks are as well—the web of interaction that allows us to share and get feedback from thousands, even millions, of like-minded artists around the globe—in an instant. In fact, this communal aspect of image sharing has become so pervasive that it's now a common and popular practice among mobile artists not just to share but also to collaborate on images, passing one piece back and forth and remixing each

other's work. Furthermore, the iPhone itself allows for a collaboration between artists and software developers, with both sides of the spectrum informing the other, teaching the other, and ultimately working together to break new ground. This interaction between the artistic and the technical sides of mobile art often produces results the software developers themselves did not even know were possible—something this book demonstrates exceptionally well.

Nicki Fitz-Gerald and Bob Weil have built a community at iPhoneography-Central.com that is dedicated to this burgeoning collaboration between art and technology. Their website, and now this book, offers extensive, in-depth tutorials both for budding iPhoneographers looking to advance their craft and professionals attempting to harness a new tool kit in service of their vision.

What they bring to the table is their belief that revealing the man behind the curtain does not diminish the teacher. Technique does not the artist make, but it does enable the newcomer to find his or her own voice. With thousands of apps available and more flooding the market daily, every new and many experienced iPhoneographers wonder which apps they should use. The answer is complex, but the illustrated tutorials

found in this book are an invaluable tool to help make that difficult decision. There is really nothing else like it.

Within these pages you will find not just the advice of a single artist or a few images from a small artistic segment. Instead, the book in your hands offers stories, knowledge, inspiration, tips, and secrets from many of the key players in the formation of this movement, as it showcases the work of 45 artists and their tutorials.

Many works included in this volume were originally exhibited at the LA Mobile Arts Festival 2012, a brick-and-mortar show mounted for the 5,000-plus online members of iPhoneArt.com at the Santa Monica Art Studios in California. It was the largest mobile arts show to date and showcased 240 iPhoneArt artists from more than 40 countries. Artists from Canada, Italy, Turkey, Lebanon, the United Kingdom, Portugal, New Caledonia, and more showed up. More than 600 images, sculptures, and film-based and environmental installations were exhibited, all created on mobile devices. There were works by well-known artists alongside prison guards next to stay-at-home moms. "Where are the photos created on phones?" asked those who came to the exhibit, not realizing they were already surrounded by them.

This mixture of professionals and beginners mentoring each other and coming together—crossing cultural, political, geographic, and economic divides to join in a conversation about contemporary art—is what makes the medium itself and the community that sustains it so valuable to mobile artists at any stage. It tells us there is a worldwide community of iPhoneographers and other mobile artists who are eager to find their voice, to create, and to learn and experiment.

The iPrints Store, also part of iPhoneArt.com, curated and produced all the artwork for the show on innovative, eco-friendly hand-crafted bamboo panels, aluminum plates, glass, and coated mirrors. Some prints were nearly four feet tall—and every piece was museum quality, disproving the idea that mobile photography is limited to low-resolution social networking.

Many high-profile artists from this festival emerged (either before or after) as early adopters and masters of their craft, and they are now part of this first attempt in print to bring the techniques of a whole community of mobile photographers into the light. And the timing is perfect. With iPhoneography gaining real traction and acceptance, this book serves not only as a guidebook for navigating the tumultuous waters of app-land, but it is essentially an

encyclopedia of artists who have pioneered the field, and it is sure to become one of the first and most significant books to document the early years of the movement.

Art and technology have always existed both in concert and at odds with each other. They often butt heads, but they also help each other along. When we consider the question, *is it ok for me to like it?* perhaps it's time we started looking solely at the merit of the work in front of us and ask ourselves whether the image, or film, or piece of music or poetry moves us. Does it offer some comment on our lives? Our humanity? Is it compelling? Is it interesting? Is it funny? Smart? Sad? Does it make us want to keep looking? Keep listening? Keep creating? If the answer is yes, then perhaps we are ready to change our question to, do I like it? and to answer without dwelling primarily on *how* a work of art was made—but on *what* was made, and how it changed our lives.

INTRODUCTION

"There are two people in every photo-graph: the photographer and the viewer."
~ Ansel Adams

Far more than a cell phone, the iPhone—and now the Android phone—are devices that have displaced the dedicated camera and forever changed the way we view and capture our world.

Soon after its introduction in 2007, the iPhone triggered something of a revolution in the world of photography. It doesn't matter that the resolution of the final image is less than images taken with the point-and-click you owned five years ago. Despite that seeming drawback, this camera is different from all previous cameras of any price, sophistication, and pretense. It is always with you, often in hand, and always on—and it has on-board photo-editing and distribution capabilities. Spontaneity—a word not normally associated with photography—is suddenly the norm.

For those of us who have felt enabled by this new device, the iPhone is perhaps this era's answer to the Polaroid SX-70—creating instant, comparatively low-fi images that travel with you like a personal portfolio and life record, which are ready to share with friends and dispatch to your favorite social networking site. The iPhone is so inconspicuous that those around you may not realize when you are taking a picture. Many iPhoneographers (there's even a name for us) have overcome their hesitation to capture people and scenes and have discovered their inner artist. The popularity of Instagram and the proliferation of dedicated iPhone photography groups on Flickr reflect this trend.

In his foreword to *Instant Gratification: 21st Century Art & the Mobile Phone Camera* Tim Wride wrote, "... images are evolving beyond their status as commodity to become the actual currency of experience."[1] We would add that images are also becoming a true medium of expression for people who have never before considered themselves photographers, let alone artists. We have become a world of chroniclers and alchemists as well as observers and participants.

Here are some interesting and revealing developments in the three years since Wride wrote these words:

- By mid-2011, the iPhone surpassed Nikon as the most commonly-used camera brand for images uploaded to Flickr.

- *The Wall Street Journal* recently published an article titled "Is the iPhone the Only Camera You Need?"

- Late last year Facebook acquired photo upload site Instagram, which has become one of the largest social networks, and iPhone submissions constitute a significant percentage of the uploaded images. One of the contributors to this book, Melissa Vincent, has more than 100,000 Instagram followers, and the iPhone has allowed her to express her creative impulses in new and unprecedented ways.

- As we write this, there are more than 800 self-published photo books for sale on Blurb in which all the photographs between the covers were taken with an iPhone.

- In 2012 a photo taken with an iPhone (by a professional photographer) graced the cover of *Time* magazine.

1 Christopher Lapp, *Instant Gratification: 21st Century Art & the Mobile Phone Camera* (West Hollywood, CA: West Hollywood Books, 2010).

Why another iPhone photography book?

"Beauty can be seen in all things; seeing and composing the beauty is what separates the snapshot from the photograph."
~ Matt Hardy

Although there are a number of picture books documenting personal journeys with iPhone snapshots, most offer little insight about how the authors created their best work. Many of these self-published books are not curated, so interesting photographs are presented alongside less memorable ones. iPhoneography is so new that an image of the family dog, the photographer's feet, or a cup of morning coffee still seems to warrant inclusion.

At this writing, there are perhaps 10 how-to books that share tips on how to get the most out of your iPhone and various apps. Each book usually presents one person's point of view, favorite subjects, and personal stylistic approach. In an effort to be comprehensive, less interesting images are sometimes included alongside the author's best work to demonstrate a particular application or technique.

It's a perfectly legitimate approach to start with a set of objectives and find the images that best illustrate each one. A number of these books, including Dan Marcolina's *iPhone Obsessed,* are excellent introductions to the iPhone as a camera and image processor, and they present great capsule information on techniques and applications. We are particularly indebted to Dan for introducing the first generation of iPhoneographers to a number of the more important apps that were available when he wrote his best seller. But *The Art of iPhone Photography* takes an entirely different approach.

We begin by assuming you're familiar with how the iPhone camera operates and that you know at least some key photo editing concepts (on the iPhone or on the computer). After nearly six years in the marketplace, we believe that readers are looking for something that goes beyond iPhone photography basics but is still very accessible to novices who are eager to learn. We think a large number of iPhoneographers are interested in evolving their own style and more effectively telling a story with their imagery. Some of them may have begun their journeys on Instagram, and others have appeared on any number of dedicated iPhoneography sites like iPhoneArt, EyeEm, P1xels, or general photo-sharing sites like Flickr and Tumblr.

With these readers in mind, we began by selecting images for this book that we believe are works of art—whether photorealistic or surrealistic or something in between—and then asked each photographer to tell us how they accomplished their vision. This includes not only the technical details of how they achieved their goal, but also the creative thinking that preceded and accompanied the process (the back story) and the challenges they encountered along the way.

How can this book help me produce better images?

"Which of my photographs is my favorite? The one I'm going to take tomorrow.
~ Imogen Cunningham

In preparing this book, we selected some of the best iPhoneographers working today. We've assembled a truly international cast of photographers from Australia, Canada, France, Hungary, Indonesia, Italy, Japan, Portugal, The Netherlands, Norway, the United Kingdom, and the United States. Our single requirement for each of the selected images was that it be visually compelling. Across the range of selections, we looked for diverse subject matter and a variety of styles and techniques. We sought everything from conceptual pieces, to realistic portraiture, abstracts,

street captures, landscapes, still lifes, and macro photography—to name just a few.

While most of our contributors used an iPhone to capture their images and create their final work, several (as you'll see from the screen captures) used an iPad to refine their images.

The 45 artists represented here reveal how they conceived, composed, captured, and post-processed their images in a step-by-step fashion that allows you to understand what went on behind the curtain. We encourage you to apply some or all of these techniques to your own work to suit your taste, level of experience, and goals.

We hope this window into the creative process helps you refine your skills and realize your own personal vision.

What next?

"If I saw something in my viewfinder that looked familiar to me, I would do something to shake it up."
~ Garry Winogrand

Whether we consider ourselves amateurs or professional photographers, we all hope to continually train our creative eye and master the tools of our craft. Any photographer will tell you that a great image is first and foremost about

somehow capturing the unseen (or unappreciated) and the beauty in the seemingly ordinary.

The arrival of the iPhone did not change what makes for a great composition, but it did give us an extensive and ever-expanding set of tools to quickly enhance, modify, and refine our images, even as we're on the move throughout the day. It allows us to remove the superfluous and add the sublime (if we so choose). We really can have it both ways, on our own terms, when we want it.

It is our sincere wish that this book inspires you and provides you with the tools you need to take your mobile journalism or art to new levels, whether you are an amateur, a novice, or a professional.

There are a number of iPhone-specific and mobile photography competitions—including the Mobile Photo Awards (www.the-mpas.com), the LA Mobile Arts Festival (www.la-maf.com/), and the iPhone Photography Awards (http://ippawards.com)—where you can submit your work. Beyond that, there are countless general photography shows, exhibitions, and contests. Whether you captured your image with an iPhone, a Canon 5D, or a brick is irrelevant to being accepted into these competitions; the only concern is whether your work has artistic merit. And as

Daria Polichetti's foreword to this book makes abundantly clear, isn't that all that really matters?

We hope you'll visit our website at iPhoneographyCentral.com to see more tutorials, product reviews, artist features, and iPhoneography news. We're eager to see your work in our iPhoneographyCentral Flickr group at www.flickr.com/groups/iphoneographycentral.com. Submit your best work, and you might be selected for inclusion in our weekly "Apps Uncovered" dynamic dozen! Be sure to stop by and say hello.

May your next photograph always be your best!

Bob Weil
Nicki Fitz-Gerald
August 2013

Note to Android users: Though the work in this book was produced on iOS devices, Android cameras have many of the same photography and graphics apps available to them. Using cross-platform apps like Snapseed, Pixlr Express, and others, Android smartphone photographers can follow along through many tutorials in the book. Where a particular app is not available for the Android platform, there is often a comparable app that will allow readers to apply the techniques and concepts presented here.

www.rockynook.com/iPhoneArt

Visit the book's companion website to view a stunning gallery of images by the artists presented in this book. Also found here is more information about the apps used in this book, with links to their respective iTunes pages.

For updates/additions to the book please visit iPhoneographyCentral.com.

People & Portraits

1. **Paula Gardener**
Study A: Mr. G
Study B: Laughter and Smiles

2. **Jack Hollingsworth**
Beautiful Young Woman, Nagaland
Festival, India

3. **Christine Sirois**
Juxtaposition of Tide

4. **Doug McNamee**
Kitava

Street

5. **Sheldon Serkin**
Zoe

6. **David Ingraham**
Rat Race

7. **Marian Rubin**
Farmers Market, Cuba

Landscape

8. **Cecily Caceu**
Long Beach in the Rain

9. **Daniel Berman**
I Offered Up My Innocence and Got
Repaid with Corn

Panoramic & HDR

10. **Rad Drew**
Stone Quarry Sawmill

Illustration/Fine Art

11. **Lindsey Thompson**
Bokeh Web

12. **Nettie Edwards**
A Faery Song

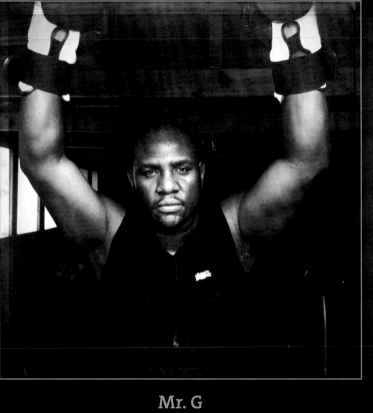

Mr. G

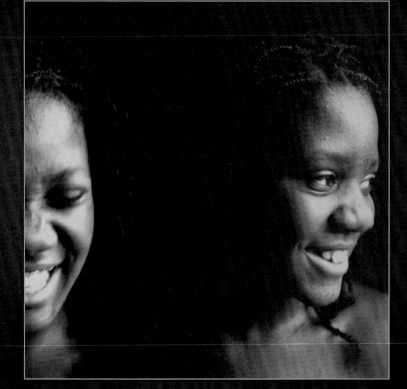

Laughter and Smiles

TUTORIAL 1

Create great atmospheric black-and-white portraits in a few easy steps

Study A: Mr. G

What You'll Learn

As you work through these two tutorials, you will learn to take great atmospheric portraits in a short period of time and with minimal apping.

You will also learn to adjust the tones of an image; the correct tones are important to draw the viewer in because a flat image will not usually appeal to anyone. Finally you'll learn how to complete an image by choosing the right border.

What You'll Need

- Hipstamatic
- Snapseed
- Camera Awesome

Back Story

The iPhone has made photographing friends and family so convenient. Instead of having to lug my huge Nikon and camera kit around with me on family occasions, I use the handy and less intrusive iPhone.

I'm obsessed with creating the perfect portrait. Light, composition, and tone are all extremely important to me. How do I achieve these goals with limited time? It's easy with the method described here for shooting black-and-white portraits and choosing an appropriate frame.

My husband built a huge shed in our garden—his own personal space. No women allowed. In this man's club my husband hung a few boxing bags, and he and our sons (11 and 6 years old) spar together. It's less harmful than it sounds. One day my husband had just finished punching the bags and was exhausted and very sweaty, so posing for a photo was the last thing on his mind. However, as he leaned on the door frame of the shed talking to me, I saw the perfect portrait opportunity. With my iPhone in hand, I quickly thought of which camera app I would use to really take advantage of the beautiful lighting.

The Process

Step 1: Capturing the Image

I knew if I took the picture with the iPhone's native camera, the background would be visible and reveal all the shed's contents. The sunlight was slightly harsh, which would have resulted in an overexposed image. I decided to use Hipstamatic's new Wonder

| 1 |

| 2 |

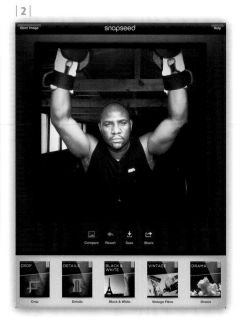

| 3 |

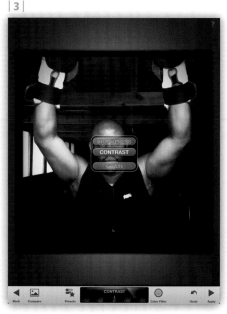

lens and W40 film, and I shot a couple of frames. They looked perfect | 1 |.

➤ Step 2: Converting the Image to Black-and-White

I opened the saved Hipstamatic image in Snapseed. Then I converted the image to black-and-white and adjusted the contrast and brightness to suit the mood of the portrait. While I was still in the black-and-white filter menu, I tweaked the color preset tones. When I had the tones how I wanted them, I moved the sliding menu to access the crop option | 2–4 |.

➤ Step 3: Removing the Preset Border

I prefer to choose my own border or not have a border at all rather than use the Hipstamatic presets. There is nothing wrong with Hipstamatic's borders, but for people who prefer borders, a number of apps offer a variety of border styles, and of course you can always create a custom border.

I chose to crop off the border. The cropping selection tool in Snapseed provides nine crop ratios. The first one is a free-form option that allows the height and width to be scaled to any proportion. The second option restricts

the crop to the aspect ratio of the original image, and the other seven options are preset aspect ratios. I usually work with the free-form option, which gives me the freedom to choose the size and proportion of my image. Within the cropping tool, I simply dragged the sides of the grid to where I wanted the image to be cropped. When I had all the sides positioned where I wanted them, I pressed the right arrow button to crop the image. Then I saved the result to the camera roll | 5 |.

| 4 |
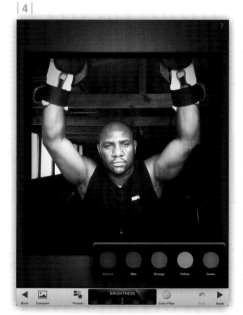

| 5 |
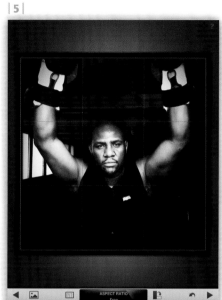

| 6 |

➔ Step 4: Deciding Whether to Add a Border

Depending on your vision for an image, the final step is to decide whether to add a border. For this portrait I opened the image in Camera Awesome, which has a superb collection of nonintrusive borders. My favorite border, which I chose for this image, is called **Skin** | 6 and 7 |.

Summary

In this tutorial I showed you how to create a beautiful black-and-white portrait from an initial capture of your subject with Hipstamatic. I then demonstrated how to convert the image to black-and-white, adjust the brightness and contrast, and use the crop tool in Snapseed. I also shared my decision-making process when I choose whether to use a border for my portraits, and I suggested an app for nonintrusive borders.

| 7 |
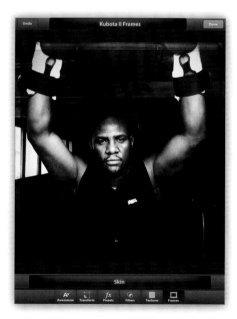

Study B:
Laughter and Smiles

What You'll Learn

In this tutorial you will learn how to adjust lighting and focus and how to blend and crop effectively.

What You'll Need

- Camera+
- Snapseed
- Diptic
- Brushes
- Filterstorm

Back Story

Portrait photography, for me, is capturing an image that will exemplify what is in my heart—my connection with the subject and the emotion of the moment. It's important for the viewer to connect with the person being photographed. A good portrait is a biography that conveys a message so personal and touching that the viewer will be compelled to engage with the image.

Portrait photography works when the lighting is spot on. Enhancing the subject's good features is particularly important in commercial photography. In the images in this tutorial, I have tried to capture the atmosphere of the moment through the subject's expression. I minimized the background to avoid distracting the viewer's eye from the subject.

I love capturing images of my children; I suppose they are my best sellers when it comes to telling stories. This particular story is of my eldest daughter, whose smile is contagious and whose laughter can fill a room with joy. I wanted to capture these two unique qualities. She always laughs when I photograph her, so it wasn't hard to provoke that reaction. I shot a series of stills of her laughing and pausing to compose herself, but she was not aware that I was still shooting away. The best portraits are the ones where the subject is relaxed. My favorites are candid shots taken when my subjects are unaware that they are being photographed. This is when their innermost emotions are captured.

The Process

➡ **Step 1: Capturing the Initial Image**
First I captured a series of images with the native iPhone 4 camera in front of patio doors where the light was perfect |8 and 9|.

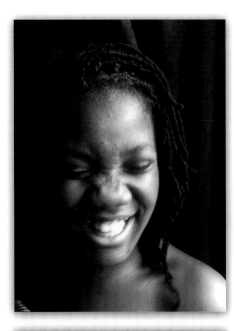

|8|

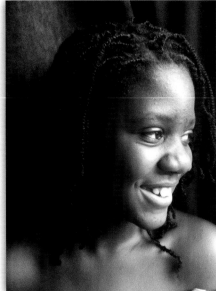

|9|

| 10 |

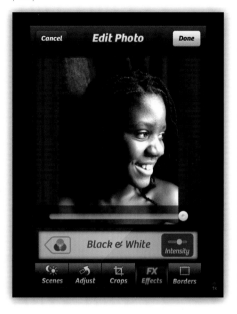

| 11 |

| 12 |

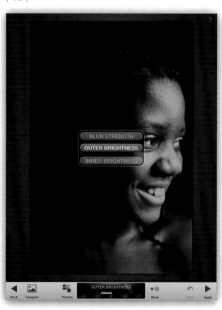

| 13 |

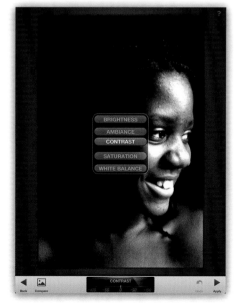

Step 2: Converting the Image to Black-and-White

I opened the image in Camera+ and applied a black-and-white filter within the **FX Effects** menu, and I adjusted the intensity slightly. When I had achieved the desired black-and-white tone, I saved the result to the camera roll | 10 and 11 |.

Step 3: Adding Center Focus and Other Adjustments

I opened the saved black-and-white image in Snapseed. Using the **Center Focus** option, I darkened the background to place more emphasis on the subject's face; I also created a soft blur and darkened the outer edges of the image to merge the detail from her hair into the background and make it darker.

Still in Snapseed, I further enhanced the tones and lighting by accessing the **Tune Image** menu and adjusting the brightness and contrast settings. These tools allow me to add subtle but effective contrasting tones to relatively flat images. Sometimes I play with the **Ambiance** setting, but too much ambiance tends to overexpose the highlights in an image. Finally, I saved my image to the camera roll | 12 and 13 |.

| 14 |

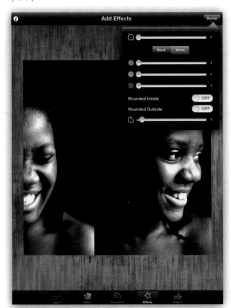

| 15 |

| 16 |

➤ Step 4: Placing the Images in Separate Frames

I opened Diptic, clicked on the layout option with the split screen, and pressed on each of the vacant windows to import the two images into each side of the split screen layout. I then used the **Transform** option from the menu tab to compose the image by moving the slider. I clicked on **Effects** on the bottom menu bar, clicked on the **Border** button (top right), and adjusted the border width to zero (I did not want borders). When I was satisfied with the composition, I saved the image to my camera roll | **14 and 15** |.

➤ Step 5: Blending the Images Together Seamlessly

I merged the two images in Brushes by creating a dark space between the photographs I composed in Diptic.

First I chose a brush stroke that is not too harsh—in this case, a nice speckled stroke. I always keep the opacity low in my brush palette so I can see the gradual buildup of tones blending seamlessly.

Depending on whether I use my fingers or a stylus as a painting tool, I adjust my brush size. I then picked black from the color palette, reduced the opacity of the color, and subtly built up the

dark tones to blend with the subject's skin tones. When I was done, I saved the image to my camera roll | **16 and 17** |.

➤ Step 6: Increasing Resolution for Print (Optional)

In the earlier steps, the image lost some resolution. Some apps do not save images at the iPhone's full resolution, and the image size can be reduced during editing. I opened the completed image in Filterstorm and upsized it. Several other apps, including iResize, Upsize, and Adobe Photoshop Touch, are also effective for resizing images.

| 17 |

Paula Gardener (jahsharn)

Paula is a wife and a mother of four wonderful children, and photography is her first language. She studied photography and fine art at various colleges in London, and she launched her own photography business in 2010. It wasn't until November 2011 that Paula realized the true potential and versatility of the iPhone. In 2012 she had the honor of exhibiting her work at the LA Mobile Arts Festival and has had her self-portrait work favorably mentioned in online national newspapers in London and the United States.
www.jahsharnphotography.co.uk

Summary

To create my photographic story, I captured images using the iPhone 4 native camera. Natural sunlight was a must to enhance my daughter's face. I used Snapseed to further refine and change the tones in the images. Camera+ provided some great black-and-white filters that I used to convert the image. I then used Diptic to merge the images, and I employed Brushes to blend out any gray or distracting lines. Finally, I used Filterstorm to resize the image.

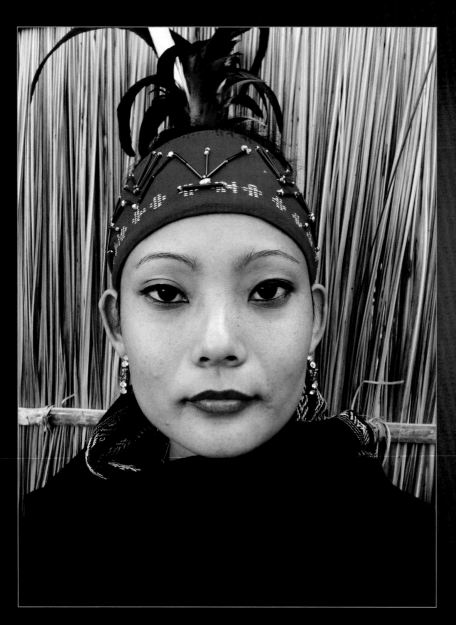

Beautiful Young Woman, Nagaland Festival, India

TUTORIAL 2

Create compelling professional portraits by focusing on composition and exposure with minimal apping

What You'll Learn

My goal was to create a portfolio of stunning cultural portraits that could be used for commercial purposes. You will learn essential techniques to maximize your chances of creating an outstanding portrait—including the position, exposure, focus, and lighting of your subject. You will also learn how to apply minimal apping to both enhance and refine your image.

Finally, I will share how, as an established professional photographer, I made the transition to shooting commercial-grade work with my iPhone and the tools and techniques I favor in my daily work.

What You'll Need
⊙ Camera+

Back Story

All the iPhone portraits in this tutorial were shot in Nagaland, a state in the far northeastern part of India. They were all shot as part of the Hornbill Festival, which is held in the first week of December and showcases the proud cultural traditions of 16 major tribes and subtribes.

The Process

I shot these images with my iPhone 5, with no auxiliary lenses or attachments | 1–6 |. I got a signed photo release from everyone I shot (with few exceptions) so I would have the authorization to license these images in stock photography, if I so desired.

☞ **Step 1: Setting Up the Shot**
I set up each of these photographs myself. In most cases I moved the subject to stand in front of different backgrounds that were free of distractions. I usually look for a simple and plain background so it doesn't compete with the subject for the viewer's attention.

☞ **Step 2: Taking the Shot**
I used the Camera+ app to capture all six portraits, and I processed them later with a wide variety of Camera+ filters (usually dialed down considerably in intensity) to get the exact look I wanted. With few exceptions, I intentionally shot in open shade to minimize harsh lighting on the subjects' faces. And with several of these portraits I used a white diffuser/bounce (Scrim Jim from F. J. Westcott).

As with most of my mobile photography work, I'm quite particular about getting the proper exposure, especially

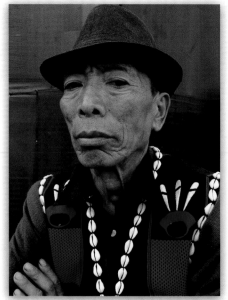

| 1 | *Tribal leader sporting a fedora*

| 2 | *Beautiful young woman*

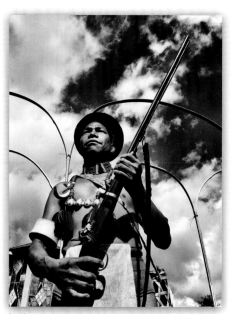

| 3 | *Tribal marksman*

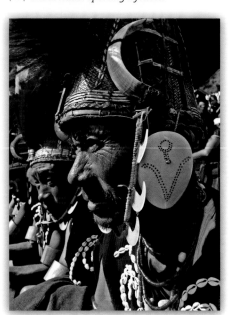

| 4 | *Black-and-white profile of Nagaland headhunter*

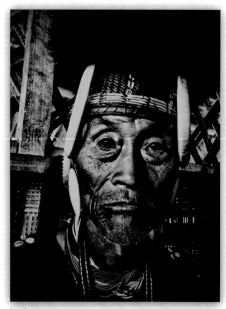

| 5 | *High-contrast portrait of Nagaland headhunter*

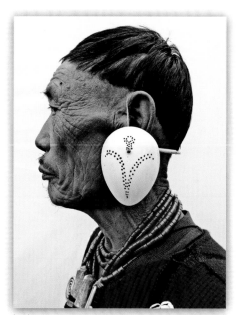

| 6 | *Headhunting tribesman showing off his earring*

with facial portraiture like this. I always use the dual reticle system (separate reticles for exposure and focus), which comes in quite handy. I normally lock the focus on the subject's eyes, then lock the exposure on some part of the subject's face (usually the brightest part).

➤ Step 3: Refining the Images

I tend to slightly underexpose my photographs rather than overexpose them. This allows me to recover detail in post-processing, as opposed to working with clipped highlights. For each of these portraits I shot a wide variety of crops (horizontal and vertical) and exposure brackets (some lighter, some darker). I then selected the exposure that was most pleasing to my eye.

In portraiture post-processing it is not uncommon for me to use the HDR slider at 10–15 percent to add some overall textural sharpening. And, as you'll probably notice, I'm a pretty big fan of black-and-white, monotones, duotones, and desaturated looks. These all seem more flattering and compelling in portraiture. Minimizing post-production processing (other than the Camera+ intensity sliders, which I previously mentioned) is what makes these shots, and many more like them, seem so arresting.

The following tips are the ingredients for successful portraiture:

- ❯ Expose for skin tones
- ❯ Bracket
- ❯ Minimize the background
- ❯ Desaturate whenever possible
- ❯ Make eye contact

My Favorite App: Camera+

All my images in this book were shot with my favorite camera replacement app, Camera+. It's simple, modern, clean, and intuitive. I latched onto it almost from the beginning of my career in mobile photography. It's far better to be a master at a few apps than to be mediocre with many.

I especially like Camera+ because it gives me independent control over both focus and exposure and allows me to lock them. Both of these adjustments are critical when exposing for portraiture.

This image of the tattooed professional model was taken with Camera+ in front of the infamous Lone Star beer bus near the Broken Spoke in Austin, Texas |7|. Generally speaking, when I shoot portraiture I set both my focus and exposure reticle points on the subject's face. I processed this image with the **Cross Processing** filter dialed down to about 50 percent.

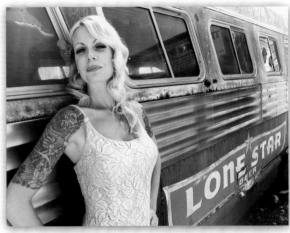

| 7 | *Lone Star model*

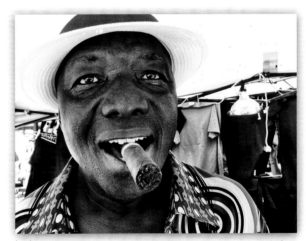

| 8 | *Cigar smoker*

The cigar smoker in figure **8** was tricky to expose. At first I set my Camera+ exposure reticle on his white hat (so I could retain detail), but his face became far too dark. Instead, I set

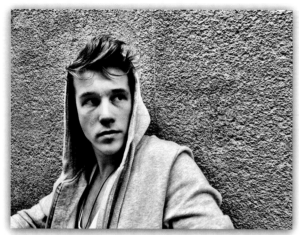

| 9 | *Stockholm teen*

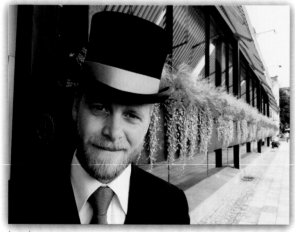

| 10 | *Concierge*

my exposure point on his face and let the hat and background go hot (over-exposed or high key). Then I used the Camera+ **Sepia** filter dialed down to about 40 percent.

I stopped to ask this guy in Stockholm, Sweden, if I could take his picture because I liked his look | 9 |. I love the magical Camera+ preset called **Clarity**. It doesn't have an intensity slider, so it usually doesn't work well with portraiture. However, in this case I elected to use the **Clarity** slider and then applied the **Faded** filter over the top. The combination of these two filters worked well and created a pleasing, desaturated look and feel.

I also took the concierge image | 10 | in Stockholm, Sweden, with Camera+. I took the exposure reading on this gentleman's cheek, and I applied the **Cross Processing** filter dialed down to about 50 percent.

Summary

To produce successful portraits to a commercial standard, I positioned my subjects in front of nondistracting backgrounds to draw attention to the subject. I experimented with different compositions and crops and used the Camera+ app to properly control exposure and focus on skin tones, and I used available light and diffusers to illuminate my subject. Finally, I used Camera+ filters to refine my images, including adjusting the HDR slider to add some overall textural sharpening.

To create spellbinding portraiture, the photographer must resist the urge to complicate the composition. The steps include the following:

- Strip the composition down to its bare essentials
- Make an emotional connection with the subject
- Get in and out as expeditiously as possible

There is no real magic here, other than ardently applying my mobile mantra: expose and compose. This is Photography 101, whether you're using a digital single-lens reflex (DSLR) or an iPhone!

MAKING THE PROFESSIONAL JUMP FROM DSLR TO IPHONE

I have been shooting assignment, stock, and personal work all over the world for the past 30 years, mostly with my DSLR kit—and now, more recently, with my iPhone 5. Mobile photography has, unquestionably, touched a nerve in me. I can't think of a single device, over my three-decade career, that has fanned the embers of passion, vision, and mission like my iPhone camera has.

I will go even further and say that the iPhone camera will likely be the most influential and popular device ever manufactured in the history of photography. There's something magical and moving about this pocket device that gives me— a world, lifestyle, and portrait photographer—unprecedented availability, accessibility, approachability, and even affordability. Mobile photography is so wildly and widely popular because of the seamless integration of key motivators—shooting, beautifying, and sharing.

In two short years I've managed to record more than 100,000 images with my iPhone. Not all of them are great. But there are enough gems to encourage me to stay the course and keep exploring, even harnessing, my iPhone as an incredible and lyrical capture device to record and celebrate life.

While many of my fellow mobile photographers are excellent at app stacking, blending, and compositing, I consider myself more of a photographic purist. I'm a global adjustment sort of guy, rather than an applicator of presets and filters. I spend more time adjusting the discriminating slider controls to get just the right levels of contrast, sharpness, saturation, and brightness. I rarely spend more than five minutes on post-processing an image. I shoot it. Tweak it. Share it. Done. Voilà!

Jack Hollingsworth (@Photojack)

Jack is an award-winning, 30-year veteran in commercial photography whose work has taken him around the world. Recently Jack fell in love with his iPhone camera as his primary capture tool. He is currently working on a long list of iPhoneography projects, including e-books, podcasts, webinars, apps, workshops, and photo tours—all aimed at sharing his mission, vision, and passion for iPhone photography as a teacher and evangelist. Jack has received the esteemed Kodak Award of Excellence and has been featured in a number of photography journals and magazines, both online and in print.
www.jackhollingsworth.com

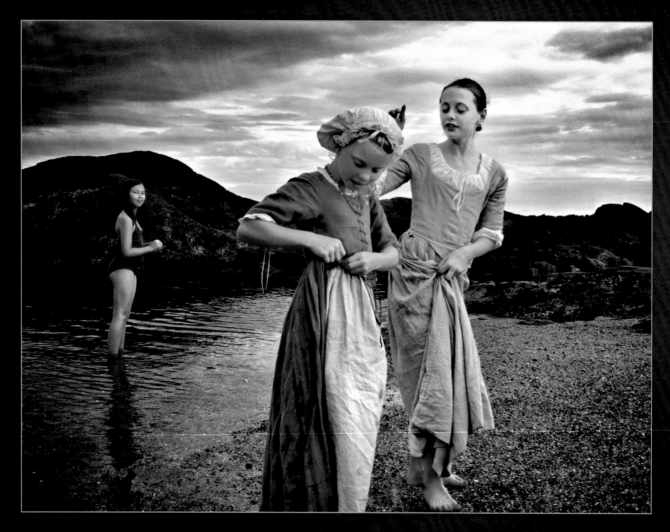

Juxtaposition of Tide

TUTORIAL 3

Create a dramatic, distraction-free image that draws in the viewer through lighting and color correction

What You'll Learn

In this tutorial I'll explain how to take a low-light, underexposed image and apply techniques to create an image that tells an inviting story.

What You'll Need

- ProCamera
- TouchRetouch (optional)
- Snapseed

Back Story

On a steamy, hot July afternoon I walked to the harbor near where I live, an old New England sailing town just bursting with history. I came upon a Revolutionary War reenactment, which is an annual event in our town. What first drew me in was the wonderful juxtaposition of two sisters dressed in period costume and the other children dressed in contemporary clothing as they played in the water. The light was low, and the green of the younger girl's dress was luscious. The older sister was lecturing the younger one, and both seemed utterly comfortable and natural, as if the other children were the ones who'd just stepped out of a time machine.

The sisters remained unconcerned and carried on with their banter, which is perfect for street photography.

I usually try to get as close to my subject as possible, and I rarely shoot straight on. I find myself on the ground a lot. To shoot the girls, I crouched down in the water to make the point of view more dramatic. Their indifference made shooting them effortless. The girl in the background noticed me but she didn't pose, which made the shot even more interesting. I didn't intend for her to be the focus of the shot, but her Mona Lisa smile just drew me in. Without her the image would still have been interesting, but the juxtaposition of time would have been lost | 1 |.

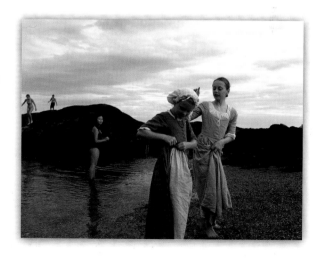

| 1 |

| 2 |

| 3 |

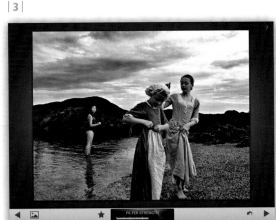

| 4 |

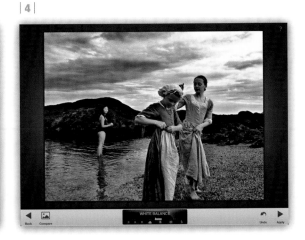

The Process

Step 1: Removing Unwanted Elements

The children on the rocks were a distraction. I opened the original image, which I shot with ProCamera, in TouchRetouch and used the **Brush** tool to paint them out of the picture, and I used the **Clone** tool to touch up smaller areas in the water | 2 |. I then saved the image and opened it in Snapseed.

Step 2: Adding a Dramatic Filter

To add a dramatic effect to the image, I selected **Drama**, then I tapped the **Star** icon and the **Drama 2** icon. Finally, I decreased the filter strength and then I tapped the **Arrow** icon on the lower right to apply the effect | 3 |.

I then reviewed the before and after by tapping the **Preview** icon before I applied the filter. This is an important step because after a filter is applied, you cannot undo it. If I didn't like the effect, I could have discarded it before applying it by tapping the arrow on the bottom left to return to the last edited image.

Step 3: Adjusting Color and Tone

Using **Tune Image**, I made overall adjustments to the color that had been lost when I applied the Drama filter. I held my finger on the image and swiped up or down to bring up the menu, then I swiped left or right to make an adjustment. The settings I chose were **Ambiance** +27, **Saturation** +25, **WB** +24. I then tapped the arrow on the bottom right to apply the effect | 4 |.

Step 4: Cropping the Image

After I saw the edited image, I decided it would be more dramatic to crop the girls more tightly, making the original removal of the other children unnecessary. It's in the nature of an artist to step back and assess the work in progress, so *c'est la vie!* I always save an uncropped version of my image, just in case. In Snapseed I selected **Crop** and tapped and adjusted the frame by pulling the edges (you can also set ratios, if desired). I tapped the arrow on the bottom right to apply the effect | 5 |.

Step 5: Making Detailed Adjustments

Because the light was low and the faces in the image were oversaturated, I wanted to select certain areas and adjust the saturation and brightness.

|5|

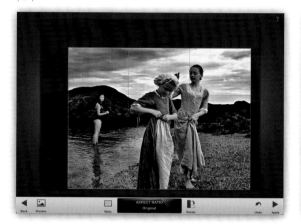

|6|

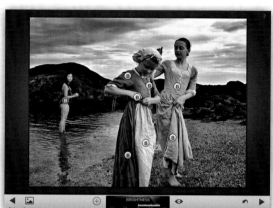

|7|

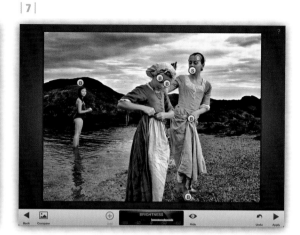

Snapseed is a very easy app to work with, and minute color adjustments can be made in **Selective Adjust**. I tapped the (+) icon, and a little circle appeared on the image. I tapped on the circle and it turned blue (active). I used the brightness button at approximately 50–100 percent in areas of the image that I wanted to brighten. I tapped the arrow on the bottom right to apply the brightness | **6–9** |.

➤ **Step 6: Adding a Vignette**
To apply a vignette around the edges I selected **Center Focus** > **Presets** > **Vignette**. I slid my finger across the image to adjust the intensity. I adjusted the image using the following settings: **Inner Brightness** 0, **Outer Brightness** –95, **Blur** 0. I tapped **Weak** in

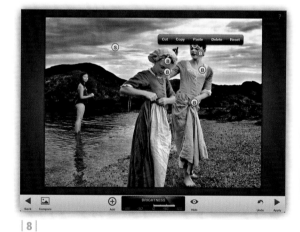

|8|

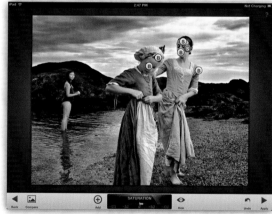

|9|

the menu bar | **10** |, and tapped the arrow on the bottom right to apply the effect. I saved the image to my camera roll by tapping the arrow in the upper right corner.

I felt as though I had captured the sisters out of time and place, and the onlooker in the image shared the secret with me. I titled this photograph *Juxtaposition of Tide* because the tides often bring us treasures and secrets

| 10 |

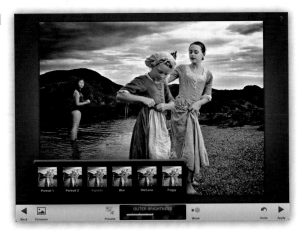

from another time and place and just as quickly sweep them away. This was my treasure from that beautiful day.

My Favorite Apps: Iris Photo Suite and Snapseed

Because I primarily shoot more realistic street photography and don't combine intricately layered and abstract images, I edit most of my work in Iris Photo Suite and Snapseed. Iris Photo Suite offers common editing tools like those found in Photoshop. Histogram, color balance, saturation, temperature, hue, masking, cropping, and layers are all intuitive and easy to use. A nice feature in Iris Photo Suite is ColorSense, which allows color replacement or creating color

within a black-and-white image by isolating the desired hue and converting the rest of the image to gray tones. If I'm feeling a little crazy, Iris Photo Suite offers about two-dozen special effect filters. The interface is easy to work with on both the iPhone and iPad.

Filterstorm and Photogene2 are more sophisticated and elegant across the board as general editing apps. They offer similar editing tools and more sharing options than Iris Photo Suite. I use Photogene2 more often since its upgrade from Photogene. Snapseed is also a favorite for tweaking and adding dramatic effects. It lacks masking and layers, but it's a powerful little app when layering isn't necessary, and I find myself using it frequently.

Summary

I shot this image with ProCamera, which offers more control than the native iPhone camera, such as setting exposure and focus point. It has editing features, but I don't edit on the fly; instead, I choose my favorite apps for post-shoot processing.

The light was fairly low behind the subject, but the skin tones were oversaturated and the overall temperature was too cool. A few other children were in the frame, and I didn't want to lose the shot by waiting for them to move, so I used TouchRetouch to paint them out of the image, and I used Snapseed to adjust the brightness, contrast, and saturation. I added some overall drama with the **Drama** filter, and I used the **Crop** and **Vignette** tools to eliminate distracting details and draw attention to the main subject.

Christine Sirois (Stina)

Christine works as a creative director in Massachusetts. She studied at the Art Institute of Boston and has been making up stories with pictures from a very young age. It wasn't until she discovered the iPhone and iPhoneArt.com that her passion for creating beautiful photographs truly caught fire. She has been recognized as Artist of the Day on iPhoneArt.com several times and Artist of the Month in March 2011. Her work was exhibited at the LA Mobile Arts Festival (2012).
www.iphoneart.com/Stina

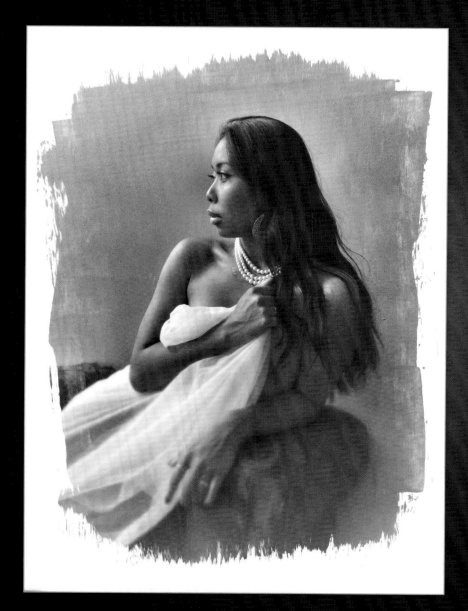

Kitava

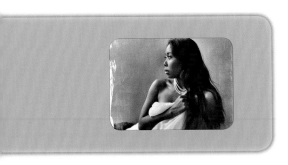

TUTORIAL 4

Create a soft, vintage-style, intimate portrait

What You'll Learn

In this tutorial you'll learn how to create a vintage-looking portrait, do the necessary image repair and touch-up, add a tilt-shift blur, and combine two images. Finally, you'll learn how to replicate the effect of a hand-applied emulsion and combine the emulsion look with the base image using blending modes.

What You'll Need

- Camera+
- TouchRetouch
- Snapseed
- Image Blender
- Lowell DP light or similar (optional)

Back Story

I love timeless portraits that look as if they could have been shot last week or last century. Within this genre I gravitate toward dark, moody, provocative imagery. I'm a big fan of Albert Watson and was inspired by the images in his coffee table books that were printed on paper using a hand-applied emulsion technique. In his photos, you can see the actual strokes and edges where the emulsion was brushed onto the photo

paper. The technique I use in this tutorial mimics that look.

The Process

➤ Step 1: Capturing the Image

The image was captured on an iPhone 4S using the Camera+ app rather than the native iPhone camera | 1 |. This camera app allowed me to keep exposure where I wanted it—that is, in a range that would preserve detail in all the skin tones. The lighting consisted of a Lowell DP light pointed toward the ceiling,

| 1 |

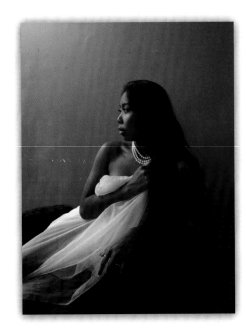

|2|

|3|

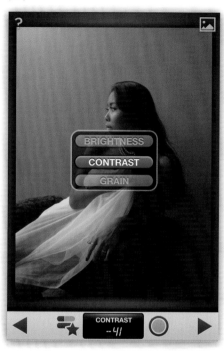

|4|

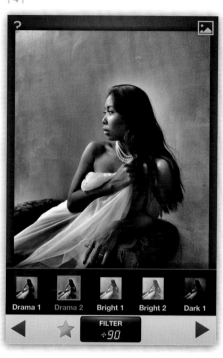

which created a broad, soft, light source without any hard shadows.

► Step 2: Retouching the Image to Remove Unwanted Elements

The first step in processing was to use the TouchRetouch app to repair the scratches and holes on the studio wall |2|.

► Step 3: Snapseed Adjustments

Using Snapseed, I selected the **Black and White** button, which converts the image to black-and-white and also allows me to make adjustments for **Brightness** and **Contrast** |3|. Because the iPhone camera hardware captures with such a high level of contrast, I always decrease contrast at this point. In addition, subsequent steps in my process are going to add contrast by default. Contrast is decreased in order to maintain detail in the highlights: I don't want any groups of pixels to appear solid white or solid black. I want every part of the image to contain visual information.

Within the **Drama** tool I used the **Drama 2** option, which adds a bit of a fake HDR look. Here it worked to reveal a desirable texture on the studio wall |4|.

Using the **Tilt-Shift** tool I added a horizontal blur |5|. This replicates the look of the shallow depth of field found in images shot with large format cameras (e.g., 4×5 and bigger). I like to blur portions of my portraits to create a bit of a dreamy, mysterious feel. Also, for nudes, it helps the images appear less overt in the details.

|5|

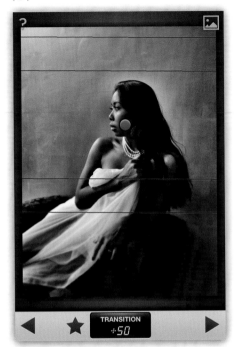

|6|

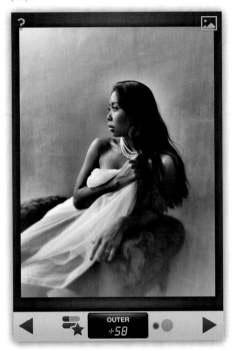

|7|

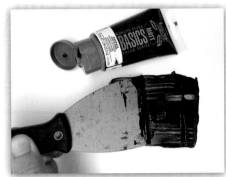

|8|

I keep a close eye on my images when adding blur. Combining blur and black-and-white gradation often results in some ugly banding that can't easily be seen on the iPhone's screen. Therefore, at this point, I usually export the image to my computer to see how the image is holding up. Sometimes things look great on the three-inch wide iPhone screen but may look horrific on a full-sized monitor. I want all my images to look great on the desktop *and* in print, so if I identify any problems at this point, I'll make changes or abandon the current process altogether. This image held up well, so I saved it to the camera roll and went on to my next step.

Using Snapseed's **Center Focus** tool, I selected **Outer Brightness** and lightened the edges (i.e., added a light vignette) |6|.

Step 4: Creating the Hand-Applied Emulsion Look

My "emulsion" is just a simple photo of black acrylic paint on white foam core board |7 and 8|. The paint moves easily

| 9 |

| 10 |

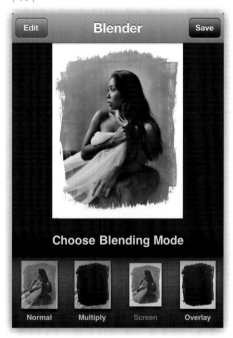

Summary

To create my vintage-looking portrait, I posed my model and created a soft portrait right in the camera by using a broad light source (with the light pointed toward the ceiling). To give it a vintage feel, I converted the image to black-and-white. The vignetting and tilt-shift effects mimic the look of a large-format film camera and de-emphasize the outer parts of the image (e.g., the hands). Blending the photo with an image of a black paint swatch mimicked the darkroom technique of hand-applied emulsion on photo paper.

on the board's slick surface. You can get multiple variations by applying the paint, photographing it, and then adding more paint or pushing it around with a different tool—taking shots along the way.

After selecting a paint image, and while still in Snapseed, I crop and add contrast, making sure my whites are indeed white, which is important when blending layers.

➤ **Step 5: Combining the Two Images**

In Image Blender, I used the button on the lower left to choose my emulsion image from my camera roll | 9 |. Using the button on the lower right, I chose my portrait. I entered **Edit** mode by selecting the center icon in the top menu and chose **Screen** for the **Blending Mode**. After selecting **Edit** again, I used the slider tool to do some fine tuning | 10 |.

MY APPROACH TO COMPOSING AND CAPTURING IMAGES

I attempt to achieve the best possible image during the capture, thus minimizing the need for heavy cropping or repairs.

The iPhone's small dynamic range means that dark areas will easily appear completely black in your final image. At the same time, the light values can easily go completely white. Once these areas go black or white, it means those pixels contain no information and therefore, no editing tool can bring back that lost information.

All digital cameras (from DSLRs to iPhones) capture more contrast than what we see with our eyes, and the iPhone's limited dynamic range results in particularly contrasty images. To demonstrate this, use your iPhone to shoot a white piece of paper in even light and you will see that the image does not maintain a consistent value.

Controlling light and contrast values as much as possible is important to me in a portrait shoot. It's very challenging, but I find the successes rewarding.

It's essential to shoot with an app that allows me to control exposure. In this case, I used Camera+. The next key to a successful image is to understand the color and brightness values in the scene. For example, I knew that the red wall would become a pleasing gray tone when converted to a black-and-white image. The white fabric reflects light well while keeping the exposure down, which, in turn, retains detail in the subject's skin. If I were to use a black fabric, the camera would open up and the skin would be over exposed. Camera+ helps me to control exposure to some extent.

In a scene like this, the position of the lighting, the color of the fabric, and the composition are adjusted until all elements maintain detail in the capture. Once I have that detail, my editing options are wide open. If more contrast is needed later, it can easily be added with most any app.

Doug McNamee

Doug has been a professional photographer for more than 20 years. He specializes in event and portrait photography and had studios in Seattle, Tokyo, and Taipei before settling in Los Angeles, which is now his home. After he got his first iPhone in 2009 it became one his favorite photographic devices. Doug also enjoys teaching iPhoneography and offers workshops in Southern California. His iPhone work has been featured in a number of exhibitions, including the LA Mobile Arts Festival (2012). *www.iphoneart.com/dougmcnamee*

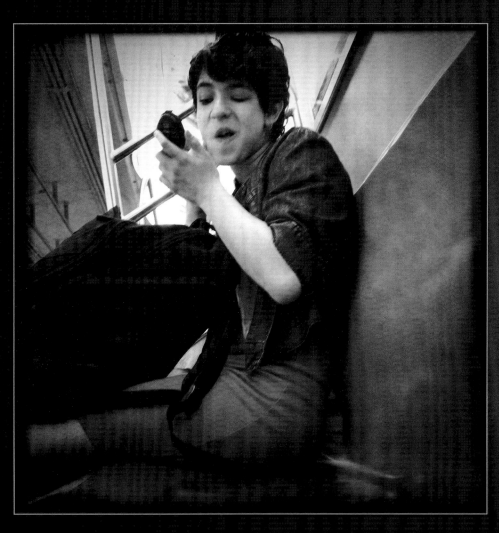

Zoe

TUTORIAL 5

Capture and create stories and emotions on the street

What You'll Learn

Ubiquitous, discreet, one-handed, and ostensibly for purposes other than taking photos of strangers, the iPhone is an ideal tool for shooting street photography. In this section you'll learn ways to approach street photography with the iPhone, including tips on how to choose subjects, frame your shots, and tell your stories.

What You'll Need

- Hipstamatic
- Hueless
- Filterstorm
- Snapseed
- Camera+
- TouchRetouch
- Juxtaposer

Back Story

I have always been a street photographer, though I've been a practitioner for only two years. The iPhone has allowed me to embrace that latent part of myself that is constantly seeing, watching, and noticing characters and stories around me. I was initially attracted to the iPhone as an instrument for street photography for the most obvious reason: inconspicuousness. You may think I'm playing a game, reading an e-book, or listening to music (this is my favorite ruse because it adds an extra level of misdirection, and the shutter release seems like headphone volume control), but I'm not. I'm taking your picture. As time went on, though, I became more forthright with my shooting. I worry less about not being noticed and more about being ready and equipped to capture the emerging story or portrait for maximum effect.

And then there are the apps—endless variations of editing choices and options resulting in endless versions of images. They served me well during my initial obsession, but I have shifted to a less-is-more approach. I use four apps in regular rotation: I shoot mainly with Hipstamatic, and my go-to editing apps are Filterstorm, Snapseed, and Camera+. I realized that if the clarity of insight, story, or character is not captured in the initial image, no amount of editing can tease it out. In this tutorial I will share my thinking about how to shoot on the street using the iPhone as your eye.

The Process

➤ Choosing a Subject: Christopher

My favorite place to shoot is on the New York subway system. People are never more themselves in public than when they are faced with an unavoidable, sometimes crowded commute where their personal space is limited and eye contact is hard to avoid. New Yorkers are masters of being alone in public. The method is simple: pretend no one else exists, even though people might be so close they can touch you. People let their guard down. For some it is a welcome, brief respite from an overscheduled day. Others cling to it as a pocket of "me" time. Or they daydream and drift off to a better place, or sometimes they wallow in the present day. Some use it as a time to prepare for their destination; they review documents or their appearance, or they shut down and reboot in anticipation of the city stresses that await them. There is an unspoken rule on the New York City subway: avoid eye contact; look, but do not see. As a street photographer I break this rule every day, with my iPhone as my eye, to capture New Yorkers in their most honest moments.

I don't attempt to capture an objective reality. Some people practice street photography as a window to reality, but I see it more as a conduit for self-expression. My own worldview, thoughts, and feelings are transposed unknowingly onto others at moments when they trust me not to see them as they are.

The majority of my subway work happens on my own commute. It's a cliché to remark on the incredible range of humanity on display in a New York subway car, but it astonishes me every time I enter one. To capture an image of every person on any given subway car is to end up with a beautiful collection of portraits. But the subjects that intuitively speak to me are the direct result of how I feel at that moment. When I enter a subway car, I don't necessarily look for a type of person, or a certain interaction or situation, or someone that stands out in a crowd. It's much more intuitive than deliberate. What I'm looking for is potential. Sometimes the most average, inconspicuous, unremarkable subjects yield the greatest insight, the most powerful emotions. Sometimes that guy with the giant hair carrying a large chicken is the one you want to shoot (actually, if you see a guy fitting this description, he is *always* the one to shoot). I scan the car with both eyes and my instinct. I allow myself to be attracted to a subject that speaks to me in ways I cannot necessarily articulate with words. I never make eye contact with potential subjects, and I look for the small, telling details out of the corner of my eye. I don't attempt to articulate why I pick one subject over others; I trust myself!

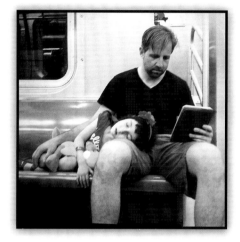

|1|

I was immediately drawn to this pair, this father and daughter, probably because I am a parent of a little girl myself |1|. I felt the small details draw me in when I sat across from them—the paternal, enveloping hand on knee, the girl's abandonment to a deep sleep, and the exhaustion betrayed by the father's face—but these details did not consciously register with me. Street photography is feeling. Look, not with your eyes, but with your instinct, sense the elusive quality that is there to be captured, and shoot before it's gone.

|2|

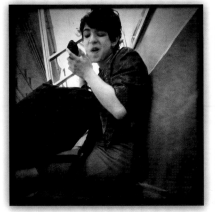

|3|

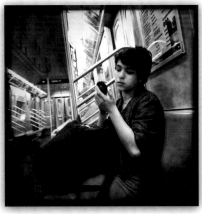

|4|

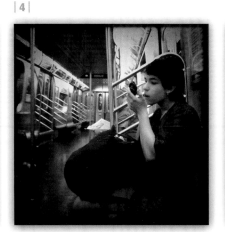

|5|

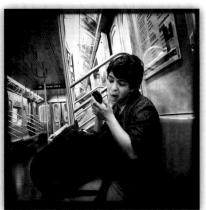

I develop this sense by shooting every day and everywhere; I shoot everything and everyone. Trial and error works. When I began to sense what makes a great image, I started looking for similar moments. I used to be afraid that I'd miss a moment if I did not shoot continuously. But I soon realized that if I hold back and wait for the moment, the images I capture are much more effective and true.

I like to name my subjects. Choosing the right name can help me emphasize what the image communicates to me. I named the father in this photo Christopher; the name of the patron saint of travelers. Also, the name Christopher, for me, connotes decency and loyalty, two qualities the father projects in the story that I created for him. Naming the people allows them to preserve their real identity, and it allows me to borrow them to tell a story of my own—one that is not their reality.

Setting Up the Shot: Zoe

A lot of my work is done from the hip, that is, aiming the camera without looking at the iPhone's display screen. Because it is small enough to be carried and operated with one hand, the iPhone allows an intimacy in street photography that I cannot achieve with an actual camera. I can get close with the iPhone; I can get low angles or high angles without having to break my cover. I'm not the most technical of photographers, so I appreciate that I don't need to worry about focal lengths, f-stops, or exposure with the iPhone, and that I can just silently point and shoot.

Shot composition depends on a number of mutable factors, the main one being where I can position myself without drawing attention. I practice a balance of discretion and assertion, doing what I can to get where I need to be to capture the subject and what interests me about him or her.

I sat next to Zoe, as I named her, to catch her exaggerated facial expressions as she applied makeup. As I started shooting, first tightly and from a low angle, I became aware of her position relative to the rest of the space. I realized that the empty car behind her provided a context for a much more interesting story. In figure 2 Zoe makes an interesting face, but the low angle

| 6 |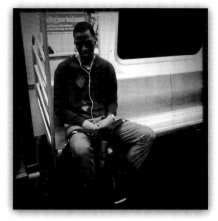 | 7 |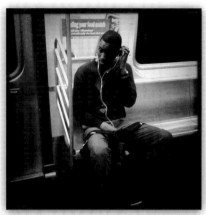 | 8 |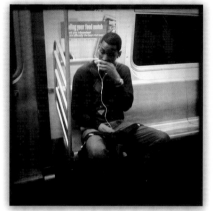 | 9 |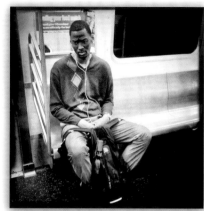

is not compelling beyond an embarrassing moment. In figure 3 I used a higher angle and included more of the background. The perspective provided by the vanishing lines of the empty car improved the story I suddenly realized I was going to tell. Zoe is preparing herself for her destination by fixing herself up, but her activity is one we usually do privately. She is acting as if she's alone, but she's in a public place. In figure 4 the angle and perspective are almost perfect, but Zoe is not captured in an unusual pose that communicates the public space/private act dichotomy. Figure 5 finally brings it all together; the composition and subject work in unison to tell the story.

I did not start out knowing what story I would tell or what composition I would create, but as I invested more of myself in the process, the image revealed itself to me. Most importantly, as my composition changed, I became more and more inconspicuous. Zoe is alone in a public space. I do not exist in her mind or in the mind of the viewer.

➤ **Choosing a Moment: Calvin**

I chose Calvin as a subject because his posture was both objective and subjective—the way the straps of his backpack were wrapped around his legs and the sense of social and emotional isolation in his expression and posture. I know that a high angle looking down on a subject communicates a sense of loneliness much more effectively than an eye-level shot, so I stood across from him and off to the side to emphasize the empty seats beside him. I shot these three exposures in quick succession.

Looking at these shots, as one would a contact sheet, it becomes clear that figure 6 is the most effective at communicating a sense of isolation and loneliness. Figures 7 and 8 tell other stories: absentmindedness, concentration, forgetfulness. But those were not the qualities that drew me to Calvin. I used Camera+ and Filterstorm to modify the image | 9 |, mostly to illuminate and clarify Calvin's eyes, which are the heart of the shot and are crucial to the communication of emotion and story.

➤ **Telling a Story: Adam**

I chose to sit across from this couple to capture the unfolding narrative: the woman was weeping and talking,

| 10 |

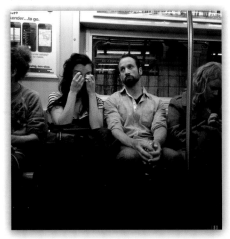

| 11 |

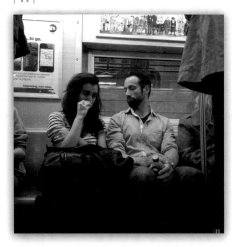

| 12 |

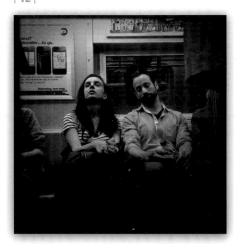

| 13 |

| 14 |

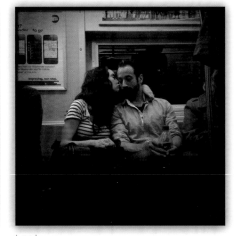

| 15 |

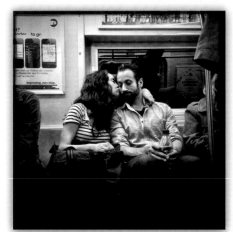

while the man, who I call Adam, was alternately at a loss for what to do and attempting to console her.

Although I took many shots of the couple | 10–15 |, I did not feel that any one photo captured the story of the woman's despair and the man's frustration with his own ineffectiveness. The genuine love story that was being told to me by these two unsuspecting strangers translated into my camera as one of triviality and disinterest, but I did not want to tell a different story from the one I experienced.

One of the greatest skills a street photographer can develop is the ability to anticipate what comes next, whether it is a facial expression, a turn toward the lens, or the continuation of a story. Accuracy of anticipation and the split second it gives you to adjust your approach—whether it is your position relative to the subject, where you hold the camera, or the gear you use—gives you an edge that allows you to be prepared for that clarifying moment. The narrative inevitably coalesces into a brief, unique moment of behavior and emotion. I do not profess to have mastered this Kreskin-like ability, but in this instance I sensed that the story was not fully told. I switched to one of my favorite Hipstamatic combinations: John S lens and BlacKeys SuperGrain. I put on

my best disinterested face and watched out of the corner of my eye.

When I looked at these images in succession, it became clear that the last image | 15 | is not only the most successful at conveying the sad yet beautiful emotion I witnessed, but it also tells the whole story leading up to that moment. I used Camera+ and Filterstorm to complete an image that tells a universal love story, not just the one I witnessed. This single final frame communicates tenderness, love, and intimacy. It encourages the viewer to construct the story, to wonder what happened before and after, to identify and empathize with the subjects.

My Favorite App: Juxtaposer

"Not everybody trusts paintings, but people believe photographs," said Ansel Adams, and that's especially true of street photography and other journalistic genres. With Juxtaposer I sometimes like to subtly (or not so subtly) test that theory. Juxtaposer allows me to stretch, enlarge, shrink and multiply specific elements of a street image to give it a touch of surrealism.

I usually try to make minor changes, so as not to call them into question, and use the same photo as both the

| 16 |

base image and the top image. As an example, in the original image for Max, I was struck by the subject's fingers and wanted to emphasize their length. Working on one finger at a time, I elongated them ever so slightly and added a new top image for each alteration until I achieved the desired effect. I also used a new top image to heighten the hood of his jacket a tad to complete the otherworldly look | 16 |.

Because my work is mostly street photography, and it is therefore based on a reality of sorts, people populate my images as objective representations of daily street life, even when I go so far as to double a subject by shooting a sequence of two or three images from a fixed position and then combine the images in Juxtaposer.

| 17 |

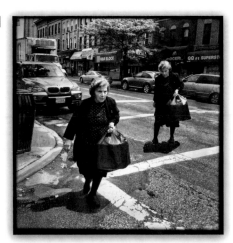

"Wow! They still dress the same!" is a common remark I hear about this image of Svetlana and Svetlana | 17 |. Don't be afraid to use Juxtaposer (and any apps you see fit) to experiment and play with your street photography, beyond contrast and brightness, and in ways that transcend expectations of the genre.

Summary

I hope this tutorial has given you some new ways to approach your art and craft. Here are some important points to remember:

- ❯ Trust your instinct when shooting mobile street photography.
- ❯ Don't over-think why a particular subject appeals to you.
- ❯ Let your instincts guide you.
- ❯ Take advantage of the iPhone's innately discrete nature to find the best shooting position while not drawing attention to yourself.
- ❯ Practice both assertiveness and discretion while shooting from the hip (i.e., without looking at the display screen).
- ❯ The moment or insight should be valued above all other considerations.
- ❯ Without a story or character, beautiful light means nothing more than beautiful light.

Finally, shoot, shoot, and shoot some more! Not only will it improve your ability to capture real characters, stories, and emotions, but also happy accidents will occur where unintentional framing, composition, and subject combine to create a unique image.

Sheldon Serkin (@shelserkin)

Sheldon Serkin has been shooting street photography in New York City with an iPhone since 2010. Since that time his work has been featured on websites such as iPhoneography.com, LifeInLoFi.com, iPhoneographyCentral.com, EyeEm.com, lysfoto.org, and gothamist.com. He is currently preparing Awful Bliss, his first book of street photographs. In February 2013 Sheldon was honored as the iPhone Artist of the Month on iPhoneArt.com. He lives in Brooklyn, New York. *www.flickr.com/photos/39186421@N04*

DAVID INGRAHAM · UNITED STATES

Rat Race

TUTORIAL 6

Create a black-and-white noir-esque street composite with a graphic-novel aesthetic

What You'll Learn

My goal was to create an image I had preconceived in my mind's eye by combining street images I'd previously taken to create a fictional reality. This tutorial will show you how to blend numerous images together and add a sense of motion as well as texture and mood.

What You'll Need

- ProCamera
- Squaready
- tadaa
- Image Blender
- FocalLab
- Cameramatic
- Snapseed

Back Story

One morning I awoke with this image stuck in my head. Was it from the lingering residue of a dream? Who knows? What I did know was that trying to capture it the way I was imagining it would be difficult, if not impossible. So I proceeded to go digging through the myriad accumulated images on my iPhone to see if I had the necessary materials to *create* it instead. Fortunately, I did.

| 1 |

Normally my images come from wandering the city streets, trying my best to get a straight-out-of-camera shot—to capture some sort of decisive moment or appealing composition—even if I frequently alter its appearance later for effect. But every now and then I'll get a preconceived idea in my head, and then the challenge is to find it in the streets, or in this case, try to create it via a compositing approach.

The challenge with this approach is to always match the light and perspective properly in order to give the image a certain degree of believability. In this case the image of the skyscrapers was shot looking up, with the inevitable distortion of lines that you get from a normal camera lens. So I had to find images of people for the foreground that were taken from that same perspective.

| 2 |

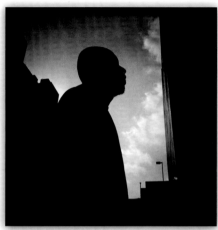

| 3 |

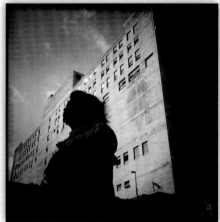

| 4 |

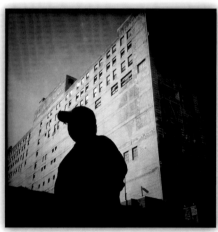

| 5 |

Fortunately, I'd spent a few minutes one late afternoon sitting on a downtown L.A. sidewalk (probably looking like a homeless person), grabbing shots of peoples' silhouettes as they walked by. I'm glad I did, because they came in quite handy for this project!

Five separate photographs were used for the composite | 1–5 |.

The Process

➥ **Step 1: Adding Space to the Bottom of the Background Image**

I knew this image of downtown L.A. skyscrapers—taken with ProCamera—would work nicely for what I had in mind, but I wanted it to be a square-format image, and somehow I needed to add an area below the buildings for the pedestrians. The only way I could think of doing this was to drag the image into Squareready and move the rectangular shot to the top of the square space, while also choosing black for the color of the additional space at the bottom | 6–9 |.

| 6 | | 7 |

| 8 | | 9 |

Step 2: Inverting Image to a Negative and Blurring Bottom Area

After saving the new square image at the highest resolution possible, I imported it into tadaa, applying the **Otherland** filter, which gives an image a negative effect. Besides wanting to create a strange, surreal sort of look, I also needed some way of making the silhouettes of the people in the foreground stand out, so I thought this inverted effect would work nicely | 10 |.

Within the same app, I applied the tilt-shift effect to the bottom third of the image in an attempt to create a subtle transition from the blank area into the actual image | 11 |.

| 10 |

| 11 |

Step 3: Adding People to the Scene

Using Image Blender (my go-to blending app) I added the first of the four pedestrians to the scene, meticulously erasing all the other surrounding elements from the photo, leaving only the silhouette | 12 |. I'd taken all of these silhouette shots using one of my favorite apps— Hipstamatic (using the John S. Lens/ BlackKeys SuperGrain combo, which gives you really punchy, strong-contrast silhouettes). I blended the first image on the **normal** setting and then saved it | 13 and 14 |.

| 12 |

| 13 |

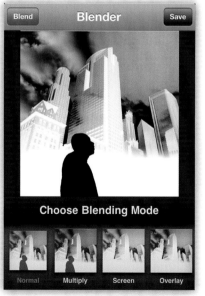

| 14 |

| 15 |

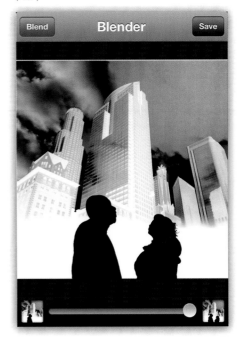

| 16 |

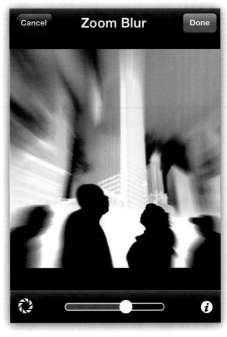

| 17 |

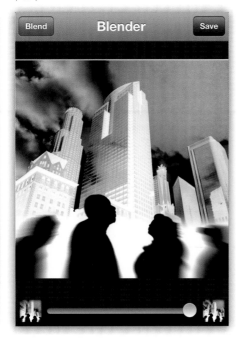

Adding the other three people to the scene, I repeated this exact process each time, saving the image after each person was added and then importing it back into Image Blender to add the next person | 15 |. (In retrospect, I could have simplified this process simply by "flattening" the two images each time I added a new person.)

☞ Step 4: Creating a Sense of Motion
I wanted to create that chaotic big-city feeling of people rushing along the streets, going about their respective business while ignoring each other. To accomplish this, I chose to import the image into FocalLab, adding the Zoom Blur effect. This certainly isn't the only app that will give you this effect, but I like how it lets you adjust the direction of the blur with the swipe of your finger, and gives a nice grainy look as well. Once I adjusted the blur effect to my liking, I saved the image | 16 |.

While wanting a sense of motion for the people, I clearly *didn't* want it for the buildings, so once again I imported the image into Image Blender, carefully masking the top of the un-blurred version with the bottom of the blurred version. I blended once again on "normal," then saved the image | 17 |.

☞ Step 5: Adding Grit and Grime
With the meticulous work out of the way, now was the fun part. Importing the image into ScratchCam, I went searching for a layer of texture to give the shot a bit of urban grunge, as well as filling in the bright, blank areas of the image. I settled on a filter I liked, adjusted its strength to my liking and

| 18 |

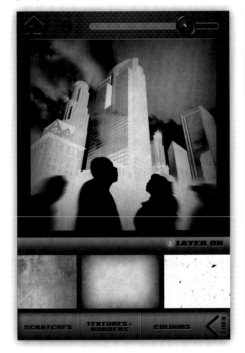

| 19 |

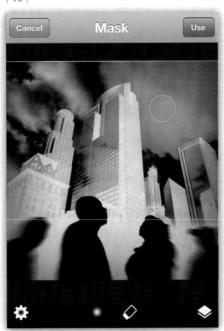

| 20 |

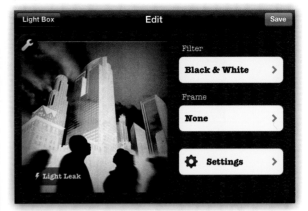

| 21 |

saved the image | 18 |. Because I wanted the texture to be on the street but not so much on the sky, I brought the image back into Image Blender for the last time and masked most of the Scratch-Cam FX effect out of the sky | 19 |.

➤ **Step 6: Converting to True Black-and-White**

I then imported the almost-finished image into Cameramatic, adding the **Black & White** film filter, giving it a strong,

grainy look, as well as adding a subtle vignette | 20 and 21 |.

Reaching the homestretch, I made a few last-minute tweaks in Snapseed—a small crop from the top, darken a bit, up the contrast a notch—and I was finally done.

I titled the finished product *Rat Race* after a quote from Lily Tomlin that I always loved: "The trouble with the rat race is that even if you win, you're still a rat!"

| 22 |

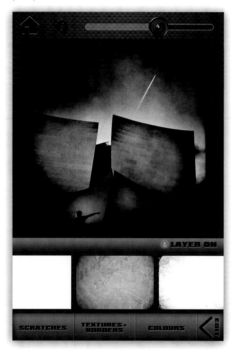

| 23 |

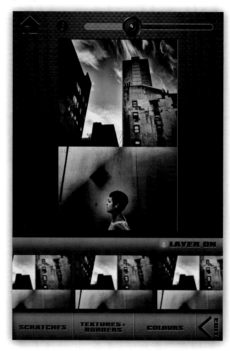

My Favorite App: ScratchCam FX

ScratchCam FX is one of my favorite icing-on-the-cake apps. It's very intuitive and perfect for adding that extra dash of grit to your images. If you're into down-and-dirty urban street imagery, a subtle use of ScratchCam can take your images to the next level.

As most apps do nowadays, Scratch-Cam gives you the option of shooting directly from the app, using the native camera, but if you're like me and have your favorite shooting apps, you can easily import any image from your photo album.

ScratchCam allows you to apply a combination of any three different filters at once, or turn off the others, using just one at a time. By continually tapping on the **scratch/texture/color** filter of choice below the image, you get three different variations of that one particular filter effect; and by using the slider at the top, you can adjust the amount to your liking.

If you want to apply one filter stronger than another, you can adjust the strength of one with the other one turned off, and then touch the **stamp** tool, which will save that filter, allowing you to stack another filter on top of the saved one. This process can be repeated until you've got your own custom filter that can then be saved and applied to future images.

ScratchCam can also be used as quick and easy way of desaturating a color shot, simply by adding one of their monochrome filters and then using the slider to back off the filter to your taste.

For anyone wanting to give Scratchcam a spin before deciding to purchase, there's ScratchCam Lite, which offers 55 different texture, layer, and color options. If you like what you see, the full version offers no advertisements, full-screen preview, the ability to save your favorite presets, access to free texture packs, and best of all, it saves at full resolution!

Summary

To pull off this composite endeavor, I used shots that were taken with Pro-Camera as well as with Hipstamatic. I used Squareready to help me create the proper dimensions for the backdrop,

tadaa to invert the background to a negative image, Image Blender to blend the five images together as well as adjusting texture masks, FocalLab to create a sense of movement, ScratchCam FX to add some urban grit as well as to fill in some highlights, Cameramatic to convert to monochrome and add some grain and subtle vignette. And last but not least, Snapseed for some final minor adjustments.

David Ingraham (D. Ingraham)

Los Angeles-based musician and photographer David Ingraham has been passionate about photography for many years. However, it wasn't until he acquired his first iPhone that his all-consuming iPhoneography obsession began. Although David has been earning his living as a full-time musician for more than 15 years, he spends most of his free time shooting and obsessing about photography. A number of his images can be licensed through Getty Images, and he was honored with a 12-page spread in Fine Art Photo magazine (issue 11). David received three awards in the Mobile Photo Awards 2013. *http://davidingraham.zenfolio.com*

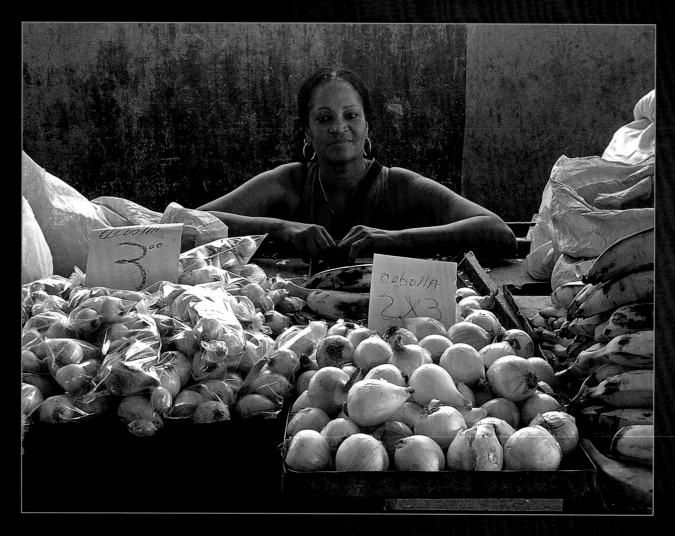

Farmers Market, Cuba

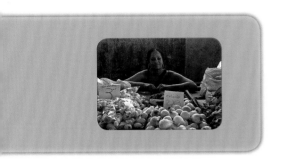

TUTORIAL 7

Create an infor-mal, engaging street portrait with minimal processing

What You'll Learn

As a relative newcomer to using apps exclusively for post-processing my iPhone images, I will show you how I use a very basic and largely intuitive ap-proach for creating an artful image with fairly uncomplicated tools.

What You'll Need

- ❯ PerfectPhoto
- ❯ PhotoToaster

Back Story

With street photography my goal is to create an enhanced artistic image with-out destroying the original integrity of the story or circumstance, so I try to avoid the look of post-processing. I want my images to be absorbed first as a story, not by the techniques used, so my post-processing is entirely a means to an end that takes the image from snap-shot to art.

This image of the woman selling on-ions at a farmers market in Cuba is part of a series of photographs in my book, *La Belleza y Tristeza de Cuba (The Beauty and Sadness of Cuba)* |1|.

The book is available at Blurb.com: www.blurb.com/bookstore/detail/3512264.

|1|

I went to Cuba in April 2012 with a group of photographers, knowing little about the country other than what I had absorbed through the years. I am not a political person, but I am old enough to remember Cuba as a once-upon-a-time playground for the wealthy.

The first thing that struck me about Cuba was the poverty. We have poverty here in the United States, but it is not so pervasive. There it seemed that every-thing was old and decayed, and every-one was begging, even the children. The crumbling buildings, the rubble on the streets, and the iconic and colorful cars are symbolic and symptomatic. Because

there are no new cars, the cars are kept running by whatever means possible—including machining parts, swapping parts from different cars, etc. The Cubans have little choice: there is no new anything and no money for repairs.

I became aware that the Cubans have few material goods and conveniences that we take for granted. One of my friends said that material goods aren't required in order to be happy. That is true, but many Cubans are too young to remember the good times when Cuba was an economic leader. There are no kitchen appliances due to the unstable electrical system, and basics such as food, toilet paper, soap, and toothpaste are rationed. The schools don't have enough supplies, and there are few personal supplies, like cosmetics. There is no Internet. What struck me about all this is that it is not about being happy or unhappy, it is about the lack of opportunity to live better, to travel, to be educated, to explore, to experience, and so on. There has been no progress in Cuba for many years.

I shot some 4,000 photos with just my iPhone. The rest of my group in Cuba had heavy equipment; some even wore harnesses to accommodate two or more heavy cameras with monster lenses, plus backpacks filled with more lenses, tripods, flashes, etc. They did not view me as a serious photographer.

I am a somewhat lazy photographer. I never carry a tripod and rarely use a flash. On a peripheral level, I am aware of light and composition, but it's not something I think about consciously. All the images in my book were shot with only available light and were processed on my iPhone or iPad.

I found the Cuban people to be warm and friendly, and it was a privilege to be invited into their homes to photograph. My images are not posed, but neither are they completely snapshots. People were very gracious and appeared happy to have visitors from the U.S. who were interested in them. Perhaps shooting with my iPhone helped me get closer to people—perhaps they were less intimidated. I think this is where the Marian Rubin app takes over. It's about seeing, feeling, and relating to people.

Shooting with the iPhone has freed me from many of the restraints and rules of more traditional cameras. This trip to Cuba, the 4,000 images I shot, and the subsequent book has pointed me in new and exciting directions in my development as a photographer and as an artist.

The Process

I took the initial image with the native iPhone camera | 2 |.

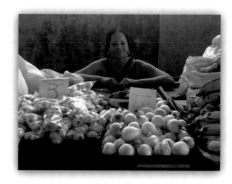

| 2 |

⬛ Step 1: Making Minor Image Adjustments

The image required no cropping, in my mind. It was, however, a little flat. I opened the image in PerfectPhoto, where I most often make my first and basic adjustments | 3 |.

First, I ajusted the levels with the **Auto Adjust** function. I then used the **Sharpen** tool and sharpened the image to 1.57. I increased the saturation by +8 to bring out the colors a bit more, and I increased the contrast by +8.

⬛ Step 2: Adding Zip

I thought this image needed more zip, so I opened it in PhotoToaster and selected **Recover Highlights**. Within that selection I increased the contrast slightly and decided I was finished | 4 |.

|3|

Summary

For this tutorial I used minimal post-processing and maintained the essence of the experience by completing my vision of emotion and drama without the look of heavy editing, which is more appropriate for other genres of photography.

I hope you will enjoy experimenting with PhotoToaster and PerfectPhoto. You can easily accomplish a lot with them.

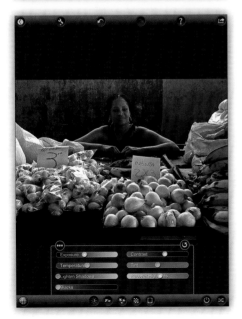

|4|

MY APPROACH TO MY WORK

I come from a lifetime career as a social worker. I have always been tuned in to people and their circumstances, especially those in need. I am sensitive to their lives, maybe too much. Sometimes the poignancy of their lives hits deep into my being, and I often feel their pain. I am very aware of the benefits of my own life.

I have been told that I am a voice for those who are unable to speak for themselves, and these days, as I develop as a photographer, I feel that my camera is my voice. My photographs disclose what I feel in my heart. I don't know why that is, and I can't help it. It just is. My daughter-in-law calls this the Marian Rubin app. I think it is about seeing and feeling.

Marian Rubin (Spring)

Marian's images are about her passions: the people, places, and moments that touch her soul. Marian has won numerous awards, has had many one-woman and group exhibitions, and her work has been published in several books. Her work is represented in private collections throughout the tri-state area (New Jersey, New York, Connecticut). A major turning point in her photographic development was the computer, and especially the iPhone. Marian's newest book, La Belleza y Tristeza de Cuba, is a collection of about 200 images that were made and processed with her iPhone and iPad.
www.MarianRubin.com

CECILY CACEU · UNITED STATES

Long Beach in the Rain

TUTORIAL 8

Create a beautiful and realistic landscape image by enhancing color tones and adding drama

What You'll Learn

I wanted to capture the incredible natural beauty and dramatic mood of the beach on a particular day. For quickly changing and multidimensional weather conditions, the Pro HDR app solves all my image capture problems at once. Pro HDR allows you to capture two images of the scene (a very light image and a very dark image) and blends them together to give you a third image that is usually a perfect blend of the initial two images.

In this tutorial you will learn how to enhance the drama of a scene by making several key adjustments to your image. You will also learn how to eliminate distracting objects and adjust the contrast, brightness, ambience, saturation, and white balance. Finally, you will learn how to manipulate the focus of your image to lead the viewer's eye to your desired point of interest.

When I work with the Pro HDR app I like to use my handheld mini iPhone tripod made by iStabilizer. The Pro HDR app takes two initial images, but first it takes several seconds to analyze the lighting. Sometimes it's hard to hold the iPhone steady during this process, which is when my tripod becomes very useful.

What You'll Need

- Pro HDR
- iStabilizer iPhone tripod
- TouchRetouch
- Snapseed

Back Story

Ever since I was little I have loved the beach. Every January 1 my family would make the drive to the beach in San Francisco for our annual New Year's Day walk. It was such a great way to start the new year, as if all the cares of the past year were washed out to sea, with new hopes and dreams for the fresh year riding in on the waves.

I find the lighting at the beach to be extremely beautiful but also very hard to capture, even with a conventional camera, and much more so with an iPhone. The day I took this photo I knew that I would need to use one of the HDR apps to fully capture and translate the beautiful light my eyes were seeing to my final iPhone image.

I am also a lover of clouds, the more dramatic the better! I knew the clouds would look moody, and I also knew I wanted to create something of a fantastical and even otherworldly atmosphere, with the clouds, sea grasses,

wet pavement, and ocean all playing an integral and dramatic part.

The Process

➤ Step 1: Capturing the Image with Pro HDR

Before you capture an image with Pro HDR, it is very important to first go to the settings in the app and select **Save original images**. By doing this I retained all three of the images in my camera roll | 1–3 |. It is extremely useful for me to see the lighter and darker images, as well as the blended image. Sometimes I prefer the initial captures instead of the blended image for my starting point. In this instance I chose the blended image | 3 | as the starting point for the additional steps in the process.

➤ Step 2: Using TouchRetouch to Eliminate Unwanted Objects

When I took this picture I did not notice the garbage can in the background. When I started working on the image I thought it would look much better without the distraction of the garbage can. Luckily the TouchRetouch app makes removing unwanted objects extremely easy. It will also clone parts of your image if you want to duplicate a pattern or an object in your image.

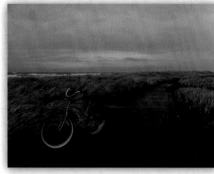

| 1 |

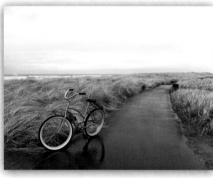

| 2 |

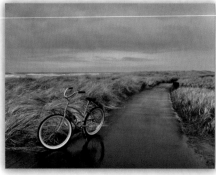

| 3 |

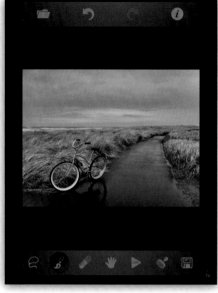

| 4 |

After I opened the image in Touch-Retouch, I pressed the **Paintbrush** icon and touched the screen exactly on the spot that I wanted to eliminate. That spot was slightly magnified in a little preview window to make it easier to see what I was doing. As I painted over the area I wanted to remove, it became highlighted in red | 4 |.

Next, I simply hit the triangular **Start** button, and TouchRetouch worked its magic and removed the area I painted over | 5 |. If I am unhappy with the edit, I can simply hit the back arrow and start again. The **Lasso** tool allows me to

| 5 |

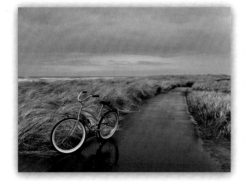

| 6 |

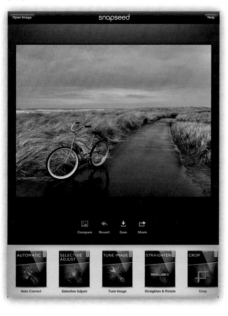

| 7 |

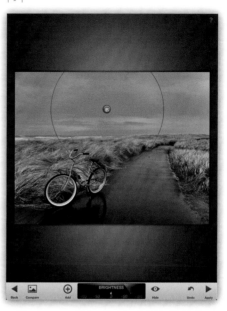

capture large areas I want to remove, and the **Paintbrush** tool can be enlarged or made very small for more precise work. When I was satisfied with the result, I saved the image to my camera roll.

➧ **Step 3: Using Snapseed for Overall Adjustments and Fine Tuning**
Next, I opened the image in Snapseed, which is one of my most frequently used apps, and it's one of the first apps I use to edit my photographs. Snapseed is an amazing app that will improve all iPhone photography images.

When my image was open in Snapseed, all of the various editing tools appeared on the bottom of the screen | 6 |. The first tool I usually go to is the **Selective Adjust** tool, which allows me to adjust the brightness, contrast, and saturation at selected points.

To start making adjustments, I needed to create an adjustment button. By tapping on the button with the (+) symbol on the bottom menu bar and then tapping on the area of the image I wanted to alter, I created a blue edit button | 7 |. Sliding my finger vertically anywhere around the blue edit button

allowed me to alter the brightness (B), contrast (C), or saturation (S). I then made my adjustments by sliding my finger horizontally across the image. Sliding my finger to the right increased the effect, whereas as sliding to the left decreased it.

Snapseed also lets me duplicate or repeat adjustments by copying and pasting edits I already did. To repeat an adjustment and apply it to another part of my image, I lightly tapped the blue edit button to reveal a bar that gave me the option to cut, copy, delete, or reset the current adjustment button.

| 8 | | 9 | | 10 |

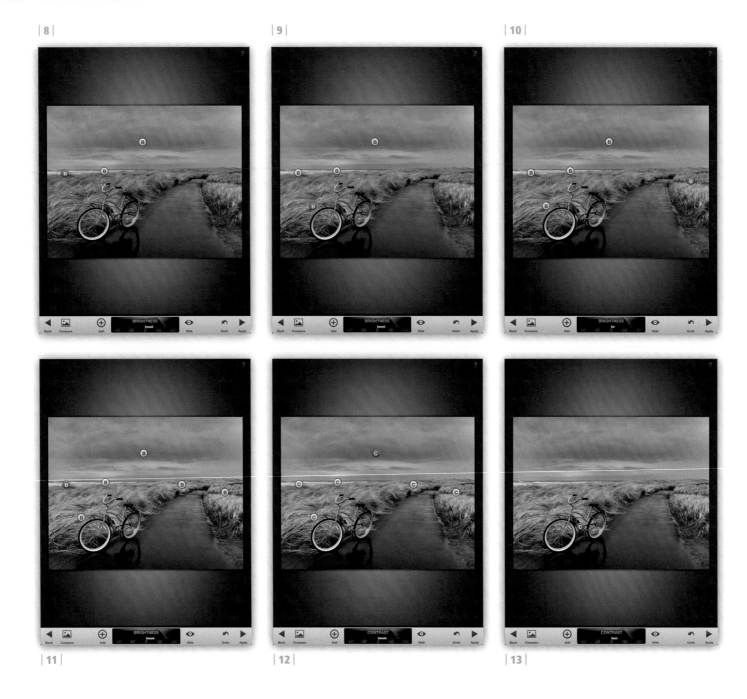

| 11 | | 12 | | 13 |

At this point I decided to selectively adjust the brightness of the sky down to −25 and to increase the shoreline brightness to +25 | 8 |. I also adjusted the sea grass on the left side of the image to +25 | 9 |.

Next I decided to adjust the brightness on the right side of the image to balance it out. I adjusted the sea grass to +10 and the sea grass in the back to +15 | 10 and 11 |.

Then I went through the entire image and made contrast adjustments as follows: sky +30; ocean +15; sea grass on left side +20; sea grass on right side +10; back center sea grass +10 | 12 |.

When you use Snapseed, be sure to hit the **Apply** button after you complete each of your adjustments. If you don't like what you have done, you can hit the **Back** button and return to the point before you applied that specific set of adjustments to undo all of your edits in that operation.

It is important to note that after you have applied the filters, there is no way to go back, even one step. If you hit the **Back** button, it will take you all the way back to the point when you first imported the image, and all of your adjustments will be lost.

➤ Step 4: Using Selective Adjust to Focus Attention on the Bicycle

The next adjustment I made was to give the bike a more prominent role in the image. Once more I chose the **Selective Adjust** tool, tapped the (+) symbol, and used my finger to expand the area of coverage to include the entire bike | 13 |. I did this by simply sliding my finger across the bike and watching the highlighted red area. I increased the brightness of the bike to +35, and I increased the contrast to +20. I then hit **Apply**.

Another one of my favorite tools in Snapseed is the **Tune Image** adjustment. It allows you to adjust the overall brightness, ambience, contrast, saturation, and white balance of your entire image.

For this image I made the following adjustments: brightness +15; ambiance +25; contrast +10; and white balance +10 | 14 and 15 |.

The **Details** filter is very important in my work. It allows me to sharpen the image and make it a bit clearer. I used it to adjust the sharpening to +20 and the structure to +25. The difference between sharpening and structure is that sharpening will affect the details in your image by increasing the contrast of the edges of objects, which will make the image appear more distinct and in focus. Structure adjustments, on the other

| 14 |

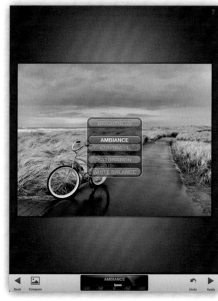

| 15 |

| 16 |

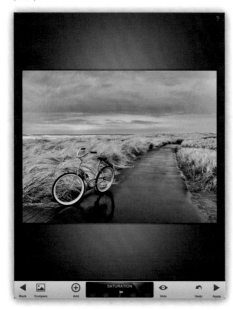

| 17 |

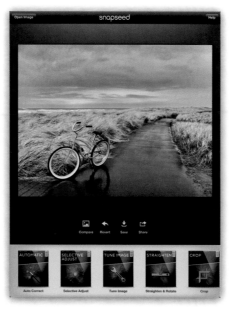

| 18 |

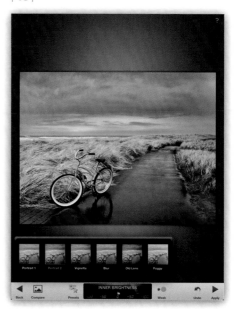

hand, enrich the textures of the objects, but will not change the edges.

There is a **Loupe** icon that, if tapped, will pop up over your image, and you can move it around to see exactly what the adjustments are doing to your image. In most cases it is best to use these adjustments toward the end of your post-processing and to use the loupe to make sure the adjustments are not overdone. I like the loupe because it reminds me of the grain focusers I used in the black-and-white photographic darkroom.

I wanted to make a few more minor selective adjustments and went through the entire image to further fine-tune it. I wanted to stay true to my initial goal of giving the bike a more prominent role in the image, so I made the following adjustments: brightness −10; contrast +10; and saturation +10 | 16 |.

I also wanted to make the Pacific Ocean in the back pop out more in the image. I went back to the **Selective Adjust** tool and made the following adjustments: brightness −10; contrast +10; and saturation +8 | 17 |.

My last adjustment in Snapseed was to make the bike the star of the image by slightly blurring the background behind it. In the **Center Focus** filter, I used the **Portrait 2** preset filter | 18 |. I adjusted the blur strength to +25; the outer brightness to −70; and the inner brightness to +10.

Finally, I saved my image to my camera roll. If I had wanted to crop the image to a square for easy uploading to Instagram, I could have done so in either Snapseed (by using the **Crop** tool) or by loading it into the Squaready app.

My Process

Pro HDR: Since the lighting at the beach that day was dramatic and constantly changing, I chose to capture my image in Pro HDR. I prefer Pro HDR to other HDR apps (True HDR, for example) because it is so user friendly. There are two settings, Manual and Auto, and there is also an optional grid that can be used to line up your image so it will be straight. It also has a zoom option.

TouchRetouch: Next, I used Touch-Retouch to eliminate the garbage can in the image. This app is easy to learn and is close to performing magic, in my opinion. The app comes with two easy-to-follow video tutorials.

Snapseed: Finally, I used Snapseed, a real powerhouse of an app. Snapseed is one of the most intuitive apps out there and should be in every iPhoneographer's toolbox. This app is simply indispensable and irreplaceable.

Glaze: Secretly, I have always wanted to be a painter. I love the whole idea of it (including having a studio with big windows looking out on the Seine), but I have never been able to paint anything I would show to anyone except my dog or cat. Luckily there is the Glaze app to make all my painting dreams come true. Glaze will painlessly convert your photographs into paintings. It is easy to use and will not intimidate even the most novice iPhone artists. The beauty of this app is that it can also become a sophisticated, complex app if the artist so desires. After your image is loaded you can choose from 30 preset painting styles, or you can roll the dice and have Glaze randomly create a masterpiece for you. This is one of the most authentic-looking painting-style apps available, and it makes me feel like a true painter!

Summary

To accomplish my vision of bringing out the dramatic light and colors I witnessed on the beach that day, I used Pro HDR to expose both the light and shadow areas of the image. I used TouchRetouch to eliminate distracting elements, and I used Snapseed to make both global and local adjustments, which included brightness, contrast, saturation, sharpening, structure, blurring, and vignetting.

Cecily Caceu (cecilyc123)

An uncreative and stressful daytime job as a paralegal pushed Cecily to rediscover her childhood passion for photography. Receiving an iPhone in 2010 changed her world dramatically. The beauty of everyday occurrences attracts her, and she is a huge admirer of church sign marquees, landscapes, trees, France, county fairs, clouds, her daughter, estate sales, animals, and items left on the street. Her work has been featured in juried shows, including Blue Nocturne, Spooky Show II, Newspace Gallery, Lake Oswego Festival of the Arts, and the Mobile Photo Awards.
www.cecilymariece.com

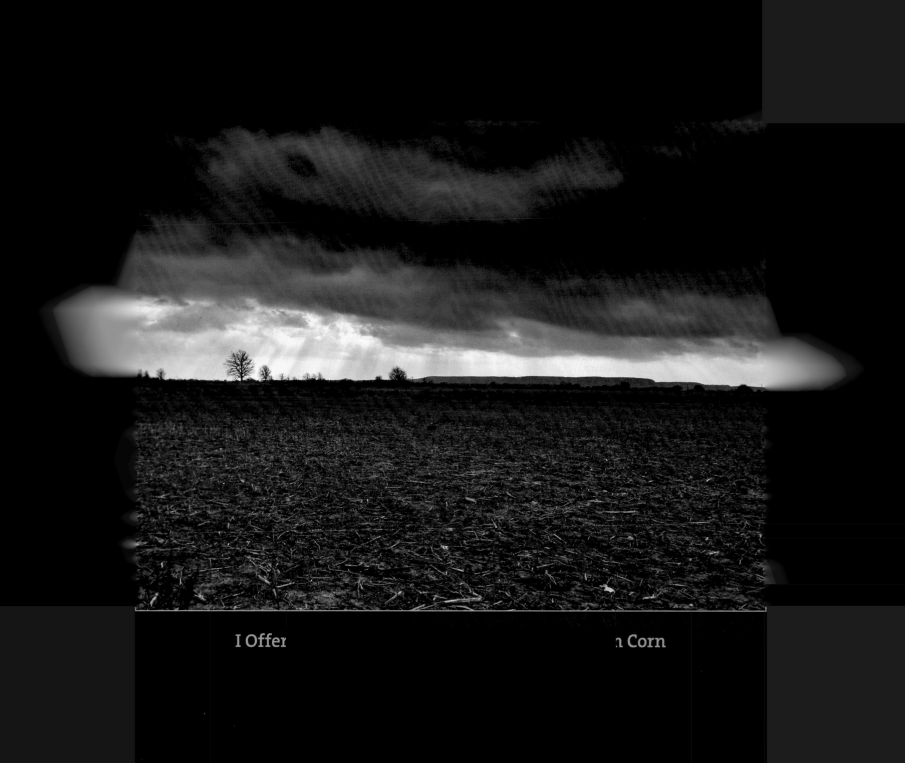

I Offer n Corn

TUTORIAL 9

Create a landscape photo with contrast adjustments, noise reduction, increased dynamic range, and color effects

What You'll Learn

The goal in this tutorial is to create an image with increased dynamic range without losing detail. You'll learn how to selectively sharpen an image, heighten saturation and contrast, darken a sky without sacrificing image quality, and utilize multiple exposures to selectively achieve effects in isolated portions of an image.

What You'll Need

- Snapseed
- Filterstorm
- LensLight
- Camera+

Back Story

Several years ago I moved from the city in which I had spent the first 37 years of my life. My wife and I wanted to raise our boys away from the concrete jungle and instill in them an appreciation of nature on a daily basis. We also wished for the serenity of small-town life. So we moved to a little town nestled against the Niagara Escarpment about 45 minutes west of the city. As a landscape photographer, it was a dream come true.

My daily routine now involves driving by cornfields and horse farms and through the hills and valleys of rural Ontario. This image was shot about an hour before sunset just as a storm front was colliding with what had been a lovely, sunny afternoon. The juxtaposition between the impending rainstorm and the last of the golden sun caught my eye, and I pulled the car over and walked to the edge of a harvested cornfield to take some photos.

The Process

→ **Step 1: Increasing Dynamic Range and Saturation, and Adjusting White Balance**

To increase the detail of the harvested cornfield and brighten the area where the clouds break and the trees stand, I brought the image into Snapseed and used the **Ambiance** adjustment located under the **Tune Image** menu. I increased the ambience to +55 | 1 |. It's important not to go too far or the colors begin to take on unrealistic hues. I also increased the **White Balance** under the same menu, just slightly, to give the image a warmer cast and bring out the detail in the red scale part of the image.

I then used the **Drama** feature to increase the dynamic range even further.

|1|

|2|

|3|

Again, I was careful not to go too far or there would have been very little contrast in the shadows. The idea here is to raise the brightness of the cornfield and the trees without sacrificing image quality.

Step 2: Selectively Darkening Part of an Image

Using Filterstorm, I brought the image into the **Curves** adjustment area and lowered the overall brightness by adding a curve point to provide more drama to the sky |2|. With the **Paintbrush/Mask** feature, I selectively applied this adjustment to the part of the image I wanted to enhance. I began to darken the sky by smoothing my finger directly over the area where I wanted to apply the curves adjustment |3|. The rest of the image remained untouched. With the sky taking on a more ominous look, I created a more radical juxtaposition of the compositional elements and heightened the drama of the oncoming storm. I then made another minor curve adjustment to decrease the dynamic range of the ground and to bring the contrast of the elements into closer visual alignment.

| 4 |

| 5 |

| 6 |

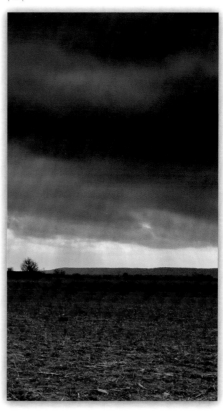

➤ **Step 3: Selectively Blurring for Noise Reduction and Softness in the Clouds**

I have learned that when I increase dynamic range or darken elements of an image with a curves adjustment, it often introduces undesired noise into the image. The noise or graininess in the clouds is visible in figure 4.

The trick I developed to overcome this with landscape photos is to apply a selective blur to the sky. Again, I used Filterstorm to achieve this with masking. I went back into the **Filters** panel and chose the **Blur** function, and I blurred only part of the image. I used the slider on the left and adjusted it until the blur level was at a point that I felt best suited the image | 5 |. I didn't try to create a noticeable blur effect, but rather attempted to hide the noise introduced from the curves adjustments and the increased dynamic range in the sky. After I selected the desired blur level, I applied the blur to the parts of the image where the noise was a little too heavy. I did this in the same manner with the **Paintbrush** that I had used to apply the curves in step 2. The resulting image detail may be seen in figure 6.

| 7 |

| 8 |

I used the **Diameter, Softness,** and **Opacity** panel to adjust the impact of the paintbrush. This helped me achieve the exact contrast I wanted between the two images and allowed me to precisely blend the two photos to achieve a more balanced final image. The example shows how the new image appeared as I swiped my fingers across the parts of the picture I wanted to replace.

Step 5: Selectively Sharpening the Image

Still in Filterstorm, I again selected the **Filters** drop-down menu, chose **Sharpening,** clicked the **Paintbrush** feature, and sharpened just the horizon line of trees and the rock escarpment that runs along the horizon line.

Step 6: Adding More Rays of Light

I opened the image in LensLight to add a set of light rays. The original image had light rays beaming down from the clouds, but since I didn't feel as though I had quite captured their beauty, I decided to add some more myself | 9 |. After adding some light rays and adjusting them to taste, I took the image back into Filterstorm. I used the **Add Exposure** feature again to paint over the rays so it looks like they are coming out of the clouds at the horizon line.

Step 4: Bringing Back Part of the Higher Dynamic Range

Now that I had some fluffy, ominous clouds, I wanted to bring back some of the dynamic range I had previously introduced into the lower part of the image. I did this by selectively compositing part of one image onto another.

Still in Filterstorm, I selected the **Filters** drop-down menu and chose **Add Exposure** | 7 |.

I chose a second image of the scene from the camera roll and then selected the **Paintbrush/Masking** feature | 8 |. When this option was open, the newly added image sat underneath the current picture, and I could selectively paint in the new image directly with my fingers.

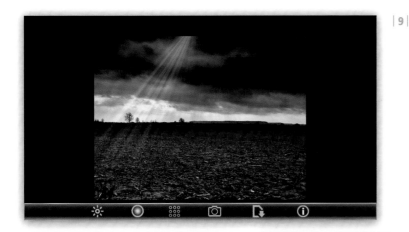

| 9 |

Step 7: Making Final Contrast Adjustments

I brought the image back into Snapseed and adjusted the contrast using the **Auto** feature | 10 |. I find that this feature usually overdoes the contrast, so I swiped down to bring up the menu and then swiped left to bring the contrast down to where it looked right to me.

Step 8: The Last Step

I made the final adjustment for vibrance in Camera+. I can achieve the same result in a number of different ways, but I like the effect of the **Vibrant** filter in Camera+ because it has a slider to allow adjustment. With the slider I chose the amount of the effect I wanted to apply. I set it to about the midpoint and saved the final image to my camera roll | 11 |.

My Favorite App: Filterstorm

Filterstorm is one of the most powerful apps available for photo editing on the iOS platform. With an array of tools familiar to anyone who has used Adobe Photoshop, Filterstorm provides unprecedented control for precision photo processing. There is a learning curve for anyone who is more comfortable with simply adding a premade filter or two to their images, but after that

| 10 |

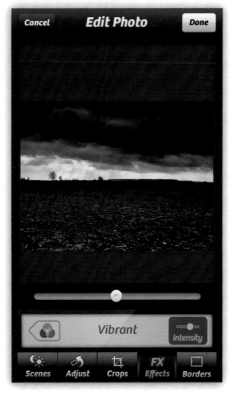

| 11 |

| 12 |

| 13 |

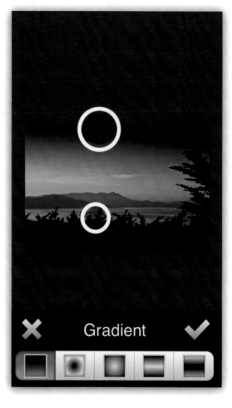

| 14 |

curve has been mastered, the power of Filterstorm's manual controls is liberating. From curves, levels, and cloning to masking, layers, and tone mapping, Filterstorm provides iPhone photographers a set of fine, granular controls unlike just about any other image-processing app.

The following is a description of some of the manual adjustments available in

Filterstorm. The filter menu is shown in figure 12.

Each effect can be selectively applied with the masking tool or to the whole picture at once. One of the more effective options for precision editing is the gradient feature. You can choose your overall look with any adjustment and then use the masking feature to apply a gradient version of the effect by rotating

two circular controls to apply the gradient on any part of the image, as shown in figure 13.

Filterstorm can handle extremely large files. The resolution is preserved and will be output at the highest possible level, as shown in the output dialogue depicted in figure 14.

The developer of Filterstorm provides some excellent video tutorials that I

highly recommend watching. What might seem daunting at first becomes clear when you see real-time examples of the app in action. If you want to challenge yourself and take your iOS photo processing to the next level, give Filterstorm a whirl. It's a great way to move beyond the simplicity of adding a retro filter or two to your image.

Summary

To achieve my goal of treating the three areas of the composition—the ground, the trees and sun, and the oncoming storm—with different effects, I used Snapseed (for contrast, dynamic range adjustments, and saturation); Filterstorm (for curves adjustments, selective sharpening, and selective blurring to decrease noise); LensLight (to increase the drama of the sun's rays); and, finally, Camera+ (to add contrast and vibrance).

Daniel Berman (Reservoir_Dan)

Daniel is a fine art photographer, filmmaker, and digital artist. He is the founder of the Mobile Photo Awards, the world's largest competition and open gallery call for mobile photography and art. With his background of running a successful television production company specializing in music and nature programs, Daniel brings a lifelong passion for the rhythm and imagery of the natural world to his photographic art.
www.mobilephotoawards.com

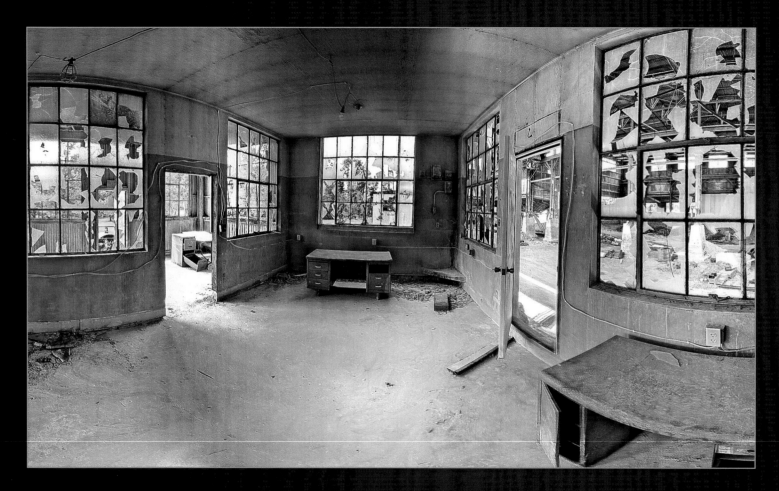

Stone Quarry Sawmill

TUTORIAL 10

Create a wide-angle image with spatial distortion and subtle high dynamic range exposure

What You'll Learn

This tutorial poses the challenge of getting proper exposures for the brighter areas outside the windows and darker areas inside a building. After completing this tutorial, you'll be able to create a high dynamic range (HDR) image comprised of multiple pairs of light and dark images stitched together to create an image with a wide-angle perspective, great exposure for both light and dark areas, and vibrant color throughout the image.

What You'll Need

- Tripod with iPhone tripod holder bracket
- Bracket Mode
- True HDR
- AutoStitch Panorama
- Photoforge
- Image Blender
- Dynamic Light

Back Story

I captured this image at the site of an abandoned stone quarry sawmill near Bloomington, Indiana. After attending Indiana University and falling in love with Bloomington, I spent a number of years living there. It was impossible to be a part of the Bloomington community without being aware of the impact of the limestone quarries that surrounded the city then.

In 1979 the movie *Breaking Away* romanticized the "cutter" culture. This abandoned site is the kind of place one of the fathers in the movie would have worked. All that remains of this site today is the huge iron frame building, scattered rusting equipment, and this business office where the men punched their time cards and picked up their paychecks. I wanted to convey a sense of the history of this place by capturing both the layout and detail of the office and a sense of the work areas outside the doors and windows.

The Process

➤ Step 1: Shooting the Images with Bracket Mode

I use a tripod with an iPhone bracket (available at www.iphone-tripodholder.com) to get the best results with Bracket Mode. It is possible to get decent results handheld, but whenever possible I like to use a tripod to reduce camera movement. Bracket Mode takes two shots with each click of the shutter button:

| 1 |

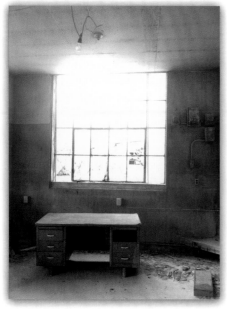

One of the images in the panoramic sequence before processing

| 2 |

Settings screen showing Auto-Save selected

| 3 |

Settings screen showing Enhanced selected

one overexposed and one underexposed image. These image pairs are later used to produce HDR images. Because this is an HDR and stitched image, there is no true before image. Figure 1 is one of the 39 original photos used in the final image. Notice how it's an overexposed piece of the final whole.

To create a multi-stitched image, I take as many Bracket Mode shots as needed to capture the entire scene. I

usually start in the lower left corner of the scene with the camera held vertically and take repeated Bracket Mode shots, and I overlap each shot by 30 to 50 percent. I generally follow an S pattern, up the left side of the scene, then down to the bottom, then up to the top, and so on until I have captured the entire scene. The finished image in this tutorial is made up of 39 pairs of images (78 individual shots). It's important to go

beyond the scene's boundaries to ensure that you don't lose part of the image you want to keep when you stitch and crop. I've lost a lot of church steeples by not extending my capture area well beyond the boundaries of what I wanted in the scene! I like to set Bracket Mode's **Auto-Save** feature to **Yes** because it speeds up the shooting process—a good thing when this many images are involved | 2 |.

| 4 |

True HDR menu screen

| 5 |

True HDR with two images in the tray and the Merge button visible

| 6 |

True HDR merged image with slider bars

 Step 2: Processing with True HDR
Before I process with True HDR, I set the preferred HDR mode to **Enhanced** for more vivid colors | 3 |.

I used True HDR to process each light and dark image pair. I selected **Choose Pictures** from the main menu | 4 | and navigated to the camera roll to access an image pair. Then I followed the prompts and selected the light and dark shot of the same image and pressed **Merge** | 5 |.

I waited briefly while True HDR combined the two images and then displayed the merged image | 6 |. At this point I could have chosen to make adjustments using the sliders, but I didn't because I'm going to be blending 39 pairs of images and I wanted them to all have the same processing. I waited to make these adjustments.

I saved the result and repeated the process for the remaining 38 image

pairs, which resulted in 39 True HDR images in my camera roll that were ready for the next step | 7 |.

| 7 |

HDR images to be stitched

| 8 |

AutoStitch Panorama's default setting

| 9 |

Step 3: Using AutoStitch Panorama to Stitch the Images Together

I wanted to use AutoStitch Panorama's maximum quality settings for the best possible result. The two AutoStitch Panorama settings to adjust are **Resolution** and **Blending**. I set resolution to **Advanced, 100 %,** and **18MP,** and I set **Blending** to **Standard** | 8 |. With these settings, I've stitched as many as 72 images. If the processing bogs down or if the application crashes while

performing a stitch, I reduce the quality settings until the app performs.

I chose **Select Photos** from the main menu and selected the camera roll (or album containing the images I wanted to stitch). I touched each of the images I wanted to stitch. A green check mark indicates that the image has been selected. After I had selected all my images, I pressed the **Stitch** button and waited as the app prepared the images | 9–13 |.

| 10 |

| 11 |

4484 x 2612

| 12 |

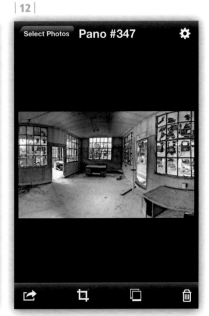

| 13 |

➤ **Step 4: Using Photoforge to Sharpen and Emboss**

Next, I imported the image into Photoforge, selected **Unsharpen Mask** from the **Funnel** icon, and set the sliders as shown in figure 14. I barely moved the **Radius** slider to avoid oversharpening. I then saved the sharpened image in **Original** resolution | 15 |.

Still in Photoforge, I selected the **Emboss** filter from the **Funnel** icon | 16 |.

I saved the embossed image in **Original** resolution.

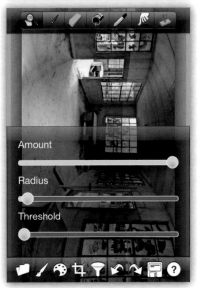

| 14 | *Unsharpen Mask sliders*

| 15 | *Original resolution*

| 16 |

Emboss filter

| 17 |

Images selected in Image Blender

| 18 |

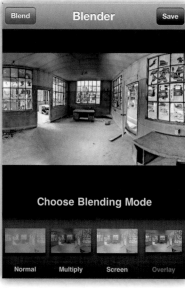

Overlay blend mode in Image Blender

| 19 |

Overlay blend mode slider at 100 %, or all the way to the right, in Image Blender

➥ Step 5: Blending Images to Bring Out Details

I then used Image Blender to blend the sharpened image with the embossed version to accentuate the details. In Image Blender I clicked the selector at the lower left to load the image I sharpened in Photoforge in step 4. In the lower right selector, I loaded the embossed image that I sharpened in step 4 | 17 |.

I selected the **Overlay** blend mode, moved the slider all the way to the right, and saved the resulting image to the camera roll | 18 and 19 |.

➥ Step 6: Applying the Orton Filter in Dynamic Light

I then opened Dynamic Light and loaded the blended image from step 5. I selected **Fx** and chose the **Orton** filter | 20 |. I adjusted the light so the image did not appear too dark—about 25 on the dial—and saved the image | 21 |.

➥ Step 7: Using Image Blender to Tone Down the Orton Effect

The Orton effect alone can be too soft and unnatural. I like to tone it down by blending it with an earlier version of the image.

Returning to Image Blender, I used the lower left selector to load the Orton filtered image from step 6. With the lower right selector, I loaded the blended image from step 5 | 22 |.

I selected the **Normal** blend mode, moved the slider to about 20 %, and saved the image | 23 and 24 |.

You can see the final image at the beginning of this tutorial. Notice that some of the richness and tone from the

| 20 |

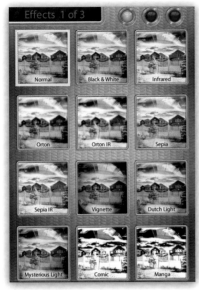

Orton filter

| 21 |

Orton dial

| 22 |

Images selected in Image Blender

| 23 |

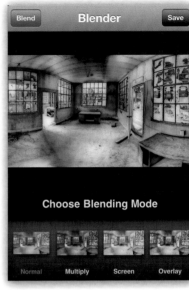

Normal blend mode in Image Blender

Orton effect has been retained without over softening the image.

Summary

I used Bracket Mode to capture 39 pairs of light and dark shots that make up the complete scene. Next I combined each light and dark pair, one pair at a time, with True HDR. I then loaded the 39 True HDR images into AutoStitch Panorama to create a vertical and horizontal panorama of the scene. Although it's possible to skip the rather time-consuming True HDR step and simply load all 39 pairs of light and dark Bracket Mode images into AutoStitch Panorama for a decent result, I find that performing the HDR step before stitching often yields a more satisfying color balance and is worth the extra effort.

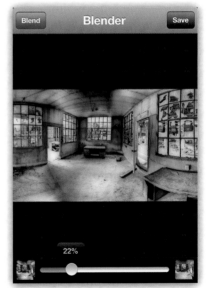

| 24 | *Normal blend mode slider at 22 % in Image Blender*

ABOUT HDR

HDR images are created by combining two or more shots with different exposures to create a final image that shows the full range of exposure. Although there are specific HDR apps such as Pro HDR and True HDR for creating HDR images from image pairs, you can create excellent HDR images using a combination of Bracket Mode and AutoStitch Panorama. Bracket Mode captures a light and a dark image with each click of the shutter. I captured my scene with multiple pairs of light and dark images in Bracket Mode and then loaded all the pairs into AutoStitch Panorama. AutoStitch Panorama puts the scene together and simultaneously combines all of the light and dark pairs into a beautiful HDR image!

Tips:
- The shoot goes quicker if you select Auto-Save in Bracket Mode to eliminate manual saving.
- Use a tripod to avoid camera movement. (I use an iPhone tripod holder bracket, available at www.iphone-tripod-holder.com.)

Rad Drew

Photography has been a part of Rad's life for as long as he can remember. He shot all through high school and college and worked intermittently as a photojournalist after earning a BA in journalism from Indiana University, Bloomington. In 2010 Rad discovered the iPhone, which completely transformed how he sees and thinks about photography. Rad's images have appeared in a number of exhibitions, including the LA Mobile Arts Festival, Mobile Photography Awards, and several Darkroom Gallery shows juried by Dan Burkholder. His self-published book, *In Good Light, Images of the Circle City*, is available on Blurb. *http://totallyradimages.blogspot.com*

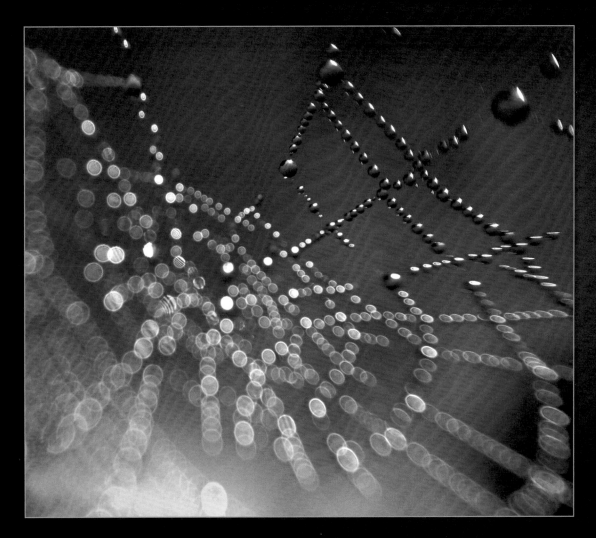

Bokeh Web

TUTORIAL 11

Create macro photos of miniature worlds using an olloclip lens and selective color adjustment

What You'll Learn

In this tutorial you will learn how to discover and capture hidden worlds all around you using a macro lens and minimal processing to emphasize selective areas of your images.

What You'll Need

- Snapseed
- Camera+
- Skina Macro attachment
- TouchRetouch
- olloclip macro lens
- ScratchCam FX

Back Story

Macro photography is, for me, all about capturing a little moment in time, whether it's a fleeting visitor, a pretty raindrop formation, or that exact, perfect moment when a flower opens in full glory—brief moments, all captured and kept forever.

The surprise of discovering those beautiful details drives me to capture more images and continue with these mini adventures.

For the majority of my macro images I choose to do very little post-processing.

I find that I spend a long time trying to achieve the best quality image in the original capture, and I feel that extensive editing could potentially detract from these details. I prefer to make minimal adjustments and concentrate on enhancing the light and color or cropping the image to a better size to draw attention to the subject and its glorious details.

Macro opportunities can be found anywhere, whether it's walking around the house or outside in the garden. If you look closely enough, you will find an abundance of potential subjects. In the house I have enjoyed capturing images of many things, from flowers, cacti, bugs, and food to needle and thread, toothpicks, and cotton swabs. Many subjects have surprisingly interesting textures and details and offer great photo opportunities. Photographing outside in the garden offers great subjects and benefits from better natural light. A slow walk around the garden, paying close attention to plants, flowers, and under leaves, will often result in interesting photo opportunities. I always make sure my camera app is open and ready to go!

Macro photography can be enjoyed throughout the year. In the spring and summer months I find plenty of great views of bugs and flowers (and bugs *in* flowers).

The Process

☞ **Step 1: Capturing the Original Image**
In this series of steps I added drama to a macro image with selective adjustments and Snapseed's **Black & White** filter. The original image was in color | 1 |.

☞ **Step 2: Adding Drama**
I opened the image in Snapseed and set the **Drama** filter to +48 | 2 |.

☞ **Step 3: Removing Color and Cropping**
Continuing in Snapseed, I made the following adjustments: **Black & White** filter, **Green,** and –39 **brightness** | 3 |.

☞ **Step 4: Cropping the Image**
Still in Snapseed, I cropped the image to a squat shape | 4 |.

| 5 |

| 6 |

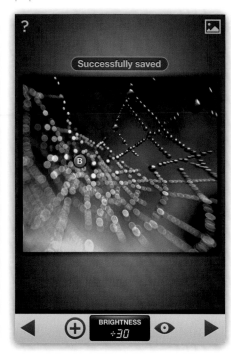

Example Macro Images

Curl – I took this shot with Camera+ and used the Skina Macro attachment. I edited the image with Camera+, then I used Snapseed and TouchRetouch to remove some imperfections on the petals.

➤ **Step 5: Adjusting the Brightness**

In Snapseed, I chose **Selective Adjust** and reduced the brightness by –31 in the lower left corner of the image | 5 |. As a final step, I also increased the brightness in the center of the web by +30 | 6 |.

Hideaway – I captured this image with the iPhone 4S camera using the olloclip macro lens attachment. I edited it with Camera+.

A Flying Visit — *I captured this image with Camera+ and the olloclip macro lens. I rotated the image and cropped it to a square in Snapseed, and I added drama with a color filter in ScratchCam FX. I then finished the image with a selective adjustment in Snapseed to add contrast to the eyes.*

Just Hangin' — *I captured this image with Camera+ and the Skina Macro attachment, and I edited it in Camera+.*

Iced Berries — *I took this image of frozen berries in ice cubes with Camera+ and the Skina Macro attachment. I edited it in Camera+.*

The Inside Story — *Another enjoyable series involved growing and photographing a sunflower. After it died, I decided to carefully dissect the inside of the flower head and photograph each part.*

Meet in the Middle — *I captured this image with Camera+ and the olloclip macro lens. I then edited it in Snapseed and used these settings: 68 Drama, Black & White Green filter and −55 Brightness.*

Just Dandy — *This image was taken with the iPhone 5 camera and the Skina Macro attachment, and I edited it in Snapseed with the Black & White filter set at −75 brightness.*

General Tips

Macro Lens Care

It's important to ensure that macro lenses are completely free of dust and fingerprints. I clean both sides of my macro lens with a small soft cloth before every use.

Starting Off

For beginners, I recommend starting with flowers and other subjects indoors to avoid movement from the wind.

Get Close

It's vital to learn the optimum distances for shooting. A macro lens has to be very close to the subject for the best results (approximately 2 cm or less). When you photograph flowers, the distance may vary depending on the desired focal point, such as the top of the stamens. The depth of field is minimal, as you can see in figure 7. Moving the camera very slowly away from the flower can give you interesting results as the camera focuses on different areas. When you are familiar with a particular macro lens, it's easier to find the ideal distance.

| 7 |

Figure 8 shows three examples of different focal points on the same subject:

- Top image: Focus on the ends of the cactus spikes
- Middle image: Focus on the lower spikes
- Bottom image: Focus on the very bottom of the plant and cactus fuzz

| 8 |

Focus

After you compose the scene with the subject, tap on the area where you want the most detail to focus the camera. This can be done with the iPhone camera or with apps like Camera+ and ProCamera.

Light and Position

It's important to photograph in good light. When I photograph inside, I place the subject near a south-facing window (in the United Kingdom) or under an artificial light source; for example, I use a light on a tripod that can be pointed to a certain area on the subject. When I photograph outdoors, I position myself at the side of the subject to prevent my own shadow from entering the picture.

I try to sit down and get comfortable before I begin shooting to help me remain steady. When I photograph indoors I sit or lean against something. If the subject is raised, I use boxes or props to rest my hand or iPhone.

When I'm in a comfortable position, I spend time finding the perfect distance, and then I gently tilt and rock the iPhone to see if the focus can be improved. A slight repositioning of the iPhone can allow more light onto the subject and dramatically improve the image.

Surroundings

Photographing outdoors is the best for light and natural surroundings. When I'm indoors I prefer to photograph subjects on paper to create a solid background color. I also use glitter paper, which can give great bokeh (soft blurred background) effects in the right light. I have captured separate images of just the glitter paper from farther away to increase the bokeh effect. I use those images as a layer for blending during post-processing.

Shooting

I recommend exploring camera replacement apps. One of my personal favorites is Camera+. I use this app set to normal mode and with the stabilizer function enabled. I also enjoy using apps like Hipstamatic and Lomora for great color results. Camera+ images are considerably sharper, though.

Don't Miss Out

When a great macro opportunity presents itself, I capture plenty of images at different angles to ensure I will have something to work with afterwards. Even when I think I've captured the best image, I'll take more as a backup.

Sometimes the best image isn't as clear as expected when I view it later and the moment has passed. I don't delete any images immediately. Even darker images may have clear details that can be enhanced with the right choice of app filters.

In the autumn and winter months, photo opportunities have arisen from raindrops, frozen foliage, and the like. If bad weather conditions are a problem, I frequently photograph my subjects inside in good light.

A New View

I use the camera view to look around for details before I shoot. Many small details may not be seen by the naked eye.

Post-Processing

Your choices for post-processing will, of course, depend on your individual taste and style. For minimal processing, apps like Camera+, Snapseed, and Filterstorm provide great filters and controls to adjust images. The area around the subject will have some great natural blur, which lends itself to texture apps such as Laminar, ScratchCam FX, and PhotoCopier.

Projects and Series

Having spent some time practicing on my favorite subjects with a macro lens, I recommend that beginning macro photographers start thematic projects or a series of images. This approach can provide great creative challenges and produce wonderful results.

I was inspired after finding some frozen foliage in the garden over the winter months. I decided to create some of my own frozen foliage using ice cube trays and various subjects from around the garden, and I froze them in my freezer. The results were very interesting.

My Favorite App: Camera+

Camera+ is an essential app both for capturing and editing images. It's fast and reliable and offers a great range of tools. I use this app as my main camera for macro photography to achieve better and clearer results. The camera has a selection of different shooting options. For example, the stabilizer and burst mode functions are useful for achieving sharp shots and getting a wide variety of images to choose from later. Many captured images can be stored in the app, saved to the camera roll, or both.

Camera+ offers a wide range of editing tools for increasing light and clarity, cropping, or adding black-and-white or color filters. For me, this app has it all. I shoot and process a large quantity of macro images with just this app alone.

Summary

In this tutorial I have shared the multitude of ordinary places where beautiful textures and tiny worlds can be found and shot with a macro lens. You have learned techniques to improve the tiny details of macro shots by sharpening and applying black-and-white color filter adjustments, brightness values, and selective adjustments to enhance specific areas. You also learned about cropping an image to create a particular composition or focus attention on a specific part of the subject.

Lindsey Thompson (Lindsey76)

Lindsey happily threw herself into motherhood when she left her position as an accounts manager to care for her children full time. Since she became involved with iPhone photography her images have been shown at various exhibitions worldwide, including EYE'EM Berlin, Pixels at the OCCCA, Pixels Los Angeles, Autunno in Musica in Italy, the Stuff Bath exhibit in Bath, a show in New Zealand, and the Lunchbox Gallery in Miami. Eight of her images were shown and sold for the Kids Co. charity at the Createhive exhibition in London. More recently, six of her pieces were shown at the Mobile Arts Festival in Santa Monica.

www.flickr.com/photos/lindsey76

A Faery Song 01

A Faery Song 02

TUTORIAL 12

Use a macro lens with experimental techniques to photograph beautiful and delightful worlds

What You'll Learn

In this tutorial you will learn post-processing techniques that will add depth and movement to your macro images. I'll share my creative approach to macro shooting and post-processing. In particular, I will describe a simple technique that can add extra life, movement, and depth to an image: layering and blending an image with a second photograph or photographic texture. I will also share my recipe for creating custom bokeh textures.

What You'll Need

- Hipstamatic (or your favorite camera replacement app)
- Image Blender (or your favorite photo blending app)

Back Story

Over the years I have used my iPhone and iPad to create a diverse range of work. I've made collages, utilizing many of the same techniques I had used in Photoshop, such as compositing, extracting, and blending layers. Of particular interest to me was replicating the look of old, damaged photographs and documents, not for a romantic vintage effect, but because I wanted to tell stories of memory, melancholy, and loss.

Gradually, a shift occurred. As I searched for new creative challenges, I became more interested in looking out than in, more interested in shooting photographs than making collages. My approach had always been to reflect on the *why* of each processing decision and discard any filter or effect that appeared merely decorative rather than adding another layer of narrative or mood to an image. I began to pare things down even more and experiment with effects created in the moment rather than imposing too much post-processing. I moved away from literal representation and sought to express poetic narrative and emotion through abstraction.

An important tool for this creative journey was my olloclip macro lens. I'm not patient or steady enough to capture pairs of mating ladybugs, but it wasn't pin-sharp detail that fascinated me—it was the trails and patterns made by tiny things as they danced before my eyes, or as I danced around *them*. This developed into a relaxing meditative activity. Each day I chose an item, such as a blade of grass, and spent 15 minutes moving it slowly in front of the lens while simultaneously moving around in search of new backgrounds and light

|1|

|2|

until a certain shape or gesture caught my eye. To push these beautiful random accidents further, I experimented with camera replacement apps, such as Hipstamatic. A love affair began. Soon I was shooting exclusively with Hipstamatic, and I eventually developed an instinctive understanding for which of my favorite lens and film combinations would work best in a particular situation.

I created the images that illustrate this tutorial one day at the end of last summer when I noticed the feathery remnant of a dandelion clock caught on an old cobweb that had been strung across the edge of my garden pond. As I approached, delicate strands fluttered in the breeze, and I was delighted to discover that I could capture the trails

of this movement with an iPhone and a macro lens.

The resulting images were beautiful, but I wanted to playfully enhance the impression of a fairy's dance captured in glass. To achieve this, I used techniques that I had learned as a theatrical designer and later applied in Photoshop. I blended translucent layers of softly mottled color and spattered texture so the eye can never quite settle, and the brain cannot figure out why. When you process an image, layers of photographic texture can be blended to achieve the same effect.

This tutorial demonstrates the use of subtle bokeh effects. It's easy to create custom bokeh textures—just attach a macro lens to your iPhone and point it at something sparkly in the distance.

The textures used in this tutorial are out-of-focus Hipstamatic macro shots of bubbles in my bathtub.

The Process

Step 1: Taking Base Shots with Hipstamatic
I shot these two macro photographs with Hipstamatic and cropped them in my camera roll to remove the frames |1 and 2|.

Step 2: Positioning an Overlay with Image Blender
A Faery Song 01 — I imported the first cropped image (the feathery, greenish dandelion) into Image Blender as the base layer. Then I imported the cropped bubble shot as the top layer, and I selected the **Overlay** blending mode and adjusted the sliders to achieve a subtle blend. I saved the flattened image to my camera roll, and then I reimported and reblended it a few more times and applied a number of different modes, including **Color**. I adjusted the slider settings to allow some of the base layer to bleed through.

A Faery Song 02 — For the second image, I chose a bubble photo with slightly more variation of color and light, and I set the **Overlay** slider on a low setting

| 3 |

making the bokeh effect almost imperceptible. I then flattened the image, imported it as a top layer above the original image, and blended it in **Color** mode. Using the **Color** mode blending technique to tint an image creates much more visual movement and life than applying flat washes of color with filter presets | 3 |.

The two final images can be seen on the opening page of this tutorial.

My Favorite App: Image Blender

You can create sophisticated composite images in Image Blender without ever leaving this deceptively simple app. Working with just two layers at a time, you can resize, rotate, or reposition the top image; switch layers around; select and modify blending modes; and erase unwanted areas before flattening and adding another layer. Image Blender is also an excellent tool for texturing and recoloring photographs, as briefly described in this tutorial.

Summary

In this tutorial I've shared my creative approach to macro work with Hipstamatic. This technique opens myriad possibilities, and through experimentation you'll discover your personal style. Don't forget to save or make note of your favorite lens and film combinations because it's all too easy to forget! I also discussed how a macro lens can be employed to create custom textures. When you start looking at the macro world, you'll discover all sorts of marvelous material to add to your texture library.

Finally, I introduced a simple but effective Image Blender technique: combining two or more photographs to give your images added depth and life. You can blend as many photographs as you choose. It's important to experiment and discover what all the blending modes do, but this technique works best when it's applied with delicacy and restraint.

Nettie Edwards (Lumilyon)

Nettie was a theatrical designer before she became one of the first digital artists and photographers to explore the possibilities of multiple-app techniques. Her work has won numerous awards, including the Fine Art category of the 4th Julia Margaret Cameron Photography Awards, and she was a finalist in the 2013 Lumen Prize for Digital Arts. She exhibited her images at the Arrangements in Black and Grey exhibition in May 2013 and at Fox Talbot Museum, Lacock Abbey, United Kingdom. Her work has been widely published and exhibited internationally. Nettie ran the United Kingdom's first iPhoneography workshops, and she also writes creative iOS tutorials for photographic and digital arts publications. *www.flickr.com/photos/Lumilyon*

Gallery

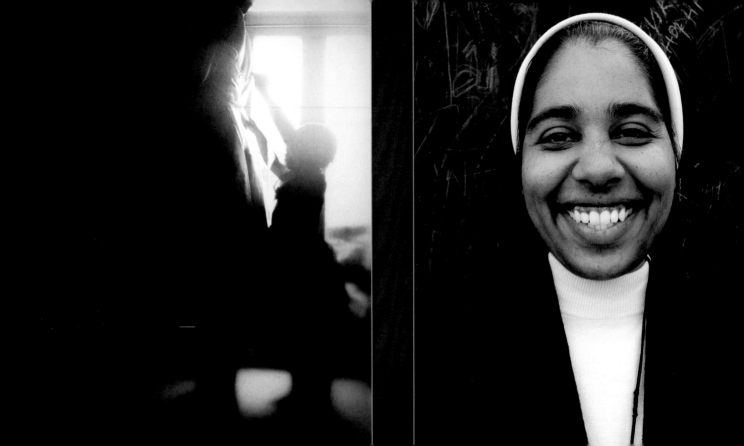

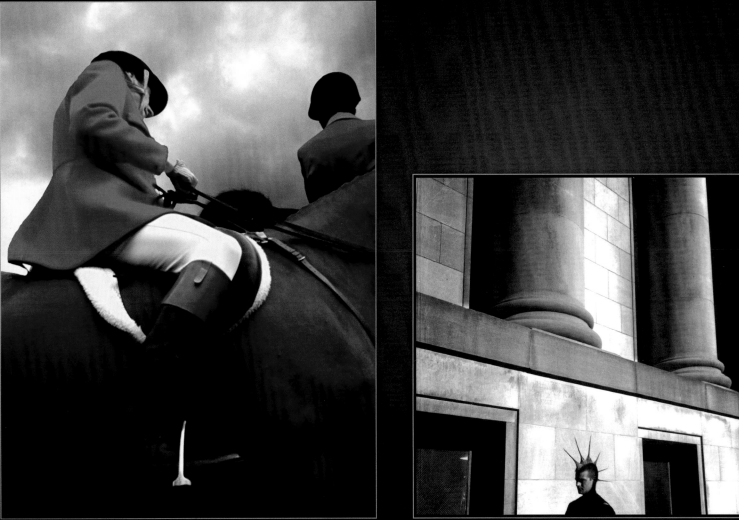

J. Q. Gaines
Impression Series
ArtistsTouch, 100 Cameras in 1,
Camera Awesome, Sketchbook

Doug McNamee
Lunch Rush

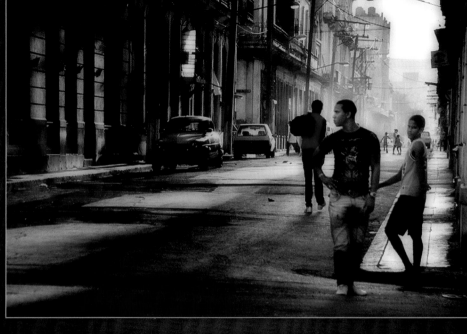

Marie Matthews
Sunday Blues Player
PhotoWizard, Photoforge2, Superimpose, BlurFX, Percolator,
Snapseed, ArtRage, AntiCrop, TouchRetouch, ProCreate, Touchup,
Luminance

Kerryn Benbow
Streets of Havana
Snapseed, Pixlr-o-matic

Cecily Caceu
North Head Lighthouse, Cape Disappointment
Pro HDR, Snapseed, Image Blender, Photocopier, PhotoToaster

Rad Drew
Continental Divide, Rocky Mountain National Park
Bracket Mode, Photoforge, Pro HDR, AutoStitch Panorama, Dynamic Light, Iris Photo Suite

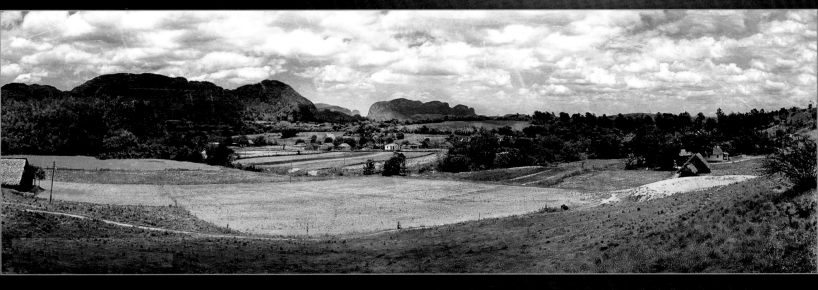

Marian Rubin
Valle de Viñales, Cuba

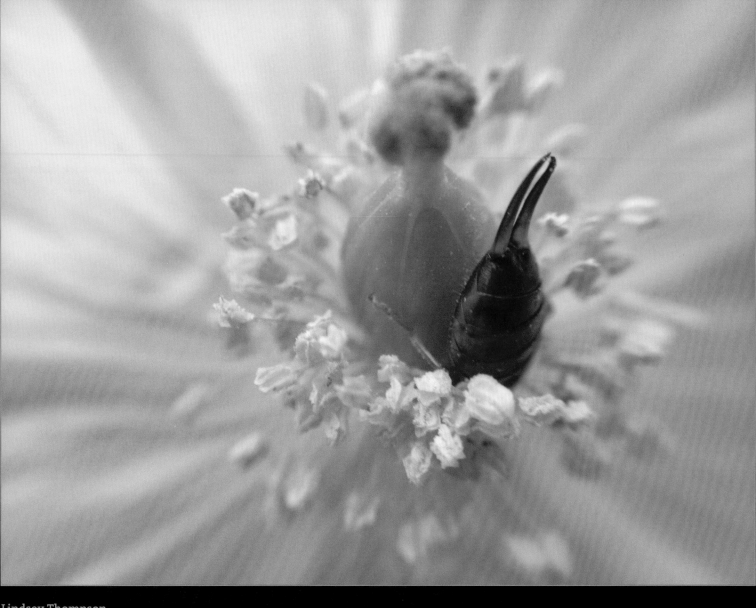

Lindsey Thompson
Hideaway

Miss Pixels
Suburban Grasshopper – Mirabel
Camera +, Snapseed, Diptic, Fuzel, EasyTitler, FX PhotoStudio

Susan Blase
Cosmic Thing
Picfx,DeluxeFX

Dan Marcolina
Bath 2
Big Lens, ScratchCam FX, Photoshop Express

Adria Ellis
She's the One
Snapseed, Grunge HD

Souichi Furusho
The Next World
ProCamera, Iris Photo Suite, Photo fx, Photo Clip, Filterstorm

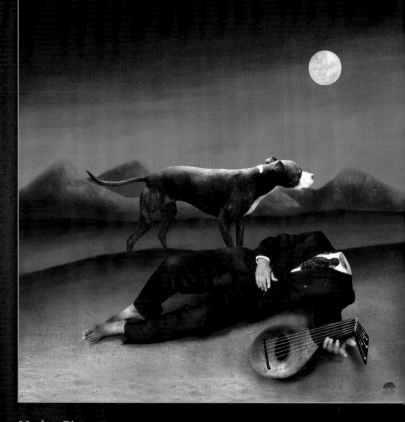

Markus Rivera
The Sleeping Gypsy
Juxtaposer, Snapseed, FX Photo Studio, ArtStudio, LensLight, ClearCam

Nicki Fitz-Gerald
They Told Me You Missed School Today
Photoshop Touch, ProCreate and Superimpose

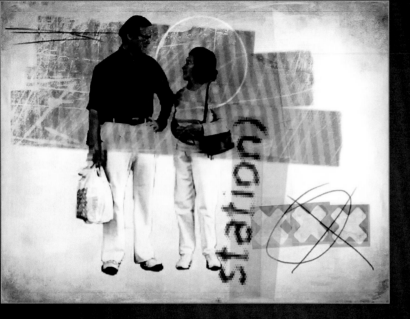

Bharat Dhaji
Station XXX
Iris Photo Suite, Juxtaposer, Pic Grunger, NewsFlash, Labelbox, ArtStudio

Lynette Jackson
Jackson_No._2027

José Antonio Fundo
The Secretly Sad Guard Dog
ASKetch, Sketchbook Pro

Cindy Patrick

Elaine Nimmo
Medical Experiment Gone Wrong
Hipstamatic, TouchRetouch, Filterstorm

Edina Herold
Life is Beautiful
BlurFX, Juxtaposer, Picfx

Robert Herold
The Visitation of Mr Horatius
ilterstorm, Tiffen Photo fx, Iris Photo Suite, TtV Photo Studio

Dax Curnew

Karen Divine
Finding Her Parts 9
Hipstamatic, ScratchCam FX, Juxtaposer, Image Blender, Snapseed

Please visit www.rockynook.com/iPhoneArt for an extended gallery that includes several images from all the contributing artists in this book.

The Clearest Way into the Universe

TUTORIAL 13

Create a botanical image closeup with textures

What You'll Learn

In this tutorial you'll learn tricks for shooting botanical specimens like a pro and how to create unique textures to enhance your images. Shooting your subject against a white, naturally lit background allows multiple textures to be layered into the resulting image with ease.

What You'll Need

- ⊙ Photo Transfer App
- ⊙ Laminar (iPad version)
- ⊙ PhotoCopier
- ⊙ Vintage Scene

Back Story

I am a student of Buddhism whose creativity is sparked by quiet observation of the natural world. The inspiration for my current work is taken from the words of Vietnamese Buddhist monk, poet, and peace activist Thich Nhat Hanh (Thay), who says that deep looking is a form of meditation. He teaches that by looking deeply, we develop insight into the Buddhist concept of impermanence. By looking closely at each leaf, blossom, stalk, or pod, I notice how each represents of all the stages of life, whether they are still blooming or withering and dying. I often keep them for weeks to more fully appreciate (and document) the impermanence that Thay speaks of. Each change is beautiful in its own way, and through observing this ongoing change I hope to more fully appreciate the effect of the steady and merciless march of time on my own body, mind, and spirit.

The Process

➤ Step 1: Shooting and Selecting the Image

To create this style of botanical imagery it is important to isolate the subject so there is no distracting background. I used a homemade light box placed in a sunny location | 1 |. Then, using the native iPhone camera, I took many shots of the subject, focusing deliberately on the areas I thought would make it pop the most. It is vital to take a lot of pictures at this stage because if that sharp focus isn't there, the final image will not be a success.

After I had at least 10 shots (though I usually take about 20), I used Photo Transfer App to transfer them from my iPhone to my iPad, where I selected the absolute sharpest image | 2 | and started the editing process.

| 1 |

Step 2: Creating Some Textures

In Laminar I created a **New Document** and selected **Blank Layer**. Choosing the dimensions is important, and in this case I typed in 2448 × 3264, the size of the image I would be working with | 3 |. I kept the background color white and saved the new blank image to the **Library**. I did the same thing again, this time tapping on the color square and selecting a light green gray, and I saved this blank gray image as well | 4 |.

To create the first texture, I opened the white image in PhotoCopier and selected **Paintings, Veláquez,** and I set the **Grain** to 0 and the **Texture** to 100 | 5 |.

After I saved the image, I opened this new version in PhotoCopier again and selected **Photos, Weston Nude**. I slid the **Texture** and **Grain** to 0 and saved the file | 6 |. This is one of the textures that I used in the final image.

| 2 |

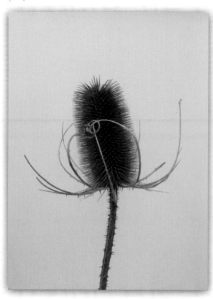

For the next texture I opened the white image in Vintage Scene. To render a full-resolution texture, I selected the **Settings** icon at the upper right and chose **High**. This app always opens to a random style, so I selected **Style** on the bottom left of the screen and chose one of the **Faded Time** selections that most closely resembled the colors I was looking for. In this case I wanted a pale green and golden brown. I tapped on the colored squares under the **Color** tab to adjust them, then I set **Image Age** to 75 and **Paper Age** to 50 | 7 |.

In Vintage Scene it is almost impossible to set the options under the **Adjust**

| 3 |

| 4 |

| 5 |

| 6 |

| 7 |

tab without settling on the border and overlay first, so first I clicked **Borders** and chose **No Border**. (It is not necessary to select the **Background Color** because it is relevant only if a border effect is desired.) Then I selected **Overlays** and chose the texture pictured in figure **8**.

Then I was ready to refine the texture. Under the **Adjust** tab, I set **Fade Out** to 100, **Image Strength** to 20, and **Texture Strength** to 90 | 9 |.

Finally I selected **Share**, then **Save**. Vintage Scene takes longer than many apps to save, and this particular image took about 10 seconds to render at high resolution.

I needed to repeat the process to create my final texture, so this time I opened the green-gray image in Vintage Scene and chose **Faded Time**. I selected the color palette pictured in figure **10**.

I set the **Image Age** to 92 and the **Paper Age** to 48, and I selected **No Border**. Then I chose the **Overlay** shown in figure **11**.

For the final step I selected **Adjust** and used the same adjustments as the previous texture: **Fade Out** to 100, **Image Strength** to 20, and **Texture Strength** to 90. I saved the image to complete my third and final texture.

| 8 |

| 9 |

| 10 |

| 11 |

☞ Step 3: Editing the Photo

In Laminar I opened the teasel image I had carefully selected from the series. I chose the version of the seed head that shows both the spiny front and stem thorns in sharp focus, and the curly bracts are clearly defined. Although this image works perfectly well in a vertical orientation, I have a particular love for squares, so I cropped the image by selecting the **Scissors** icon on the bottom and chose a **Ratio** of 1:1 to create the square. (This also took care of some pesky spots at the bottom of the image that I would have otherwise had to remove in an app such as TouchRetouch.) Since I wanted to retain the size of the image as much as possible, I kept the full width and cropped only the top and bottom | 12 |.

Next I selected the **Fx** function at the lower left of the screen, chose **Fx & Filters, Photo Fx, HDR,** and set the effect to 70 percent. I clicked **Apply** to render the image.

To give the image a little more pop, I again selected the **Fx** function, **Fx & Filters,** and I chose **Blur, Sharpen.** It is important to *never* overuse the **Sharpen** function because it can leave artifacts that will easily ruin an image. But I felt a sharpen setting of 20 would be perfect for this image.

| 12 |

| 13 |

➤ Step 4: Adding the Layers and Performing Final Adjustments

There are several ways to add layers in Laminar, but since I did not need to size each individual layer for this image, I chose the simplest method. Using the **Fx** function on the lower left of the screen, I selected **Add Texture**. This opened my photo album, and I selected the first texture I had created in Vintage Scene. I set it to the **Multiply** blend setting and applied it | 13 |.

To add the second layer I repeated the previous step by choosing the **Fx** function again and clicking **Add Texture**. This time I selected the texture I had created in PhotoCopier and chose **Overlay,** and I used the slider to change the **Alpha** setting to 65.

To brighten up the image before I added the final layer, I chose the **Light** tool to the right of the **Fx** button on the lower left of the screen, and I selected **Artificial Flash** | 14 |.

For the final layer I used the **Fx** function **Add Texture** and chose the other Vintage Scene texture that I had created earlier. I selected **Soft Light** as the blend mode and clicked **Apply**.

In the final image, I love the way the teasel remains sharp and strong against such a limited palette and how the textures are simple yet have great depth. This image can be printed or otherwise displayed quite large because all the spiky goodness of the teasel is in perfect focus. Sometimes I name my botanicals simply by their common or Latin names,

| 14 |

but this time I thought I would use part of a John Muir quote: "The clearest way into the universe" (John Muir, *Travels in Alaska*. Boston: Houghton Mifflin, 1915, 5).

Summary

To create the textures, I made two blank, full-resolution images in slightly different shades using the powerful editing app Laminar. I used them as bases in both PhotoCopier and Vintage Scene, and I created several texture layers in those apps. Then I edited the composited image (in this case a teasel seed head) in Laminar, and finally I assembled all the parts using layers.

Kimberly Post Rowe (iPhotoArtist)

The title of Kimberly's current body of work, Deep Looking, is taken from the words of Vietnamese Buddhist monk Thich Nhat Hanh, who teaches that by looking deeply we develop insight into the Buddhist concept of impermanence. Her images look deeply at each leaf, blossom, stalk, or pod and each is a representation of a stage of life, whether they are still blooming or withering and dying. Kimberly's work has appeared in print, online, and in galleries, including the LA Mobile Arts Festival 2012, Kiernan Gallery, Orange County Center for Contemporary Art, Art House (Portland) and many others. She is currently represented by VoxPhotographs, Maine.
about.me/kimberlypostrowe

MY APPROACH TO CAPTURING BOTANICAL IMAGES

This particular style of shooting (isolated botanicals, specimen-style) evolved out of winter shooting. I live in Maine, and the winter landscape is covered in snow with random leaves, pods, and other dried artifacts poking up through the frozen blanket of white. I grew accustomed to shooting my subjects against the snow and realized I missed this ability to isolate them during the warmer months. I had a light table from the days of shooting film, so I repurposed it into a rustic light box, as shown in figure 1.

I usually bring my light box outside to make the most of the available natural light. Sometimes I lay a specimen on the bottom and shoot downward, other times I tape it to the back wall and shoot through. To effectively shoot this way, two things are critical: an impeccably clean surface and even lighting. Almost all my work starts in the light box now, even in the wintertime.

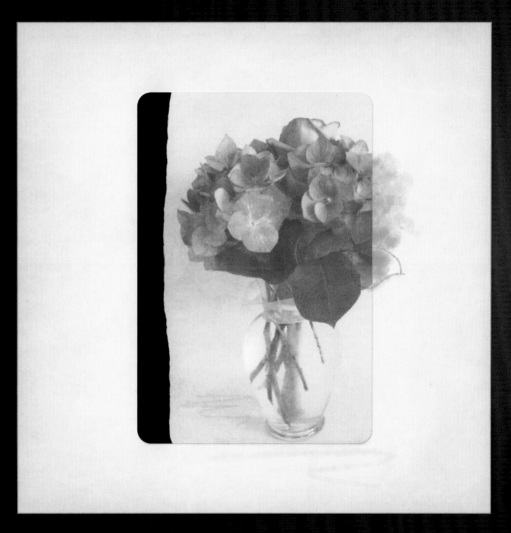

Still Life (12-03)

TUTORIAL 14

Create a still life from a photograph using drawing tools

What You'll Learn

I wanted to create an image that incorporates the spontaneous marks and tones of a Conté drawing with the textures and feel of an old daguerreotype photograph. I took my source image with an iPhone 3GS. I really love the graininess (and relatively low resolution) that it gives this kind of work.

What You'll Need

- Pixlr-o-matic
- lo-mob
- Camera Awesome
- TouchRetouch
- SketchBook Pro

Back Story

From the moment my first art professor introduced me to the old masters (especially Rubens, da Vinci, van Dyck, and Rembrandt), I knew that drawing was the foundational skill that all artists, including photographers, should possess. It's now 25 years later, and I'm still learning to draw—now with digital tools.

Drawing forces an artist to truly understand how to design a strong and dynamic composition. I don't know of any better way for a person to express his or her thoughts and feelings more genuinely than with the spontaneous gesture of a hand. When an artist lays down his or her impressions and expressions—with the stroke of a pencil, a piece of charcoal, a Conté crayon, or even a stylus—the resulting image creates a unique and powerful sense of intimacy between the artist and the viewer.

When I got my first iPhone I was thrilled to be able to explore photography. I was impressed that such a small device could take such crisp and vibrant images, and I was intrigued that I could employ so many clever techniques that altered my shots and made them more artistic.

The Process

➤ **Step 1: Adjusting the Image Tone and Adding a Torn Edge**

I wanted to give the image red tones and a torn-edged frame, so I imported my source photograph | 1 | into Pixlr-o-matic. I applied the **Amy** color filter and the **Tretton** frame | 2 |. I saved the image to the Camera Roll.

|1|

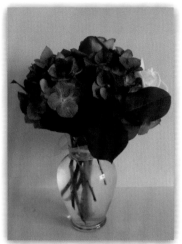

|2|

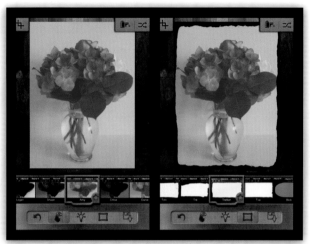

|3|

➤ **Step 2: Adding an Old-Fashioned Slide Frame**

Next I imported the image into lo-mob to find an old-fashioned slide frame to draw on. (Please note that whenever I say "import the image," I am referring to the most recently saved image in the camera roll.) I selected **Slide One Colder,** then I turned the **Photo Filter** and **Vignetting** off, leaving only the **Frame** filter on. I also pinched the image slightly to reduce its size, and I positioned it in the frame until I saw some of the gray-and-white checkered background on the left side (this area will become black when previewed) |3|. Then I previewed the image and saved it to the camera roll.

➤ **Step 3: Adding a Vintage Texture to the Overall Image**

To simulate an old daguerreotype look, I needed to apply a vintage texture. I imported the image into Camera Awesome and selected the **Classic** filter and the **Tang** texture |4|. Then I saved the image to the camera roll.

➤ **Step 4: Removing Unwanted Parts of the Image**

It was time to delete all the unwanted parts of the image, so I imported it into TouchRetouch. Using the **Brush** tool, I painted out the letters and a few unwanted areas on the image. Then I hit the **Go** arrow to erase the painted-out

areas |5|, and I saved the image to the camera roll.

➤ **Step 5: Incorporating Hand-Drawn Marks into the Image**

At this point I was ready to begin my drawing process. I imported the image into **SketchBook Pro** and used **Pencil #2** and **Sponge Brushes** |6|.

I never draw directly on my photography. I prefer making all of my marks on a layer so I can explore freely without worrying that I will do irreparable damage to the image. Also, by working in layers, I can adjust the opacity level of my drawing marks without affecting the background image. Therefore, first I added a layer and positioned

| 4 |

| 5 |

| 6 |

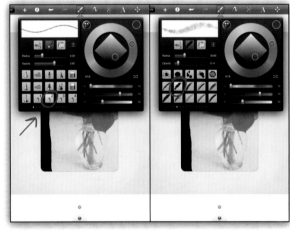

| 7 |

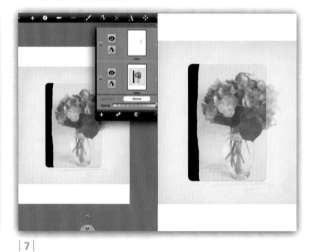

it at the top of my queue so I could view my marks on the photograph as I drew them. I clicked the **Color Picker** (eyedropper) and selected a color from my photograph to draw with. I used a

Sponge Brush to paint some flowers onto the slide frame, and I used **Pencil #2** to draw the leaves and lines | 7 |.

I then saved the image to the **Sketch-book** gallery and to my camera roll.

➤ **Step 6: Cropping the Image to a Square**

The last step was to crop the image to a square. This is one of the few features that SketchBook Pro does not have, so I

reimported my final image into Camera Awesome and cropped it there | 8 |.

My Favorite App: SketchBook Pro

Every artist knows that a studio (physical or digital) is expensive. There are costs for tools, like a drafting table or easel; and there are costs for consumable supplies, like paper, pencils, canvases, and brushes. I think of *most* of my apps like consumable supplies. I know where they are if I need a specific effect (like I know where each brush is in my physical studio).

I think of SketchBook Pro as my drafting table. I use it for layout, touch-ups, textures, cropping, blending, and simple drawing. This single app lets me create and merge my drawings with photography (thanks to sophisticated layering controls). And I can remix multiple versions of the same image along with my hand-drawn marks and textures. No matter how many apps I work with to achieve a specific effect, this is one of the core tools I regularly use to assemble my final images.

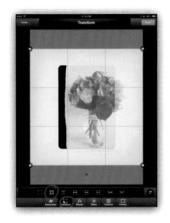

| 8 |

Summary

Before I put down any drawing marks, I spend a great deal of time making sure that the composition, tones, and textures are all in place. Here are the basic steps for this project:

- ❯ Start with Pixlr-o-matic to adjust the image tone and add a torn edge
- ❯ Jump into lo-mob to add an old-fashioned slide frame
- ❯ Switch over to Camera Awesome to add a vintage texture
- ❯ Spend time in TouchRetouch removing unwanted parts of the image.
- ❯ Load SketchBook Pro for the actual drawing and blending
- ❯ Crop to square in Camera Awesome

J. Q. Gaines (jq_gaines)

After studying painting and printmaking at Pratt Institute, J. Q. owned and operated a book arts and textiles studio in New York City, where she designed and created one-of-a-kind books. After her first child was born, J. Q. put her career on hold. However, three years ago her husband and kids surprised her with an iPad and an iPhone. These devices instantly rekindled her passion for painting and introduced her to photography. J. Q.'s work has been exhibited in SoHo Gallery for Digital Art, Kat Kiernan Gallery, the LA Mobile Arts Festival, and others. She received three awards in the Mobile Photo Awards 2013.
www.iphoneart.com/users/2347/galleries

Avian

TUTORIAL 15

Create an image series that expresses the inherent nature of the subject by enhancing color tones and adding dramatic lighting, textures, and framing

What You'll Learn

In this tutorial about editing shots of birds you will learn how to highlight specific details, such as feathers or eyes, and add a strategic shadow or ray of light to draw the viewer's eye to a particular part of the image or subject. You'll learn about some apps you can use to help you add flair and drama to your photos.

What You'll Need

- Snapseed
- Pixlr-o-matic
- Rays
- LensLight
- Pixlr Express PLUS
- ScratchCam FX
- Iris Photo Suite (iPhone version, now replaced by Laminar).

Back Story

As a lifelong bird lover, I was thrilled to move to a town that has direct access to Puget Sound, a beautiful scenic inlet of the Pacific Ocean. Here we are treated to frequent sightings of bald eagles, blue herons, cormorants, ravens and crows, and of course seagulls. Feeding the gulls began as an amusing pastime with my

young children, as did snapping pictures of my kids laughing at the birds and their antics. I quickly realized, by happy accident, how beautiful some of the shots of the birds were. I also discovered (and fell madly in love with) numerous photo editing apps that transformed my ordinary, random photographs. As I experimented with the apps, I also began to explore and re-create myself through heavily layered self-portraits.

After all my app experiments, applying various apping techniques to the shots of the birds was a natural creative choice, and I used the different filters and effects to highlight the birds' natural beauty and grace. My goal, when shooting and editing avian images, is really very simple: I want a moment of the drama, emotion, and miracle of flight to be showcased. I rarely edit the photos heavily; instead, I prefer to focus on drawing out the already existing beauty of the birds. The iPhone still amazes me, with its ability to capture such beautifully precise still shots of birds in motion. I shot all of the photos in this tutorial with an iPhone 4S.

The Process

My tutorial consists of eight different projects, each demonstrating various techniques I use to create my images.

| 1 |

| 2 |

| 4 |

| 3 | *Avian1 (final)*

Avian1: Bringing Focus to a Subject

The glow of light underneath the wing in the foreground caught my eye the most in the original image | 1 |. To focus on that light, I used Snapseed to crop the original, and then I used its randomized **Grunge** option. This provided the softness, color, blur, and subtle textures I wanted. I finished the image in Pixlr-o-matic, using the **Smoke** frame option | 2 and 3 |.

Avian2: Adding Intensity to a Scene

This shot | 4 |was so striking on its own that it did not need to be cropped at all.

I simply used Snapseed's **Grunge** option and lowered the saturation to zero. When I was happy with the soft turquoise color, I used the **Drama 1** option to enhance the shadows and define the feathers very slightly. I chose the **Center**

| 5 | *Avian2 (final)*

| 6 |

| 8 |

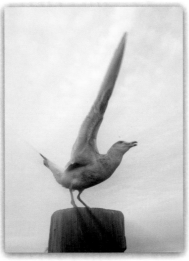

| 9 |

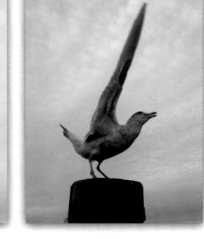

| 10 | *Avian4 (final)*

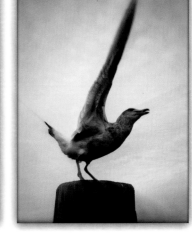

| 7 | *Avian3 (final)*

Focus option for the last step to add the vignette and the slight blur in the upper portion of the image | 5 |.

➤ Avian3: Drawing the Viewer's Eye to Your Focus Point

With this image | 6 | I wanted to highlight the individual feathers and the beautiful positioning of the wings. In Snapseed I desaturated the color and performed a simple crop. I then used the **Tilt-Shift** option (elliptical) to slightly blur all of the area in the image except the bird. I reduced the brightness, increased the contrast, and finished the image with the **Smoke** frame in Pixlr-o-matic | 7 |.

➤ Avian4: Adding Effective and Realistic Lighting and Shadows

This bird's unusual wing posture caught my eye | 8 |. I imported the image straight into the Rays app and added some dramatic light and the shadows coming from the bird's legs. I then used Snapseed's trusty **Grunge** option to achieve the olive green coloring and the increased contrast, as well as the blur and slight vignette around the edges of the image | 9 and 10 |.

➤ Avian5: Creating an Effective, Distraction-Free Image

I loved this matched pair of birds flying in tandem | 11 |, so I used Snapseed to crop the shot to showcase the pair

| 11 |

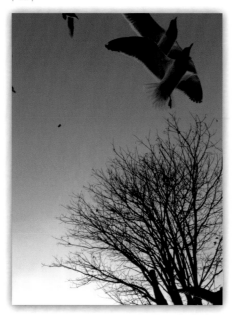

and eliminate distracting elements that would draw attention away from the birds. I wanted to do a simple yet dramatic black-and-white shot, so I used the **Tilt-Shift** feature to take away all saturation and to blur everything but the bird in the foreground. I then used **Center Focus** and **Drama** to make adjustments as I worked until I was happy with the brightness and the overall feel of the image. I used the **Perga** frame in Pixlr-o-matic to complete the image | 12 |.

Avian6: Adding Dramatic Light and Color

I was drawn to the glow of light under the wing in the foreground | 13 |. I cropped the shot in Snapseed, increased the saturation, and added a slight blur. I then imported the image into LensLight to add more light and drama. To create the illusion that light from the setting sun was falling on the bird, I used the **Sun Beam** effect. I put the sun itself off the edge of the image and focused it under the wing on the right | 14 and 15 |.

Avian7: Reducing Extremes in Lighting

The birds posed so beautifully in this shot | 16 |, but because they were directly in front of the sun I needed to reduce the extreme contrast. I used Snapseed

| 13 |

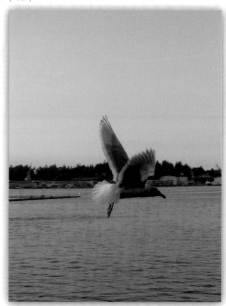

to crop the image, remove all color, and add some shadows and blur around the edges with the **AutoFocus** option. I then used Pixlr Express PLUS to add some textures, darken the vignette, and add the cornered frame to finish it off. Pixlr Express PLUS is a fantastic app that allows you to easily customize any filter, frame, or texture you choose | 17 |.

Avian8: Adding an Aged and Textured Look

After a very slight crop in Snapseed, I used the **Tilt-Shift** and **Grunge** features to blur this image and add some soft

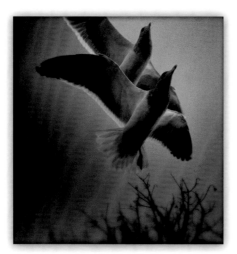

| 12 | *Avian5 (final)*

| 14 |

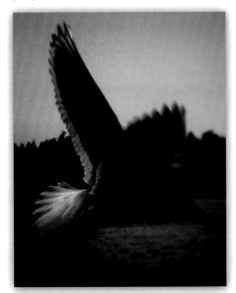

| 15 | *Avian6 (final)*

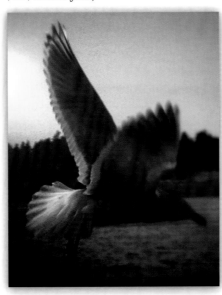

| 16 |

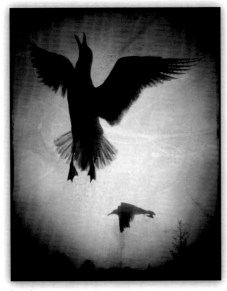

| 17 | *Avian7 (final)*

texture. I removed all color using the **Black & White** option | 18 |. I then used the Rays app to add some subtle drama and to bring the bird in the center of the shot into even better focus. Next I used Pixlr Express PLUS to add a slight grunge texture, and I used ScratchCam FX for the scratches and to complete the image. I then imported the image into the Iris Photo Suite app and used the **Rotate/Flip** feature to flip the shot from right to left | 19 |.

My Favorite App: Pixlr Express PLUS

Pixlr Express PLUS is versatile and user friendly; it's one of my most frequently used editing apps. It offers an incredibly large and diverse selection of filters, overlays, borders, and textures. My favorite feature of the app is the **Fade** function, which allows you to control the strength of any effect. This allows either subtle or dramatic textures or lighting to be applied to an image. You can download only the effects you want, and you can designate your favorite effects within groups of effects. The **Undo/Redo** option is also a great tool that I use a lot.

| 18 |

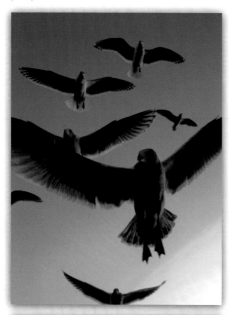

Summary

I hope this tutorial has given you some useful tools, examples, and tips to turn your good shots into great ones. You can use Snapseed, for example, to effectively crop, blur, desaturate, or add pleasing drama to an image. If you want to add even more drama, you can easily add amazing special effects or light rays with the LensLight or Rays apps, and you can easily apply grunge and age to your images with ScratchCam FX. The selection of creative editing apps is enormous, varied, and ever evolving. Start collecting apps slowly, begin with a great base image, and don't be afraid to experiment. You will amaze yourself in no time!

Liz Grilli (themoaningtree)

Liz Grilli is an artist who divides her time between taxiing her children and stalking the local bird, book, and tree populations in and around Port Orchard, Washington. Liz's medium of choice is the iPhone, which gives her the freedom to capture and create vibrant, intense images anywhere, anytime. Her creations are inspired by her immense gratitude, respect, and wonder for great literature and for all things natural. Her images have been collected and exhibited across the United States and Europe.

www.iphoneart.com/themoaningtree

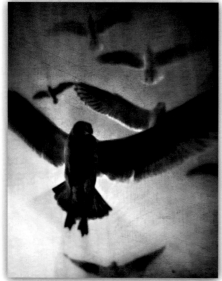

| 19 | *Avian8 (final)*

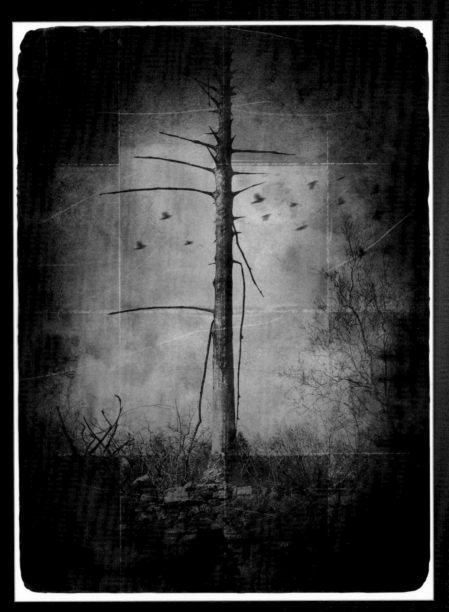

Burned Tree

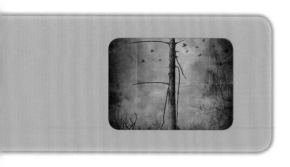

TUTORIAL 16

Create an enchanting image from a burned tree

What You'll Learn

In this tutorial you'll learn how to turn a throw-away photo into something interesting.

What You'll Need

- Lens+
- ScratchCam FX
- Vintage Scene
- Microsoft Tag
- Image Blender
- Snapseed

Back Story

There is a great location very near my house that I visit often when the light is interesting or when I am on my way to the grocery store on Saturdays. It is an abandoned farmhouse and has several interesting areas to shoot—from old magazines that have been lying outside for decades, to three creaky old houses to explore.

I began to explore the large house by myself one weekend and was excited to bring my two kids, Dan and Dana, to shoot with me the very next weekend. When we arrived we discovered, much to my disappointment, that the house

had burned to the ground after standing for more than a hundred years.

We all shot around the smoldering shell of the house, which proved to be a unique opportunity. The shot of the burned tree you see here | 1 | is sculpted from an image that, at the time, felt like a throw-away frame (as many do). But it has since become one of my favorites.

The Process

Step 1: Visualizing a Throw-Away Shot

Lens+ was one of the first usable full-resolution, real-time filter preview iPhone camera replacements. This meant I could quickly swipe through 30 different film and lens looks before I took a picture. I usually like to adjust the look of an image after I take the shot, so I generally use the built-in Apple camera app. This was the first time I understood that I could make different image capture choices when I visualize the image as Lens+ would treat it. For instance, visualizing a scene in black-and-white as you take it allows you to compose the shot with shapes and light, rather than color, to balance the frame. Or visualizing a setting in a different color tone or mood may inspire you to take a picture

|1|

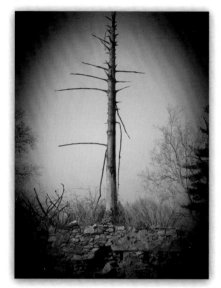

|2|

|3|

|4|

that you may not have taken. Figure **1** is the initial shot as captured by Lens+.

Figures **2** and **3** show a few of the styles that Lens+ can render.

The app also allows the addition of a vignette or a frame and will capture an image in a square format if desired. I ended up using the **Early Bird Fashion** filter with a vignette |**4**|.

The final result has a sepia feel, but it has a slight bit of the original color showing through.

Step 2: Revealing the Beauty of the Image with ScratchCam FX

I moved the image into ScratchCam FX and chose the **Folded Paper** look from the **Textures+Borders** menu. For the **Colours** setting I used the gold tone |**5**|.

I switched to the **Scratches** tab and turned on the scratch type shown in figure **6**.

Step 3: Giving it That Visual Edge with Vintage Scene

I was happy to find that I had saved my tree preset from the time I had originally created this image |**7**|.

There are so many variations possible in Vintage Scene that it would have been hard to create the original look. Figure **8** shows the settings I used for **Color** to create this preset.

The sliders can be used to incrementally colorize the image or to change the paper color, and you can tap the color squares to select a color from a palette. You can also add textures to the image by tapping **Textured** (as I did on this image). I used the **Adjust** dialog to increase the strength of the texture and the image and to fade out the image from the center outward |**9**|.

| 5 |

| 6 |

| 7 |

| 8 |

| 9 |

| 10 |

| 11 |

| 12 | | 13 | | 14 | | 15 |

From the **Overlay** tab I selected a texture that I thought would work well | 10 |.

I decided to add a **Border** and chose from 27 great possibilities. It's important to remember that adding a border in Vintage Scene introduces additional texture or vignetting to the body of the image | 11 |.

➤ Step 4: Capturing the Birds

The birds are taken from my book *iPhone Obsessed* as shown in the sequence found in figures 12 through 15. Using the Microsoft Tag app, I scanned the 2D code on page 41 of the book to trigger a mini/micro site to appear, from which I chose an alpha PNG. I tapped on the birds, which opened the image full screen. I then tapped and held the screen, and the **Save Image** dialog appeared. The saved image has alpha (transparency) information that can be read in Image Blender, Photoforge, and Adobe Photoshop Touch.

➤ Step 5: Making the Birds Fly

I imported the last-saved version of the tree photo into Image Blender as the base layer, then I brought in the birds on the top layer. I used the **Multiply** blend mode to overlay the black birds on the background with a transparency of about 90 percent so the birds appeared perfectly black to provide some additional atmosphere | 16 |.

I then scaled the birds down and positioned them with the **Arrange** tool, which you can access by swiping to the left | 17 |.

➤ Step 6: Making the Image Snappier with Snapseed

Next I used the most powerful, unique tool in Snapseed: the **Selective Adjust** feature. I wanted to make the image a

| 16 |

| 17 |

| 18 |

| 19 |

bit brighter and strengthen some of the areas of color. To brighten the vignette I placed control points around the edge and turned up the brightness to add a bit of contrast and reduce the saturation. This brought out the texture and opened the shadows.

Adjusting the node at the base of the tree strengthened the little bit of red by increasing the saturation | 18 |.

In the last step I added some sharpness (+30) and structure (+27) | 19 |.

My Favorite Apps: Vintage Scene and Snapseed

Vintage Scene: There are so many great textures and borders in Vintage Scene that at times I just want the texture with no image to use in a compositing app like Adobe Photoshop Touch. To accomplish this I place my thumb over the lens and take a picture to create a black frame, then I bring the resulting image into Vintage Scene. I apply the desired texture and adjust the settings (image strength) to taste, and I save it as a texture for later use.

Snapseed: It's important to not oversharpen, which is a telltale sign that an image has been overworked. If the image is low resolution, sharpening will affect it even more. The **Selective Tool** in Snapseed is available from Nik Software for the desktop. It is called Viveza and is a plug-in for Photoshop Lightroom and Aperture. It provides even more control than **Selective Tool** in the Snapseed app.

Summary

I was able to previsualize the moody possibilities of this scene by using Lens+. The image became more luminous through the color and texture manipulation in ScratchCam FX.
I contained the scene by framing and vignetting the image in Vintage Scene, and I ensured dimension and a sense of place by adding birds in the background. In Snapseed I refined the tones to calm the visual impact. The final picture is a pleasant memory of a day out shooting with my kids.

Dan Marcolina (@Marcolina)

Dan is the owner of Philadelphia-based Marcolina Design Inc. Over the past 20 years, his company has become a nationally recognized leader in print, web, video, and now digital publishing design. Over the past two years Dan has found iPhoneography a perfect bridge between his digital design side and traditional alternative photo side. Dan is the author of the critically acclaimed book iPhone Obsessed and four iTunes e-books. He is the organizer of the landmark iPhoneography event The Mobile Masters Sessions, held in January 2013 in San Francisco. He has lectured on iPhoneography nationally, and interviews with Dan can be found in Graphis and Zoom magazines and at many online venues.
www.marcolina.com/v2

ADRIA ELLIS · UNITED STATES

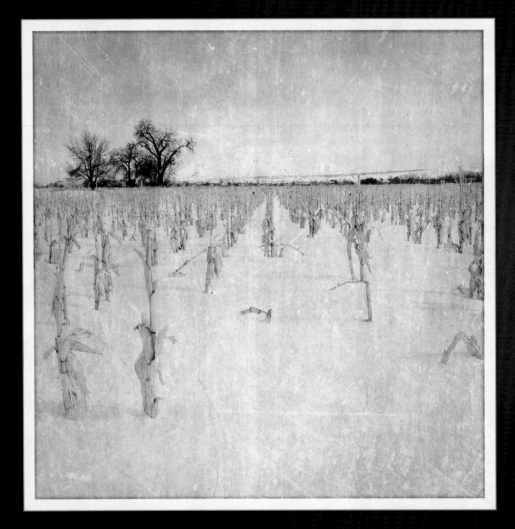

A Winter Landscape

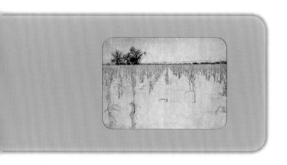

TUTORIAL 17

Create a landscape and enhance it by adding depth, color, and texture

What You'll Learn

In this tutorial you will learn how to sharpen an image, add a variety of textures, adjust the colors, then blend and mask the image to create the final look.

What You'll Need

- Hipstamatic
- Iris Photo Suite (iPad version)
- ScratchCam FX

Back Story

I have always loved photographing landscapes. Fifteen years ago I was taking images like this with my 4×5 camera. Today my iPhone—combined with the art of apping—is my tool of choice. I love snowy, wintry days when there is almost no visible distinction between the sky and the ground. I take images with a lot of negative space, or with a very simple composition, knowing that I will app them later. I love adding distressed textures and scratches that leave viewers wondering if they are looking at a photograph or a vintage image or maybe even a painting.

| 1 |

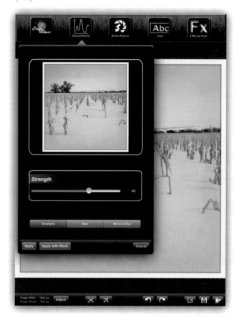

The Process

→ **Step 1: Preparing the Base Image**
I took my base image with Hipstamatic. I used the Helga Viking lens, which is a very neutral lens, and combined it with the Blanko film | 1 |. This provides a square format and a thin black line framing the image with a white border. In Laminar I sharpened the image to pull more detail out of the trees. This became the base image that I blended later with the other textured images. I wanted the detail in the corn and the trees to be prevalent. I liked the

| 2 |

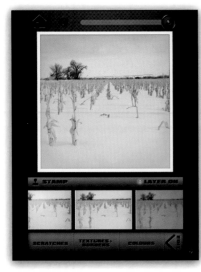

| 3 |

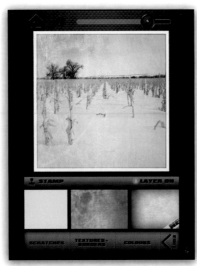

| 4 |

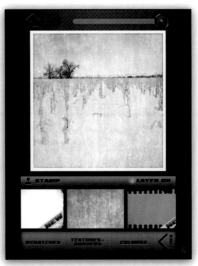

| 5 |

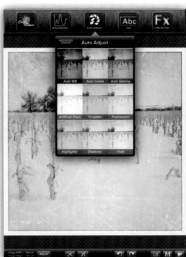

exposure and contrast, so I didn't make any changes. I saved this version of the image.

➤ Step 2: Selecting Colors

Switching to ScratchCam FX, I turned off the texture and border layers so I could easily see the colors. I like this selection because it adds a nice blue gray to the sky and a warmer color to the ground. Adding density to the image would give the textures a bit more to act on during the blending steps. With the slider tool on the top, I decreased the opacity just a bit | 2 |. At this point I stamped the image so I could add another effect and have the color I selected remain the same.

➤ Step 3: Adding Textures

After I chose the color, I went to the **Scratches** section of the app and turned the layer on. My plan was to add depth by building on the sky and the snow in the foreground. With the slider on the top, I decreased the opacity of the texture. I stamped the image again so the current levels stayed the same | 3 |. I selected **Textures+Borders** and added a bit more texture, which removed some of the color. I like the less saturated look for a winter scene | 4 |.

➤ Step 4: Blending Versions of the Image for Greater Contrast

I opened the image in Iris Photo Suite and selected the **Auto Adjust** function. I wanted the textures and colors to come out of the highlights a bit more, so I chose the **Highlights** setting | 5 |.

Under the **Adjustments** section, I chose **Layers** and **Set Layer as Base**. This allowed me to import the original image that I had sharpened in step 1 and blend the two together a bit. By clicking the film roll on the bottom right, I chose the new image option and selected the first one I had sharpened and saved. I went to **Adjustments > Layers** and chose to blend it with my base image | 6 |.

| 6 |

| 7 |

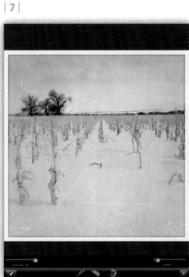

| 8 |

| 9 |

My plan was to bring in a little of the original image to add details back to the trees and the corn. I pressed **Done** and then **Draw Mask**. This mask drawing option is the reason I use Iris Photo Suite. I used the brush on the left and adjusted the opacity to taste to remove some of the texture in select places and to bring out the details in the trees and in the corn. (For me, this is a back-and-forth process between apps and sections of apps, and it feels like painting.) My goal was to have more texture in the foreground, a little less texture in the sky, much less texture in the trees, and an overall softening of some of the harder scratches so it would be less

apparent to the viewer exactly which filters I had used | 7 |.

Step 5: Making Final Color and Texture Adjustments

Although I liked the density in the lower and upper portions of the image, it felt a bit too green and cool to me. I added a little red and took out a little green | 8 |.

I saved my image at every step so I could go back and make changes without having to completely start over. Before saving an image in Iris Photo Suite it is important to check the **Image Width** and **Image Height** in the lower left corner. I set the size to 2200 × 2200

and pressed **Go**. When the size was correct, I saved the image.

I found myself wanting a little more texture after the blending was done. I returned to ScratchCam FX and selected **Textures+Borders**. I set the opacity at just a little over 50 percent, with the **Colours** and **Scratches** layers set to **Off**. I like this texture because it adds a little more grunge and almost a snow-like feel. I was happy with the image at this point, so I saved it as the final version | 9 |.

My Favorite App:
Iris Photo Suite (iPad version)

The first app that really inspired me and has remained at the top of my most-used list is Iris Photo Suite. It allows me to correct the brightness, contrast, sharpness, and color and apply different grunge textures. I like the fact that there are just the right number of filters and effects. Sometimes I get lost in too many choices. The features that keep Iris Photo Suite at the top for me are the masking and blending capabilities. When I choose a filter or effect, I can control the degree of intensity and opacity. This allows me to make the smallest adjustment when it's called for.

To accomplish this I frequently create a base layer and then open a new image. At this point I like to blend the two together. For me the key is being able to erase or intensify specific aspects of an image. For example, if I had a portrait to which I had added a lot of textures and scratches, I could easily load the original image as the base and open the new image (with the effects) in the top layer, blend them together, then erase all the effects from the face to ensure it remains recognizable.

There are several other apps, such as ScratchCam FX, Grungetastic, and Modern Grunge HD, that I use to create a variety of different textures, scratches, and grunge looks, but the blending and masking in Iris Photo Suite gives me the ability to achieve an important aspect of my style. Without the blending and masking in Iris Photo Suite, I wouldn't be happy with any of the effects in other apps.

Summary

To create this image I began by fine-tuning the image in Iris Photo Suite. I used ScratchCam FX to add tone and textures. I also used Iris Photo Suite to create several different versions of the base image so I could selectively blend and refine the final image. Finally, I returned to ScratchCam FX to blend the different elements and make final color adjustments.

Adria Ellis (@adriaellis)

Adria attended Parsons School of Design in Paris, France, and graduated from Brooks Institute of Photography in Santa Barbara, California. She has spent more than a decade behind the lens and now finds herself among those artists who introduced the world to iPhoneography. Adria's work was featured at the 2012 International iPhone Arts Awards and the LA Mobile Arts Festival, and she won honorable mention in the Flowers and Travel categories of the Mobile Photo Awards (2013). Her work was also featured in the October 2012 issue of World Photo magazine. *www.aconica.com*

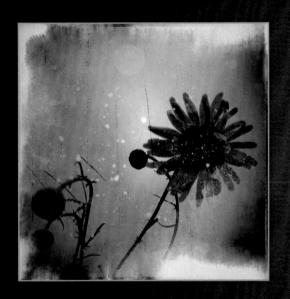

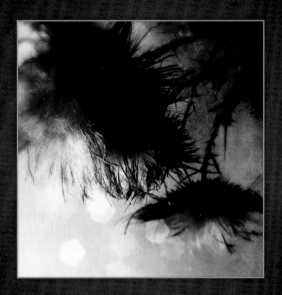

Flowers in December

Spent

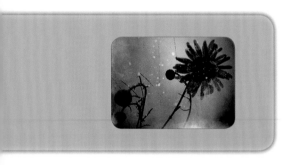

TUTORIAL 18

Create poetic and dreamlike images that use backlighting and magical textures to bring subjects to life

What You'll Learn

In this tutorial you will learn how to take an image from nature and transform it into a dreamlike work of art using apps to add texture and drama. You'll see how to apply layer effects that will take your ordinary shot to wherever your inspiration leads you. In just a few steps you will see the images go from common to a place of surreal beauty.

Back Story

I have come to love taking what I affectionately call my something-against-sky shots. I live in the woods and among many wildflower fields, and I am constantly pausing to snap something that catches my eye. People often ask me how I get the results I do, so I will share a few tips and inspirations with you.

My first tip is, don't limit yourself! Light, or lack thereof, is so important in my shots. I sometimes find it best to pick the specimen and take several shots of it against different parts of the sky to see what happens. A steady hand and a great base app with a random mode can yield many surprises. I randomly started using Hipstamatic and still think it's a wonderful app for this

style of shooting; I highly recommend it as a base tool for any iPhoneographer.

My favorite time of day to shoot is sunset. I find it gives me the most visual interest and variety. But I also love a stormy, dramatic sky. And don't forget that flower shots don't have to be bright. Many of my shots are captured in very low light or shadowy situations. You can always add a bit of light in the processing stage, or take light away.

I tend to take many shots while I vary the distance and focus and move the object I'm shooting into different positions against the background. Apps with double-exposure features or mirrored effects are also great fun and produce unique images that just don't happen in nature. I strongly suggest you make sure your apps are set to high resolution to ensure you don't have issues later on or if you decide to have your creations printed or published.

I love using subjects, such as dandelions, that have different life stages and let light show through them; I often combine the different life cycle stages or sizes in one shot. After you have your base shots, you are ready to create. I am often inspired by music, and many of my titles and my direction are driven by a particular song and the mood it conveys. The process for most of my images begins with cropping or zooming in as

needed. I then like to play with the over-all look of the photo, and this is where I create most of the dreamy texture in my work. I find that Pixlr-o-matic and PhotoToaster are great app choices with lots of options to add overlays or tweak colors.

I also love to add a bit of what I like to think of as magic to my images. I find that Lumiè and FilterMania 2 are simple and fun apps that allow me to do so. I find that bokeh, smoky, or glittery effects are the most pleasing additions to layer into shots. However, the choices are endless, so don't be afraid to add more than one. Always check out your work on a full-size screen before finishing because sometimes the image can look totally different. If you are not happy with your image, go back and adjust it in an app that will help you achieve the thing you find lacking or distorted in the larger view.

Most importantly, don't be afraid of variety and experimenting. The worst you can do is end up with a vase full of flowers that you picked and the knowledge to figure out what works best for you in future shots!

Study A: Flowers in December

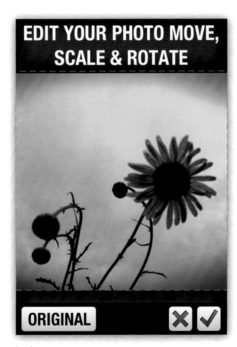

| 1 |

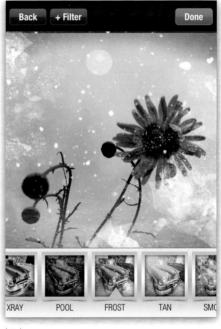

| 2 |

What You'll Need

- Hipstamatic
- FilterMania 2
- Pixlr-o-matic
- ScratchCam FX

The Process

▶ **Step 1: Creating the Base Image**
I took my base shot in Hipstamatic (in **Random** mode) and cropped it. I then loaded the image into FilterMania 2 | 1 |.

▶ **Step 2: Applying a Filter**
In FilterMania 2 I chose the **Frost** filter and saved the photo so I could move on to Pixlr-o-matic | 2 |.

| 3 |

| 4 |

| 5 |

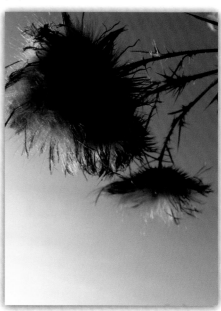

➤ **Step 3: Adjusting Color and Adding a Frame**

In Pixlr-o-matic I chose the **Sophia** film to adjust the color and the **Whitefiv** frame to add an icy effect to the edge of the image | 3 |.

➤ **Step 4: Adding a Final Effect**

As a final touch I opened the image in ScratchCam FX and played with the **Random** mode until I found an effect I liked. I then manually adjusted its strength as necessary, then I saved the image to my camera roll | 4 |.

Study B: Spent

What You'll Need

❯ PhotoToaster
❯ Lumiè

| 6 |

| 7 |

| 8 |

The Process

➤ **Step 1: Creating the Base Image**
I started out with an image of spent wildflowers taken with the native camera on my iPhone. I took it at sunset while holding the wildflowers up to catch the glow of the sun | 5 |.

➤ **Step 2: Adjusting an Image Using a Preset**
I then loaded the image into Photo-Toaster and used one of its **Supreme** presets. I tweaked the image manually until I was satisfied with the result | 6 |.

➤ **Step 3: Cropping the Image**
I loaded the image into Lumiè and cropped it to pull the subject closer | 7 |.

➤ **Step 4: Adding the Final Effect**
Finally, I added a wonderful **Glitter** effect in Lumiè. I chose the **Dark** option. Remember to try different options until you are satisfied, then save your image | 8 |.

The process is fairly straightforward, and the light and added textures were key in creating this look.

| 9 | | 10 | | 11 |

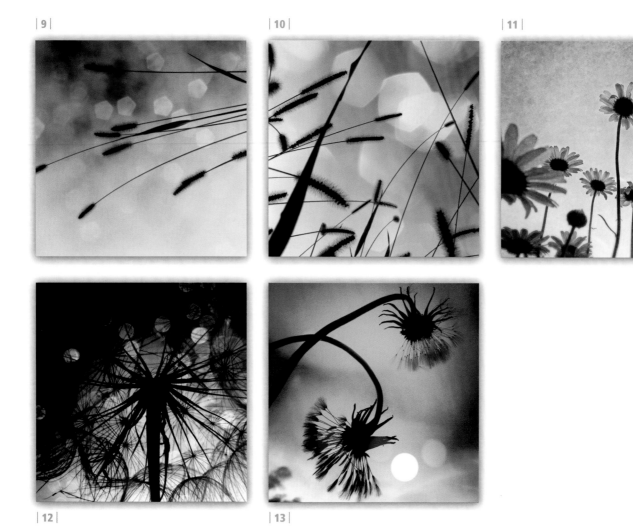

| 12 | | 13 |

My Favorite App: Lumiè

I like to enhance many of my images by adding effects that create a dreamlike mood. One app I have great success with is Lumiè. I like Lumiè because it's simple to use, yet it can give an image quite a visual punch.

Lumiè offers the option of either snapping a photo or loading one from your library. You then have several filters—such as **Glitter, Dots, Stars, Disco,** and **Hearts,** to name a few—that are quite fun to work with. Most effects layer over your image as a bokeh-like effect. The Lumiè interface is fairly easy to maneuver, and the app gives you the option to move or rotate filters and pick the level of intensity for an effect. It offers a nice preview screen so you can clearly see the resulting image.

After you have completed your creation, you can export it with or without a Polaroid-like frame. You can then save, print, or email your image, or you can share it via online services such as Twitter, Facebook, Tumblr, or Flickr.

Overall, I find Lumiè to be a very valuable tool for adding some magic to my photos without much time or trouble. To me it can very easily turn the ordinary into the otherworldly!

Figures **9** through **13** were created using techniques similar to those described in this tutorial.

Summary

I hope my tutorials give you some ideas about how to use apps to enhance a mood. You learned how an app that features a random mode, such as Hipstamatic, can be a vital tool for taking creative shots that provide a good starting point and inspiration. You also learned how to crop an image and adjust depth and color with apps such as Pixlr-o-matic and PhotoToaster.

Finally, you saw how to add some magic and surreal effects with apps such as Lumiè, FilterMania 2, and ScratchCam FX. It's my wish that some of my images and techniques have inspired you to take common objects found in nature and transform them into dreamy masterpieces.

Susan Blase (Black Eyed Suzy)

Susan is a landscape designer and currently resides in Bear Gap, Pennsylvania. Having earned a degree in earth science and environmental planning, she has an appreciation for the environment and for creating beauty with things found in nature. Susan received her first iPhone two years ago, which revived her interest in taking photos, and it allowed her to express herself creatively outside of work. She began to post her work on Flickr and Instagram, and her images have been invited for inclusion on a number of websites, including iPhoneogenic, iPhoneographyCentral and Life In LoFi.

www.flickr.com/photos/blackeyedsuzy

SOUICHI FURUSHO · JAPAN

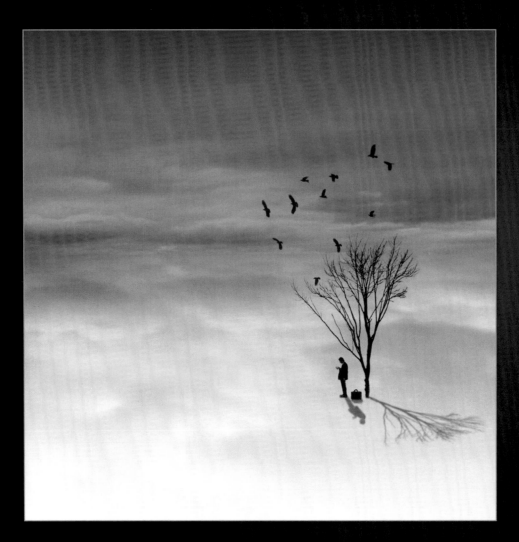

Rest

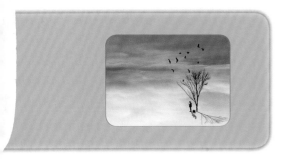

TUTORIAL 19

Create a minimal-ist, surreal piece of art using masking and compositing techniques

What You'll Learn

In this tutorial you'll learn how to create a surreal photomontage, convert an image to black-and-white, create realistic shadows, and use layering, blending, and masking techniques.

What You'll Need

- Photo Clip
- Photo fx
- FX Photo Studio
- Iris Photo Suite (iPhone version)
- Filterstorm

Back Story

I began by visualizing the image I wished to create based on photos in my camera roll while I developed my concept for the final piece, the colors to be used, and the processes I would employ. I received inspiration for this piece at the very moment when I saw the person in the image standing on a train platform. The concept for this image was born from the words "We are seeking a place of peace, people... Rest." I imagined a scene in which a person was resting under a tree, which I see as a place of peacefulness, emphasized by the presence of birds. To extend the idea

| 1 |

| 2 |

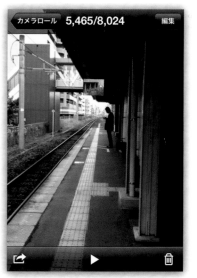

| 3 |

| 4 |

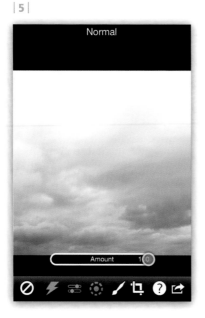

| 5 |

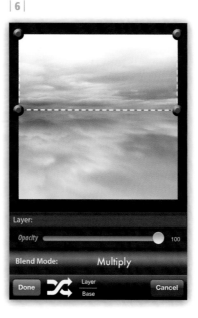

| 6 |

| 7 |

of rest and peacefulness, I added a vast space all around the subjects.

For this particular piece, the fundamental premise was to first fully compose the final image in my head. I then selected the four photos that would allow me to achieve my desired result. The next steps involved combining the sky (background), the man, the tree, and the birds as shown in figures 1 through 4.

The Process

➤ Step 1: Creating the Background

In Photo Clip I cropped the photo of the sky to a square format (1:1) and adjusted its position. I then opened the cropped photo in Photo fx, converted it to black-and-white, adjusted the tones, and saved it back to my camera roll. Still in Photo fx, I flipped the photo vertically and saved it as a second file. Next I opened the flipped image in FX Photo Studio and applied the **Explosion** blur filter to give the clouds a sense of motion | 5 |.

In Iris Photo Suite I opened the two edited versions of the file and combined

them with the **Multiply** blend mode in the app's **Layers** tool. To introduce a sense of perspective, I set the opacity for the lower half at 50 percent to alter its tone and create a difference between it and the upper half. I then selected **Mask Over Base** and tweaked the horizon to make it appear more natural | 6 |.

In Filterstorm I applied a black gradient to the upper half of the image and a white gradient to the lower half. Doing so added a shadow tone to the upper and lower halves of the sky | 7 |. The result was a background with the depth and breadth I sought. This completed my preparation of the background.

|8|

|9|

|10|

|11|

Step 2: Processing the Man, Birds, and Tree

In Photo fx I converted the three photos containing the man, tree, and birds to black-and-white. I then adjusted the tones in Photo fx to increase the contrast of black and white. I adjusted the tones for each image and used the **Paint** tool in Photo fx to white out all of the areas except for the ones I wanted to incorporate into my piece. Photo fx doesn't offer enough control to mask out the finer details, so I performed that part of the process in Filterstorm | 8–11 |.

Step 3: Compositing the Tree and Background

I opened the background image from step 2 in Iris Photo Suite, went to the **Layers** tool, and selected it as the base image. I blended the image with the tree image from step 3 using the **Multiply** blend mode while carefully positioning the tree to maintain the overall balance of the composition | 12 |.

Step 4: Creating the Shadow of the Tree

I vertically flipped the image of the tree from step 3 and added

a slight amount of blur in FX Photo Studio. I then adjusted the angle in Photo Clip. When that was done, I returned to Iris Photo Suite, positioned the image on the background, and used the **Multiply** blend mode with a setting of 50 percent opacity to create the tree's shadow | 13–15 |.

Step 5: Adding the Man and Birds

In the same fashion as with the tree in step 4, I used the **Layer** tool and **Multiply** blend mode in Laminar to position and add the man and the birds to the background. I

|12|

| 13 |

| 14 |

Blur

Amount

| 15 |

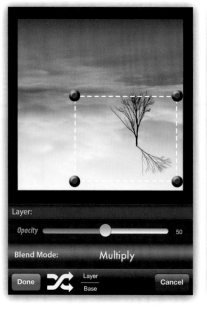

Layer:

Opacity 50

Blend Mode: Multiply

Done Layer / Base Cancel

| 16 |

then used the same technique as in step 4 to create and add the man's shadow | 16 and 17 |.

▶ **Step 6: Making Final Adjustments**
Working in Photo fx, I completed the piece by applying fine adjustments to compensate for the neutral black-and-white tones | 18 |.

My Favorite App: Iris Photo Suite (iPhone version)

I use Iris Photo Suite because it has a great compositing function to blend images together. It is also a great tool for blending the various textures that I have gathered over time. There are many built-in preset textures with strengths that can be individually adjusted. Additionally, the app makes it easy to adjust color intensities or even replace colors altogether using the **ColorSense** button. Iris Photo Suite also has all the classic image adjustment tools, including highlights and shadows, histogram, RGB color balance, selective

color, and noise reduction. Overall, it's an excellent, multifaceted app | 19 and 20 |.

Summary

In this tutorial I explained how I merged an idea with images from my camera roll. I showed how to crop an image to a square, convert it to black-and-white, add blur, flip an image, blend and mask elements onto different layers, apply black-and-white gradations to add depth, and make final tonal adjustments to harmonize the overall scene | 21 and 22 |.

| 17 |

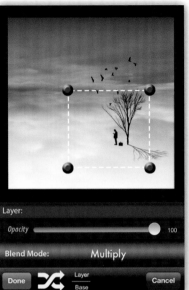

| 18 |

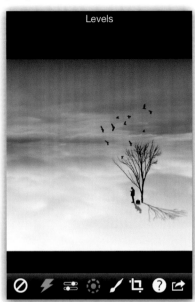

| 19 |

| 20 |

| 21 |

| 22 |

Souichi Furusho (@sfurusho)

Souichi works as a graphic designer in advertising. He discovered iPhoneography on Facebook and Flickr a few years ago, at about the same time that he bought an iPhone 3GS. Although he had no prior experience as a photographer, he had worked with photographs as part of his career in graphics. His work has been exhibited in Spain (La Huelva, 2012), The Netherlands, and California, and has been featured in showcases and interviews on a number of iPhoneography websites.
www.flickr.com/photos/sfurusho

MUTABLEND · JAPAN

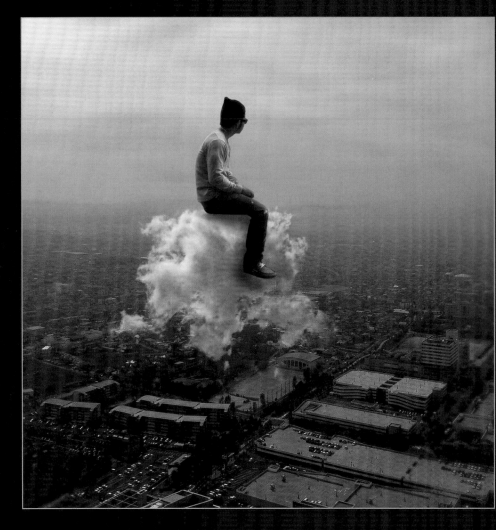

Secret Eye in the Sky

TUTORIAL 20

Create a surreal
photographic
image using
blending
and masking
techniques

What You'll Learn

Having never learned techniques by reading tutorials such as those found in this book, all the pieces I have created are the product of repeated experiments that have led to the methods I use. I can't say whether this was the best way to go about learning. The image I introduce in my tutorial requires no special techniques. I created it using the basic skills of cropping, layering, and masking.

First and foremost, I maintain a clear vision of what I wish to create, and I constantly consider how I can give my image the form I feel it deserves. The vision to conceptualize a piece and the story it might tell are not born from apps, so what I hope you will learn from this tutorial is not how to composite a cloud onto a background. It is that there is no single approach to create an image, and you can achieve a creative goal even if you employ no special techniques. My wish is that this tutorial serves as an opportunity to think about how to best express yourself visually using the basic techniques such as those outlined here.

What You'll Need

- ◉ Filterstorm
- ◉ Superimpose
- ◉ Juxtaposer
- ◉ Snapseed
- ◉ PhotoWizard-Photo Editor

Back Story

The story in this image is that of a man who is tired of interacting with people and seeks solace in the sky as a refuge from the drone of the crowd. He imagines himself riding on a cloud, only to discover that the sky does not offer the idyllic freedom he seeks. Instead, he finds before him the limited visibility of a cloudy sky that spreads out to the horizon. It brings him the same depressing mood he experienced on the ground, and this leaves him troubled, once again, as he finds himself trapped between his ideal and reality. He looks down on the city below as he realizes the problem is not that he can no longer find a place where he can have peace of mind, but rather that he is a restless soul to begin with.

Such is the basic premise for this story. It is based on an expression from an ancient Chinese philosopher: "It is not that there is no peaceful abode, but

| 1 |

| 2 |

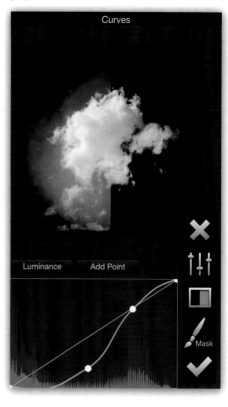

| 3 |

that I have no peaceful heart." The simple explanation might be that if one's heart is content, then that person can live peacefully regardless of the circumstances. The inability to live peacefully is a problem of one's own heart. It was while I was experiencing such a mood that I conceived the image, and I set out to give form to those feelings.

In the same manner that there is shadow where there is light, the relationship between ideals and reality represent two sides of a single coin, and people must spend their lives carrying that relationship with them. Changing one's perspective allows a person to recognize that the seemingly contradictory relationship between light and shadow, and between the ideal and reality, are not completely different states; they are

one and the same thing. These are the thoughts I pondered as I created this piece.

The Process

☛ Step 1: Preparing the Background

I opened the cloud image in Filterstorm to adjust the background | 1 |. I wanted to render the entire background in black,

so I adjusted the contrast using tone curves and levels | 2 |. Having blackened the background, I saved the file to my camera roll | 3 |.

☛ Step 2: Preparing the Second Image

I launched Superimpose and opened the background image | 4 |, and I opened the cloud image as the foreground.

I selected **Transform**, tapped the **Settings** button, and selected the **Screen** blending mode | 5 |. I returned to the **Home** screen and saved the file to my camera roll | 6 |.

Moving once again to **Transform**, I selected the **Settings** button and then the **Normal** blending mode | 7 |. I returned again to the **Home** screen and saved the file | 8 |.

| 4 |

| 5 |

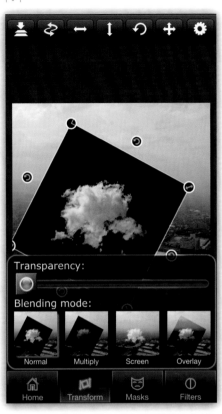

| 7 |

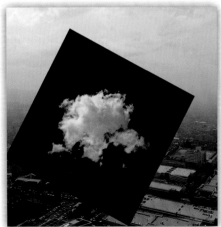

☞ **Step 3: Making Adjustments to the Cloud Image to Add More Definition**

I once again launched Filterstorm and opened figure 6. I selected **Add Exposure** from the **Filters** menu, and I opened figure 8 and tapped the **Fit to Image** button. This placed figure 8 on top of figure 6.

I selected the **Brush** tool, set its opacity between 20–30 percent, and used the **Brush** to paint in the cloud | 9 |. As I painted, I could see the cloud gradually appearing in the image. I took care to get the edges right when I painted. Having painted over most of the cloud, I saw how the original shading and depth of the cloud had been restored to the image. I saved the resulting image | 10 |.

| 6 |

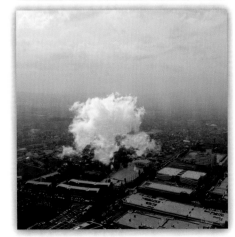

| 8 |

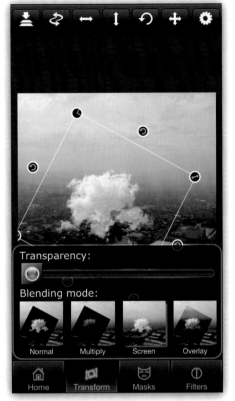

| 9 |

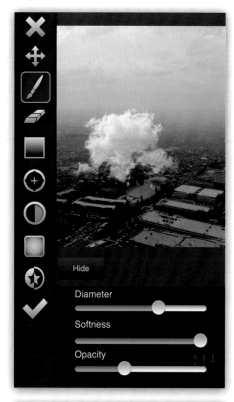

| 10 |

| 11 |

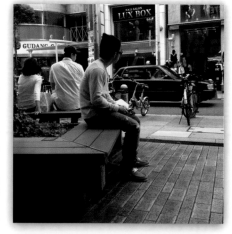

| 12 |

| 13 |

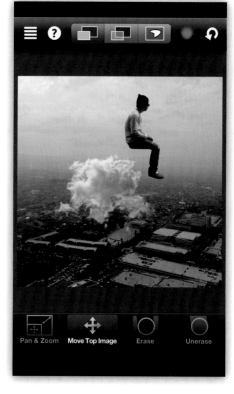

➤ **Step 4: Isolating the Figure from the Original Background**

I launched Juxtaposer and imported figure 10 as the base image and figure 11 as the top image.

I wanted to erase everything except for the seated man in figure 11, so I used the **Brush** tool to mask out the entire background | 12 |.

I then positioned the man on the cloud and saved the image to my camera roll | 13 and 14 |.

| 14 |

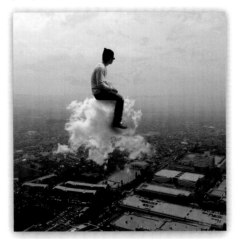

| 16 |

| 17 |

| 15 |

➡ Step 5: Adding Sense of Motion to the Cloud

I opened figure **14** in Snapseed, tapped on **Black & White,** and chose the style I felt was most appropriate for this image. I saved the converted file to my camera roll | 15 |.

Next I opened figure **15** in Photo-Wizard-Photo Editor. To add a subtle sense of motion to the cloud, I applied a small amount of horizontal blur to the sky. Because I wanted to add blur only to the sky, I first selected **Mask** and used the **Brush** and **Detail** tools to mask out everything but the sky | 16 |. When the masking was complete, I selected **Filters > Motion Blur > Horizontal** and added the blur. To add the right sense of motion, I set the **Speed** slider to a relatively weak setting, about 20 | 17 |.

The man was slightly affected by the blur effect, but I intended to correct this

| 18 |

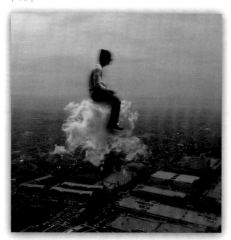

in the next step, so I went ahead and saved the file | 18 |.

➤ **Step 6: Erasing the Unwanted Blur**

I opened figure 18 in Filterstorm. In the same manner as in step 3, I selected **Add Exposure** from the **Filters** menu, chose figure 15, and tapped the **Fit to Image** button. This loaded figure 15 on top of figure 18 within the app. I selected the **Brush** tool and once again set the opacity between 20–30 percent. I wanted to erase the blur around the man, so I carefully painted as though I were tracing the outline of his body | 19 |. Because it's very easy to get an unnatural look where the subject and the background meet, one effective approach is to employ the circular **Gradient** tool to create

| 19 |

a natural blend. When the area surrounding the seated man was cleaned up, I saved the final image.

My Creative Process

My process in creating this image was to give form to the image as I had envisioned it by using cutting, pasting,

and layering techniques. The common thread that linked all tasks was to clearly determine which elements were necessary. Such clarification was vital for my image to clearly convey my message. Layering a number of photos to create a collage, of sorts, leads to a desire to include more and more elements. The message is lost if I have too many things to say in a given piece, so I pursue the simplest possible form to express my idea. Similar to how cutting away excess words in verbal communication better conveys a message, the message of an image is better conveyed if all but the necessary elements are stripped away. Think about this if you find yourself unable to effectively combine a number of disparate elements. The piece is almost complete when disparate elements come together to form a single image in your head.

The most important process in creating a collage or other multilayered image is to visualize the result before you start layering in apps. As in art, music, or other aspects of daily life, all you can do is keep your eyes and ears open, respond to what pulls your heartstrings, and create images based on ruminations about your response. Apps are no more than tools we use to give form to our ideas. A rich mind gives birth to rich images. As you go about creating images, the

working environment of the iPhone and apps are sure to throw any number of obstacles in your path. We discover our creative process in an effort to surmount those hurdles.

Summary

I used Filterstorm to adjust the contrast of the cloud that I intended to blend into the image and to perform localized blending of specific elements from pairs of images. I then used Superimpose to blend the cloud with the background. For objects with complex shapes, such as the cloud in this piece, blending is more effective than cutting and pasting to achieve natural-looking results. I used Snapseed to convert the image to black-and-white, and then I used Juxtaposer to cut out the seated man. One convenient feature of this app is that cut-out elements can be saved as stamps that can be stored for reuse. The **Mask** tool in PhotoWizard-Photo Editor allowed me to add motion blur to a specific location in my image. I used a small amount of motion in the sky, so the effect isn't obvious.

Mutablend

Mutablend's life has taken a number of twists and turns since he graduated from college. Mutablend found himself working in the print industry, clothing sales, and several other positions before he arrived at his current career as a freelance designer. Mutablend's work focuses primarily on web design and development of printed materials. The Imaginary Foundation recently released Mutablend's cloud image as a T-shirt design. Mutablend's work has been featured on many of the most popular iPhone art and photography websites, including iPhoneography.com, LifeInLoFi.com, iPhoneographyCentral.com, and iPhoneogenic. *www.flickr.com/photos/mutablend*

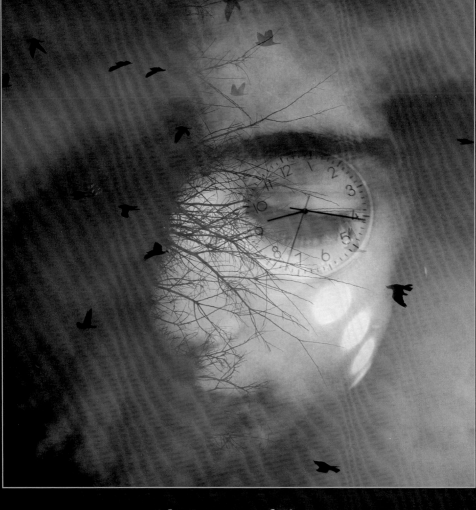

The Essence of Time

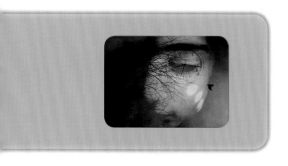

TUTORIAL 21

Create a dream-like image with layers to convey a dramatic atmosphere with a cinematic feel

What You'll Learn

My aim was to produce an emotive image that has an overall cinematic feel. In this tutorial you will learn how to manipulate and blend multiple images to create a collage based on an idea or concept. You will use apps to crop, blend, layer, mask, and adjust the brightness and contrast to achieve the overall look of a dramatic situation.

What You'll Need

- Hipstamatic
- Superimpose
- Squaready
- Filterstorm

Back Story

When I capture people I try to photograph natural movements and behavior rather than a staged scene. I find that this approach results in far more expressive images. My images are random and deeply personal, and the people around me play a huge part in them, whether they are family members or a person that passes by with an interesting expression that catches my eye. They form the basis of the story and provide an opportunity for dramatic experimentation.

One morning I was just sitting around, reading a book at home, when I noticed a stream of light from the shutters beaming down onto my youngest daughter's face. The light was making quite a pattern on her face, and her expression suited the moment. She was absorbed in watching a kid's show on television and did not notice me quickly capturing a few shots of this light play.

I never have a clear idea how I'll use most of the images I capture until I scroll through the camera roll and work out which image complements another—a bit like finding the right pieces to fit a puzzle. The first thing that came to mind with this image was a sense of stillness. I wanted to capture the experience of being there and being part of a dreamlike state. The image reminded me of a scene from the Ingmar Bergman film *Persona,* and it influenced the direction and overall theme. I tried to convey that feeling by blending a few images—branches of trees, birds in flight, and a clock—to give a surreal sense of time.

Foliage is heavily featured in most of my work, and I thought combining this element with the themes of flight and time would be a successful combination for this piece.

| 1 |

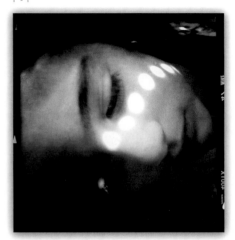

| 2 |

| 3 |

The Process

➤ **Step 1: Capturing the Original Image**
I find that Hipstamatic produces rich
black-and-white images when it's used
with the right combination of lenses
and film. It also provides a touch of
grain, which was important in this in-
stance since I wanted to achieve an aged
film look. If the base image is not cor-
rect to begin with, it can throw off the
rest of the process. For the initial shot
I used one of my favorite black-and-
white combinations: the **John S** lens and
AO DLX film | 1 |.

➤ **Step 2: Rotating the Image**
Because I captured the image with the
wrong orientation, I used Squaready

to rotate it counterclockwise | 2 |. Many
other apps can rotate an image, but
Squaready's ease of use and ability to
save files in PNG format is a quick and
simple solution.

➤ **Step 3: Importing and Blending the
Tree Image**
For the next step I loaded the rotated
image as the background layer in Su-
perimpose, and I imported an image of
branches as the foreground layer | 3 |. I
played around with blending settings,

such as **Multiply, Overlay,** and **Screen,**
and I left the opacity (transparency) at
0 percent. Blending is a great way to add
depth to a visual story, and it's great for
collage work. After I tried a few settings,
I decided that **Multiply** worked best | 4 |.

I wanted the branches to cover only
part of the face, so I played around with
the imported image and increased
the scale to find the best positioning.
The **Multiply** setting still suited the
increased scale, and after I altered the
opacity percentage a couple of times, I

|4|

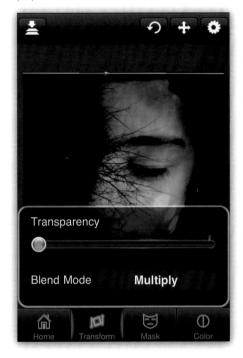

|5|

|6|

found that a low level (10 percent) was sufficient. I then merged the two images together |5| and exported a test image in case I wanted to pass it through another app. I find exporting test images a necessity in case I would like to return to earlier incarnations of the image. It also documents the step-by-step process.

➥ **Step 4: Removing the Background Detail**

There was some unnecessary detail in the border and at the bottom right-hand corner of the background image. To remove it I decided to import a black image to the foreground and decrease its opacity to reveal the image below and mask out the areas with the **Pen** and **Lasso** tool, all within Superimpose |6|. I then increased the opacity back to its original level, merged the two images together, and exported a test image.

A number of apps have healing and cloning functions that could have achieved the same result, but the area to be deleted was quite large, and it was easier to work within Superimpose.

➥ **Step 5: Importing and Blending the Sky**

For the next step I used a similar procedure as in step 3. I wanted the birds to be flying upside down to add a surreal touch. Still in Superimpose, I loaded the sky and birds image to the foreground,

| 7 |

| 8 |

| 9 |

| 10 |

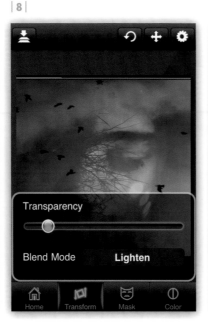

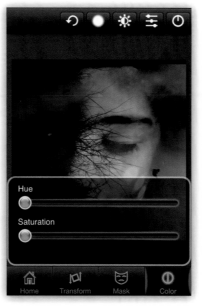

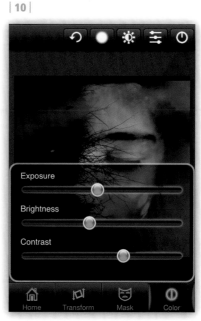

decreased the opacity (transparency) to see the merged image below, and scaled and rotated the foreground image until I was happy with the position | 7 |. I then played around with the blending settings until I settled on **Lighten,** and I increased the opacity back to about 15 percent | 8 |.

➡ Step 6: Adjusting Contrast, Brightness, and Hue

After I blended in the sky, there was a hint of blue throughout the image. I adjusted the hue and saturation in Superimpose to bring the image back to black-and-white | 9 |. To darken the image, I increased the contrast and decreased the brightness and exposure to add much-needed depth | 10 |. Once again I merged the two images and exported a test image.

➡ Step 7: Importing, Masking, and Blending the Clock

I stayed in Superimpose and repeated the procedures in the previous steps to add the final image into the collage. First I imported the image of the clock, then I masked out the unneeded areas with the **Pen** and **Lasso** tool | 11 |. The edges looked a little rough after masking, so I smoothed out the edges by 35 percent | 12 |. I then adjusted both the hue and saturation to –100 percent.

I wanted the clock to cover the eye to resemble and imply an eye patch. I maneuvered the clock over the eye, then I went back to the **Home** menu and zoomed in to make it easier to position the clock. After I was happy with the position of the clock I played around with the blending settings.

Using the **Multiply** setting at an opacity of 15 percent, I was able find a suitable blend mode, then I increased

| 11 |

| 12 |

| 13 |

| 14 |

the contrast and brightness a little to add atmosphere | 13 |.

➤ **Step 8: Adjusting Tones and Tweaking**
I loaded the image into Filterstorm to slightly adjust the tones (**Normal** blend mode) and crop the top | 14 |. I find the **Tone Mapping** function in Filterstorm to be quite useful in bringing out highlights. I thought about adding some clarity by sharpening the image, but I decided against it because I wanted to retain the dreamlike quality.

When I was happy with the fine-tuning, I exported the final image and named it *The Essence of Time,* which I felt encapsulated the initial concept perfectly.

(Please note that a newer version of Superimpose was released after this tutorial was completed.)

My Favorite App: Superimpose

Superimpose is my go-to app for layering and blending, particularly since I do a lot of collage work. I downloaded this app when it first appeared in the app store and didn't expect much from it. After I started playing around with some of its functions, my opinion totally changed. There are a number of apps on the market that do pretty much the same thing, such as DXP and Image Blender, but I found the

versatility of some of the functions and tool sets offered by Superimpose to be more beneficial for my work. The ability to scale, move, rotate, flip, or resize the foreground image and place it in the correct position with the background image is one of the features that keeps me coming back to this app.

There are 18 blending settings; anyone who has worked with Photoshop will be familiar with most of them. With the large variety of settings, there is bound to be one to fit your needs. The opacity (transparency) is also adjustable, which makes it easy to blend images.

The masking tool is where this app shows the full extent of its abilities. With a selection of five tool sets and three mask edges to choose from, the masking capabilities are quite exhaustive, which makes Superimpose one the best and most powerful apps of its kind. Masking a foreground image can be a little tedious at a small scale, but you will get the hang of it after a while.

Additionally, Superimpose can save a foreground image into a mask library, and if you use similar elements throughout your workflow, like I do, this can be quite a useful tool, particularly when you produce a series with the same background or foreground image. The ability to tweak an image by adjusting the colors, exposure, brightness, contrast, hue, and saturation of the foreground and background images via sliders is an added bonus.

The Superimpose interface can be quite confusing to begin with, but if you invest enough time in it, you will be more than happy with its capabilities and the results it provides. The program also outputs to full resolution, but be careful to enable it in the settings. There is also an option to share images to Facebook, Twitter, and Tumblr.

Summary

I always feature my family in my work. For this piece I chose a photo of my youngest daughter, added layered images of foliage and birds, and completed the image with a timepiece to add a surreal touch. To accomplish my vision I used Hipstamatic to capture the black-and-white base layer, and I used Squaready for rotation. I used Superimpose to layer, blend, mask, adjust the contrast, and improve the brightness. Finally, I used Filterstorm for fine-tuning the tones and cropping the image. I think that less is more, and I always try to limit myself to four apps to keep the processing as simple as possible.

George Politis (_giorgopoliti_)

George is a mobile photographer based in Australia. With a background in cartography, he found the transition from working with colors and layers to the creative side of mobile photography to be a natural progression. George's work has been featured internationally, including the LA Mobile Arts Festival 2012 and London's mObilepixatiOn 2012, and his work appeared at the P1xels at an Exhibition LA Giorgi Gallery Show in 2011. He has been voted Artist of the Month on iPhoneArt and was a finalist for their 2011 Mobile Grant Award. Several of his images have been showcased on the Huffington Post, the Los Angeles Times, and numerous blogs.
iprints.iphoneart.com/artist_studio/ _giorgopoliti_

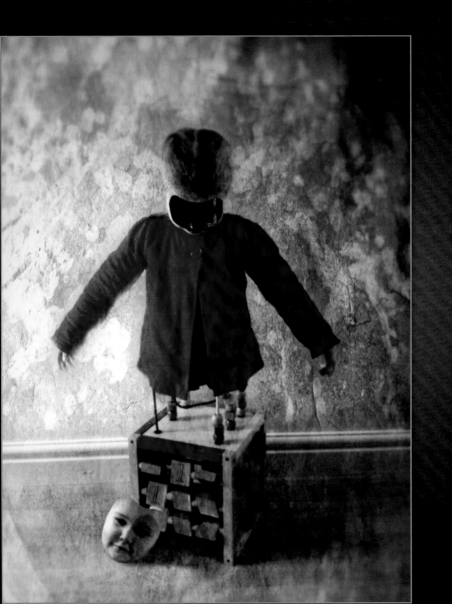

TUTORIAL 22

Create a surreal image using multiple photographic layers

What You'll Learn

In this tutorial you will learn to use layers, masks, and type to tell a story with a surreal image composited from multiple realistic photographs.

What You'll Need

- ProCamera
- Juxtaposer
- lo-mob
- Iris Photo Suite (iPhone version)
- Color Splash
- Photo Editor – Fotolr
- Snapseed
- ScratchCam FX

Back Story

Storytelling is at the heart of what I do. Before I discovered photography, my main creative outlet was writing. Although it has been set aside to some degree since my involvement with photography, the need to create and tell a story is still very strong within me.

After I had moved past my first flush of photography—seeing everything anew through the lens and taking shots of everything—I found myself returning to storytelling again. At first I created

| 1 |

elaborate titles, so the photography became a moment in a story that it had inspired. However, as my photography developed, more and more I created the image itself. As much as I can appreciate and enjoy street photography, landscapes, and all the other categories of image making, to me they were someone else's story, and I needed to tell *mine*.

In creating the *Clockwork Sister,* I imagined a Victorian playroom and a single child with stern parents who had left her to be educated and nurtured by the latest in mechanical marvels. Though we would see the mechanical toy as a cold and lifeless thing, the child

|2|

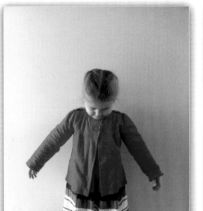

|3|

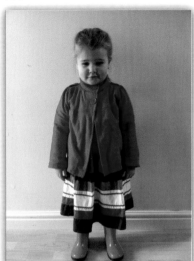

|4|

|5|

would have seen her through different eyes, not noticing the half-finished appearance and stilted movement, but accepting her as her clockwork sister.

The Process

➡ **Step 1: Capturing the Image**
I took the initial images with Pro-Camera. It's a more precise tool than the standard iPhone camera and allows for ISO and focus control. This was beneficial since these shots were taken indoors. I also find the whole-screen trigger button far more practical to use. The three shots used here were taken

close together and placed at the same angle to ensure a far more realistic match during compositing |1–3|.

➡ **Step 2: Using Juxtaposer to Position Image Elements in the Scene**
I began the initial construction by using the shot of the toy as the base image. I then added the shot of my daughter and started the task of removing unwanted elements of the image. Juxtaposer offers three ways to do this: take off the top layer and reveal the base layer; make the top layer semitransparent; or use **Mask Mode,** which will show only the top

layer and show all deleted image elements in red.

I find the last approach to be the most accurate way to remove the unwanted parts of an image. As I removed the distraction of the base image, I could more clearly see what I might have missed, not just in the outline, but also on the edges or missed corners that might be overlooked until much later (when it might be harder to correct). With pinch and zoom and control of

| 6 |

| 7 |

| 8 |

the brush size and hardness, I was able to remove bigger sections of the image, and then I moved in closer for the fine detail of refining the edges with a softer brush | 4–5 |.

After I had finished removing the excess, I switched back to the **Layers** mode and adjusted the figure over the toy frame. When I was happy with the image, I saved the session and also saved the trimmed top image as a stamp for later use | 6 |.

➤ Step 3: Continuing Refinement of Scene Elements in Juxtaposer

I wanted to do a bit of work on the toy's frame to remove the fruit symbols. Still within Juxtaposer, I took a small section from the wooden floor and saved it as a stamp. I then loaded this stamp and used it to cover each square to give me a blank surface | 7 |. I then saved the image.

➤ Step 4: Adding Type in Photo Editor – Fotolr

I opened the image in Photo Editor – Fotolr. This app is a general editor, but I use it almost exclusively for adding

text because it offers many font choices, transparencies, colors, and sizes. After I added several numbers, I saved the image again | 8–9 |.

➤ Step 5: Adding Detail to the Face

Returning to Juxtaposer, I decided to make the subject more obviously an automaton and decided to show the face as a mask. I first inserted a stamp from a previous session (part of an escalator floor) over the face and then layered over it with the first image again. I was

| 9 |

| 10 |

| 11 |

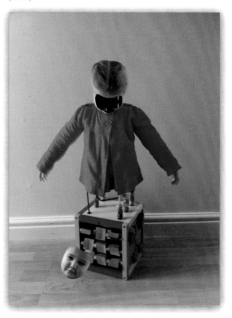

| 12 |

then able to brush off the face and re-veal the mechanics underneath, sculpt-ing the brushed-out section to create the illusion of a mask | 10 |.

I then layered on the image of my daughter looking down and removed everything except the face, which I then brushed to match the shape of the gap in the face | 11 |.

I then positioned the face against the toy box as if it were propped up against the base. I again saved the head as a stamp and saved the image | 12 |.

☞ **Step 6: Refining the Mask in Iris Photo Suite (iPhone version)**
With the piece constructed, I began work on the textures and colors. I opened the image in Laminar, then I opened the **FX** box and selected **Stone** from the **Grunge** category | 13 |.

This is where Iris Photo Suite starts to show its versatility. The filter function offers a strength option and allowed me

| 13 |

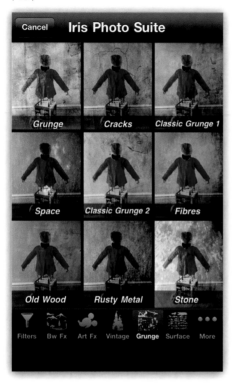

| 14 |

| 15 |

to apply it as a mask so I could further refine my choices. I kept the **Mask** at 100, followed by the **Apply with Mask** option, and finally the **Draw Mask** option from the next option box.

Within Iris Photo Suite I was presented with the image fully masked and a set of tools to make further modifications. I was able to move to the area I wanted to modify using pinch and zoom. I usually set the **Opacity** to

around 5 percent, and then I can start to modify the image with the **Brush**. With such a low opacity, I was able to clear the mask and bring out the figure but still leave some opacity in place to add extra texture to the figure | 14 |.

When I finished editing, I pressed the **Check** and returned to the **Home** screen where I selected another filter **(Classic Grunge 1)** and repeated the process. This allowed me to add textures to the

background and the figure without the two becoming merged. Modifying the filters also makes for a more subtle and individual creation even though I used stock filters | 15 |.

➤ **Step 7: Recombining Versions of the Image in Juxtaposer**

Returning to Juxtaposer, I opened the image as the base layer and opened another copy over the top of it. I then removed all elements of the top image, apart from a section of the shadow behind the box—a detail that I added to the front of the box to give the mask

| 16 |

| 17 |

| 18 |

some shadow and help create depth and lend reality to the piece | 16 |.

Step 8: Desaturating the Image in Color Splash

For the next stage I used Color Splash, an app that is made by the same company as Juxtaposer and allows for selective desaturation. The user interface is very similar to Juxtaposer and offers the same level of control. Opening the image renders it in black-and-white, and I used the **Brush** tools to selectively bring color back to specific areas. For this image I brought red back to the coat

and on some elements of the box. This helped to further tie in the two original images, and the resulting darker and simpler color scheme added more of a period and edgy feel to the piece. I also brushed in the hair and skin. These changes were subtle enough not to soften the image, and they added a realistic quality to the figure | 17 |.

Step 9: Using Snapseed for Final Adjustments

I opened the image in Snapseed to give the image a final tune-up. I first used the selective **Adjust** to mark a small

section of the image and adjust the **Brightness, Contrast,** and **Saturation** | 18 |. This can be done with multiple points and with an adjustable effect radius. After I had adjusted several parts of the image, including increasing the shadow on the face and on the top to allow the material folds to be more defined, I saved the image and returned to the first screen.

| 19 |

| 20 |

I then selected **Center Focus,** which allowed me to give the figure more definition by blurring the background and adding a subtle vignette | 19 |. I then saved the completed piece to the camera roll.

At this point I usually open the Notes app on my iPhone where I work on the title and any background or story that

has come to mind. In the case of this one I came up with two. The piece was called *Clockwork Sister,* but I also named the model Automatic Eloise and went on to create a mock Victorian advertisement to provide additional background.

I created the advertisement also with my iPhone. First I framed the images I had created with lo-mob and then using

Juxtaposer I placed them on a white image (made from a shot of a white wall). I added the text with Photo Editor – Fotolr and then added an aged look to it with Laminar and ScratchCam FX.

My Favorite App: Iris Photo Suite (iPhone version)

Iris Photo Suite was one of the first full editing suites available for the iPhone, and it is one of my core apps. Iris Photo Suite offers the usual range of crop, rotate, and mirror; images can be adjusted on almost every point from brightness to color balance, with built in sharpen, blur, and noise reduction tools. This app was one of the first to include layering with graduated and blend controls and manual selective removal. Iris Photo Suite has a very useful undo and redo function that allows me to continually review my work and commit to changes. Iris Photo Suite also has an extensive filter and FX with 72 filters and frames that can be further modified and selectively controlled. For those with an iPad, the app has been reworked and was given even more power as Laminar.

Summary

My aim was to create the image of a clockwork automaton and present it as a portrait of something real, not just constructed on the screen. I used component images taken with ProCamera and assembled the piece in Juxtaposer, blending in the child's toy with multiple images of my daughter. I added extra detail with Photo Editor – Fotolr. I added texture with Iris Photo Suite to help age the piece and give it a more unified feel. I then selectively colored the piece using Color Splash to give it a stronger color scheme. I finished the image in Snapseed, with minor adjustments to the contrast and brightness, along with selective point adjustments and a final addition of background blur and vignetting.

Benamon Tame (Benamon)

Benamon discovered photography with his iPhone in 2009 and has been active in the iPhoneography and mobile photography community ever since. His work ranges from street photography, to images taken from stories and dreams, to dark fantasy and gothic surrealism. Benamon lives in Cornwall with his wife and children and a cat named Midnight. Benamon's work has been exhibited and featured widely, including Light Impressions at Art Basel Miami 2012, International iPhoneography Show 2011 (SoHo Gallery), LA Mobile Arts Festival 2012, several galleries in the United Kingdom, and all the major iPhoneography websites.
www.flickr.com/photos/mycameraeye

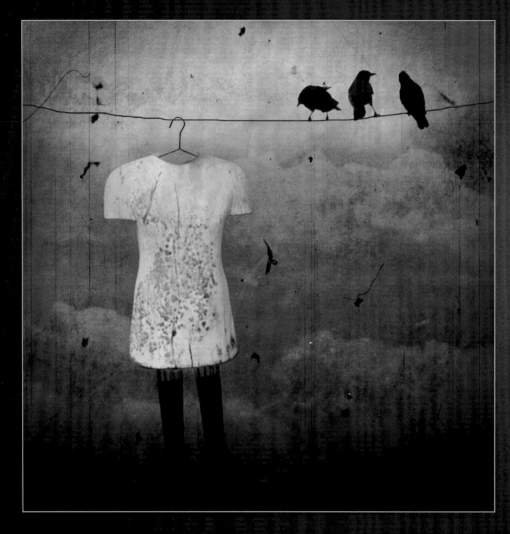

Hung Out to Dry

TUTORIAL 23

Create a surreal image working from instinct and imagination, using unrelated elements

What You'll Learn

In this tutorial you will learn how to create a surreal image without a preconceived idea. You will be working with masking techniques and different filter options. By following your instincts with unconnected elements, you will learn several masking and blending techniques with different filters using apps like Superimpose and ScratchCam FX.

What You'll Need

- 6x6
- Superimpose
- PhotoCopier
- ScratchCam FX
- ArtStudio

Back Story

I generally start working without a preconceived idea of a final image. The work evolves from each preceding step until I reach a point where all the elements come together to portray an interesting and well-composed image. The final edit tends to incorporate a surreal relationship or narrative. I tend to derive inspiration from combining unrelated elements to tell a story or convey an idea. For instance, I might combine an inanimate object with an animate object to create an interesting image. I am always looking for new ways to interpret the world around me.

In this image there are relatively few steps that involved a limited number of apps, but this isn't always the case. There can be a lot of shuffling around from one app to another with a lot of steps within each app, but this image is fairly straightforward.

The Process

➥ **Step 1: Capturing the Background Image**
The initial picture is a closeup of a candle that I shot with the app 6x6 | 1 |.

| 1 |

| 2 |

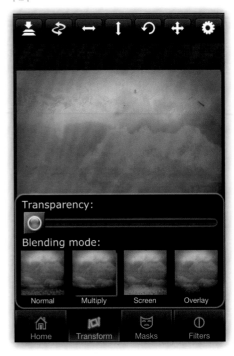

| 3 |

| 4 |

I use this app to create square format images. At this point in my process, I look for interesting objects or textures to build upon.

Step 2: Adding a Foreground Element
I decided to add some clouds to the foreground. For this step I used Superimpose with the **Multiply** filter | 2 |.

Step 3: Filtering the Image with PhotoCopier
I brought the image into PhotoCopier. I often import an image into this app to explore different color or process options. There are four main categories: **Movie, Painting, Process,** and **Photo.** There are additional adjustments under each category, such as texture, vignette, and color settings. For this image I used the **Atget** selection in the **Photo** category | 3 |. There are no steadfast rules as to when you should add a particular

filter or effect to your image. Sometimes adding a filter earlier in the process is desirable if you do not want elements you introduce later to be processed with the same effect.

Step 4: Adding a Texture
I considered adding a texture effect to the image in ScratchCam FX. I don't always use this app, but it doesn't hurt to explore the various effects it can add to a particular image. After I looked at some different options, I

| 5 |

| 6 |

| 7 |

decided on the effect shown here in the **Textures+Borders** section | 4 |. It gave the image an old, worn film or photo effect that I like.

Step 5: Adding a Foreground Motif

Next I added a motif to the image by using Superimpose to create a new layer. I masked and superimposed an image of an old mannequin bust with a coat hanger onto the image with the **Normal** setting | 5 |. Remember to edit objects beforehand that you plan to introduce

separately. This can be useful if you want different elements within your image to contain different textures or color schemes than the base image.

Step 6: Refining the Foreground

At this point I was not sure what elements I would add next. I had committed to building a narrative around the mannequin and had to brainstorm about to how to proceed. After some deliberation, I decided to add a clothesline. I opened the image in ArtStudio. You can

do many things with this app, but I used it to simply add a black line to act as a clothesline that the mannequin would be hanging from. I used the **Pencil** tool at a small size and full opacity | 6 |.

Step 7: Completing the Story with Additional Foreground Elements

Last, I added the silhouettes of the birds to the image using Superimpose | 7 |. I thought these last elements balanced out the image and contributed to the overall theme.

My Favorite App: Superimpose

The most important app I used to construct this image was Superimpose. It is a great app for adding or removing elements, and it also provides additional editing options. There are 15 filter options and 10 masking tools to achieve nearly any desired effect. To add or remove elements within an image, there should be a fair amount of contrast between the elements to be selected or masked. This makes some of the masking tools, such as the **Magic Wand,** more effective. If the tints and tones or colors are too closely related, this tool will tend to mask the wrong areas of an object. In this situation the best approach is to either adjust the strength of the masking tool or manually mask the area using the **Brush** or **Marquee** tools. If there is a good amount of contrast or separation between the elements, this will be less of an issue.

There are a few other really useful features within this app. The transparency bar lets you adjust the transparency of the active layer, which makes it easy to adjust the placement of foreground objects. Within the **Transform** section you can merge the two current layers to create another layer. (Unlike some apps—such as Filterstorm for the iPhone, and Adobe Photoshop Touch and Laminar for the iPad—Superimpose allows only one active layer at a time.)

Superimpose saves images at a high resolution and does not reduce the resolution of full-size images of up to 4,000 pixels on the longest side. This is convenient if you plan to manipulate the image in other apps or print it. There are several new options in Superimpose that were not available in the older version, including the **Flip** tool, which flips the top layer vertically or horizontally, and the **Swap** tool, which allows the base layer and the active layer to be interchanged.

Summary

My goal was to produce a surreal image and work intuitively as each step suggested a new way forward. I blended the background from separate elements in Superimpose, added interest to the image by applying textures in PhotoCopier and ScratchCam FX, and finished the image by layering previously prepared images in Superimpose. To add greater detail and interest, I drew some final linear elements in ArtStudio.

Dax Curnew (Timezone0)

Dax studied drawing and painting at the Ontario College of Fine Arts and Design in Canada. His influences originate from many different styles and movements in art. Surrealism had the greatest influence on his work. After a long period of creative inactivity, Dax discovered the medium of the iPhone. He has created paintings for Envers Chapin fine art print gallery, various fine art events, and private galleries. Six of his pieces were exhibited at the 2012 LA Mobile Arts Festival.
www.iphoneart.com/users/3797/galleries

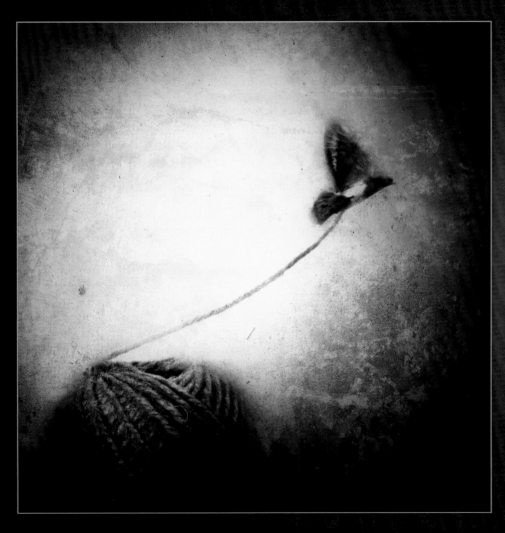

EDINA HEROLD · HUNGARY

Free

TUTORIAL 24

Express abstract concepts in a surreal way

What You'll Learn

In this tutorial you will learn how to add an element from one picture to another, as if the new element had always belonged to the background image. You will also learn how to use blur to remove unwanted parts of the background and how to enhance the overall look and feel of an image by adding a vignette and some texture.

What You'll Need

- ❯ Juxtaposer
- ❯ Photogene
- ❯ BlurFX
- ❯ Picfx

Back Story

I usually like to express abstract things in a surrealistic way. In this image I explored the contradictions between freedom and constraint. To express this conflict I used the metaphors of a flying bird and a ball of yarn. Freedom and constraint mutually define each other. Freedom is borne of constraint, but the length of the rope determines the degree of freedom.

|1|

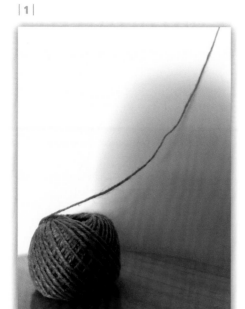

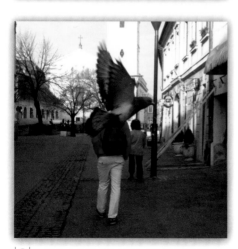

|2|

|3|

|4|

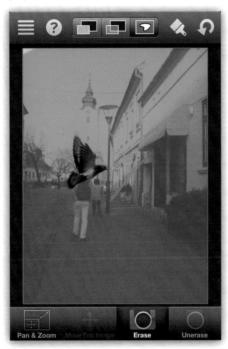

|5|

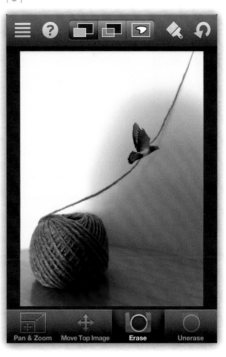

The Process

➤ **Step 1: Transferring an Element of an Image to Another Picture**

There are multiple applications for blending images, but my favorite is Juxtaposer because its intuitive tools allow great precision. First I loaded the base image |1| and the top image |2| from the camera roll. I touched the **Pan & Zoom** function to align the images precisely according to my concept |3|.

After I positioned the elements where I wanted them, I used the **Red Mask** option from the upper menu bar to accurately isolate the bird from the top image |4|. I fine-tuned the image with pixel-level accuracy using the **Erase** and **Unerase** functions, and then I saved the resulting image |5| to the camera roll for further processing.

➤ **Step 2: Cropping the Image to a Square Format**

I love square format images because a square is a very stable shape and it gives me different composition options. I decided to crop the picture before processing it any further. I like to use Photogene for cropping, so I opened the image in this app, selected the **Scissors** icon, then chose the **1:1** icon, which represents a square ratio |6|. I pressed **Crop** and saved the square format image to the camera roll.

| 6 |

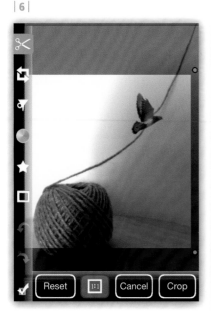

| 7 |

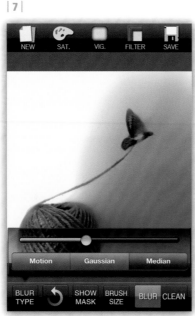

| 8 |

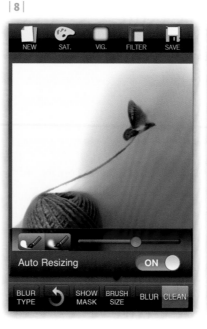

| 9 |

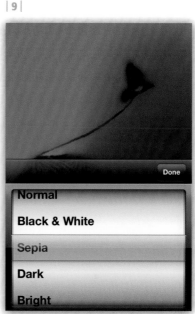

➤ Step 3: Blurring Unwanted Background Elements

I now had a square format image with the base elements of the picture, but there were a lot of distracting elements that I decided to soften and remove by applying blur. The blurring process usually produces a soft surface, which serves as an excellent foundation for textures later. I imported the image into BlurFX, which offers several types of blur: **Motion, Gaussian,** and **Median** | 7 |. I selected **Median** blur. The **Brush** size can be adjusted | 8 | for precise work. BlurFX has a red masking option, similar to Juxtaposer, which can be activated by touching the **Show Mask** icon. I was able to work with pixel accuracy by alternating between the **Blur** and **Clean** buttons.

➤ Step 4: Modifying Colors and Adding Textures and a Vignette

Picfx is my favorite app for adding textures to images. After I loaded the blurred image, I decided to add a tarnished-looking color by hitting the **Brush** icon and selecting **Sepia** | 9 |. After this I applied the **Grit** filter from the **Classic** set | 10 |. The slider at the right edge of the screen allowed me to adjust the strength of the filter. Because I wanted to add more filters without reloading the image several times, I pressed the icon with the **+** symbol, which allowed me to add another option | 11 |. I chose **Vignette** from the **Frames** set | 12 | then **Brown Scratch** from the **Premixed** set | 13 |. I then touched the **Send** button to save the final image to the camera roll.

Because of the complexity of the abstract concept and the surreal look of the image, I decided to give the piece a simple title: *Free.*

| 10 |

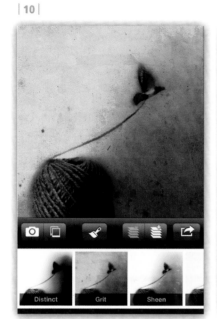

| 11 |

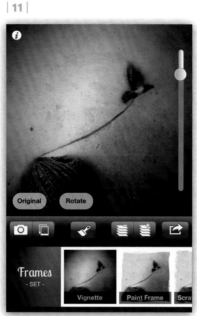

| 12 |

| 13 |

My Favorite App: Picfx

Picfx is my favorite app to add texture to an image. More effects are available with each software update. In addition to textures, it has intuitive opacity controls so you can make subtle adjustments to the intensity of an effect. The interface is well organized so you can easily choose from the grouped effects. The filtering option for different color modes is an additional feature that helps you achieve your editing goals. Picfx allows multiple texture layers that result in endless combinations, which give your images a unique look and feel.

Summary

To realize my abstract content objectives, I used Juxtaposer to add an element of the first image to the second image, Photogene to crop the image to a square format, BlurFX to blur the background, and Picfx to modify the colors and add some gorgeous textures with a vignette.

Edina Herold (HeDyna)

Edina lives in Pécs, Hungary, with her mobile photographer husband, Robert, their kids, and a dog. Her exclusive creative platform is the iPhone. Edina has been a featured artist on iPhoneogenic and P1xels at an Exhibition. Her images have been exhibited at gallery shows throughout the United States. Edina was identified as one of the top 50 mobile photographers of 2011. Her work has also appeared in several print publications, including Expressions magazine (2011) and P1XELS magazine's The Daily Pic: The First Sixty Images (2011).
www.flickr.com/photos/hedyna

Run!

TUTORIAL 25

Create a photo-realistic, surreal fantasy using blending, photo touching, and lighting techniques

What You'll Learn

You will learn to create a photorealistic, surreal fantasy using ClearCam to take the initial shots, then you'll use additional apps to blend layers, add drama with special light effects, correct the exposure, and fine-tune your image.

What You'll Need

- ClearCam
- Juxtaposer
- Snapseed
- FX Photo Studio
- ArtStudio
- LensLight
- Squaready

Back Story

I am obsessed with creating images on my iPhone. It is the only camera I use for my work because I like the challenges it presents and the convenience of having my studio in my pocket. I use a myriad of apps that serve as my palette to create my work. The immediacy of working this way is unquantifiable because good ideas are fleeting, and I am always on the move. This format allows me to express myself with my images and to meet wonderful, talented people who share this obsessive passion. I employed my earlybirdninja character as a vehicle to travel to different worlds between fiction and reality, dreams and nightmares, and memories and premonitions.

The Process

➤ **Step 1: Preparing the Main Foreground Image**
I began with a source photo that I captured in natural light using an app called ClearCam. I usually start with a high-resolution square and the highest-resolution background image that an app can export. In Juxtaposer I placed the image over a white square to fill it as much as possible, then I worked on the foreground image to create the headless effect. I accomplished this by placing a photo of an empty shirt over the original and cutting out the neckline to match the figure. I added volume to the neck of the shirt to lend some realism to the illusion, and then I started adding other photographs and cutting them in |1|. I use the white soft-edged tool in Juxtaposer for erasing large areas and the gray hard-edged tool for cutting in details.

I wanted to express more movement than the original tie conveyed, so

|1|

|2|

|3|

|4|

I added a larger detailed photo of the tie and cut it in |2|. I then cut out the completed image and saved it as a stamp within Juxtaposer |3|.

Step 2: Preparing the Background

To create the background I merged two photos: one of the ground and one of the sky. When I blended them together, the two images created a surreal environment. I then reintroduced the stamp of the figure into the new environment |4|.

The basic work was done, but the details I added next would determine the success of the image. At this stage I thought the image was too flat, with areas that were over- and underexposed.

Step 3: Selectively Adding Drama and Light

This is where Snapseed came into play. First I chose **Selective Adjust** to emphasize and brighten some areas. I then used the **Drama** filter, which created a strong contrast |5|.

The **Drama** filter should be used in small doses to work properly. I like to control my apps, instead of them controlling me, so I went back into Juxtaposer, loaded the flat image from step 2 (before Snapseed), and placed the new image over it. Before moving on to the next step I made sure that the first and second images were precisely aligned by tapping **Move Top Image** and then tapping the screen with two fingers.

Step 4: Emphasizing Lighting and Dramatic Effects

While still in Juxtaposer, I touched the red square and erased the entire new image |6|. Then I tapped **Unerase**, and with the gray fuzzy tool I began to paint in the areas where I wanted to emphasize lighting and dramatic effects. A combination of the darker, flat image and the new brighter image created a high dynamic range effect that I hand manipulated and refined.

Step 5: Adding Exposure and Reviewing the Image

In FX Photo Studio I added a **Vignette** and a small amount of the **Daytona** filter |7|. At this point I was close to completing the image, but the right side of the image was badly overexposed and needed to be addressed.

Step 6: Fixing an Overexposed Area

I imported the image into ArtStudio and used the **Wet Paintbrush** to paint over the overexposed area of the hand and blend it into the rest of the hand |8|.

|5|

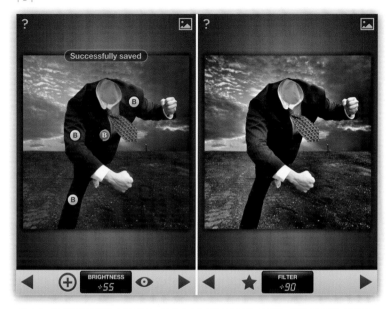

|6|

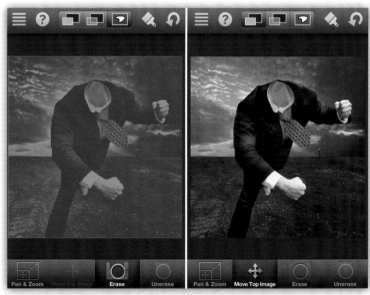

| 7 |

| 8 |

| 9 |

| 10 |

→ Step 7: Cueing the Zombies

I was happy with where the image was going at this point, but there was something missing: zombies! I used ArtStudio to paint them in using a combination of the **Wet Paintbrush, Pencil, Spray Paint,** and **Blending** tools | 9 |. ArtStudio exports at a high resolution, so I was knew all my tedious work would be worthwhile.

→ Step 8: Adding a Setting Sun to Create More Drama

To lend a little urgency and drama to the scene, I used LensLight to add a setting sun. LensLight changes the overall coloring of the image. To control this I saved the image and used Juxtaposer to erase the sunlight in the areas I did not want it to affect. This maintained the dynamic range of the original image.

→ Step 9: Adding a Surreal Sky

To create a surreal-looking sky, I returned to FX Photo Studio and used the **Symmetry Vertical** filter | 10 |. I saved the image and then cut the upper right part of the new sky into the previous image using Juxtaposer.

→ Step 10: Adding Pop and Final Adjustments

I made two versions of the image in Snapseed: one sharpened and one blurred. I then returned to Juxtaposer to layer these new images over the prefinal version, and then I cut in the areas that added pop. From the sharpened image I added the ground, tie, and parts of the right arm, including the buttons. From the blurred image, I added the horizon line. I usually import my final image into Squaready and create a PNG version to save.

The image was finally complete, and I was satisfied that the color, composition, and content were balanced and effective. This is the time when I scrutinize my work and check for any glaring flaws. I enjoy looking back in the camera roll and reflecting on the evolution of the image and thinking of ways to challenge myself in future endeavors.

My Favorite App: Juxtaposer

Juxtaposer is the app I use most. It is intuitive and is great for cutting out images and creating surreal work. I appreciate the **Zoom** feature to work in close detail without having to change the brush's diameter. I find the Save **Top Image as Stamp** option great for experimental work, and I have amassed a large stamp collection within the app. I like Juxtaposed for its features and speed, but I wish it would export at a higher resolution than 2048×2048 (as of this writing).

Summary

I hope that as a result of reading this tutorial you can begin creating an image that goes beyond what you see in reality and that you now feel an optimistic liberation to create what your inner mind sees. I will reiterate the importance of controlling the dynamics of an image and encourage you to resist the temptation of allowing an app to do all the work for you. Remember that your work is your vision, and it should reflect what you see or the journey you take in pursuit of the next level. Have fun, and push your limits.

Markus Rivera (earlybirdninja)

Markus received a Bachelor of Fine Arts degree with a concentration in painting. His years of creative inactivity came to an end with his purchase of an iPhone. Markus is obsessed with iPhone imagery and revels in the challenge of creating a resonant, quality image. He has employed his earlybirdninja character as a vehicle to travel into different worlds that exist between fiction and reality, dreams and nightmares, memories and premonitions. Markus exhibited at the 2011 International iPhoneography Show in New York City (SGDA) and the 2012 LA Mobile Arts Festival, and his work has been published in #PHOTOGRAPHY the Online Photography Magazine (issue 3) and No Words (1x.com). *www.earlybirdninja.com*

ROBERT HEROLD · HUNGARY

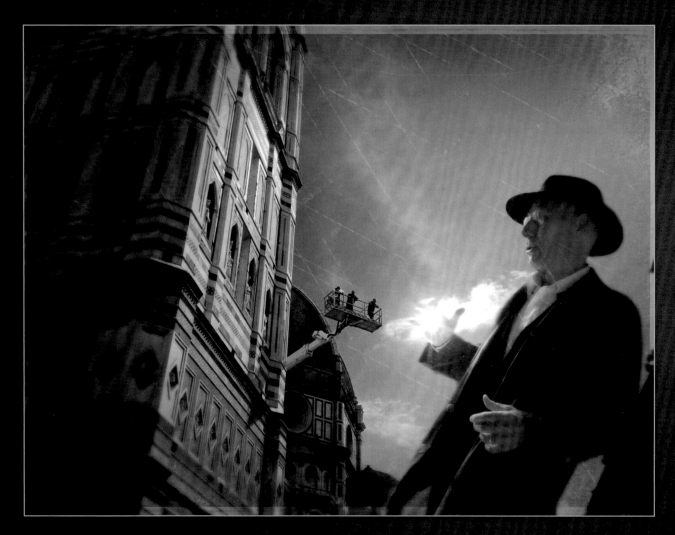

Cipolla in Florence

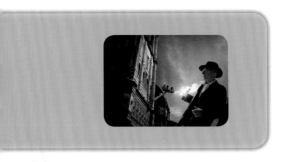

TUTORIAL 26

Add some magic to a simple street shot with classic lighting, blending, texturing, and layers, and incorporate a literary allusion

What You'll Learn

In this tutorial you will learn how to transpose an interesting character to another environment to strengthen the storytelling power of an image. You will also learn how to make the image more compelling by adding a timeless enhancement using texture and light.

What You'll Need

- ProCamera
- Filterstorm
- Snapseed
- LensLight
- Big Lens
- ScratchCam FX

Back Story

I spent a few days in Florence, Italy, in the spring of 2012. While I obsessively took photos of the city, I was struck by the appearance of a man I almost bumped into who had undeniable charisma. Thanks to the ProCamera app, I was able to quickly take a candid shot. Later, when I checked the shot, I realized that although I managed to capture the man in a relatively good picture, the rest of the image was poorly exposed and the angle was quite tilted. However, I was still drawn to the man, who reminded me of Thomas Mann's Cipolla in the novella *Mario and the Magician*. He conjured the mesmerizing power of Mann's hypnotist/magician. I decided to place him in another environment that corresponded to the ideas I had about the character. Fortunately, on that same day, I took a photo of the cathedral Santa Maria del Fiore. The cathedral was being renovated at the time of my visit, and this scene seemed to be perfect for my magician.

The Process

➤ Step 1: Capturing and Blending the Images

I generally use Filterstorm for blending images. Filterstorm has an excellent masking capability that allows me to make adjustments with pixel-level accuracy. It also retains the quality and the size of the image since it doesn't compress the final picture.

Figures 1 and 2 show my original images, and figure 3 shows the background image I loaded into Filterstorm.

First I loaded the background image by choosing the **Add Exposure** option from the **Filters** menu. Then I loaded figure 1, and both images became visible

| 1 |

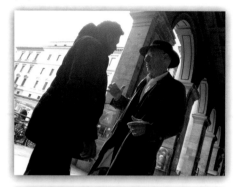

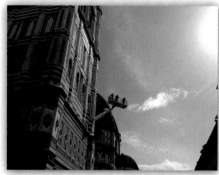

| 2 |

| 3 |

| 4 |

in the **Double Exposure** screen, where I could alter the blending modes by touching the sliders near the bottom on the left side | 4 |. I used the **Normal** blending option, which is my usual choice.

I touched the **Brush** icon to bring up the **Masking** screen. Here I used the brush and eraser tools to isolate the figure of the man and focus attention on him | 5 |. I adjusted the diameter, softness, and opacity of the Masking tool,

which helped me get the precision I needed as I worked around the figure. When I was finished, I hit the **Accept** icon and saved the image to the camera roll.

➤ Step 2: Converting the Image to Black-and-White

I opened the blended image in Snapseed to convert it to black-and-white. Snapseed has very good color filters to adjust the tonal range of a photograph. I tapped on the **Black and White** tab in

the bottom menu and chose the **Red** filter to produce a dramatic sky and to emphasize the details in the face | 6 |. I applied the effect by hitting the right arrow, then I saved the black-and-white image to the camera roll.

➤ Step 3: Adding Light

Because the subject evoked a magician, I wanted to add some magical feature, so I chose LensLight to add a surreal light effect. I loaded the image and selected the **Bright Sun** effect | 7 |.

| 5 |

| 6 |

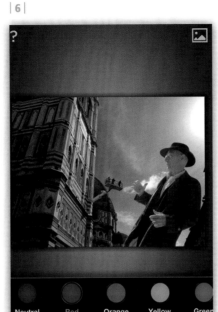

| 7 |

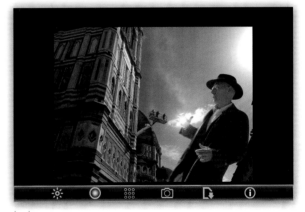

| 8 |

I adjusted the size and location of the effect by using finger gestures | 8 |. When I was happy with the position and size, I selected the high-resolution export option and saved the image to the camera roll.

☛ Step 4: Adding Blur and a Lomo Effect

Cipolla represents a timeless archetypical figure, so I decided to add a Lomo effect to the image. The Lomo effect resembles the look and feel of damaged film and is typically characterized

by blur, twisted colors, and noticeable vignetting. I opened the image in Big Lens and chose the **Basic** editing option, which generated a red circle. The inside of the circle represents a clear (in-focus) area, and areas outside the circle will be blurred with a tilt-shift effect. I adjusted the area with finger gestures, and when I was happy with the result I adjusted the aperture to f/3.5 to decrease the strength of the blur | 9 and 10 |.

Then I hit the **Filter** icon and selected the **Lomo1** filter, which gave the image a

nice brownish-green tone and a subtle vignette | 11 |. I adjusted the strength of the effect by adjusting the slider.

☛ Step 5: Adding Texture

Finally, I added an aged look and feel by applying textures in ScratchCam FX. After I opened the image, ScratchCam FX

| 9 |

| 10 |

| 11 |

automatically generated a random effect. If you hit the **Rand** button several times, you can preview thousands of random effects, but fortunately I was able to modify this process by selecting the **Edit** option.

The **Edit** option gives you access to three editing parameters, which can be used individually or combined: **Scratches, Colours,** and **Textures+Borders**. I used only **Scratches**. I played with the different **Scratches** layers until I found one that I thought fit

the mood of the picture, and I adjusted the strength of the layer with the slider above the image | 12 |. After I applied the effect, I hit the **Send** button and saved the final image to the camera roll.

To complete the storytelling idea, I named my image *Cipolla in Florence*. It integrates both the real experience and the associated story inspired by the writing of Thomas Mann.

My Favorite App: Filterstorm

Filterstorm is a must-have app for dedicated iPhoneographers. It's a full-featured editing tool—the Photoshop of the iPhone. Besides the basic correcting and editing tools, it has remarkable versatility and editing options to help you make compelling images. Its masking tools allow for precise editing of the selected part of an image. If you could take only one app to a desert island, you should choose Filterstorm.

| 12 |

Robert Herold (HerRo)

Robert works exclusively on his iPhone. He lives in Pécs, Hungary, with his iPhoneographer wife, Edina, their kids, and a dog. Robert's images have been exhibited throughout the United States. He was tagged as one of the top 50 mobile photographers of 2011, and he was a featured artist on iPhoneogenic, iPhoneArt, P1xels at an Exhibition, the Mobile Photo Awards Blog, fotogriPhone, iPhoneogenic, Life In LoFi, iPhoneography Blog, and Eye'em, and he has had multiple works appear in print media. Robert won the Digital Art & Collage category at the 2011 International Mobile Photo Awards (MPA).
www.robertherold.com

Summary

To achieve the result I had envisioned, I used Filterstorm to blend the images, Snapseed to convert the blended image to black-and-white, LensLight to add a light ball to intensify the magical quality of the character, Big Lens to add blur and a Lomo effect, and ScratchCam FX to add texture.

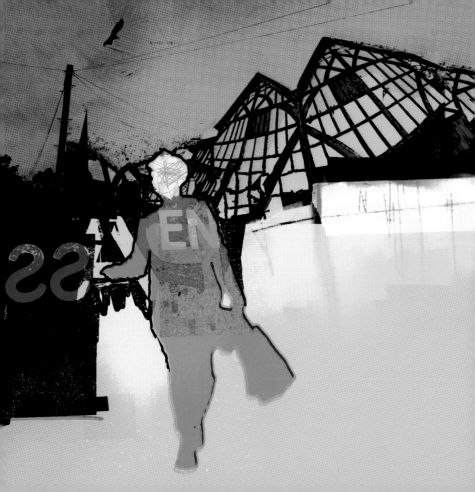

TUTORIAL 27

Create a painterly collage with collected elements using masking and blending techniques

What You'll Learn

You will learn how to put together a reimagined image using various apps, in conventional and unconventional ways, and understand my thought process as I work toward a finished image.

What You'll Need

- Camera+
- ArtStudio
- AutoStitch Panorama
- AntiCrop
- ArtRage
- Iris Photo Suite (iPhone version now replaced by Laminar)
- Photoforge2
- Real Halftone
- TouchRetouch
- Juxtaposer

Back Story

When I started this image I had a fresh, new iPhone 5, and it had been a long time since I created anything new. On my regular walk to the train station I decided to take lots of photos and then use the time on the train to pull together some ideas and get something going. As I walked from my house, through my home city, and onto the train station, I took a variety of images—from closeup details to wider shots of people and buildings. I was hoping to encapsulate this personal journey within my final image and planned to refine and tinker with the piece until I was happy with the result. I used Camera+ with the **Stabilizer** setting to take about 100 photos, and I chose a few to use in my final image. Work on the first part of the image moved at a very fast pace. I was literally throwing things together until I felt that I was getting somewhere.

The last part was a very slow process; I spent quite a bit of time thinking before I attempted my ideas with various apps. Things never turn out as I imagine, and I find that with each edit something new is presented to me and it triggers another thought process. I eventually got to a stage when I thought the image was almost finished. I say *almost* because I don't think I ever really finish anything—I just refrain from doing more in case I overdo it and ruin it.

The Process

➛ Step 1: Creating a Base

I needed a base image to start doodling on, so I simply created a 2048 × 2048 image in ArtStudio and filled it with a

| 1 |

| 2 |

| 3 |

gradient from blue green to yellow. I then ran it through a few random **FX Effects** in Camera+ to create some extra undulations and randomness | 1 |.

➤ Step 2: Creating the Main Background Image

Based on my selection of photos, I decided to start with some buildings | 2 |. This particular medieval hall is one

I pass every time I enter the city I live in. I stitched together a few shots of the building using AutoStitch Panorama and decided this would be my starting point.

I wanted this element to extend from the top of the canvas to about one-third of the way down, and because I had not taken enough photos to accomplish this, I used AntiCrop to add extra made-up

buildings to each side | 3 |. I was not trying to be precise; I was just experimenting at this point. It wasn't very clean, but I was not worried because I knew that I would later make adjustments or simply use it as is to help me move the image along.

I imported the image into ArtRage and roughly painted in the sky with

| 4 | | 5 | | 6 |

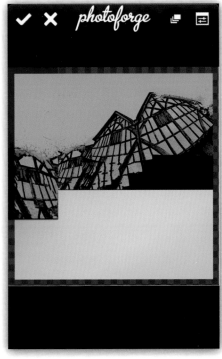

the thick paintbrush to add texture and interest |4|.

I then used Iris Photo Suite to add a graphic quality to the building. I randomly ran it through about six effects, mainly filters and **Art FX,** and I altered the strength to vary the degree of the effects.

➥ **Step 3: Layering the Background, Building, Silhouette, and Lettering**

In Photoforge2 I imported the background from step 1 and the building from step 2 onto separate layers. The building took up too much space, so I duplicated it, flipped it, slightly enlarged the overall canvas, and placed the building to the left.

I still thought the building was too dominant, so I expanded the edges of the image in AntiCrop again. I brought the image back into Photoforge2 and slightly adjusted the tones, mainly with curves |5|.

Back in ArtRage, I worked on the yellow foreground with the brush, pencil, and palette knife tools on a fresh layer |6|. I exported this element without the

| 7 |

Opacity

Blend Mode: Hue

| 8 |

Opacity

Blend Mode: Color Burn

| 9 |

Brush Color

Brush Size

Brush Hardness

Invert

original image and imported it as a new layer in Photoforge2. I placed it on top of the evolving image and played around with the **Blend Mode** and **Opacity** until it looked like it fit in with the colors and style. First I used the **Blending Mode: Overlay,** then I used the **Blending Mode: Lighten**.

I exported the image and passed it through Real Halftone, and then I

imported it as a layer in Photoforge2. I set the **Blend Mode: Hue** with the **Opacity** at about 85 percent | 7 |.

➤ Step 4: Refining the Left Side of the Image

I wanted to balance the left side of the image and cover the mess that was created when the main building was expanded. In Photoforge2 I went through

my collection of photos and placed another photo with the **Blend Mode: Color Burn** (I was interested only in the silhouette) | 8 |.

I then used curves to really increase the contrast by darkening the dark areas and lightening the light areas. I duplicated this layer and masked most of the right side because I was interested only

| 10 |

| 11 |

settled on **Add** and **Hard Light** for the final **Blend Modes**.

➤ Step 5: Cleaning Up the Image

Up until this point the pace was quite fast and frenetic—I was simply trying lots of things very rapidly and letting the creative juices flow and dictate the direction. I decided to clean up a few things and really slowed down in order to think about what to do next. I knew I needed to add some foreground interest, but I was concerned that the detail was becoming fussy and messy.

I used TouchRetouch to mask a few details, ArtStudio to fill in the open areas, and Camera+ to run a few effects at low intensity to neutralize the colors a little.

➤ Step 6: Adding the Foreground Focus

I decided to place an image of a person in the foreground, so I went through my shots and managed to find one that would look good. Unfortunately, the subject was not close enough to the camera, so I knew I would need to abstract her in some way. I extracted the subject from the background using Juxtaposer so I could position her in the composition without any background distractions.

I imported the image into ArtStudio and carefully drew a red border around

in the details on the far left (the telegraph pole and wires) | 9 |.

Continuing down the left side of the image, I decided to add some closeup details—possibly lettering. The image I used was the Passenger Lift sign painted on the train station platform. I trimmed it into a square, mirrored it, and placed it as a new layer at the top | 10 |.

I decided to slice the cropped word roughly down the middle and then played around with curves to darken and alter it and to bring out some extreme colors. Back in Photoforge2, I arranged these two halves on the left side of the image | 11 |. I repeatedly played around with the **Blend Modes** until the image worked with the background. I

| 12 |

| 13 |

| 14 |

the figure and saved it | 12 |. I filled in the outline with dark yellow and saved another version | 13 |.

I added the two versions of the figure as new layers in Photoforge2 with the **Blend Modes** called **Exclusion** and **Color Burn**. I tweaked the curves until the contrast and colors worked for me. I duplicated the outline and changed the

Blend Mode of this layer to **Multiply** to create a dark black line, and I masked the lower half of this layer so it covered only the top half of the figure. Then I gently blurred the outline and continued to tweak the color balance and hues on the filled version until the lettering and background showed through the top half of the figure | 14 |.

I decided to hide the red details on the figure's head, so in ArtRage I created a brush and pencil scribble and layered it over the head. I carefully masked around the head so the scribble appeared only on the head.

I felt like the image was almost finished, and I decided to name it *Passenger*. I imported the letters ENGER

| 15 |
| 16 |
| 17 |

and placed them on the girl's chest with the **Blend Mode: Overlay** | 15 |. I then modified the whole image, primarily with curves, to bring out some of the colors and add contrast.

➤ **Step 7: Making the Final Tweaks**
I wasn't too happy with the right side of the image, under the background building, so I photographed a bit of masking

tape on a black card and imported it with the **Blend Mode: Add**. I positioned the new image over the pencil scribbles, which lightened that area | 16 |.

I also added a bird that I took from the photograph of the telegraph poles and wires in step 4. I increased the contrast and set the layer in **Blend Mode: Color Burn** to darken the silhouette | 17 |.

My work was nearing completion, so I continued to make small adjustments with lines and small blocks, then I tweaked the whole image again until it looked balanced.

The finished image is my own personal story and a diary of my journey.

My Favorite App: Photoforge2

The main app I use is Photoforge2. It is a versatile, well thought-out and stable editing app. The key elements of my work are layering and masking and the constant process of moving forward and backward through edits (which are essentially digital accidents). Not everything works, so I need to be able to go back and revisit earlier versions of the image.

Photoforge2 supports my work style perfectly with unlimited layers and by allowing me to move back and forth through the editing history. Each layer can be reworked over and over again while everything else is left alone. If any part of the layer is not useful in the overall edit, you can always mask part of it. The best thing about masking is that it's nondestructive, so you can mask and unmask areas if needed.

Summary

In this tutorial I demonstrated how I made a digital collage of a visual story from a set of photographs. I used various apps to apply different effects to individual images, which I then organized and layered in Photoforge2. The process of assembling the final piece required me to initially throw almost random elements onto the canvas. I then made lots of rapid, and then slower, more deliberate editing decisions as I experimented with different effects to refine the image and work toward a result that was visually complete.

Bharat Darji (that_bman)

Bharat studied fine art painting in college. Although he is based in England, Bharat's work involves a considerable amount of travel. This gives him the opportunity to create digital artwork using his portable studio (i.e., iPhone). Although Bharat's paintings are very different, graphically, than his iPhone work, he uses the same process; he likes to let an image appear through a series of layered experiments and accidents. Bharat's work has been invited for inclusion on a number of websites, including iPhoneography, iPhoneographyCentral, and Life In LoFi.

www.flickr.com/photos/the_bman

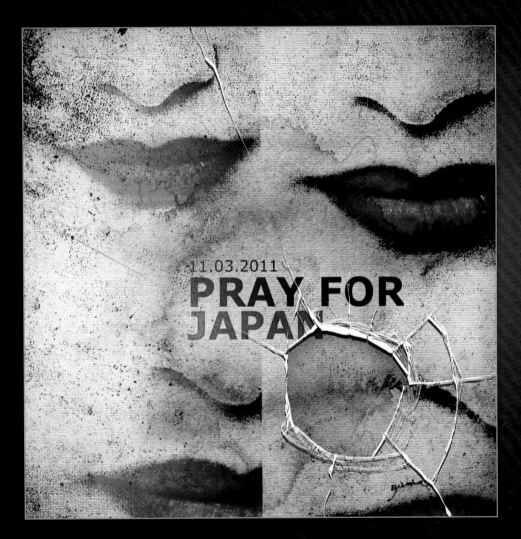

11.03.2011
PRAY FOR
JAPAN

Pray for Japan

TUTORIAL 28

Create a realistic, grungy flyer with a message of hope

What You'll Learn

In this tutorial I will show you how to create a flyer and add dirt and grunge textures to give it an authentic look. You will learn how to create this image starting with adjusting the color of the lips, then adding text and effects, and finally masking and blending textures.

Although a photograph can be a powerful image on its own, a piece of graphic design, such as this flyer, uses a combination of photography and text to convey a message. I like to portray a subtle contradiction between the image and the text, which is characteristic of my style.

What You'll Need

- ColorBlast!
- Snapseed
- TouchRetouch
- PictureShow
- Photo fx
- Picfx
- EasyTitler
- Iris Photo Suite (iPhone version)
- PhotoWizard-Photo Editor
- ScratchCam FX
- iDarkroom
- Image Blender
- RetroCamera
- SpookyPic

Back Story

In all of my iPhoneography graphic design work, the message is more important to me than the image itself. Generally, before I start to create a piece, I already have a clear message in mind. The *11.03.2011 Pray for Japan* text was the hope I gave to a world helplessly watching those terribly sad images that appeared all over the media. The word *pray* is meant to be both spiritual and physical—it is my way of telling the people of the world to do something to help the Japanese population that was affected by the triple disaster.

It was Thursday, November 3, 2011, a beautiful sunny day here in Italy. In fact, it was a beautiful day in many parts of the world, but not in Japan. I was traveling to work, and while checking the news on Twitter, I saw that something looked strange; earthquake and tsunami alarms were blinking on my Twitter stream. The images and videos I saw later were shocking.

The image in this tutorial is part of the set I created for my *Pray for Japan* series, which links to another of my sets titled *Scorie* (which means *toxic waste* in Italian). *Pray for Japan* uses contrasting visuals to create a strong image and remind people to never forget the bewildering Japanese triple disaster. The flyer is intended as a message of strength

| 1 |

| 2 |

| 3 |

and better expectations for the future in terms of spiritual attitudes and political choices. During those sad days I was reading a book by a Japanese writer. The book's cover inspired me to make this image, and this is where my tutorial begins.

The Process

▸ **Step 1: Preparing Key Elements**
Each of my pieces begins with cleaning and preparing my starting image. My idea for the flyer was to focus on a pair of vibrant red lips that contrasted well with the skin color in a square-format image | 1 |. I also wanted the final image to contrast with the message of hope,

the environment, and the red lips, which symbolize life.

First I needed to make sure that the focus of my image was concentrated on the lips, away from the neck and the nose. To further emphasize this contrast, I decided to make the whole image black-and-white except the lips. Many apps can easily colorize or retain one color and desaturate the others. I used ColorBlast! to isolate the lips in red simply by painting over them with the **Paintbrush** | 2 |.

Next I used Snapseed to crop the image, and I used the **Automatic** feature to increase the contrast between the white face and the colored lips.

I then used TouchRetouch, a powerful yet easy-to-use app, to remove the unwanted shadow on the neck and under the chin. I removed the darker area by using a pinching gesture to zoom in close. Then I tapped on the **Paintbrush** on the bottom menu and highlighted the darker tone with my finger (a stylus would work just as well) | 3 |.

|4|

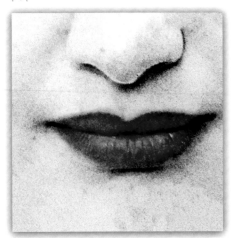

|5|

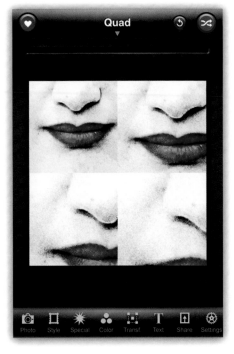

|6|

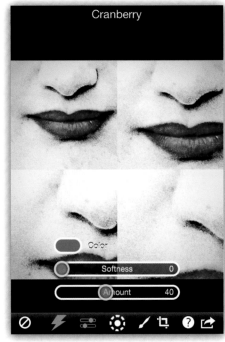

I tapped the **Start** icon, and Touch-Retouch magically performed its disappearing trick. The app works by filling in the darker area with nearby lighter pixels. In this case, the shadow under the chin was removed, which resulted in a more even tone on the neck.

When you use the same technique, TouchRetouch does an excellent job of removing particles, scratches, shadows, and practically any other distracting elements. However, a better result is often achieved by using the more advanced **Stamp** tool, which works the same way as the clone tool in professional software editing tools like Photoshop.

With the base image completed, I was ready to continue |4|.

➤ **Step 2: Creating a Vintage Motion Mood and Red Pinhole Effect**

Without using a motion blur filter, I wanted to give the image a more dynamic but retro look because Japanese culture is a fluid, flavorful blend of corporeal futurism that is still connected to its spiritual roots.

I used the **Quad** filter in PictureShow, which is a nice retro action-sampler filter |5|.

I decided to focus attention on the center by using a colored pinhole filter.

I used the Grad/Tints > Color Spot > **Cranberry** filter in Photo fx. I reduced the pinhole effect setting to 40 percent, and the color changed to a red similar to the lips |6|.

Before I moved to the next step, I thought the image needed some grain and a bit of reality. I imported the image into Picfx and added texture with the **Canvas** setting |7|.

| 7 |

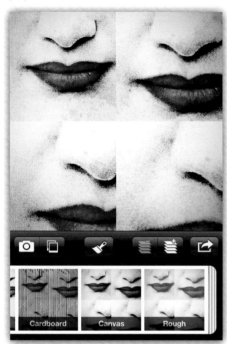

| 8 |

| 9 |

Step 3: Adding the Message

Many apps can add text to a picture but my go-to app for this is EasyTitler, which allowed me to add three different types of text just by tapping the **+ (Add)** icon. I used the **T (Edit)** icon to add the Verdana bold typeface, and I used the eyedropper tool to select three different shades of red from the lips | 8 |. The **FX (Effects)** icon would have allowed me to use different options to blend the text over the image, but I did not use it for this tutorial.

Step 4: Adding Retro Grunge Texture and Desaturating the Image

In keeping with the concept of the flyer, and to imply a dirty mark or stain on the environment, I used Iris Photo Suite to desaturate the image and to give it a retro yellowish color. I tapped **FX > Grunge > Grunge Filter** to apply the texture with a strength of 60 percent | 9 |.

My idea was to add a grunge look but retain the bright red color of the lips. PhotoWizard-Photo Editor is consistently my go-to app when I blend

images and apply a mask. I opened the last black-and-white image, tapped the **Mask** and **Gear** icons, and chose the **Paintbrush**. With my finger I erased the lips. I then tapped on the **White Point** (to the left of the **Gear** icon) and adjusted the smoothness of the erasure to 20 | 10 |.

I opened the previous color image (the final image from step 3) by tapping **Tools > Blend Images** and the **Double Square** icon at the top. Because both images are square, it was easy to match

| 10 |

| 11 |

| 12 |

| 13 |

them by tapping the **Dotted Triangle** on the top and choosing the **Scale Fit** option | 11 |. I then superimposed the images with the **Normal** blending mode. The layer with the text erased was on top of the newly opened layer. Finally, I pressed the **Check** icon to save the blending, then I exported the image to my photo library by clicking the **Home** button at the bottom left of the screen then clicking the export **Arrow** icon at the top of the screen.

Apps like ScratchCam FX have a great variety of realistic textures, but other than adjusting the strength, some texture apps offer no further manual adjustments, such as masking. For that reason I always have a full-resolution blank image in my gallery that I can easily import into an app like Scratch-Cam FX, apply the texture, and save for blending and masking in PhotoWizard-Photo Editor.

I opened my blank image in Scratch-Cam FX and applied a 100 percent

| 14 |

| 15 |

| 16 |

Classic Grunge texture by tapping **FX > More > Dust 'n' Scratches > Classic Grunge** and saving the texture for use in the next step | 12 |.

▸ Step 5: Adding Final Textures and Tweaks

Next, I gave the flyer a dirty, used look. I used a horizontal paper texture from iDarkroom by selecting **Texture > Structure1** | 13 |.

After applying the **Tutti** filter in Picfx to create a light leak effect | 14 |, I used

Image Blender to add the dirty texture that I had created in ScratchCam FX to the surface of the image.

In Image Blender I clicked the bottom left button to import the flyer image then clicked the bottom right button to open the texture image. I tapped **Blender** and used **Multiply** for the **Blending Mode** | 15 |. I then tapped the image itself to position the texture over it using pinch and zoom gestures.

Next I added some imperfections with RetroCamera by navigating to

Tool > **Texture** and from the options I chose the stain texture | 16 |.

For some final adjustments, I imported the image into Snapseed and used the powerful **Selective Adjust** tool. I tweaked the color of the final image by adding four points and increasing the saturation to highlight the top right of the lips and the word *Japan* | 17 |.

I wasn't satisfied with the colors in the image because they had become quite washed out. Still in Snapseed, I adjusted the levels, contrast, and color

| 17 |

| 18 |

| 19 |

| 20 |

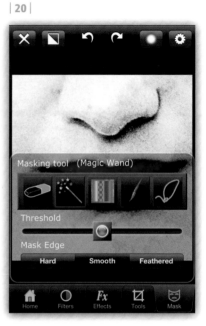

| 21 |

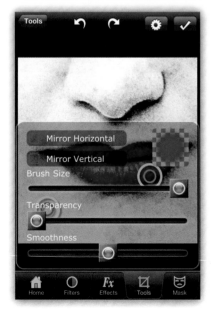

| 22 |

balance with a single tap on the **Automatic** button on the bottom (the **Tune** button provides more advanced features). The **Automatic** setting does a wonderful job of harmonizing the light and tone of the whole image.

Finally, in keeping with my theme (the earthquake disaster), I wanted to give the appearance that the flyer was being viewed through broken glass to imply a smashed shop window. To create this illusion I chose one of the effects from SpookyPic | 18 |.

My Favorite App: PhotoWizard-Photo Editor

PhotoWizard-Photo Editor offers an experience similar to Photoshop. Although it is not a particularly intuitive app, it is powerful and fast, and it features a comprehensive set of tools. I use it for numerous tasks, including adjusting levels, cloning, masking, cropping and adding text, textures, and light leaks | 19 |.

This app has powerful and precise masking tools for masking parts of an image and blending them together, and it has excellent adjustment filters that can be applied to selected areas | 20 |. The clone tool is easy to use and offers amazing results | 21 |. Also included is a comprehensive set of customizable filters, including classic black-and-white, negative, textures, pixelate, printshake, etc. | 22 |.

For the price of a cup of coffee, this app has a great set of tools contained in a single place. I recommend the much-underestimated PhotoWizard-Photo Editor. The interface is a little tricky, but after you learn it you'll have all the graphic tools you need!

Summary

In this tutorial you learned how to create a graphic image with a message based on real events. You saw how to prepare key elements for compositing by cropping and adjusting colors in Snapseed, applying selective colors in ColorBlast!, eliminating distracting elements and cleaning up an image in TouchRetouch, applying masks with layers in PhotoWizard-Photo Editor, and blending textures in Image Blender. You also learned how to enhance a mood with vintage and pinhole effects in Photo fx and Picfx and how to add further textures and effects in Retro-Camera, Laminar, and SpookyPic. Finally, you learned how add a message by applying type to your graphic in EasyTitler.

Daniele Martire (@MDphotography)

Daniele is an automation and management engineer, freelance concert photographer, web designer, iPhoneographer, intermittent student of Japanese language and culture, amateur musician, music lover, and Asian movie fan. Daniele's work has been published in print and online, and he was recognized as global Winner of the Year in Percezioni Fotografiche, Firenze 2008/2009 and as Italian National Finalist, Metro Photo Contest 2008 and 2009. His exhibitions include *and silence is another way* in 2010 at Giardini Segreti, Italy, and the photographic set pray for japan (projected during the Concert for Japan by the Japan Society in New York City in 2011, supported by Mitsubishi and Kikkoman Corporation).
www.iphoneart.com/MDphotography

Deco Moon

TUTORIAL 29

Create an original abstract painting by exploring different painting media, including brushes, pens, and canvasses

What You'll Learn

My goal was to explore the incredible potential of iPad painting apps to create a piece of original abstract art.

What You'll Need
▶ ArtRage

Back Story

Sometimes I start a painting with a clear idea of what I want to paint—a portrait, a still life, or a landscape—but this is not my favored approach. Most of the time I begin with an abstract challenge to create either a texture or a color, or sometimes to adapt an idea I get from another artist, such as letting a line dance to create an idea of an image like in a Picasso drawing, or using red and yellow in one painting to reflect the use of color like Matisse or van Gogh. I might try to balance line and color like Kandinsky, Miro, or Kline. I rarely copy other painters, but I respond to something in their work that intrigues or moves me. It's a dialog or a dance I enter with other artists. I don't start out with a plan for my painting; I begin with an idea, then the process of painting itself determines what comes next.

In this painting I challenged myself to use gold as a decorative element, like Klimt, and to paint a flat, stylized bridge and moon influenced (in my mind's eye) by Hokusai and some of the graphic designs of the Vienna secessionist painters. Though I was painting a somewhat conventional landscape, I chose to distort the elements by making the moon tear-shaped and the bridge and trees mere intimations of their forms.

I primarily use ArtRage for my iPad paintings because, as a painting simulator, it allows me to experiment with enough different techniques and combinations of techniques that I am constantly inspired to try new things. Right now I don't feel the need to learn other apps. When I initially started painting, first on my iPhone and later on my iPad, I combined many apps and filters to try to get painterly effects in my work. I may still go back to them at times, but right now I am plumbing the depths of ArtRage and find that it meets most of my artistic and creative needs.

I have always loved the art from the Vienna secessionist movement and their interpretation of Japanese prints. I wanted to use some of the possibilities in ArtRage to pay homage to the decorative qualities of both traditions.

Note: Although Helene does not start directly from a photograph for this tutorial; she uses an iPhone to capture images that are used as reference material and inspiration for her paintings. For this tutorial Helene works in ArtRage on an iPad. An iPhone version of this app is also available and the menus and functions are nearly identical.

| 1 |

| 2 |

| 3 |

The Process

➤ Step 1: Choosing a Canvas

I began in ArtRage for iPad by opening the **Start** window. When you first open the app, you are presented with a choice of canvas textures and canvas colors. There are many canvas textures to choose from, including various grades of canvas weaves or paper surfaces. For this painting I chose a fine canvas texture with minimal roughness and an off-white canvas color | 1 |.

➤ Step 2: Preparing the Background

I chose the **Metallic** option (a choice in the **Color Wheel**) set at 62 percent, and the off-white canvas took on the look of pale gold | 2 |.

I often experiment with rough textures or metallics to create different textures or depth. I wanted a neutral ground, so I blocked in some large areas with the roller brush in pale gold and then made the paint thicker by going over my brushwork to create variation in the texture | 3 |. I was aiming to create the impression of gold leaf that is used both in Japanese painting and borrowed

by the Viennese expressionists in their reinterpretation of the Japanese decorative style.

➤ Step 3: Painting in the Larger Areas

I opened a second layer and with the roller brush I blocked out a large area of black, but I left a large irregular ovoid shape and a wide swath of gold in the bottom third of the painting, like a gold lake or a river with a strange moon above it. I painted some wide black strips across the gold on the bottom to cut away part of the lower gold swath to give the impression of a bridge and

| 4 | | 5 | | 6 | | 7 |

to confuse the impression of figure and ground and leave three asymmetrical windows and a small slice of background gold above the black bridge railing | 4 |.

➤ Step 4: Adding Detail as the Painting Starts to Emerge

A very stylized, abstract Asian landscape was beginning to emerge. I wanted to enhance this impression while keeping the Viennese expressionist decorative flavor. I wanted to keep the painting abstract and give only a nod to a realistic landscape with just a slight indication of trees, reeds, and stars in a flat plane, in a decorative minimalist way | 5 |.

I drew two green horizontal lines with the drawing pen. My intention was to hint at a horizon, and I added two groups of vertical lines (four red and three gold) reaching from the bottom to the top of the canvas that were meant to indicate trees and reeds.

The three vertical lines in the center right are curved and meet at the bottom to imply a tree and branches silhouetted against the moon. I gave each branch three leaves by just touching the watercolor brush. I colored the lower leaves green and the highest leaves black to hint at space.

I made the lines on the left more or less vertical, and I made them slightly

wavy to hint at swaying reeds. I made the reeds red to introduce contrast and weight to balance the rest of the painting.

My final touches were the four green dots, indicating either stars low in the sky or lights on the bridge. They stand out in the painting because I used a very fine dab from the app's paint tube. (Usually, in traditional painting, paint straight from the paint tube is brushed in with the oil brush or palette knife, but here I wanted a slight relief effect to give the smallest elements in the painting more weight.)

☞ Step 5: Merging Layers 1 and 2

I went back to the **Layer** menu and chose the **Layer Option** in the bottom right corner | 6 |. From the pop-up menu I chose **Merge All Layers,** which merged all the layers into one.

☞ Step 6: Creating a Frame

I wanted to emphasize the decorative poster-like quality of the painting by giving it a gold mat and allude to the Japanese tradition of framing the central painting within a screen. There were internal compositional reasons for this approach, too. I didn't want the black to bleed off the painting, and I wanted it contained in a frame.

I opened a new layer and moved it under the merged painting layer simply by pressing on the layer image thumbnail and dragging it under the painting layer. In the newly created layer I chose a rough paper canvas setting and a 64 percent metallic setting. To choose the canvas settings, I clicked on the **Layers** icon to open the pop-up menu, then I selected the little square button in the bottom right corner. Next I chose the paint can fill brush from the menu on the left side of the canvas and filled the whole layer with a gold color by tapping once on the image area. I hid the top layer by clicking the little eye icon in the painting layer to see the new

gold layer | 7 |. I then clicked the eye icon again to reveal the painting layer.

☞ Step 7: Reducing the Image Size

In the top layer I chose **Transform Layer** from the pop-up menu, where I reduced the image size by using a pinching gesture. Alternatively, you can grab one of the corners and slide your finger toward the center of the image. This action allowed the lower gold layer to form a frame around my image.

☞ Step 8: Finishing Up

When I was satisfied with the position of the main painting within the frame, I signed the lower gold layer so it would be clear that the frame was part of the composition.

My Favorite App: ArtRage

ArtRage is such a complex and powerful app that I am always discovering new things, which makes me feel like a beginner or an explorer. It offers an entire studio of tools: oil paint, watercolor, palette knife, airbrush, paint tube, pencil, drawing pen, marker, crayon, charcoal, eraser, and paint can. It is more than a painting app; it is a painting simulator with many choices of brushes and techniques. The app allows you to emulate

the actual feeling of painting in various media. These exceptional tools allow you to emulate all the classic painting media, or you can transcend the physical limitations of each tool and combine their effects in entirely new ways. For instance, you can paint with watercolor over an oil painting so that oil and water do mix, and in the course of a single painting the boundaries of centuries of paint are stretched and expanded into a new art medium.

If you are using oils, you can choose to use either the color picker and create a palette or lay down some pure color using the oil paint tube and blend it on the canvas as you work. ArtRage remembers the amount of paint you placed on your canvas so you can get the realistic effects of blending or thick impasto. You can use the palette knife or brush to blend directly, so it feels like you are actually painting. This is also true of some of the other brush tools. You can smear the watercolor and paint with a dirty brush to pick up color that's already on the canvas, or you can use a clean brush to create a clear color. Each brush offers many options, with almost infinite possibilities for creativity.

The layer options are powerful and are comparable to the layers in Photoshop. They allow you incredible scope to alter your paintings on separate layers.

You can also import photos and trace over them or pin them to your easel for reference.

For as complex and powerful as ArtRage is, it's not hard to get started. I suggest beginning with one brush—oil, watercolor, charcoal, or pencil—and start painting or drawing. But the best way to learn ArtRage is to experiment freely and go to ArtRage.com for tutorials and discussions to see what other painters have discovered. I have just scratched the surface (which is another effect you can choose, by the way, with the palette knife) of ArtRage. You need to play with this app to find your own way.

Summary

I did the painting for my tutorial entirely in ArtRage. The program offers so many possibilities that it was not necessary for me to use other apps.

I began by using the roller brush to give a rough textured gold for the background. I then applied black to block out the composition and used the drawing pen and watercolor brush to add details to indicate abstract features of a landscape. I used layers to create a gold mat as part of the painting, then I used the **Transform** menu to shrink my painting

and place it on a separate gold layer to create a frame.

Many people use ArtRage to simulate classical painting forms, but I like to stretch the limits and create new effects by combining various brushes and media.

Though I have done figurative work, abstract painting is what excites me. I find that ArtRage offers almost unlimited possibilities for discovering new effects, and it empowers my creativity.

Helene Goldberg (hgberk)

Helene Goldberg has been an art enthusiast all her life, but it wasn't until June 2009, with her iPhone and the Brushes app, that she became an artist. Her iPad paintings have been shown around the world. When she's not painting, she is a psychologist with a private practice in Berkeley, California; she also teaches and does some writing about politics and psychology. Her recent exhibitions have included the LA Mobile Arts Festival, San Francisco Apple Store, ACCI Gallery in Berkeley, Art Fest in Bosnia and Herzegovina, Art from the iPad (SXSW) in Austin, and Zoo Station, Scotland.
www.helenegoldberg.com

New Car Smell

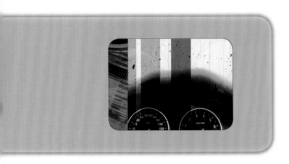

TUTORIAL 30

Take a mundane image and transform it into a poetic and sensory collage

What You'll Learn

You will learn how to enhance and manipulate an image through collage. This tutorial will help you understand my process when I transform and create distinct samples of a simple image with various apps. You will also learn how I reconstruct all of these transformed images to create an organized, structured, and conceptual composition. My goal is always to add a certain lyricism to an image that possessed none to begin with.

What You'll Need

- Snapseed
- Camera+
- ScratchCam FX
- Photo fx
- Diptic
- EasyTitler

Back Story

While I was at a luxury car dealership near my home on a job for my design studio, I snapped a few pictures. I subsequently created a brand new series titled *New Car Smell*.

 While I was shooting I didn't really have a clear vision of where all of this would lead me. I decided, however, to use only the details of these luxury automobiles to render the brand completely unrecognizable. I wanted my inspiration to come not only from the design of the automobiles, but also from those who drive them. My idea was to create a series inspired by the drivers and their vehicles and try to develop a graphic language that would appeal to this type of person. I also accepted the challenge that the quasi-abstract images would provoke; my images would be recognizable only to the individuals who drive these cars.

 All of my images begin, and sometimes end, with a mandatory stop in Snapseed. This app is the most comprehensive for image color correction. I use it as much to crop as to rebalance brightness and contrast. Depending on my impulsive inspiration or creative requirements, I also randomly use other apps. But I always leave a lot of room for spontaneity and absolutely no room for censorship.

 To maintain consistency in the visual signature of my images, I usually create them in a series and work on them simultaneously. Every image goes through each stage of creation at the same time. This method allows me to keep uniformity throughout an entire series.

|1|

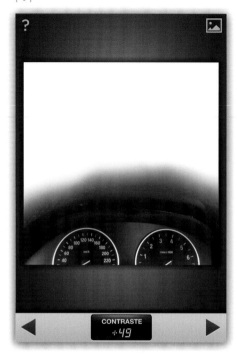

|2|

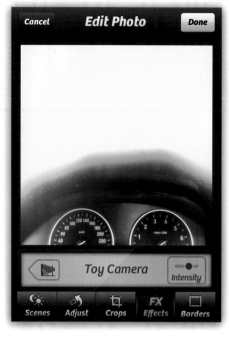

|3|

The Process

➤ Step 1: Cropping and Tuning the Image

I used Snapseed to crop the image to a square format. Then I selected the **Tune Image** function to decrease the brightness and significantly increase the contrast |1|. I then saved the image to my photo album.

➤ Step 2: Making Initial Image Adjustments

I imported the image into Camera+. With the **FX Effects** option, I used the **Toy Camera** filter at 95 percent intensity to slightly wash out the glow |2|. Why do I use this particular filter? My choices are intuitive, but on reflection it becomes quite clear that the reddish zone and the general harmony of colors are consistent with my preferred color palette. I saved the image in my photo album.

➤ Step 3: Adding Scratch Textures to the Image

I imported the image into ScratchCam FX and used the **Edit** tab to customize my image with the desired effect. I don't use the pre-established filters and always make sure that all of the layers are turned off. In the **Scratches** tab I selected an effect that, instinctively, seemed to be in harmony with the image as a whole |3|. I then saved the image to my photo album.

| 4 | | 5 | | 6 | | 7 |

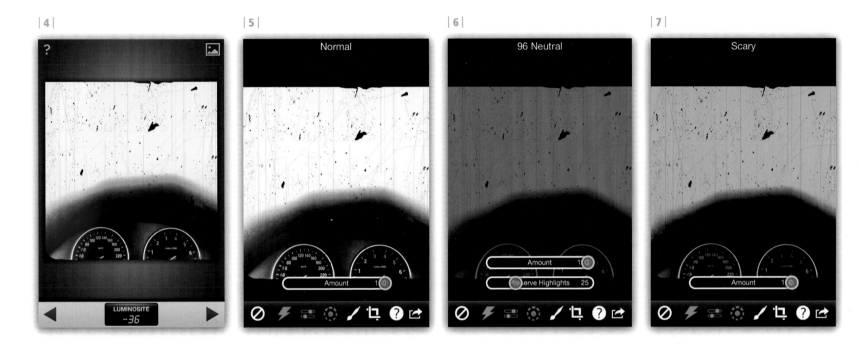

Step 4: Further Tuning of the Image

I imported the image back into Snapseed. In the **Tune Image** tab I lowered the luminosity to increase the color density of the negative area in the image. I also wanted to emphasize the contrast and saturation, so I adjusted them a little. Finally I chose the **Details** option from the menu and adjusted the structure of the image slightly to detach the details from the background | 4 |.

Step 5: Converting the Initial Image to Black-and-White

Still in Snapseed, I converted the image to black-and-white and saved it in my photo album | 5 |. I planned to use this image as a base to create the monochrome copies for assembly in the diptych.

Step 6: Modifying the Monochromatic Image

I imported figure 5 into Photo fx. I have liked this app since it first came out because I find it very useful in the development of rich, textured, and varied monochromes. In the **Photographic** section, I selected **Photographic, 96 Neutral** then decreased the highlights to make the monochrome of the image flatter | 6 |. I then saved the image in my photo album.

Again in Photo fx, I reimported figure 5, but this time I selected the **Special FX** option at the extreme right of the menu, under **More,** then I chose the **B/W Looks > Scary** tab to create a new and warmer monochrome | 7 |. I then saved the image to my photo album.

| 8 |

| 9 |

| 10 |

➤ Step 7: Editing the Taillight

I put the taillight image through the stages described in steps 1 through 3— first I cropped it in Snapseed and made some brightness adjustments, then I ran it through Camera+ and applied the **Toy Camera** filter, and in ScratchCam FX I applied the same texture (figures **8–10**). I used the textures as a device to connect all the images when they were finally combined in the diptych toward the end of this tutorial.

➤ Step 8: Using Diptic to Create the Collage

I opened Diptic and selected the frame with four columns | 11 |. I inserted images shown in figures 6 and 7 and alternated them with figure 4. In the Transform tab I customized the width of the columns by clicking on the top right two-headed arrow to add liveliness and vivacity to the image and to break the rhythm | 12 |.

In the **Add Effects** tab I removed the frame and then adjusted the images side-by-side as precisely as possible to give the impression that one image was visible through the Diptic windows | 13 |.

Needless to say, this can be a major challenge on an iPhone screen, so it isn't always perfect! Finally I made sure the **High Resolution** setting was on, and I saved the image to my photo album.

I repeated this step to integrate the taillight image | 10 | into the composition and to break the rhythm of the first collage | 14 |.

| 11 |

| 12 |

| 13 |

| 14 |

➤ **Step 9: Adding Typographic Elements**

I imported figure 14 into EasyTitler. I did not use this application to add text in a conventional sense, to label my work for example, but I used this app as a tool to enrich my creation with abstract graphic elements. Using the **Text** tool I typed the letter *w* and selected a nuptial-type font because I was looking for strong linear strokes that would carry across the different columns of the collage. I enlarged the letter, rotated it clockwise, and positioned it so it became unrecognizable. With the eyedropper I took a color sample from my image and colored the *w* with that color | 15 |.

I repeated these steps with the letter *m* and used a font called Technique. To create a visual reminder and balance the visual symmetry of the image, I positioned the *m* opposite the red band and then saved the final image to my photo album | 16 |.

| 15 |

| 16 |

My Favorite APP: Diptic

Diptic allows you to combine multiple adjacent images. There are 52 layouts to choose from; they can all be customized with a variety of options, including the width and color of the inner frames that separate the juxtaposed images. I particularly like the option of not having to use inner frames at all. Diptic can be used for editing, but I never use the image correction options. I prefer to use the **Frame Slider** function, which allows you to customize the width of each image and gives you complete control over the structure of your diptych.

Summary

Now you know the creative process behind my mobile art. I hope I have inspired you to use these applications: Diptic to create linear collages; Camera+ for its wonderful palette of filters; ScratchCam FX for its variety of textures; Photo fx for its wonderful range of filters to develop rich, textured, and varied monochromes; and EasyTitler to add typography as a graphic element in your composition.

MissPixels

Photo: Joseph Elfassi

MissPixels has worked in the visual arts for more than 20 years and is currently an illustrator, artistic director, and blogger for the cultural newspaper Voir.ca. In 2010 Wired magazine named two of her images Best Smartphone Photos of the year. Her work has appeared in a number of exhibitions worldwide, including in Italy, Australia, the United Sates, the United Kingdom, Spain, Germany, and Canada. In 2012 she presented her first solo show at an Arts Council exhibition. MissPixels has spoken at numerous conferences around the world. Her series Winter Project was acquired by the Pan-Canadian public collection Art for Healing, and it now resides alongside works by such revered artists as Marc Séguin, Dürer, and Molinari. *www.flickr.com/photos/misspixels*

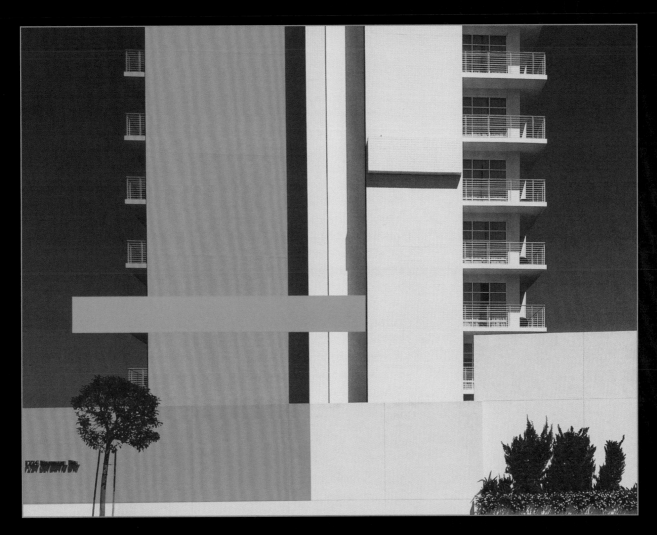

Abstract No. 2023

TUTORIAL 31

Create abstract art from architectural photos and imagery using geometric shapes and typography

What You'll Learn

You will learn how to create an abstract piece of work based on the forms found in midcentury modern architecture. You will discover how to straighten, crop, and sharpen images, create colored geometric shapes with transparent backgrounds, import them into your design to produce balanced compositions, create, manage, and store custom colors sampled from existing elements for reuse in future projects, and apply blend modes and special effects to give a unique vintage look to an image.

What You'll Need

- Snapseed
- Image Blender
- VSCO CAM
- iDesign
- ColorSchemer
- Phonto
- Picfx
- Cameramatic
- PictureShow

Back Story

My base image is a picture of a hotel on Pico Boulevard in Los Angeles. I often come up with themes to keep me focused when I shoot architecture, but I don't shoot any and all things architectural. My favorite architecture is modern, especially midcentury modern, which is frequently found in Los Angeles. I narrowed my theme to white midcentury modern architecture. Because I convert all my images to black-and-white for design and art pieces, it was a no-brainer to go with a white color theme. The vertical and horizontal lines of this hotel are perfect for adding color shapes.

Figure 1 shows the original image—nothing special—but the building has a beautiful white surface with simple horizontal and vertical lines and nice shadows.

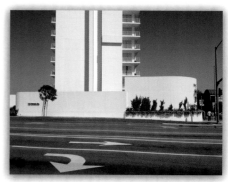

| 1 |

|2|

|3|

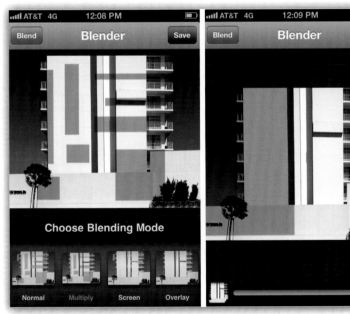

|4|

The Process

➥ **Step 1: Cropping and Converting to Black-and-White**

First I brought the image into Snapseed, where I straightened, cropped, and sharpened it and converted it to black-and-white |2|. Although my favorite crop ratio is 1:1, my original crop size seemed like a better choice. From the black-and-white filter, I selected the **Dark** effect, which imparted the best contrast and created a smooth, dark sky |3|. After the black-and-white conversion, I adjusted the image a little more with **Tune Image**.

➥ **Step 2: Arranging the Color Shape Elements in Image Blender**

Next I decided on the color shape templates I would use from my library of shapes. In most cases I select two differently colored shapes; for this piece I decided on yellow and blue. I brought the black-and-white image from the previous step into Image Blender. I decided that yellow would be my main color shape, and it would have the largest amount of coverage over the base image. I moved the color onto the image until it felt right. Is there a science to this? Not really. I tend to place elements to the left. I selected **Multiply** as the **Blending Mode** |4|.

| 5 |

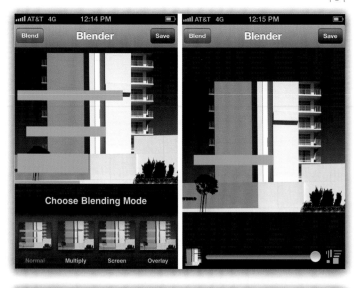

➤ Step 3: Introducing a Secondary Shape

I selected a blue template for my secondary shape. I played with the positioning until it felt right, and I selected **Normal** as the **Blending Mode** | 5 |.

➤ Step 4: Adding a Temperature

After I was satisfied with the positions of the colored shapes, I brought the image into VSCO CAM to complete the piece. I selected **Temperature 1** and **Fade 4** | 6 |. I usually choose these settings to give a muted or retro look to the final image.

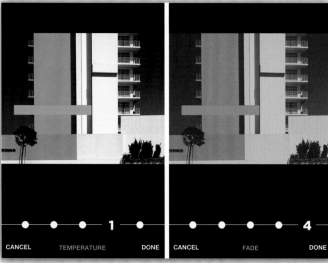

| 6 |

HOW I MAKE SHAPES

In iDesign I created a template file that has several rectangular and square shapes. I change the colors based on my design needs and create them on a white or black background | 7 |. I export the templates as transparent PNG files, which makes it easy to erase the shapes that are not needed and to superimpose them over my base images in Image Blender.

| 7 |

When working on a new piece I open the shapes design file in iDesign, select Designs, then select +. This allows me to save the template file as a new design with any changes I want to make to the base shape. I then select **Save as a new design** and rename the file. To change the colors of the new design, I select all shapes by swiping from the top left to the bottom right.

When all the items are selected, I press the Properties icon (wheel) to change the colors. There are 29 colors to choose from, or you can use the mixer to create a custom color with red, green, and blue (RGB) values. When I am satisfied with the colors, I export the file via email as a transparent PNG by selecting Export > Export Type > PNG (Email) | 9 |. With iDesign, you have to export transparent PNG files as email attachments; you can't save them to the camera roll | 8 and 9 |.

I use ColorSchemer to customize my colors and I can reuse them at any time. It allows me to select from millions of color combinations uploaded by users, or I can create my own palettes. For custom colors I make screenshots of colors that I'd like to use in my images and sample them.

To add custom colors, I select My Palette. To create a new color from a screenshot, I select the + icon, and the Create Palette screen appears. I then select PhotoSchemer > Photos and select an image from my camera roll | 10 |. ▶

| 11 |

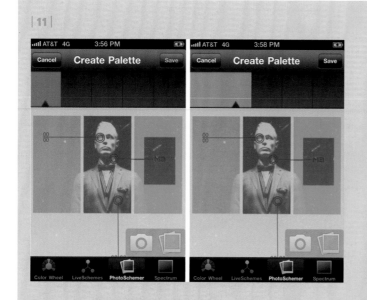

| 12 |

To create a custom color from an image, I tap the default red color palette and touch an area on the image I want to sample | 11 |. You need to fill at least two color slots to have the option to save. Then I select Save and name my color palette.

It's important to know RGB values so you can duplicate colors and keep them consistent as your designs move through the apps. To identify the RGB values for use in iDesign, I open a new color palette, touch the middle of the screen, and scroll up until I see the color names or hex color codes (six-character alphanumeric name). I tap the color name so the app displays the three RGB values. I enter the values into the color mixer to customize the colors of my saved templates | 12 |.

MY PROCESS

The Getty Center is my favorite place to visit in Los Angeles. I often refer to it as my happy place. I don't ever tire of shooting architect Richard Meier's masterpiece. With the image shown in figure 13 I followed a process similar to the one I used for *Abstract No. 2023*. I placed the monogram dots in Phonto, which is a typography app that has several built-in fonts and also allows you to upload fonts to the app via iTunes or email. For the final touch, I brought the image into Picfx and applied a canvas texture filter.

| 13 | *Abstract No. 1108*

Figure 14 shows an image of Veer Towers in Las Vegas. Once again I used Phonto to place typography (the number *1* and monogram dots). The tone and texture are a custom blend that I created in Cameramatic.

| 14 | *Abstract No. 408*

While I was on vacation in Las Vegas, I took the base image used to create Abstract No. 471 | 15 |. I anxiously waited for people and cars to stop entering my shot, but because of time limitations I gave up and began taking images. I was disappointed to not get a clean architectural shot. After I returned home and reviewed the images again, there was something I liked about

the biker, so I began looking through my library of shape designs to find a piece to blend with the image. Fortunately there was a design that resembled the architectural details of the structure. This piece came together because I followed an important self-imposed rule—I do not delete images in the field, no matter how disappointed I am about not getting the shot. With Image Blender I imported a blank white square then placed the shape design on the left, saved the image, and imported it back into Image Blender and placed my base image to the right to create a new base image. I filtered it through the Retro filter in PictureShow.

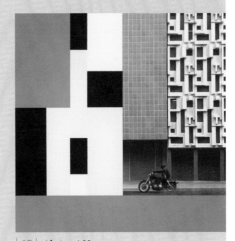

| 15 | *Abstract No. 471*

Summary

In this tutorial I shared information about some of my favorite go-to apps. Snapseed is my foundation app. It's the most versatile app for adjusting and enhancing my images because it offers lots of control. Image Blender is the second most important app I use for editing. It allows me to blend images, and the various blend modes offer many possibilities for completing my edits.

Experiment with different blend modes because different looks can spark editing creativity. Although it seems complicated, iDesign is a great vector-based app. It's worth it to master certain commands to get smooth lines and shapes. ColorSchemer may not be an obvious choice, and you probably won't use it every day, but it's a must-have app if you are particular about selecting the right colors.

Lynette Jackson (@_LynetteJackson)

Lynette lives in Atlanta, Georgia, and works as a project manager for a major telecommunications company. As part of her education, she studied mechanical engineering drafting and began her career as a manual and digital drafter in a host of engineering firms in different industries. It was her love for architecture, great design, and art that drove her desire to create as an iPhoneographer. Lynette's work has been exhibited at the LA Mobile Arts Festival (2012) and has been featured online. She has been interviewed about her work by iPhoneogenic.com and TheAtlanticCities.com, and her work has been featured on FastCoDesign.com.
www.flickr.com/photos/p67

The Red Pencil Portrait

TUTORIAL 32

Create a painterly, contemporary portrait with loose brushstrokes and grunge textures

What You'll Learn

My goal was to create a beautiful portrait with an artistic, painterly feel. In this tutorial you will learn the basics of capturing a good base photo to work with (and avoid the distorted look that is characteristic of the iPhone lens), making it cartoon-like in preparation for painting, applying paint on different layers with a variety of brushes, and adding the finishing touches with textures and fine pencil work.

What You'll Need

- ToonPAINT
- Pic Grunger
- SketchBook Mobile (iPhone) or SketchBook Pro (iPad)

Back Story

Long ago, I thought I would never be able to make a good portrait on my iPhone. But I became interested in making a collection of photographs that I edited and painted in ToonPAINT. The final images look like drawings. When SketchBook came along, I painted over one of my ToonPAINT images and discovered a way to make beautiful pictures that look like real paintings. Adding thin pencil messages or decorative drawings over the painting came naturally to me.

The Process

➤ Step 1: Knowing the Model

To capture a good portrait, the photographer must know the model. You need to gain the model's trust to achieve intimacy and beauty. The iPhone camera is prone to distorting images because the lens is very small; therefore it's important to carefully consider the shooting angle so the model's face doesn't get distorted like an egg. I don't worry too much about the composition—that can always be changed later. The next most

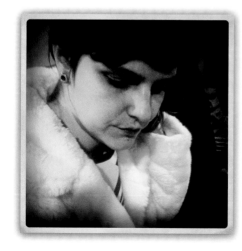

|1|

| 2 |

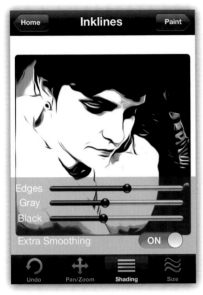

| 3 |

| 4 |

| 5 |

important consideration is lighting. Nicely defined shadows are ideal, but too much contrast or hard light is not. A beautiful female face is always helpful, but remember that it's the artist's job to render the beauty.

Step 2: Making the Image Cartoonlike

ToonPAINT is a great app that will turn a photograph into a black-and-white, high-contrast image like a cartoon. From there, it's a matter of tweaking it.

First I imported the original photo from my photo library | 1 |. I adjusted the edges and the gray and black levels to my liking. I like to keep **Extra Smoothing** set to **ON** because it gives a much softer line with smooth blending between the middle and dark tones | 2 |. I wanted to keep the lines elegant, so I used the configuration shown in figure 3. I saved the ToonPAINT drawing to my Photo Gallery (by clicking on Paint) with High-res output set to ON (the setting is located under Preferences) | 4 |.

Step 3: Adding Grunge Effects

I opened Pic Grunger, selected **resolution,** and set **High Resolution** to **ON.** Then I closed the **resolution** screen and pressed **start,** which gave me the option to import my ToonPAINT image from my camera roll. When my image was loaded into Pic Grunger, I chose **Scratched** from the various grunge options | 5 |. On the bottom menu I set the Style to **Gig** and kept the other options at the default settings. I pressed the top right button to save my image.

Step 4: Using SketchBook and Becoming an Artist

This is where I became an artist. I opened SketchBook, pressed the + button, and began a new project. On the white canvas, I pressed the small circle at the bottom. This opened the menu,

| 6 |

| 7 |

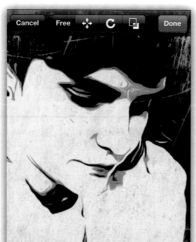

| 8 |

| 9 |

and I selected the **Layers** icon. From the **Layers** menu, I chose the **Import** command from the **Library** icon and loaded the image from the photo library. After the image appeared on the canvas, I adjusted the size and position of the layer by using the **Free Transform** button | 6 |.

I positioned the image on the canvas so it felt balanced | 7 |. Then I added a new blank layer on top of the image by pressing the + button. I set the **Opacity** to 33 % and pressed the **Back** button to start painting on the top layer | 8 |.

It is important to select the right brush and colors to paint with | 9 and 10 |.

After I made my selections, I started to add paint and layers. I generally use transparent layers of a warm white paint on the face and darker colors on the background and the clothes. I use lighter tones on the top layers. It is important to let the brush strokes stay visible and create a painterly crosshatch pattern.

It is also important to make sure the colors blend nicely. I used blue tones on the face and added white underneath the layers to give it a cooler look. I added some contrast by adding warmer tones to the clothes and very dark tones to

| 10 |

| 11 |
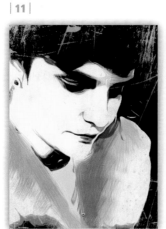

| 12 |
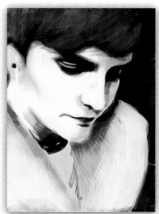

| 13 |
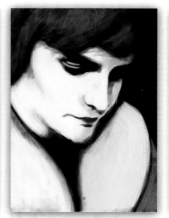

| 14 |
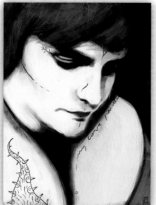

| 15 |
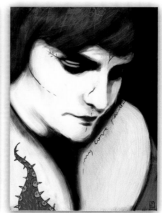

the background. It's not necessary to be exact. I simply followed the shapes and lines on the photograph and applied loose strokes. SketchBook makes this painting process very smooth.

On an additional top layer, I added a drawing with a pencil to give the image a more artistic look. Figures **11** through **15** show the evolution of the image as I applied various colors and details. Figure **16** shows the build up of layers in SketchBook.

➤ **Step 5: Adding the Final Effects**
I imported the image into Pic Grunger and selected the **Aged** effect | **17** |. I adjusted the strength to one-third and set the **Border** to **ON** | **18 and 19** |.

Finally my image was finished, and I saved it.

| 16 |

| 17 |

| 18 |

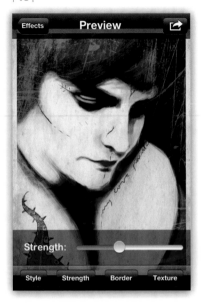

| 19 |

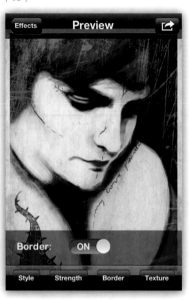

base black-and-white image to use in SketchBook. You also saw how to add pencil details and grunge textures in Pic Grunger. You are now ready to create an image in ToonPAINT and practice your technique to paint over a picture in SketchBook, and you can try some of the amazing filters in Pic Grunger. In SketchBook you can try the various brushes and add as many layers as you want. Explore the possibilities and give yourself a chance to make a stunning portrait.

My Favorite App: SketchBook Mobile

SketchBook Mobile is one of the best drawing tools for the iPhone. It is simple and intuitive, it has a great full-screen canvas feature, and it easy to access the tools I need. It has more than 40 customizable brushes, and you can switch between them by tapping a button.

Layers is a powerful feature of the app. It is easy to work with a photograph taken with the iPhone and add layers that may be reordered as needed. The color palette is comprehensive and features an amazing range of hues and tones. The brush workflow is wonderful. You can save SketchBook images to iCloud to effortlessly continue your work on an iPad. The app will also export a PSD (Photoshop) file to Dropbox so you can continue your work on a laptop or desktop computer. The SketchBook family of apps includes both iPad and desktop versions.

Summary

You learned to consider the shooting angle when you capture the image and how to use ToonPAINT to create a

José António Fundo (Jafundo)

José graduated from the University of Porto School of Fine Arts with a degree in painting in 1995. He is now a vice principal at Soares dos Reis Artistic high school where he teaches media studies and cinema and photography history. In 2009 he began experimenting with mobile art on an iPhone 3G and it soon became José's major form of artistic expression. In 2011 his works were part of Autodesk's The Digital Canvas exhibition at One Market in San Francisco and the Autodesk University Creative Studio exhibit in Las Vegas and Beijing. In 2012 his work was also shown at the LA Mobile Arts Festival.
www.flickr.com/jafundo

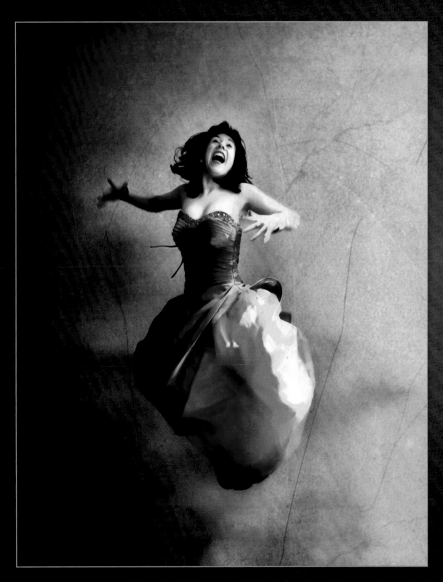

Flamin' Amy

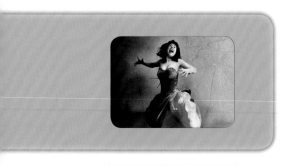

TUTORIAL 33

Create a dramatic and surreal image with color enhancement and retouching

What You'll Learn

My goal was to capture the spirit of my friend Amy on her birthday in her brand new dress. In this tutorial I hope to inspire you to have fun with your iPhone, approach your shot with an open mind, and experiment with different compositions and angles. You'll learn how to eliminate distracting background elements to draw focus to your main subject and use color filters to enhance, clarify, and add punch to your subject. Finally, I will show you how to bring the whole image together with texture and color to give the overall picture a similar tone.

What You'll Need

- Camera+
- Filterstorm (or any app with a cloning tool)
- TouchRetouch
- ScratchCam FX (or other texture app)

Back Story

My goal is to always have fun with my iPhone and to experiment as much as possible. In 2011 I was fortunate enough to have a great muse at work—my good friend and colleague Amy Maslin. She dresses in a very individual style, and it is great fun to capture different Amy personas almost every day (always outside of work hours, of course).

On Amy's birthday she had a new dress delivered at work from eBay. At lunchtime she eagerly unpacked the dress and hurried to a more private room to climb into it. The dress was fantastic, with lots of gorgeous colors and shimmering textures. I could see that this was going to be a perfect iPhoneography opportunity. However, our office was cluttered and cramped and I really wanted to show off Amy and her new dress without background distractions.

The Process

➤ Step 1: Using Available Light and Shooting from Various Angles
What I really needed was light and space, so we moved to the stairway, where there are huge glass windows running down the sides of the building with generous floor space, plain backgrounds, and perfect golden ambient light pouring through the window.

Often the image I choose to edit is one I select from many photographs with different angles of the same subject. This was certainly the case for

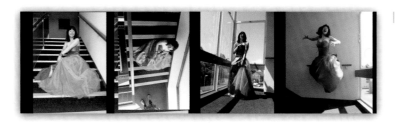

| 1 |

Flamin' Amy. Because the iPhone is so lightweight and easy to lift high above my head or hold low near the floor, it is ideal for getting unusual shots. In the series of images shown in figure 1, you can see some of the other angles I took before settling on the fourth image. Notice the fantastic light coming through the large windows to the right. I knew I could make use of this wonderful light and it would look great reflecting off Amy's brightly colored dress. Always use available light as much as you can to your advantage. I also liked the energy that oozed out of the fourth image—particularly the position of Amy's hands and fingers and the expression on her face. The fact that her legs had disappeared under the billowing ball of her dress added a sense of surrealism, which I liked.

➤ Step 2: Removing Distracting Background Elements

Part of what makes this image compelling is the fact that you can't see Amy's legs, which gives the impression that she is hovering in the air. I liked the surrealism of this and wanted to emphasize the sense of detachment by erasing all the distracting elements around her. I brought the image into Filterstorm and used the **Clone** tool to paint over and remove the background details | 2 |. This tool is an essential part of any toolbox for making photo collages. With it you can sample another part of the image and paint over whatever you wish to remove.

➤ Step 3: Zooming in to Refine the Image

Using the **Zoom** tool in Filterstorm, it's possible to get in really close | 3 |. Don't worry if it looks a little messy—with practice it becomes much easier. I usually start off with a medium-sized brush at 100 percent opacity and then smooth

over the area with a much larger brush at a lower opacity to get a more even tone. I wasn't too worried about the cloning resulting in a perfect finish since I planned to add a rough texture later to mask imperfections.

In addition to Filterstorm's excellent cloning tool, I also use the brilliant retouching app TouchRetouch. It has some powerful quick-fix tools that do a remarkable job of removing unwanted parts of an image.

| 2 |

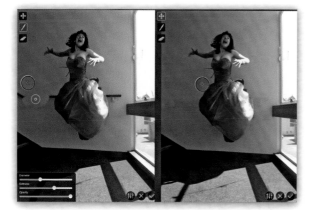

| 3 |

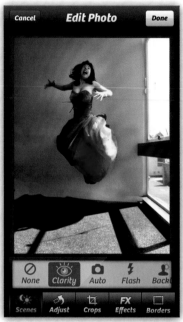

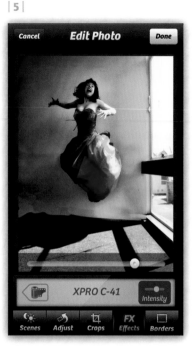

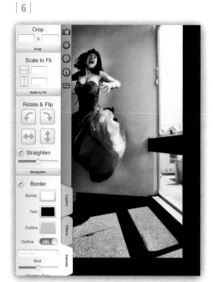

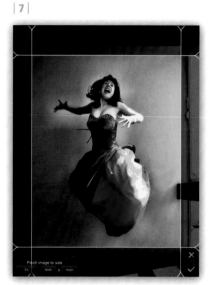

| 4 | | 5 | | 6 | | 7 |

Step 4: Changing the Color Tones to Add Drama

To add contrast and give a subject some punch, I often run my image through the **Clarity** filter in Camera+ | 4 |. This filter highlights the lighter areas and darkens the midtones and shadows. Sometimes the effect can be harsh and result in blown-out highlights from too much contrast, but in this case it brightened Amy's skin tones nicely and added a slight glow around her, which separated her from the background. This added to the overall surreal look I was after.

Step 5: Making Final Color Adjustments

I wasn't happy with the overall color tone, which seemed flat and lifeless. I thought more drama could be added to the image.

Still in Camera+, I ran the image through a few filters before settling on **XPRO C-41**, which gave it a great cross-processed feel | 5 |. It added fire and punch to the orange dress and changed the background to a greenish gold, which emphasized the bright, warm colors of the dress even more. At this point

I felt the image had really come to life.

It's useful to remember that cool colors, like blue and green, will always seem farther away in an image; and warm colors, like red, orange, and yellow, will jump forward. Use this concept to add punch to your images.

Step 6: Cropping the Image

In the next step I used Filterstorm to crop the image and get rid of any remaining distracting elements in Amy's surroundings, including cropping out the floor to enhance the surreal look

| 8 |

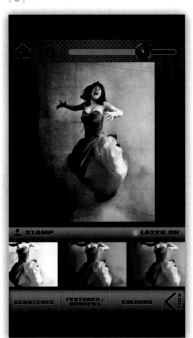

| 6 and 7 |. I used Filterstorm because it has a particularly versatile cropping tool that allows a frame to be created by either dragging any of the individual sides inward or pinching the image with your fingers to make the frame. Either method allows the subject to be easily positioned within the frame. Filterstorm also has many cropping presets, such as square or 3:4. Lots of apps have perfectly good cropping tools, including Photoshop Express and Camera+.

➥ Step 7: Adding Texture and Tone to Augment the Image

At this stage I was pretty happy with the overall image, but somehow it looked a little too smooth. I thought I had perhaps separated Amy from the back wall a little too much, and I looked for a way to pull the background and the subject closer together again.

I brought the image into Scratch-Cam FX to add some texture and scratches and to help tone down the greenish color | 8 |. Not only did the ScratchCam FX filters help unify the tone and texture of the image, but they also gave the background an old stone wall effect. Amy had suddenly emerged like a flame burning against the wall.

Texture filters such as those in ScratchCam FX often apply a subtle color tint along with the texture. The effect can really pull an image together and give it an overall tone, a bit like adding glaze to a painting.

Summary

To accomplish my vision for the image, I used Filterstorm's cloning tool to eliminate distracting background elements; the **Clarity** filter in Camera+ to help bring Amy into focus by separating her from the background and enhancing the highlights and shadows; and Scratch-Cam FX to add some overall texture and tone to augment the image and express the rebellious and irreverent mood and give the image a shabby chic look.

Nicki Fitz-Gerald (FlickrFitzy)

Nicki Fitz-Gerald earns her living as a graphic designer. She balances iPhoneography and family life—and often joyfully mixes the two. Her iPhone photos have been featured in a number of online and gallery exhibitions, including the first Eyephoneography exhibition in Madrid and FORMAT, a UK photography festival. Nicki's image Flamin' Amy, shown on the cover of this book, won fourth place in Life In LoFi's Faved of the Year 2011. Her image Fish Oil won the top prize, and four of her other images won honorable mentions in the Appstract Digital Painting category of the Mobile Photo Awards 2013. All five images were displayed at the Soho Gallery for Digital Art in New York City. Nicki founded the website iPhoneographyCentral.com in 2011 and now comanages it with Bob Weil. *www.iphoneart.com/FlickrFitzy*

BOB WEIL · UNITED STATES

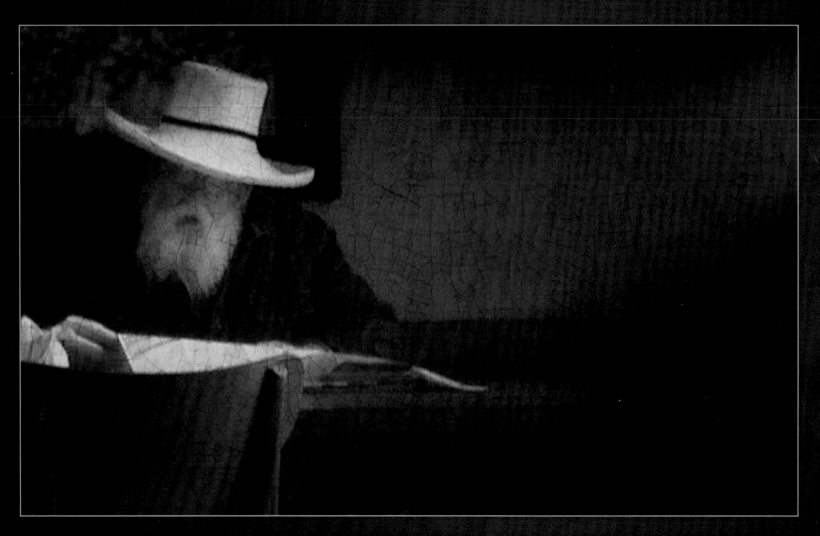

Letter from the Beloved

TUTORIAL 34

Create a paint-erly image with classic lighting effects, a tiled texture, and layers

What You'll Learn

My goal was to produce a piece that, in a small way, emulates a painting by a minor Dutch artist in the 1800s. In this tutorial you'll learn how to crop and rotate an image, adjust lighting, drop in a tiled background, and add highlights with blending modes.

What You'll Need

- AntiCrop
- PhotoWizard-Photo Editor
- Photogene2 (or a similar image-editing program)
- Noir Photo
- DXP
- LensLight
- FlickStackr
- Tile Wallpaper
- Superimpose
- iResize

Back Story

One of my favorite haunts on a Saturday morning is the local Starbucks. Over the course of a few hours while reading the morning paper, I see an amazing parade of humanity—every imaginable type of person.

One day in early 2012, a man sat alone at a long, naturally lit wood table along the wall. I recognized him as a local tow truck driver. But that day, with his broad-brimmed straw hat, long beard, and the shirt he had chosen, he looked like a farmer you might see in the countryside, sitting in his cottage and preparing for a day in the fields. The morning light was almost golden as it streamed in through the front window, so I quickly captured a few pictures, and this was the best one.

I have always been fascinated by the Dutch painters and their mastery of light and shade, and their choice of color (or lack of it). I thought a similar approach to the scene and subject in my image would make perfect sense.

The Process

➤ **Step 1: Capturing, Rotating, and Cropping the Image**

To capture the scene before a large group of people moved to the man's table, I took this picture quickly and at an unfortunate angle | 1 |. I needed to crop it by about 50 percent to eliminate someone who had entered the left side of the frame.

To successfully crop and rotate the image, I needed to extend it slightly at

| 1 |

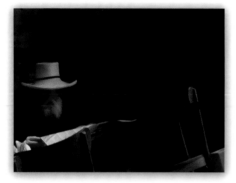

| 2 |

| 3 |

| 4 |

the margins. I used AntiCrop to first increase the canvas size by extending the height and width of the image to the maximum the app allows | 2 |. AntiCrop accomplishes this by using an algorithm to identify nearby pixels and extend them outward from the picture. It does not always give a gracious result, but my only purpose was to enlarge the canvas to allow for the best possible rotation and crop.

I used PhotoWizard-Photo Editor to rotate the enlarged image and

maximize the area to the left of the subject so the elements in the image would be more balanced. When the table was parallel to the bottom of the crop box, I cropped the image to a better proportion that did not clip the subject's right hand | 3 |.

Step 2: Removing the Fire Alarm from the Wall

I took advantage of Photogene2's healing and cloning capabilities to select a

| 5 |

| 6 |

| 7 |

solid area of the image and eliminate the fire alarm on the wall | 4 |.

Because it provides many of the same features as Photoshop, Photogene2 is my initial go-to image editor—several other apps might work just as well for you. I made minor color corrections and removed a bit of noise that resulted from the image being shot in somewhat low light. I also applied a very slight blur to hide some of the remaining noise.

➤ **Step 3: Creating and Applying a Mask to Focus Light**

I used Noir Photo to create a black-and-white mask to better highlight the subject—specifically his hat and the papers in front of him | 5 |.

Noir Photo is a great app for converting images to black-and-white and selectively applying a vignette to establish a mood. Mask creation is not its primary purpose, but it did the job nicely.

I used DXP to composite the original color image on top of the

black-and-white image I had just created | 6 |. I then applied the **Color** blend setting and adjusted it to taste with the slider | 7 |. (**Halfmix** and **Multiply** would have produced similar results.) DXP is one of several layering apps that allow multiple images to be placed on top of one another, edited with masks or brushes (to select or deselect specific areas), and merged as desired.

| 8 |

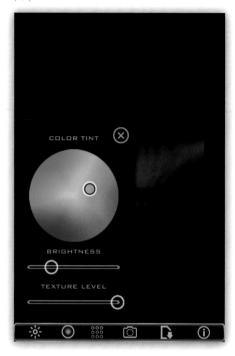

| 9 |

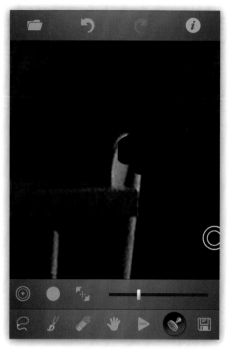

| 10 |

Step 4: Importing, Scaling, and Compositing a Light Ray into the Scene

I wanted to imitate the emphasis on the contrast between light and dark that was common to the Dutch painters of the 1800s, so I turned to LensLight, an app that allows you to add lighting effects to your scene | 8 |. I selected **Search Cone,** then I angled, scaled, and rotated it to enhance the effect of light coming in the window from the right side. I used the **Brightness** setting and found

a suitable level. I also gave the light a yellow cast, in keeping with the color of morning light.

Step 5: Erasing an Unwanted Element

In PhotoWizard-Photo Editor I used the **Clone** tool to carefully remove the chair on the right side of the table | 9 |. It didn't seem to add anything to the scene, and it drew the eye away from the main subject. I wanted the setting to look like a cottage, not a coffee shop.

Step 6: Creating, Tiling, and Applying a Craquelure Texture

As many old paintings age, they develop unique cracks that we naturally associate with the passage of time. I located a beautiful craquelure pattern on a plate that was uploaded by lisabee73 on Flickr. The creator had placed the image in the public domain (with a Creative Commons license at the time I was processing this image), which means that anyone could use it. I located the texture and downloaded it with FlickStackr | 10 |.

| 11 |

| 12 |

| 13 |

I imported the texture into Photo-gene2 and cropped it to avoid the curves and irregularities of the plate, which resulted in a very small image that I thought would tile nicely.

I used Tile Wallpaper to import the texture, and I created a larger wallpaper made of a 5×10 tiled pattern | 11 and 12 |.

Unfortunately, the textures cannot be blended, so you might have to use a cloning tool to hide repetitive seams or lines. You can also do this in advance to just the layer image. I did a little of

both to get the best possible outcome. Fortunately my image is quite dark, so the repetitiveness of the pattern is not obvious.

➤ **Step 7: Importing and Blending the Texture Layer over the Image Layer**

I brought my main image into Superimpose and imported the tiled texture as a layer | 13 |.

I adjusted the blending to ensure that the most important areas of the scene (the man's hat, face, and paper) were

realistically and seamlessly textured. I tried different settings, such as **Darken, Overlay, Multiply,** and **Dodge** at various **Transparency** settings, and I exported test images. I finally selected the **Overlay** mode as the best solution, and I adjusted the **Transparency** slider to about one-third | 14 |.

Another way to refine and darken the texture is to reapply the texture a second time, perhaps with the **Darken** mode.

| 14 |

| 15 |

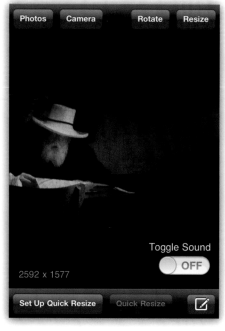

| 16 |

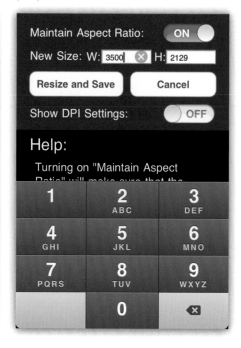

➤ Step 8: Resizing the Final Image

Since I wanted to print the image, and the original size was quite small (about 2592 × 1577 pixels), I decided to resize it. Both Adobe Photoshop Touch and Filterstorm will resize images, but I chose iResize, which is one of those great one-trick-pony apps that can quickly complete a single task well.

First I loaded the image in iResize | 15 |. Then I selected **Resize,** which gave me the option to resize the image and maintain the aspect ratio (the relative length and width of the image) or scale the image unilaterally in one direction or the other.

The app provides dots per inch (dpi) information to help you determine the ideal dimensions for printing, which is very handy for those who are not familiar with resolutions. I set the **Maintain Aspect Ratio** option to **ON** and the **Show DPI Settings** option to **OFF,** and I typed in the desired number of pixels for the width. The app automatically filled in the height | 16 |.

I exported the image, which was as simple as pressing **Resize and Save.**

My Favorite App: Superimpose

I find that some images I shoot are instantly usable and I know exactly what I want to do with them—what effects I will apply, and what the final look will be. The subject of this tutorial fits into that category. I save images that don't seem to work on their own for later use.

| 17 |

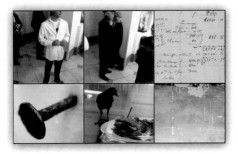

| 18 |

I often see an opportunity to use them at a later time as part of a composite image—possibly in a collage, sometimes in a seamlessly integrated piece. Figure 17, titled The Upper Limits of Human Calculus, is an example of this approach.

This piece consists of six images: two men shot at a social event, and three objects and one texture captured at different places and times | 16 |. The nail was captured with an olloclip close-up lens.

The photo of math calculations written in a European hand lent an aura of mystery when superimposed on top of the completed image.

To create this piece, I used Superimpose to position, mask, and blend all the elements together. I used the Selection tool to separate the two people from their backgrounds. I also used the Exclusion blend mode to apply the texture after the fact. With a low opacity setting, I was able to add some artifacting as well as color to the image. After using Pixlr-o-matic to get a sepia tone, I applied a previously-saved stamp (or selection) consisting of the standing man and the outer black frame to keep both those elements black.

A video discussion of my approach to creating conceptual collage art may be seen here: www.tinyurl.com/BobWVideo.

Summary

To accomplish my vision for the scene, I used Photogene2 to crop the subject and create a tile, and to flip an image; PhotoWizard-Photo Editor to layer, rotate, crop, erase, and heal images; DXP to composite masking layers; Tile Wallpaper to create a repeating texture; Superimpose to apply that texture; Noir Photo to create a black mask to create focus on the lighted area around the subject; and AntiCrop to enlarge an image so I could rotate it. I also used FlickStackr to locate and download the Creative Commons craquelure texture to simulate the cracked lacquer often found on paintings that are several hundred years old.

Bob Weil

Bob leads something of a double life: marketing professional by day and covert iPhoneography creative and evangelist by night. Bob's work was exhibited at the LA Mobile Arts Festival 2012, the Orange County Center for Contemporary Art, and the Darkroom Gallery in Vermont. Five of his pieces were awarded at the 2013 Mobile Photo Awards and exhibited at the Soho Gallery in New York City, and 12 were on display at Macworld/iWorld 2013. Bob was also a featured artist in Dan Marcolina's eBook, Mobile Masters. He was a 2013 American Aperture Awards juror and was selected as a Photographer of the Year by the iPhone Photography Awards in 2013. Bob co-manages iPhoneographyCentral.com and writes and speaks on iPhoneography topics.
www.iphoneart.com/users/4431/galleries

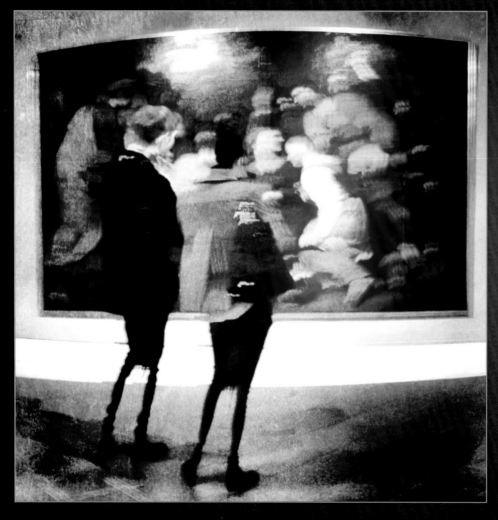

Mutual Appreciation (Blending of the Ages)

TUTORIAL 35

Create a monochrome abstract image enhanced through the application of texture and a color highlight

What You'll Learn

My goal was to produce a somewhat abstract piece that reflected the mood and experience of a special moment in an art gallery while preserving my original composition at the time of capture. This tutorial begins with the use of the Slow Shutter Cam app to capture an abstract image, then it walks through how to crop the original, distort the perspective, apply texture, blend different versions to affect the lighting and tone, and add a focal highlight by introducing a splash of subdued color.

What You'll Need

- Slow Shutter Cam
- Photo fx
- Dynamic Light
- Simply B&W
- AutoStitch Panorama
- TouchRetouch
- Filterstorm
- ScratchCam FX
- DXP
- Pixlr-o-matic

Back Story

I captured the original photo for this piece at Museo de Bellas Artes de Sevilla during a visit to Spain in February 2012. The trip provided new stimulation and the right opportunity to achieve a thematic reboot while continuing to enjoy the slow shutter experimentation I had begun a few months earlier. As I visited museums and galleries, I turned my eye to presenting different views of people interacting with the art on the walls. In some images they blend with the work they observe and almost become part of it. In others, their dynamism stands in contrast to the staid pieces on the wall. All explore a complicit relationship in the making of art and meaning. *Mutual Appreciation* is of the former variety—those that blend with the work they observe—and is the second piece in a series.

The Process

➤ **Step 1: Using Slow Shutter Cam to Capture the Original Image**
I wanted to blur the lines of reality somewhat while adding a unique physical character to the human subjects, so I used Slow Shutter Cam to capture the image. The basic technique I employed

| 1 |

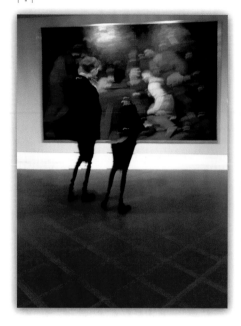

| 2 |

| 3 |

was to set the app's capture mode to **Light trail** and shoot stationary subjects while moving the iPhone just enough to create the amount of distortion I was after | 1 |.

Step 2: Cropping to a Square Format

I compose for a square format, even though Slow Shutter Cam offers only a 4:3 aspect ratio for capturing images. Photo fx is handy for the conversion task; you simply select its **Square** tool to grab the maximum possible width. It

continuously displays the pixel count of the crop size when you select a smaller area, which helps you remain conscious of retaining as much of the original resolution as possible. First you select **Levels,** which appears in the middle of the screen after you open an image, then you can select the **Crop** tool on the toolbar along the bottom of the screen. The maximum available size of my captured image was 1936 × 2592 pixels, and I cropped it to 1890 × 1890 pixels | 2 |.

Step 3: Enhancing Brightness and Contrast While Preparing a Second Black-and-White Version

Photos taken with Slow Shutter Cam in darker situations often lack contrast. To compensate for this somewhat, I opened the cropped file in Dynamic Light, adjusted the angle and strength of the lighting effect, and then saved the modified image back to my camera roll | 3 |.

I then converted the enhanced image to black-and-white in Simply B&W, and I used the red color filter to further

| 4 |

| 5 |

enhance the tone values | 4 |. You can tap on each of the color filters to display the change on the screen in real time and see a brief written description of how that color filter will affect your image. I had a motive for creating both an enhanced color version and a black-and-white version of the same image, as you will see later.

➤ **Step 4: Combining Two Versions to Distort the Frame**

Combining two or more images in AutoStitch Panorama can create an interesting distortion, but it does not work when you try to use two identical copies of the same image. The slight tonal differences in the color and black-and-white versions of my image were enough to get the result I wanted | 5 |. I cropped the curved bottom section and a little of the left side of the resulting

2096 × 2096 pixel image, which gave me a 1998 × 1998 pixel image.

Another approach to create distorted perspectives with an interesting effect in AutoStitch Panorama is to shoot the same scene from slightly different angles and then combine the resulting images. AutoStitch Panorama also does interesting things to images that already have borders from apps that add them at the time of capture.

➤ **Step 5: Filling the Upper Corners and Converting to Monochrome**

The cropped version of the file left curved black areas in the upper corners. I didn't want to crop them out because I wanted to preserve some space above the painting in the image, so I filled them with the wall color. TouchRetouch made this easy to accomplish. I used the **Paint** tool to define the areas I wanted to fill and tapped the **Start** button | 6 and 7 |. I opened the resulting image in Filterstorm and applied a bit of blur to each of the upper corners to eliminate the slight roughness that TouchRetouch left in the color gradation.

The final process in this step was to convert the file to monochrome in Simply B&W. This time I used the orange filter to achieve the tone and contrast I wanted, and I slightly adjusted the contrast and brightness | 8 |.

| 6 |

| 7 |

| 8 |

| 9 |

➤ Step 6: Applying Texture

I ran the monochrome version of the image through ScratchCam FX twice. In the first pass I added a **Scratches** layer and left the **Textures+Borders** and **Colours** layers turned off | 9 |.

I applied the same **Scratches** layer in the second pass, and I also incorporated a **Colours** layer | 10 |.

Tapping more than once on a selection in ScratchCam FX's **Colours** layer window toggles through a couple of slightly different variations in tone and contrast. This can be useful to get an ideal result.

I finished this part of the process by opening the two resulting files in DXP and blending them with its **Normal** blend mode | 11 |.

You can blend images in Image Blender, Superimpose, Filterstorm, Laminar, and other apps. Each app has its own strengths when it comes to blending a specific region of an image.

➤ Step 7: Introducing a Color Highlight

I wanted a splash of modest color to serve as a subtle visual cue, so I began by adding a light leak in Pixlr-o-matic | 12 |.

The next task was to tone down the effect and limit its impact to the painting on the wall. In Filterstorm I opened the file as it appeared before I added the light leak. I tapped the **Filters** icon, selected **Add Exposure** from the bottom of the menu, selected the image with the light leak, and tapped **Fit to Image**.

Next I selected the **Gradient** tool from the toolbar on the left and chose the icon on the far right, which adds visual data from the second image to the first image in a linear fashion from the center | 13 |. The farther away the smaller circle is placed from the center point, the

| 10 |

| 11 |

| 12 |

| 13 |

more subtle the effect. This was more effective for my purpose than blending in other apps because it allowed me to add a more subtle color that fades from the center in a narrow range.

After I introduced the subtle touch of color from top to bottom, and before I hit the **Check** button to accept the edit, I returned to the toolbar on the left, selected the **Eraser** tool, and erased the color from above and below the frame of the painting. The **Show Mask Color** masking view worked well for this task | 14 |.

When I was finished I tapped the **Check** button to accept the edit, confirmed the results, and saved the final image.

My Favorite App: Slow Shutter Cam

Slow Shutter Cam is a versatile camera replacement app that offers near-infinite possibilities for introducing the blurred motion effects of slow shutter speed capture. The more you experiment with it, the more it will encourage

| 14 |

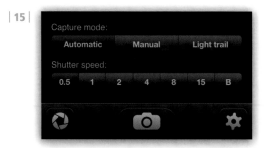

| 15 |

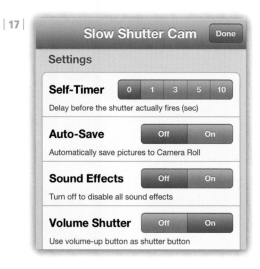

| 16 |

| 17 |

you to discover new approaches to unique visual expression.

The app features three different capture modes—**Automatic, Manual,** and **Light trail**—each with highly flexible speed settings | 15 |. Access the **Capture mode** options by tapping on the **Capture settings** button in the lower left corner of the screen.

Automatic mode emulates the shutter priority mode of a digital single-lens reflex (DSLR) camera. You can use it to capture dreamy images of water flowing smoothly over waterfalls and rapids or ghostlike figures that suggest movement in the frame.

Manual mode is useful in low-light conditions because it keeps the shutter open for the amount of time you specify. Manual exposure compensation is available with a slider control after you take the shot. **Light trail** mode lets you paint with light to create interesting effects. For example, you might use it to capture the trails of car headlights and taillights at night or fireworks exploding in the night sky.

Light trail mode features a **Sensitivity** setting in addition to the **Shutter speed** settings that are available for each of the three capture modes | 16 |. The best way to understand how the **Sensitivity** setting affects your images is to experiment with it at the high and low extremes.

A **Self-Timer** setting is one of the many options found on the general **Settings** screen, which you access from the lower right corner of the main shooting window | 17 |. The **Self-Timer** is handy for those who wish to use Slow Shutter Cam for shooting self-portraits.

The best way to learn the ins and outs of Slow Shutter Cam is through extensive experimentation. The following are my recommendations for discovering what effects inspire you to experiment:

- ❯ Aim to capture subjects that stand in distinct contrast to the background.
- ❯ Try all three of the capture modes in conjunction with a variety of different shutter speeds and sensitivity settings.
- ❯ Take advantage of the capture mode that you find best suits subjects in your immediate surroundings. This will allow you to experiment often.
- ❯ Try experimenting with the **Freeze** and **Exposure** controls after capture. (**Exposure** is available in **Manual** capture mode, **Freeze** is available in **Light trail** mode, and both are available in **Automatic** mode.)
- ❯ Use a tripod when you use **Manual** mode, when you want to capture smooth light trails of traffic at night, or when you shoot self-portraits.

Summary

The techniques you learned in this tutorial include an easy method for cropping to a square format or other aspect ratios in Photo fx while retaining maximum resolution. You also learned how to enhance lighting and contrast with Dynamic Light, use color filters and contrast and brightness controls in Simply B&W to enhance shadows and tone values, and how to distort perspective and frames as an effective creative process with AutoStitch Panorama.

In addition, you learned how to apply texture in ScratchCam FX and how to blend different versions of an image in DXP to create a unique finish. Finally, you learned how to add a color highlight with Pixlr-o-matic and how to use Filterstorm to apply that highlight in a specific manner that is limited to a certain area.

Alan Kastner (Tabiwallah)

As a Canadian living and working in Tokyo for nearly 25 years, Alan's ongoing struggle to make sense of his environment and daily life drives his passion for capturing the mood of given moments. Whether his images are rendered unaltered as observed, or more often as a somewhat abstract reflection of his emotional response, they all reflect his fascination with light, geometry, form, and motion. Alan has employed his iPhone exclusively to capture, process, and post all his images since late 2010. His work has been featured around the world in numerous galleries and publications, perhaps most notably Museo de Huelva in Spain in 2012, where his images were featured alongside the Magnum classic photographers. More recently, his works were exhibited at Unit24 Gallery in London.
www.iphoneart.com/users/1297/galleries

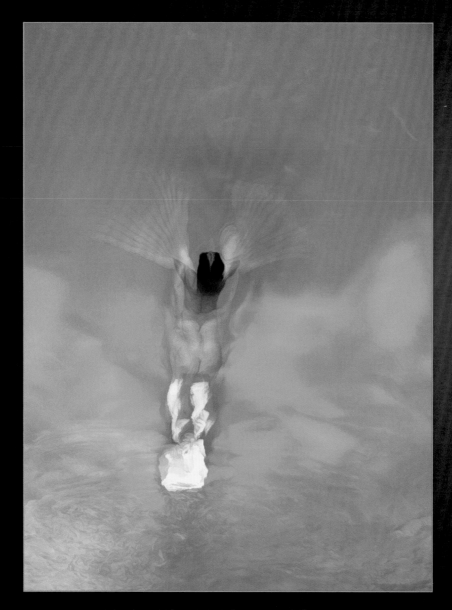

Water Was My Strange Flower

TUTORIAL 36

Create an extra-ordinary and surreal piece of art from an ordinary image

What You'll Learn

In this tutorial you will learn how to transform an ordinary image into something extraordinary by using layering apps and effects to achieve an expressive, painterly piece of artwork. To accomplish my vision for this image, I used Slow Shutter Cam to capture a swimmer underwater in a swimming pool, ShockMyPic to add texture and interest, and Iris Photo Suite to layer images, adjust the color, and rotate the image.

What You'll Need

- Slow Shutter Cam
- ShockMyPic
- Iris Photo Suite (for iPad)

Back Story

In the summer of 2011 I began a series of images of a swimmer underwater in a swimming pool. The image in this tutorial, *Water Was My Strange Flower*, is part of that series. When I stood at the edge of the pool, the crystalline surface of the water became my canvas, and my iPhone and Slow Shutter Cam became my paintbrush.

In much of my work I am not overly concerned with rendering reality. I am much more interested in suggestion and how it engages the imagination of the viewer. My preference is to create an image from my heart rather than to represent physical reality, and Slow Shutter Cam is the perfect tool for me to express my personal vision in this way. Slow Shutter Cam allows me to achieve what I like to call *poetic distortion*—distorting the subject just enough to engage viewers' imaginations and invite them to become an active participant in the work. In this way the work becomes more personal and resembles a dream or a memory as opposed to physical reality.

The Process

➤ **Step 1: Capturing the Initial Image**
I captured the original image of a swimmer in a swimming pool on my iPhone with the app Slow Shutter Cam, rather than using the native iPhone camera | 1 |.

I chose the following settings in Slow Shutter Cam | 2 |:

- Capture mode: Light trail
- Shutter speed: 0.5
- Sensitivity: 1

| 1 |

| 2 |

| 3 |

I highly recommend experimenting with these settings to achieve your desired effect. If I had wanted more blurred motion I might have used a **Shutter speed** of 1 or slower. For this image, 0.5 worked well.

I saved the image to my camera roll.

➤ Step 2: Creating a Second Version of the Image

I opened ShockMyPic and went into the **Settings** menu (middle button at the bottom of the screen). I chose **Maximum**

Image Resolution (at the time of this writing, the maximum resolution is 1440 × 2160). I set the **Filter Width** slider all the way to the left by pressing the minus (–) button, which gave me the finest line width | 3 |. You will notice the subtle changes on the sample tiger image as you click the button. Alternatively I could use the plus (+) button to give me a thicker line width. I encourage you to experiment with this setting. You may prefer a wider filter width depending on

| 4 |

| 5 |

| 6 |

| 7 |

| 8 |

your personal taste and the look you are trying to achieve.

Next I clicked the **Filter** button (at the bottom-left of the screen). I clicked on the empty grey area to bring up a menu | 4 |. I chose **Photo Albums** and then selected the original image from my camera roll. The app immediately began to process the image with the settings I selected. I saved the new version | 5 |.

☛ Step 3: Layering and Blending the Images

I opened the original image in Iris Photo Suite (for iPad). On the top menu bar, I selected **Adjustments > Layers > Set**

Layer as Base | 6 and 7 |. This placed my original image on the base, or bottom, layer.

Next I clicked the **Film Canister** icon in the lower right corner of the screen, which opened a dialog box | 8 |. I chose **Open a New Image,** which opened my camera roll. From my camera roll I selected the image I created and saved in ShockMyPic | 9 |.

Then I selected **Adjustments > Layers > Blend with Base.** A **Layer Dimensions** dialog box opened and said that the base layer and current layer were different dimensions | 10 |. I chose to retain the dimensions of the **Base** layer

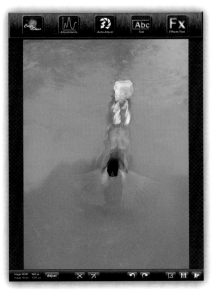

| 9 |

| 10 |

| 11 |

| 12 |

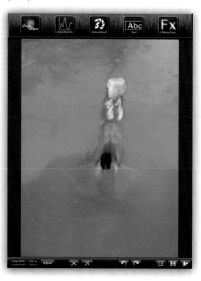

| 13 |

because it was the highest resolution (it was the original image) and would force the upper image to the larger size.

I could then choose from several **Blend Mode** options for blending the two layers together. Each option creates a different effect. The options are **Normal, Darken, Multiply, Linear Burn, Color Burn, Lighten, Screen, Color Dodge, Linear Dodge, Overlay, Soft Light, Hard Light, Vivid Light, Linear Light, Pin Light,** and **Hard Mix.** For each **Blend Mode** there is a slider bar that allows you to vary the opacity of the blend. The one you choose will be a matter of personal taste. I tend to favor **Soft Light, Hard Light,** or **Normal.** For this

image I selected **Normal** at an **Opacity** of 50 percent | 11 |.

The resulting image is a subtle blend of the original image and the Shock-MyPic version of the image | 12 |.

➤ Step 4: Adjusting the Color

In 2011 I vacationed in Turks and Caicos. I was awestruck by the color of the ocean—an impossible color of turquoise that has since found its way into much of my work. I wanted to use that color in this image, so I used the **Auto-Adjust** tab on the top menu bar and selected the **Fluorescent** filter, which provided the exact color of blue-green I was looking for | 13 |.

There are many presets beneath this tab, and I often start here before moving on to other color adjustment options. Had I wanted to fine-tune the color to a greater degree, I could have selected the **Color Sense** tab, which allows a more precise approach to color adjustment. In this case I was lucky that the **Fluorescent** filter perfectly matched my vision | 14 |.

➤ Step 5: Rotating the Image

I thought the image would be stronger with the swimmer's head at the top—swimming up rather than down. To rotate the image, I clicked the **Rotate** icon at the bottom of the screen (next to

| 14 | | 15 | | 16 | | 17 |

the **Scissor** icon) | 15 |. I clicked one of the 90 degrees buttons twice to rotate the image 180 degrees | 16 |.

My Favorite App: Slow Shutter Cam

Slow Shutter Cam is a camera replacement app that replaces the native iPhone camera software. This powerful app allows you to reproduce the effects of using a slow shutter speed on a digital single-lens reflex (DSLR) camera. It is my go-to app for creating unique and artful images. It offers three **Capture** modes: **Automatic**, **Manual**, and **Light**

trail | 17 |. The following paragraphs describe how these three modes work:

Automatic mode allows you to capture the appearance of motion, such as a waterfall or a speeding car, by adding a blurred effect. It is similar to using the shutter-priority mode on a DSLR. You can set the shutter speed depending on the look you want to achieve. Shutter speed options range from 1/2 to 1/15 second. There is also a B (bulb) setting that allows the shutter to remain open until you tap the shutter button again. The **Automatic** mode also features automatic exposure compensation so that your pictures will always be perfectly

exposed, regardless of the selected shutter speed.

Manual mode works well in low-light conditions because you can set the shutter speed manually. There is no automatic exposure compensation in this mode, so it's best to use it only if you have a complete understanding of exposure or if you want to experiment with the settings.

Light trail mode is the mode I use the most because it allows me to "paint" with light. It does exactly what the name implies: it captures light trails streaming from behind bright lights or other moving lit objects. Unlike the **Automatic** or **Manual** modes, **Light trail**

allows you to set the sensitivity of the effect. Sensitivity can be set in increments ranging from 1 (most sensitive) to 1/64 (least sensitive).

Summary

In this tutorial you learned how to capture an image with Slow Shutter Cam in an unusual way that shows movement, create a texture layer with ShockMyPic, blend two layers with Iris Photo Suite, and adjust color and rotate an image with the Iris Photo Suite filters and tools.

I am often inspired by music and poetry. This particular image—and the larger series—was inspired by a poem titled "The Nude Swim" by Anne Sexton. A line in the poem reads, "Water was my strange flower," which made for a wonderful title and a wonderful concept for the entire series of images. I strongly believe that titling your finished pieces can greatly add to the emotional response of viewers, so don't settle for weak or lackluster titles. Give it some thought and show your viewers that you value your work enough to give it a worthy title!

Cindy Patrick (cpatrickphoto)

 Cindy is an award-winning professional photographer, iPhoneographer, and fine artist whose work has been exhibited globally, most notably in February 2012 at the Latitudes International Photography Festival in Huelva, Spain (alongside world-renowned Magnum photographers). Her work has also been shown at the Arthaus Gallery in San Francisco, the Los Angeles Center for Digital Art, the Giorgi Gallery in Berkeley, the LA Mobile Arts Festival, and the Lunchbox Gallery in Miami. Her work has been published on all the notable iPhoneography blogs and online publications, and in January 2013 Cindy was a presenter at the annual Macworld/iWorld convention as part of the Mobile Masters Sessions. Cindy received six honorable mentions at the Mobile Photo Awards 2013.

www.cpatrickphoto.500px.com

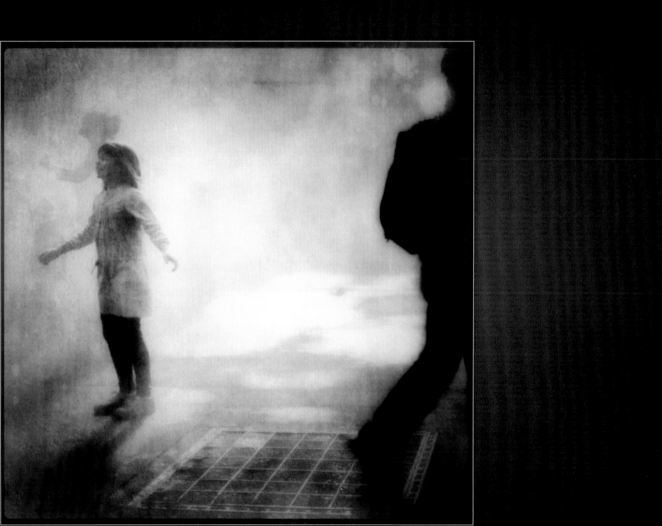

TUTORIAL 37

Capture the emotions and inner light of children at play

What You'll Learn

My aim was to create an image that shows a child's abandon and emotion during play—to show the purity of a person who is totally in the moment and has abandoned all the usual thought processes that cause people to self-edit or be on guard. In this tutorial you will learn how to use apps to create atmosphere and enhance emotion through lighting, blending, layering, and effects.

What You'll Need

- Camera+
- Snapseed
- Autopainter HD (for iPad)
- BlendCam
- Layers – Pro Edition for iPad
- ScratchCam FX
- Pixlr-o-matic

Back Story

I love to capture people, especially children, in the natural moments of their lives. Through my love of travel and culture, I have learned, generally speaking, that children are very similar all around the world. What they become is a reflection of their society, but for the most part they all start out with very similar attitudes about fun, play, and a sense of wonder about life. I have been photographing people for a long time, and I'm always intrigued with portraying their inner being, thoughts, or emotions rather than simply creating a portrait of how they look externally.

One of my favorite places in Sydney is Cockatoo Island on Sydney Harbour, a UNESCO World Heritage site. It is saturated with a complicated and intriguing history and has an ethereal and textural vibe. You just can't help being happy there, despite the sad incidents that have befallen it in the past. It's a dichotomy of beauty and sadness. The island is host to the Sydney Biennale, and while I was scouting for film locations and having site visits for two major events, I came across the fabulous cloud installation *Cloud Parking in Liz* by artist Fujiko Nakaya. It represents an artist's haven and inspires experiential and photographic art that you can ponder.

The designated area on the island was engulfed in layers of mist designed to mimic cloud vapor. The layers expanded and contracted, at times overwhelming participants as they struggled to move through it with outstretched arms. It made me feel vulnerable and excited at the same time,

| 1 |

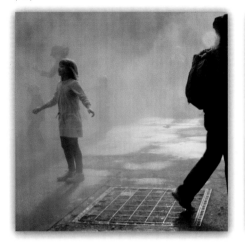

| 2 |

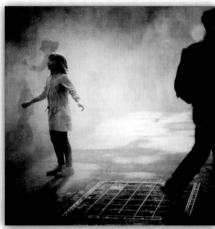

and I could see it was a highlight of the Biennale for many children and adults, who instantly turned into children.

Of course, I took out my phone straight away and fell into the abandon that the numerous children were feeling. The whole world had stopped, differences were put aside, the outside world ceased to exist, and I felt like I was having a special experience with a close group of friends. People ran, skipped, hopped without a care in the world. Colors changed, expressions were full of delight and curiosity. I remembered what it was actually like to be as carefree as most children, and I realized that what I was capturing was pure-form childhood. I tried to protect my phone from the water vapor (living in hope!)

and I sat on the ground in the middle of it all as an observer, and nobody cared! That was how I captured such wonderfully unedited emotions. People were so absorbed in the experience that they threw out all normal apprehension of being watched.

The Process

→ **Step 1: Improving Contrast and Texture**
Because there was a lot of mist (meaning that the light conditions were affected), I knew my original image would not be properly exposed and it would be flat and have color issues | 1 |. I use Camera+ to shoot all my images

because it allows me to control the shot in some way. However, my vision was not to counteract the shooting conditions at the scene and potentially miss moments fiddling about, but to concentrate on capturing the essence of this child's emotion and use various apps to enhance it.

In Snapseed, my primary editing tool, I started to increase the tonal qualities by experimenting with the **Drama** tool. I'm not a big fan of this tool in a lot of circumstances, but because the shot was about mood, and I wasn't that concerned about losing detail, I gave it a go. The scene was about emotion and not detail, after all.

Notice that the filter decreased the detail of the character on the right side of the frame | 2 |. I wasn't sure of his role in the image and whether I would eventually crop him out, so I wasn't concerned.

Because the child's hair and skin were originally lighter, they maintained more detail but did lose highlights. The **Drama** filter added luminosity and contrast to the wet areas and the grate on the ground, and it gave more depth to the clouds. I liked the grain, or noise, that it created, and I knew I could smooth it later if I wanted to.

| 3 |

| 4 |

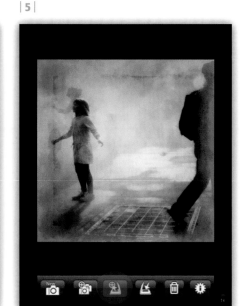

| 5 |

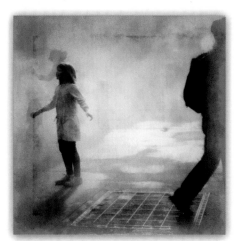

| 6 |

☞ Step 2: Adding Painterly Effects to Create a Mood

At this stage I wanted to explore how I could add emotion, so I decided to try using Autopainter HD and chose the **Aquarelle** effect to create a softer feel and to see what it would do to the wet elements in the image | 3 |. As it turned out, I wasn't particularly happy with the result because it took out far too many details. Still, I kept this version of the image for blending later.

☞ Step 3: Blending

Blending different versions of an image is a great way to provide tonal depth, new color effects, and interesting anomalies you could not usually achieve through simple editing or apps that do all the processing for you. It's also great for creating abstracts, collages, or surreal images.

I played around in BlendCam for a while to see what results I could achieve with the **Balance Superimpose** method until I was reasonably happy with the effect | 4–6 |. I knew I was losing a lot of detail, but my focus was on mood, not perfection, so I persisted.

| 7 |

| 8 |

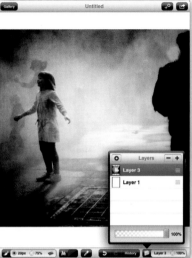

| 9 |

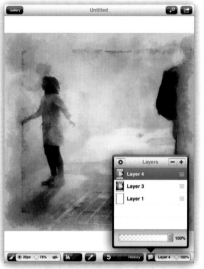

| 10 |

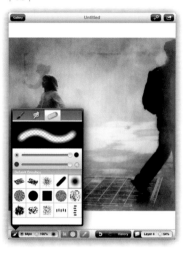

📌 **Step 4: Bringing Back Detail through Layers**

You may ask what the difference is between blending and layering. These techniques get confused at times, and of course it's subjective, but for me blending is more about art and layering is more about science. From my perspective, blending builds up an image with various versions of the same or different images, and it plays with opacity. The fundamental image in each blend doesn't change.

Layering lets you have more control and you can change or eliminate specific areas of an image. No doubt you can blend through layers by playing

with opacity; however, layering enables you to take very precise actions using individual layers and tools that allow you to paint, draw, erase, rotate, change brushes, blur, write, and so forth on individual layers.

Getting back to the image, I wasn't happy with the lack of detail in the child's face, but I liked everything else, so I decided to use Layers – Pro Edition for iPad to correct this specific issue. I planned to layer the current version of the image with an older version where the facial detail was desirable and erase specific areas on the current version.

I created a **New painting** and added a picture layer using the image from step

2, which showed more detail | 7 |. This created **Layer 3** | 8 |. Then I added **Layer 4** by using the current image, which had less detail | 9 |.

I decreased the opacity of **Layer 4** so I could see the layer underneath for ease of editing. I used the eraser tool to start erasing the image of the child on **Layer 4** and reveal the details of her face and body on **Layer 3** | 10 |. I then increased the opacity of **Layer 4** until I was happy with the detail in the resulting image.

📌 **Step 5: Cropping and Tweaking**

I imported the resulting image back into Snapseed, cropped away the edges that were created by the larger canvas

| 11 |

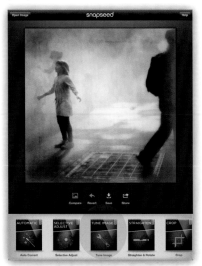

| 12 |

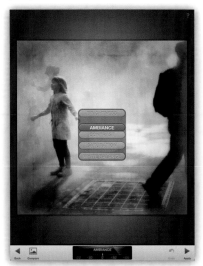

| 13 |

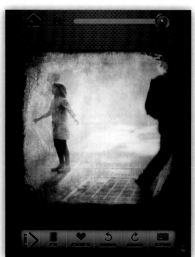

| 14 |

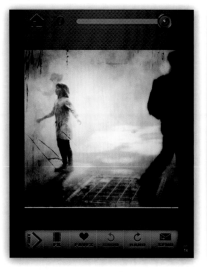

space in Layers Pro Edition for iPad, and started adjusting the **Ambience, Contrast,** and **Saturation** within the **Tune Image** tool until I had an image with more tonal depth | 11 and 12 |.

Step 6: Adding Color and Effects

I was unhappy with the color and the lack of emotion, so I started to play with different color and effects filters in ScratchCam FX | 13 and 14 |. I have my favorite settings in this app, but sometimes I run an image through the random filter many times until something resonates with me. I might have a look and feel in mind, or I wait for something that really jumps out. If

I like a few results, I keep them all and blend the best ones with BlendCam or Image Blender, which is what I did with this image. I'm not normally a fan of frames as part of an image (or frames in general), but I thought it worked in this instance. If I like an effect that has a frame, I usually crop out the frame.

At this stage I also thought about cropping out the figure on the right, but I thought his dark presence within the frame actually drew more focus to the child.

Step 7: Softening the Light

As was my approach with most images in this series, I wanted to soften the

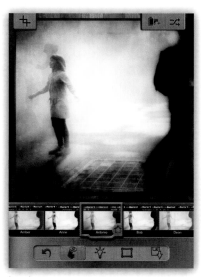

| 15 |

| 16 |

light in the image by adding more atmosphere and making it a little more ethereal. I used Pixlr-o-matic and applied the **Antonio** filter (one of my favorite softening techniques) | 15 |. Sometimes, though, it can blow out the highlights and darken an image too much, so I use it cautiously.

➤ **Step 8: Sharpening and Adding Highlights**

I imported the image back into Snapseed, and although it might sound counterintuitive, I used the **Details** tool to maximize the sharpening. I was going for a soft look, and I find that while other sharpening tools pixelate images and add noise, this tool adds clarity (and a little noise) while keeping soft edges and luminosity.

I wanted a little more highlight on the girl's face, so I went to the **Selective Adjust** tool and used the drop-down **Contrast** and **Brightness** filters to add a bit more of a subtle glow | 16 |.

TIPS FOR CAPTURING CANDID EMOTIONS

It can be difficult to capture genuine emotion in a photograph, especially if the subject knows you are taking a picture. Children (and adults) tend to put on their cheese face when they see a camera, and they abandon their candid selves.

Because of its sometimes anonymous nature, mobile phone photography has attracted both positive and negative thinking about the nature of privacy and candid photography (and disclosure). However, as history has shown, capturing candid and emotional moments creates a photographic memory for our world and provides us with a mirror on the true nature of humanity.

And what a wonderful thing it is to feel the world through the mind of a child, using apps like Snapseed, Pixlr-o-matic, and ScratchCam FX to highlight specific areas of a face or scene.

Here are some ideas for capturing the emotion of children through mobile photography:

• Don't be afraid to think outside the box and tamper with a technically good image. Your image may be well exposed, clear, and color balanced, but does it portray the extent of emotion you see in your mind's eye? Would the Antonio filter in Pixlr-o-matic, some layering, or some careful isolation of the face with selective adjustment in Snapseed emphasize the emotion you feel in the scene? Push the boundaries of the rules of photography with your apps. Emotions have no rules!

• Experiment with movement. For the most part, emotion is not static. The movement of subjects, the background, or light can add a lot to the emotional story of a scene. Additionally, you can use apps such as Decim8, BlurFX, ScratchCam FX, Snapseed, Noir Photo, BlendCam, iAwesomizer, or the smudge tool in Photoforge to create texture, movement, or fluidity and play with light effects.

• Provide distraction. If your subjects are participating in an activity, they will usually get absorbed in the feeling surrounding the activity and forget you are there.

I was happy with the final image, which is pretty much exactly how it felt at the time. It captured the look of the girl, who emanated a freedom of spirit, light, and life that we all felt while sharing that experience.

Summary

To accomplish my vision for this photo, I used Snapseed for cropping and all basic editing; working on tonal quality, contrast, and clarity; and creating the light space that affected the subject within the image. I used Autopainter HD to add painterly aquarelle effects, and I used ScratchCam FX filters to add color, scratches, and texture. I used BlendCam and Layers Pro Edition for iPad to blend the various versions of the image and add more detail. I also used Pixlr-o-matic to soften the light and edges, then finally (as often is the case for me) I went back to Snapseed to sharpen the detail and highlight the areas that needed it to draw the eye to the expression on the child's face.

Kerryn Benbow (Imokko)

 Kerryn is a Sydney, Australia-based iPhoneographer who has been described as Australia's premier iPhone fine artist. Kerryn was included in the Google+ list of the world's top 100 iPhoneographers and has been showcased on EyeEm, Life In LoFi, iPhoneArt.com, Pixels: Art of the iPhone, and Mobitog. Her images have been featured on ABC's *Art Nation* program and in various music video clips, and they have been exhibited in New York, Los Angeles, Miami, London, Berlin, Sydney, and other locations around the world. *www.flickr.com/photos/imokko*

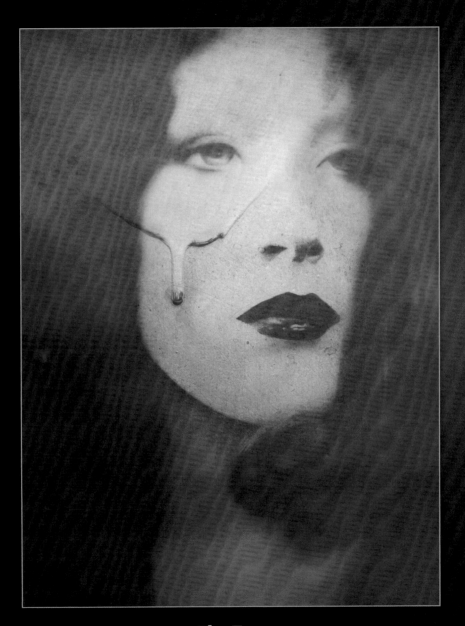

The Tear

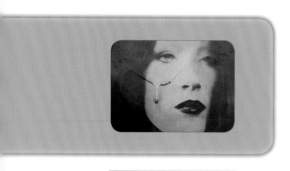

TUTORIAL 38

Create a haunting image by layering and blending images

What You'll Learn

In this tutorial you'll learn how to edit an image in Snapseed, blend two images in Image Blender, remove an unwanted feature in TouchRetouch, and add a masked blur in iColorama.

What You'll Need

- Snapseed
- Image Blender
- TouchRetouch
- iColorama

Back Story

Mannequins and dolls are a favorite subject of mine. There's something eerie about them—something rather haunting and, well, almost human. I have favorite ones in certain stores that I have returned to more than once, including the one in this image. A change of clothing and new wig can inspire me all over again.

After taking a texture shot of a painted door one day, the drips of paint reminded me of tears dripping. While I studied the photograph of the mannequin | 1 |, it occurred to me that the dripping paint texture might blend well

with the mannequin image and add the suggestion of human emotion to the rather blank expression on the mannequin's face.

A lot of my work is spontaneous, and this layered image falls into that category. I didn't create the image in one sitting (or even in one day), and I took a lot of wrong turns along the way. But I love the process itself—the possibility of happy surprises.

The Process

➤ Step 1: Cropping and Making Adjustments

First I cropped the original image | 1 | in Snapseed to remove the distracting background and focus on the mannequin's face | 2 |.

| 1 |

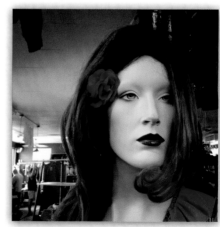

| 2 |

| 3 |

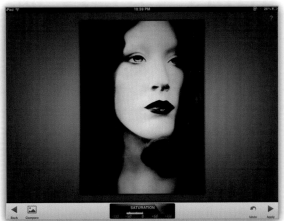

| 4 |

When I work on an image, I tend to experiment with this excellent app more than any other, and this time was no exception. After I adjusted the saturation, contrast, and texture values within the **Grunge** filter | 2 |. I experimented with the **Vintage** filter choices and the **Saturation** control until the image became almost black-and-white | 3 |. Although I liked the color version, the black-and-white version appealed to me more and added what seemed to be a touch of elegance.

Step 2: Blending the Main Image and Texture Image

In Image Blender, I was ready to combine the mannequin image with the black-and-white paint texture | 4 |. I used the **Arrange** function to move the texture layer until I was satisfied with its placement. After I tried several blending modes, including **Multiply** and **Hard Light,** I decided to use the **Normal** mode (despite its flat appearance), knowing that I would further adjust the image after this step | 5 |.

Step 3: Removing an Unwanted Element

I was pleased with how a tear appeared to be on the mannequin's cheek, but the texture image had also placed a mark across her lower face that I found distracting. I opened the image in TouchRetouch and used the **Lasso** tool to select and remove the mark | 6 |. This app has become invaluable to me; it performs well, and I have no complaints.

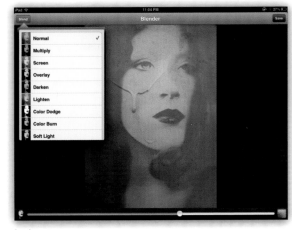

| 5 |

| 6 |

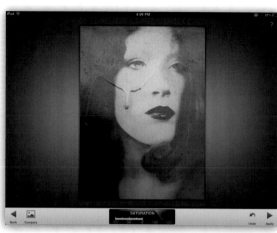

| 7 |

| 8 |

Step 4: Readjusting the Image

I brought the image back into Snapseed and made further adjustments, including lowering the saturation in **Tune Image** | 7 |.

Step 5: Applying a Mask and Blur Effect

I opened the current version of the image in iColorama. After I experimented with the app and decided against several of its interesting options, I masked the center of the mannequin's face and selected one of the **Blur** presets under the **Effects** option for the rest of the image | 8 |. My objective was to draw

attention to the tear on the mannequin's cheek rather than her eyes.

Step 6: Applying a Black-and-White Filter

I opened the current version of the image in Snapseed again, chose the **Black & White** filter option, and applied various adjustments to achieve the desired tone and contrast for the final image | 9 |.

My Favorite App: Snapseed

Even before the upgrade containing **Retrolux** and the new frame options, nearly every one of my images, at one point or another, has made a journey

through Snapseed. I once sung its praises in an app review for iPhoneArt. com, and nothing has occurred since then to change my opinion of this extremely useful app. Often Snapseed is the first app I use, simply to straighten it or crop it to the desired size and shape.

From there I may use **Tune Image**, with its many options for editing, such as brightness and contrast adjustments, or changing the saturation level. If I feel particularly adventurous, I might experiment with the **Grunge** filters or the newly introduced **Retrolux** option. The **Drama** filter is another favorite; it can mean the difference between a so-so image and one that really captures the viewer's attention. All in all, if I were

| 9 |

ever forced to choose one app over all others, Snapseed would be that app.

Summary

To create this composite image I used Snapseed for cropping and making multiple adjustments that affect color and contrast, Image Blender to combine the main image with a texture image, TouchRetouch to remove an unwanted element, and iColorama to mask the center of the image and add a blur pre-set to the rest of the image.

Elaine Nimmo (Luxtra)

Elaine Nimmo is a self-taught artist and photographer in central Texas. Her work has been featured on various iPhoneography websites, including Life In LoFi, iPhoneogenic, iphoneographyCentral, P1xels, and The App Whisperer. Elaine's *Landscape 101* made the shortlist in the Appstracts & Graphic Art category in the 2011 Mobile Photo Awards. Several of her works were included in the International iPhoneography Show (2011). Four of her images were shown at the 2012 LA Mobile Arts Festival. Elaine was recognized as Artist of the Month on iPhoneArt.com in June 2012.
www.iphoneart.com/luxtra

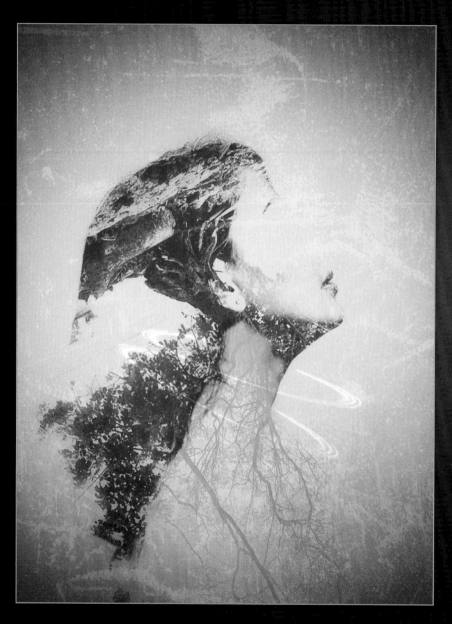

Human Tree

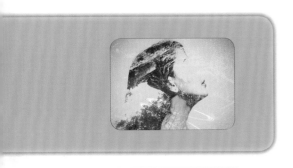

TUTORIAL 39

Create a human tree using double-exposure techniques

What You'll Learn

This tutorial describes the process of compositing three different exposures into a single artistic human portrait. You will learn how to blend and mask layers and how to crop, rotate, and place images in a collage. You will also learn how to create a dramatic black-and-white effect, apply textures or elements, and adjust color tones for the final image.

What You'll Need

- ProCamera
- Noir Photo
- Superimpose
- Photo Power
- Snapseed
- VSCO CAM
- Alien Sky

Back Story

I love creating closeup portraits of people, whether man, woman, or child. On the other hand, I also like to take pictures of landscapes or other interesting objects I see around me. I had an idea to create a double-exposure photo series consisting of both types of images. The series includes my lovely wife in all images, as the first exposure, and different places or interesting objects as additional exposures, resulting in multiple studies of the same person. For this particular image in the series, I chose two tree images as the secondary exposures.

The Process

- **Step 1: Capturing Three Initial Images**
I shot the three images I planned to use for the collage with ProCamera, an iPhone camera replacement app that I particularly like | 1–3 |.

- **Step 2: Creating a White Vignette Around the Head**
I used Noir Photo to create a selection around the head with the following settings, shown in descending order in figure 4:

- **Contrast:** 60
- **Inner exposure:** 31
- **Outer exposure:** 92

I saved the resulting image to my camera roll.

| 1 | | 2 | | 3 | | 5 | | 6 |

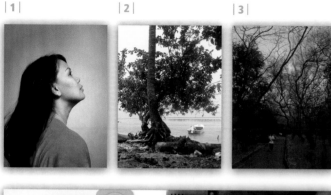

| 4 |

Step 3: Creating the Initial Composite Image

I used Superimpose to import the background image of the woman, then I added the big tree as the foreground image | 5 |. In the **Transform** section, I first rotated the tree into position to trail down the back of the woman's head in place of her hair, and I selected

the **Lighten Blending** mode | 6 |. I used selection tools to eliminate all elements except the portion of the tree I wanted to use.

From the **Filters** menu, I clicked the **F** icon to select the foreground image (the tree), then I adjusted the **Exposure, Brightness,** and **Contrast** | 7 |.

I clicked the **B** icon to select the background image (the woman), then I adjusted the **Exposure, Brightness,** and **Contrast** | 8 |. I saved the resulting image to my camera roll.

Step 4: Adjusting Curves and Color Balance

I used Photo Power to adjust the **Curves** | 9 |. I also adjusted the **Color Balance** with the following settings under **Midtones** | 10 |:

- Cyan: −14
- Magenta: +15
- Yellow: +26

I saved the resulting image to my camera roll.

| 7 |

| 8 |
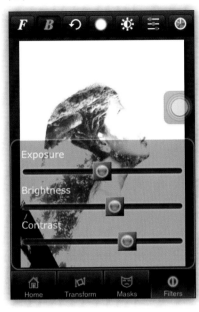

| 9 |
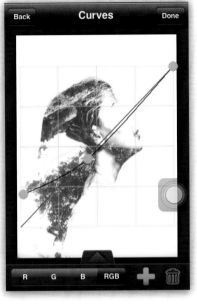

| 10 |
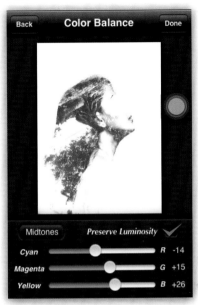

- **Step 5: Adding Grunge Texture and a Vignette**

I imported the image into Snapseed for further adjustment | 11 |. I accessed the **Grunge** function and used the following settings:

- **Style:** +120
- **Brightness:** 0
- **Contrast:** 0
- **Texture strength:** +25 No.5
- **Saturation:** +100

(Note: In Snapseed, the adjustments available under each function only become accessible and visible by pressing on the center of the screen, and stroking up or down to select a specific setting.)

I then opened **Center Focus** and made the following adjustments | 12 |:

- **Blur strength:** 0
- **Outer brightness:** −90
- **Inner brightness:** +25

I saved the resulting image to my camera roll.

| 11 |

| 12 |

| 13 |

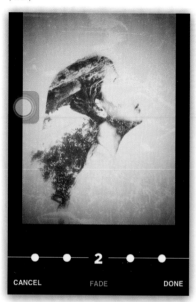

| 14 |

I imported the image into VSCO CAM and selected **Fade 2,** then I saved the image to my camera roll | 13 |.

Step 6: Adding a Ring and Making Additional Curves and Channel Adjustments

I opened the last saved version of the image in Alien Sky and selected the second ring, then I set the **Brightness** to 40 percent | 14 and 15 |. I clicked the **Save** icon and **Render (Add Effect)** to output the image to the camera roll.

I opened the resulting image in Photo Power and selected **Adjust Curves** (blue channel) | 16 |. I adjusted the image to taste, then saved it.

Step 7: Layering Images and Masking Elements

I imported the image from the previous step into Superimpose as the background image, and I imported the image of the tree as the foreground image for the element above the neck. I selected the **Transform** menu, rotated the foreground image, and picked the **Hard Light Blending mode** from the **Filters** menu | 17 |.

I clicked **F** to select the foreground image, and I adjusted the **Exposure, Brightness,** and **Contrast** | 18 |.

From the **Masks** menu I used the **Brush** tool to remove elements of the foreground image that I didn't need, then I saved the final image to my camera roll | 19 |.

My Favorite Apps

I have a few favorite apps that I use frequently. They include two camera replacement apps: ProCamera for taking normal color pictures and Hueless for taking black-and-white pictures. My preferred editing apps are Superimpose for blending and layering multiple photos, and Snapseed and Photo Power for basic photo editing and final editing after the layering process. I sometimes use VSCO CAM and Afterglow for finishing pictures. I often use Noir Photo to create dramatic black-and-white effects and AfterFocus to create a depth of field effect.

Summary

To accomplish my vision for this image, I used ProCamera to find the desired exposure; Noir Photo to create a white mask around the face of the model and to more easily mask and blend layers; Superimpose to combine images, mask and blend layers, and adjust exposure, brightness, contrast, and saturation; Photo Power to adjust the color tone and contrast with curves and color balance; Snapseed to apply a grunge effect and create a vignette; VSCO CAM to add a fade effect and reduce the contrast and saturation; and Alien Sky to create a new ring element.

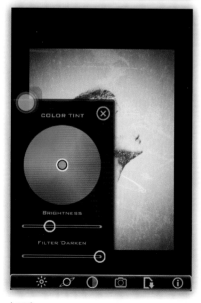

| 15 |

| 16 |

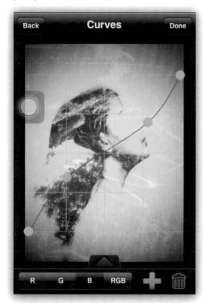

| 17 |

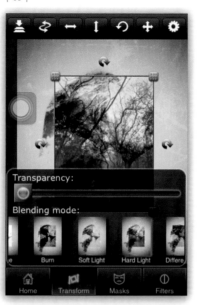

| 18 |

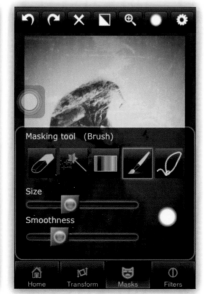

| 19 |

Ade Santora

The third of four children, Ade lives in Jakarta, Indonesia, and works as a graphic designer, with a second job as a freelance photographer. Since early 2012 he has had an iPhone 3GS (which he still uses) and has continued to refine his mobile photography skills. He has conducted several mobile photography workshops using the iPhone. Ade loves to shoot portraits with a particular concept in mind (either with a conventional camera or an iPhone), but he has also been known to shoot macro, landscape, and abstract photographs as well.

www.flickr.com/photos/spikabiz

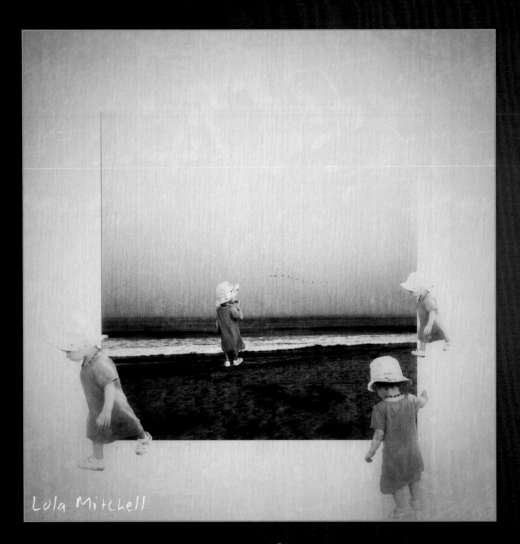

Lola Mitchell

Regarde

TUTORIAL 40

Create a whimsical, surreal collage using family photos

What You'll Learn

You will learn how to mix different photographic elements into a landscape to create a surreal fairy tale-like image. To accomplish this you will select image elements; crop, blend, and mask images; and use apps to add textures.

What You'll Need

- Camera+
- Image Blender
- Pix: Pixel Mixer
- Snapseed

Back Story

I take care of my children during the day and always delight in seeing them discover and explore the world. When I take photos of them, I try to make them forget I am there and allow them to just be themselves. Their expressions or poses always inspire me, and I often imagine them in more dramatic settings.

I have a photo of the beach in Malibu, California that I love because no one is in the image—just a flock of birds. It had been floating in my photo stream for a while. Over time I had made some minor adjustments to the image in Snapseed. It seemed like a great setting.

In the three photos of my daughter that I used in this image, I felt that she was very thoughtful and contemplative. She just needed a beautiful, peaceful background that was not our backyard to make a beautiful image.

The Process

→ **Step 1: Cropping, Adjusting, and Framing the Background Image**
I used the original images shown in figures **1–4** to create the scene.

For this step I used Camera+. I generally use the native iPhone camera app, but I prefer a square format. At the time I was having fun creating images where my subjects were moving in and out of the frame. I used one of the Camera+ frames.

In Camera+ I selected **Scenes** and **Auto** to adjust the image | 5 |. I then selected the **Crops** tool and cropped the image to a **Square** | 6 |. Finally, I selected **Borders** and the **Light Mat** under **Simple Borders** | 7 |.

| 1 |

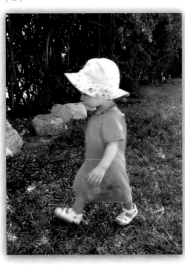

| 2 |

| 3 |

| 4 |

| 5 |

| 6 |

| 7 |

| 8 |

| 9 |

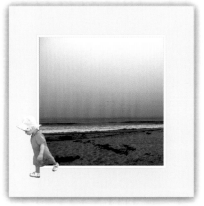

| 10 |

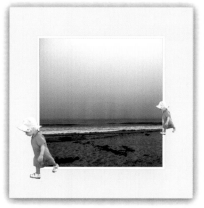

| 11 |

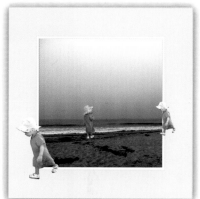

| 12 |

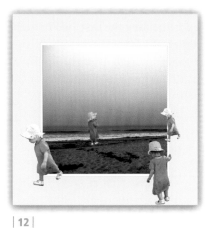

➤ Step 2: Placing Three Images onto the Background Image

I used Image Blender to import both the background frame image and the first image of my daughter. I used the bottom left button to import my background image and the bottom right button to import the first image of my daughter.

I tapped **Edit** at the top left of the image and chose **Arrange**, positioned the image, and resized it. Then I tapped **Edit** again and this time selected **Mask** | 8 |. By selecting carefully around my daughter to isolate her, I erased everything in the image except her | 9 |.

Because I use this image of my daughter twice in the final piece, I pressed **Save** and replaced the previous image with the new one, while leaving the top image of my daughter in place. I then duplicated the image of my daughter, positioned it on the other side, and made it smaller | 10 |.

After I saved the image, I did the same with the other two images of my daughter | 11 and 12 |.

➤ Step 3: Applying Different Filters to Create a Unified Look

I returned to Camera+ and, from the **Retro** category, I applied the **'70s** filter and saved the resulting image | 13 and 14 |.

I reloaded the unfiltered photo again and applied the **Contessa** filter from the **I Love Analog** category | 15 |.

➤ Step 4: Blending Filtered Photos to Create a Unique Filter Combination

I returned to Image Blender and layered the **'70s** and **Contessa** versions of the image and set the **Blender** percentage to

| 13 |

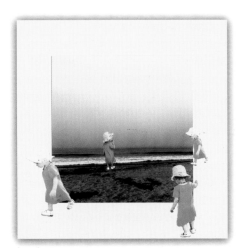

| 15 |

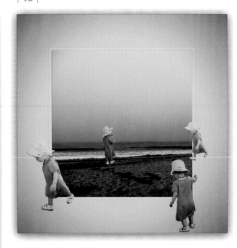

| 14 |

| 16 |

approximately 50 percent, then I saved the image | 16 |.

➤ **Step 5: Adding a Wallpaper Texture**

I opened Pix: Pixel Mixer, imported the most recent version of the image, and added the **Wallpaper** texture | 17 |. I then used Image Blender to combine the layers containing the untextured and textured versions to soften the wallpaper effect | 18 |.

➤ **Step 6: Adding a Grunge Texture**

In Snapseed I imported the untextured final version, added a grunge effect, and adjusted the intensity and style to taste | 19 and 20 |.

➤ **Step 7: Blending the Last Two Images to Create the Final Version**

In Image Blender, I then combined the Pix: Pixel Mixer and Snapseed versions of the image to create the final image.

I named the final image *Regarde*, which translates to *Look*. (I grew up in Paris, France, hence the French word.) The final image shows my daughter walking around in a bit of a reverie, not really paying attention, and in the center of the image she is contemplating this peaceful beach scene with a flock of birds.

| 17 |

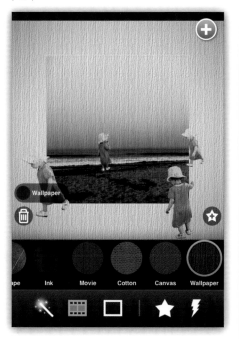

| 18 |

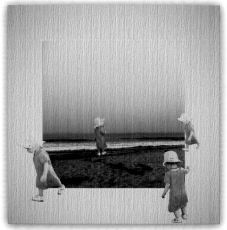

| 19 |

| 20 |

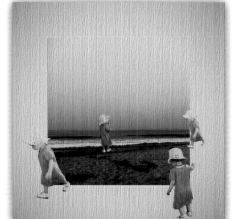

My Favorite App: Image Blender

Image Blender is a very powerful yet straightforward app. Placing images on each side of the main image allows them to be combined in a number of different ways. Pressing the **Edit** option presents three choices: **Arrange**, **Mask**, and **Blend**:

- **Arrange** allows the top image to be positioned over the photo as desired
- **Mask** allows parts of the top image to be erased so the lower image is revealed
- **Blend** gives you 18 blending modes that allow the two images to be merged with different algorithms that produce various color and texture effects

I highly recommend experimenting with the blending modes when you work with Image Blender. Some of the most interesting results come as surprises when you blend multiple images and textures. You can use Image Blender to create custom filters using either your own photos or blending filtered images from different apps. It is a great app to both make a collage and texture an image.

The only downside is that Image Blender supports only two images at a

time (background and foreground). To add multiple layers, you must flatten each layered combination or save the blended images as one image and then reopen it.

Summary

To create this image, I used Camera+ to crop the first image and add a frame, Image Blender to incorporate my daughter, and Camera+ filters to create a texture and a color tone that would allow all the images to blend together. My goal was to create the illusion that the entire image was shot at the same time and create a mood.

I then used Image Blender to combine the different filtered images from Camera+ to create a unique look. Next I used Pix: Pixel Mixer to add texture and Image Blender to blend the Pix: Pixel Mixer image and the Camera+ image. Then I used Snapseed to add a grunge texture, and I returned one final time to Image Blender to combine the Pix: Pixel Mixer and Snapseed versions of the image to create the final image.

Lola Mitchell (sasseefrench)

 Lola's love of photography began early, thanks to her father's work as a professional fashion photographer. She always took photos but never felt the urge to share them or do anything with them. That changed with the iPhone. Her career before her kids was in documentary television production, but the iPhone gave her an outlet for more artistic montages. Lola's work has been featured in Life In LoFi, iPhoneogenic, The App Whisperer, P1xels at an Exhibition, and iPhoneographyCentral. Her work was invited for inclusion in the LA Mobile Arts Festival in 2012. She currently writes a bi-weekly column for TheAppWhisperer.com. *www.iphoneart.com/sasseefrench*

The Fabulous Reappearing into an Unknown Destiny

TUTORIAL 41

Create a semi-abstract impressionist image with movement by adding color, light filters, and texture

What You'll Learn

In this tutorial I'll show you how to create a semi-abstract impressionist image by capturing a slow-shutter shot and layering and merging several images and textures to enhance a certain mood and depth. I will also share my ideas for coming up with titles for my images.

What You'll Need

- Slow Shutter Cam
- Squaready
- ScratchCam FX
- King Camera
- Pixlr-o-matic
- PhotoToaster
- Superimpose

Back Story

It was a cold day in February, shortly before I left for Canada. The pond was frozen and covered with a thin layer of fresh snow. It was a great opportunity to take my iPhone for a shoot. I was not alone on the ice—two Japanese tourists were also taking photos, trying to get a shot of a swan sitting and preening.

I used Slow Shutter Cam on my iPhone 4S to take a few shots of the tourists carefully shuffling over the ice. The lighting and the contrast of the white surface with the men dressed in black coats was perfect for Slow Shutter Cam. I also like the abstract effect I get with this app, which is not unrelated to my background as a painter. The abstract effect allows the viewers—even though I title my images—to freely associate and follow their own thoughts and ideas when they see the end result.

I chose to work with an image in which I had isolated one of the men with buildings in the background. I liked the way the trails of footsteps in the snow came out as shards of ice. The overall mood of the image gave me the impression he was heading for a long journey into the unknown, not unlike my leaving Holland to live in Canada. It was this feeling I wanted to use as a starting point for working on this image—walking toward an unknown destiny, but surrounded by light and a future full of hope.

| 1 |

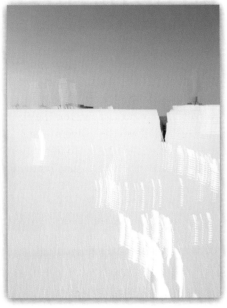

| 2 |

| 3 |

The Process

➤ Step 1: Capturing the Original Slow-Shutter Shot

I captured the original slow-shutter shot with Slow Shutter Cam | 1 |.

➤ Step 2: Cropping to a Square

I used Squaready to crop the image to a square, which is the format I usually work with | 2 |. Squaready is easy to use and saves at 2448 × 2448 pixels on the iPhone4S and iPhone5. It is a free app, hence the ads, but if that doesn't bother you, it's great. Other features include the choice of background color; rotate; flip; send in Instagram format; send to other apps; and save in JPEG, PNG, or other formats. If you want a more advanced app for cropping I suggest either Filterstorm or Photo fx.

➤ Step 3: Adding Texture to Enhance Depth

I open the cropped version of my image in ScratchCam FX, which offers some great textures. Even though the texture with staples is seen very often in iPhone work, I still chose to use it. The staples fit perfectly with the buildings in the background and almost mimicked a high rise. I used the slider to adjust the effect to my liking | 3 |.

For most of my work, I use textures I've shot myself, such as rust, textured floors and walls, text (from posters or books), and parts of my paintings— anything goes if you think you can use it. I made a folder in iTunes with these textures and always have them handy on my iPhone.

| 4 |

| 5 |

| 6 |

➤ Step 4: Highlighting the Mood of the Image

Next I worked on highlighting the mood of the image. I decided to add more warmth to the colors, so I opened the image in King Camera, used the **Pro** setting, and chose **Light-Leaker**. You can combine different effects, but in this case I used only one effect and adjusted the slider to tone it down a bit | 4 |.

➤ Step 5: Adding Grain and Extra Texture

Still in King Camera, I used the **Texturizer** to add a bit of grain and extra texture. Again, I used the slider to refine the effect to my liking | 5 |.

➤ Step 6: Adding More Depth with Darker Colors

I thought some darker colors were needed to add more depth, so I turned to Pixlr-o-matic | 6 |. I like this app a lot because of the many possibilities it offers, including filters, light leak effects, textures, and frames. The downside of the

app is that there are no sliders to control the effects. (As of this writing, there is a new version of Pixlr-o-matic for iPad called Pixlr Express PLUS, which has a redesigned interface that allows you to adjust the intensity of the effects.)

➤ Step 7: Intensifying Colors with a Light Leak

In Pixlr-o-matic I added a light leak that also boosted the colors and made them deeper and more intense | 7 |. Most of what I do is based on gut feelings and thinking about what an image needs.

| 7 | | 8 | | 9 |
|---|---|---|

➤ **Step 8: Toning Down the Colors**

In PhotoToaster I added a thin white frame and made a copy of the image in black-and-white.

I wanted to use the black-and-white copy in Superimpose to further intensify the image and tone down the colors a bit. I opened the color image as the background and the black-and-white version as the foreground. In **Transform** mode, I selected the four-way stretch icon at the top to make both images the same size.

I used **Multiply** for the blend mode and used the slider to achieve the effect

I wanted | 8 |. At the time of this writing, if you use Superimpose on an iPhone you need to hit the settings button (the little cog) in the top right corner to access the blend modes. Figure **8** shows Superimpose for iPad.

➤ **Step 9: Choosing a Title**

Finally, I chose the title for my completed image: *The Fabulous Reappearing into an Unknown Destiny*—my destiny.

For my titles I often find inspiration in song lyrics, poems, books, and movies. I carry a little notebook to jot down anything I hear or see that I might be able to

use. The title for this image is based on the title of the movie *Le Fabuleux Destin d'Amélie Poulain*.

My Favorite App: Superimpose

One of my most frequently used apps is Superimpose. It allows me to blend, merge, and layer multiple images and save them at full resolution. For this image I used just a few of the many possibilities that this app offers.

In **Home** mode I begin by opening the background image, then I load the

| 10 |

the icon at the top-left. After the images are merged, another foreground image can be loaded, if desired.

This is only a small sampling of what Superimpose has to offer. In the **Home** menu there is a small guide under the **i** button that describes how to use the app and its features: filters (blur, hue, saturation, and so forth), masks and masking tools, and how to superimpose and juxtapose.

Summary

In this tutorial I have shown you that Slow Shutter Cam is a wonderful app to use when there is a significant contrast in an image and you wish to abstract it. King Camera and Pixlr-o-matic are great apps for applying a wide range of effects and textures to highlight particular moods. Superimpose is, for me, *the* app to blend and mix images, and using the sliders gives me more control over the effects.

foreground image. In **Transform** mode I can transform an image (make it bigger or smaller, or rotate it) by hand or by clicking the icon in the top-right corner to scale the foreground image to fit the background image | 9 |.

The **Blend** mode is my next most frequently used feature in Superimpose. There is a list of blend modes, each of which creates a different effect in combining the foreground image with the background image. Sliders give me control over the degree of the effect | 10 |.

When I am content with the result, I can merge the two images by clicking

Carlein van der Beek (©arlein)

Carlein was born and raised in The Netherlands and moved to Toronto in 2012. Her background is in painting abstracts and mixed media. Her iPhone work has been widely featured in galleries and online, including Eyephoneography #2 in Madrid (2011), the Atlanta Celebrates Photography Festival, Latitudes in Huelva, Spain (where her work was featured along with renowned Magnum photographers), LA Mobile Arts Festival 2012, and mObilepixatiOn in London (2012). In 2012 Carlein was one of five artists featured in the German National Geographic hardbound book iPhone Fotografie. Carlein was also included in the Mobile Masters 2013 eBook by Dan Marcolina.
www.flickr.com/photos/carlein

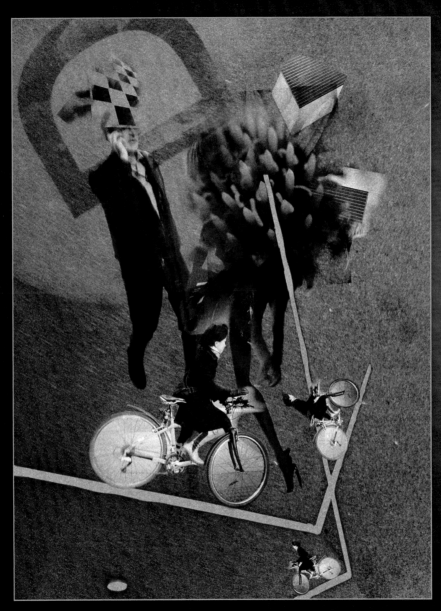

Dissipatas Lineas

TUTORIAL 42

Create a surrealistic collage by blending and juxtaposing multiple images

What You'll Learn

My goal was to produce a piece that transmitted a feeling of the dadaist/surrealist works from the 1930s, based on elements from different pictures I had taken in previous weeks.

In this tutorial you'll learn how to mask, blend, and juxtapose images and parts of images, including preparing them for use in a collage by turning them into black-and-white images, and finally adjusting the lighting and contrast.

What You'll Need

- Noir Photo
- Juxtaposer
- Image Blender
- PhotoCopier

Back Story

This image started with a picture I took of a man walking down the street and talking on his phone. When I took the picture I knew how I would like to use the image, as I previously had with a businessman for a series of images called *The Business Man*. In that series I used the outlines and postures of men and placed them in various surreal settings.

My work is heavily influenced by dadaism/surrealism, especially the paranoid-critical method, where you lose yourself in delirious, irrational associations and interpretations.

I seldom have a finished and composed scene in my mind when I start working with a picture. My images usually start with one figure or element that I isolate and add to a neutral background or canvas. From there I add and test different elements and pieces of images in a stream-of-consciousness process, and I evaluate the graphical and compositional qualities as I go along until I am pleased with the result.

The Process

Step 1: Converting the Image to Black-and-White

I find that features are more prominent in a black-and-white picture, compared to the same image in color. Since black-and-white images have a special graphical quality, I usually convert my pictures from color to black-and-white with Noir Photo before I use them in a composite work.

Figure 1 shows the original shot of the man walking down the street.

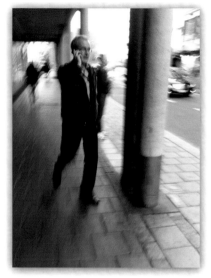

| 1 |

| 2 |

| 3 |

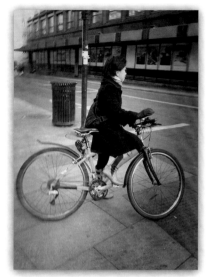

| 4 |

I used Noir Photo to convert the original picture to black-and-white to highlight the figure and make it easier to mask him out in the next step. Figure 2 shows the conversion to black and white in Noir Photo.

I also converted two other images that make up this particular piece to black-and-white | 3 and 4 |.

Step 2: Juxtaposing the Main Character on the Background
I decided to use an image of a playground surface as the background in this piece because the structure and the subtle differences in the lighting created an interesting texture | 5 |. I used Juxtaposer to open the image of the playground as my base image, and I opened the black-and-white image of the walking man as my top image. I used the masking tool—I almost exclusively use the soft brush—to isolate the man from the background and position him in the top left quadrant | 6 and 7 |.

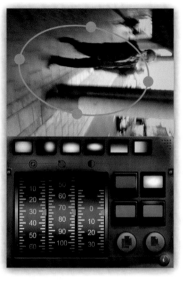

| 5 |

| 6 |

| 7 |

| 8 |

| 9 |

➤ Step 3: Juxtaposing New Elements in the Scene

I continued to use Juxtaposer and the same masking procedure to add different elements to the composition.

When I want to add a new element in Juxtaposer, I tap the menu in the top left corner and select **Load/Add** > **Add/ Replace**. If I want to continue building a collage, I choose the **Add Top Image** option. The other option, **Replace Top Image,** will remove the masked image

and allow me to start over with a clean background.

Juxtaposer then presents me with three choices: taking a photo, adding an image from my library (which I can then mask), or loading a saved stamp, meaning that I can add an image that I have previously masked and saved as a stamp by choosing **Save** > **Save masked top image as stamp**. In this piece I used two previously saved stamps. I masked and positioned the other images especially for this piece. Figure 8 shows

a composite of several elements that I added to the composition.

Juxtaposer also has an option to save the work session. I often use this feature whenever I test different compositional arrangements. It allows me to return to an earlier stage if I am not pleased with where the piece is headed.

➤ Step 4: Using Image Blender to Add More Elements

I wanted to add a few more elements to the image, but since Juxtaposer does

| 10 |

![Mask screen]

| 11 |

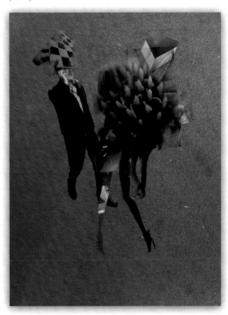

| 12 |

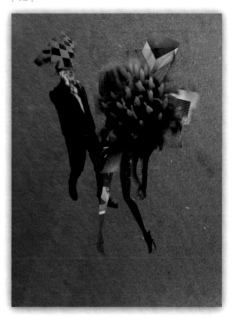

not let you adjust the opacity or use blend modes to create different effects, I shifted to Image Blender.

I selected the result of the Juxtaposer process as my base image. I chose a picture of a flower from my iPhone library as the second image, then I selected the **Overlay** blend mode and adjusted the opacity slider. I also had the option to **Copy, Switch,** or **Flatten** by pressing and holding the image screen. Figure **9** shows the main Image Blender screen, with the image from Juxtaposer and the first blended image. When I was

satisfied, I flattened the image by pressing it and choosing the **Flatten** option.

I then added another image of a flower from my archives. This time I used the **Mask** option, which I accessed by tapping the image. I masked out the parts of the flower I did not want and used the soft brush and the pinch and zoom feature to get an accurate result. Figure **10** shows the mask screen with the soft brush selected.

After I confirmed the masking (here I used the **Normal** blend mode), I flattened the image again. Finally, I added

part of an image of a chessboard, which I masked in the same way as before. I used the **Normal** blend mode and adjusted the opacity until I got the result I wanted. The result can be seen in figure **11**.

➤ Step 5: Making a Quick Side Trip Back to Juxtaposer

I was not happy with the way the group of people looked in the overall composition, so I returned to Juxtaposer. I used one of the stamps from step 3 and covered the parts of the image that were

| 13 |

| 14 |

| 15 |

| 16 |

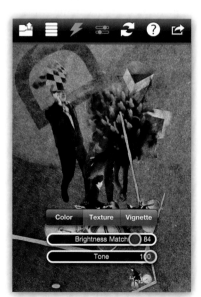

still visible to the right of the flowers, as can be seen in figure 12.

➤ Step 6: Using Image Blender to Add Several More Elements

I returned to Image Blender and added two more elements: a letter *D* along with the **Overlay** blending mode to mask the dark edges of the image; and some light trails that I had converted to black-and-white in Noir Photo | 13 and 14 |. I used the **Screen** blending mode and flattened the image between each step.

➤ Step 7: Making a Final Return to Juxtaposer

I was still not happy with the overall composition, so I returned to Juxtaposer. I used the result from Image Blender as my base image, and I masked and stamped in a female cyclist three times | 15 |. I experimented with orientation and placement of the cyclist along the lines made by the light trails.

➤ Step 8: Adding a Finishing Touch in PhotoCopier

After the last round of modifications in Juxtaposer, I was pleased with the composition, but the colors were too bright

| 17 |

and varied to convey the mood I was aiming for. I imported the image into PhotoCopier to fix it. I often use this app to get an overall coherent finish. I experimented with different filters and ended up choosing the **Andreev: Winter** filter, which can be found under the **Photo** tab | 16 |. I adjusted the settings to taste and saved the final image | 17 |.

My Favorite App: Juxtaposer

My images are always a compilation, or collage, of different images. The most important advantage of Juxtaposer is that it allows me to turn bits and pieces of pictures from my archive into stamps, which I can save and reuse in several compositions. I find this feature particularly interesting when I work with a series of images that have the same theme.

Because the app is solely a juxtaposing tool, no blend modes are provided. Working with Juxtaposer is similar to doing traditional collage construction. I find that the masking brush offers a lot of control, which makes it possible to get precise results. In addition, because my image-making process is based on trying out different combinations of pieces of images, the option to save sessions is very useful. Opening saved sessions gives me the opportunity to go back and start over if I am not happy with where a particular process takes me.

Summary

My work is never based on a vision of the finished image. In this tutorial you learned how to use Juxtaposer and Image Blender to work with bits and pieces of different images to intuitively develop a collage by experimenting. This included using PhotoCopier to create a stylistically coherent final result.

Johnny Eckó (squarepixel)

Johnny was educated as a multimedia designer and specializes in video editing and production and photography, and he is also a composer. His iPhone work is immediately recognizable because of how it conveys a strange humor and incorporates a mix of organic elements with machine parts. It bears more than a passing reference to the early 20th century dada movement and the sci-fi motifs of the 1950s and 1960s. Johnny's work has been exhibited in Norway, Russia, and at the 2012 LA Mobile Arts Festival.

www.flickr.com/photos/squarepixel

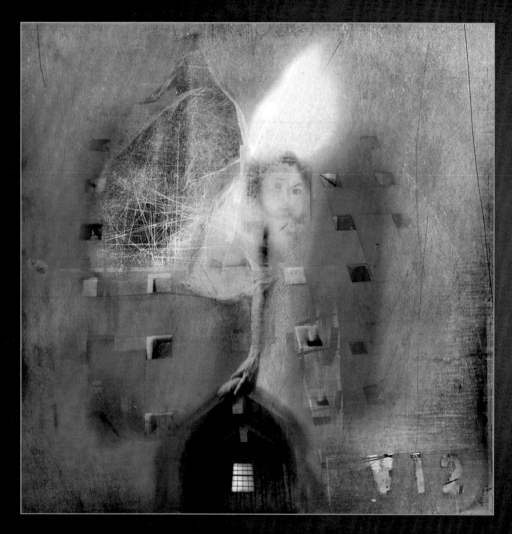

Watchful

TUTORIAL 43

Inspire your creative spirit and tap into the surreal

What You'll Learn

Using your images as a palette for color, shapes, and forms, you will learn to combine parts of your photographs to create an entirely new piece of art. With Image Blender and Juxtaposer, you will mask, blend, and create layers and build on a background using only your imagination.

What You'll Need

- ScratchCam FX
- Hipstamatic
- Image Blender
- Juxtaposer
- Snapseed
- Thicket: Classic

Back Story

I approach my work in one of two ways: sometimes I begin with a single image of a landscape or a person and build from there; or, as in this tutorial, I create a canvas of a single textured color and build the piece with other images that I use as a palette for colors, forms, and textures. I don't plan or know the end result. I make decisions in the moment and rely not only on my intuition, but also on my underlying knowledge of composition and color.

The Process

☛ Step 1: Creating the Background

After I blended several images to create a solid color background, I brought my image into ScratchCam FX, where I created more textures and smoothed the edges to make an inspiring canvas to work on | 1 |.

I decided to add a shot that I took with Hipstamatic of a tile floor, so I brought it into Image Blender to play with it | 2 |.

With 18 options, Image Blender is a wonderful app for creating a variety of

| 1 |

| 2 |

| 3 |

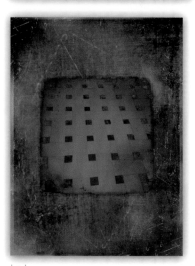

| 5 |

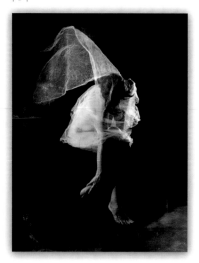

| 7 |

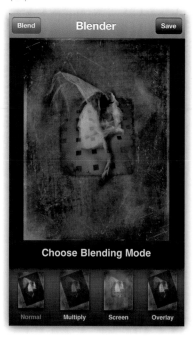

| 8 |

| 4 |

| 6 |

opacities | 3 |. I initially chose **Hard Light** and then **Difference,** then I combined the two images. I flattened them, and then added smaller cutout images into the squares. I continued to play with Image Blender until I got a finished result I liked, with the tiled piece on top of the background | 4 |.

➤ Step 2: Creating the Foreground Elements

I wanted to bring in something figurative and decided to grab an image from my *Nude* series | 5 |. I brought the picture into Juxtaposer and erased the parts of the image I did not want | 6 |. Then I used Image Blender to place the image in the center of the background | 7 |.

I brought the image into Snapseed to crop it to square format | 8 |.

Next I decided that the image needed some kind of structure on the bottom to ground it, so I added a picture that I took in a room | 9 |. In Image Blender I erased the parts of the image I didn't need with the

| 9 |

| 11 |

| 10 |

| 12 |

Mask feature, and I chose a blend mode that I liked | 10 |.

I added windows from another image to the house structure on the bottom to give it a bit more depth. I also brought the image into ScratchCam FX to see if adding texture would smooth over the sharper edges | 11 |. I then added a window (which was taken from another image) to the bottom of the wall structure to add a bit more depth in a step that is not shown here.

I wanted to add more texture to the fabric over the woman's head, so I used Juxtaposer to open an image I had made in Thicket: Classic, and I masked the parts I didn't want | 12 |.

➤ Step 3: Adding the Final Touches

I reviewed my work so far and felt that the image was incomplete and needed something more | 13 |. I decided that the woman needed a face. I had previously created an image of a woman | 14 |. I loved the shape of her face and decided to use the red version to add more color to my image. When I originally created the image, I saved the red face as a stamp in Juxtaposer, so I opened my image in Juxtaposer and applied the stamp to it | 15 |.

| 13 |

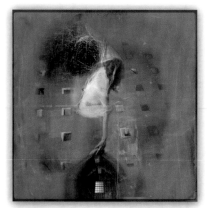

| 15 |

| 16 |

| 18 |

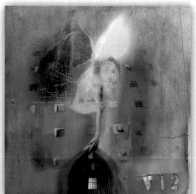

| 14 |

| 17 |

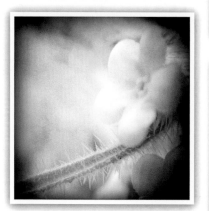

| 19 |

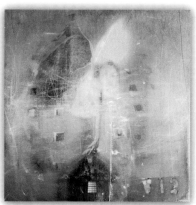

I had also taken a picture of the characters *V12* in a parking garage and decided to add them to the image | 16 |. I used Image Blender to layer in the image and place it on the bottom right of the final image.

I then incorporated a flower into my image, which is a closeup I had taken of some printed fabric | 17 |. I blended the flower image into my final piece until there was a white area above the woman's head and over the V12 in the lower corner | 18 |.

I then brought the completed image into ScratchCam FX to soften the edges and add more texture, but I didn't like the result | 19 |.

Because I found the image at the top to be too much, I opened the last two versions of my image in Juxtaposer, where I erased much of the white texture to produce the final image.

My Favorite App: Juxtaposer

Juxtaposer is probably my favorite app. It's one of the first apps I learned and is very user friendly. It allows you to save a layer as a stamp to be used again in other images. Juxtaposer saves the entire layer and the cutout so you can use other image components with the stamp. You can lightly erase the foreground elements to create a subtle blending effect. I consistently use previously created images when I build a new piece, so this functionality is invaluable for my work.

Summary

Starting with a simple background is often a provocative way to begin a new imaginative piece. It will inspire the creative spirit in you and, by focusing on just a few apps like Image Blender and Juxtaposer, you can learn to crop, blend, mask, and texture a few images into a final and very personal painting. Spontaneity is important, as you are trusting your instincts, quieting your internal critic, and learning to be free.

Karen Divine (kdivineboulder)

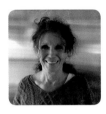

Karen Divine was introduced to photography in the early 1970s and went on to study painting, drawing, and alternative photographic processes. She discovered the iPhone in 2011. She tells her stories by compositing seemingly random images and watching them evolve. Karen has won numerous awards, including Discovery of the Year (International Photography Awards), First Place in the Florida Museum of Photographic Arts, Eyephonegraphy #3 in Madrid, WPGA Pollux Award First Place, and the Center for Fine Art Photography. Karen teaches creative iPhone classes and taught at the Santa Fe Workshops in March 2013. *www.karendivinephotography.com*

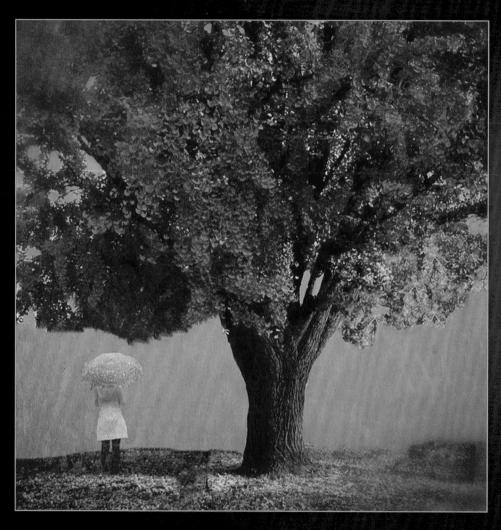

Waiting

TUTORIAL 44

Create a dreamy, fine art landscape using digital collage techniques

What You'll Learn

In this tutorial you'll learn how to combine multiple images, create texture, erase unwanted objects from a photo, use the cloning tool to fine-tune an image, create personal clip art stamps, and add a pop of red to landscapes.

What You'll Need

- Photo fx
- Juxtaposer
- TouchRetouch
- Pic Grunger
- Pixlr-o-matic
- TiltShift

Back Story

The base photo I used to start this piece is a picture of my youngest son sitting under a beautiful yellow fall tree in Mississippi near a church down the street from my home. Even though I love this photo as is, I had a vision of an image I wanted to create that would include an image of myself. I am drawn to red in my art, and I developed my own style of turning certain landscapes into the red found in many of my pieces. The technique cannot be used in every circumstance, but it worked well with the yellow tree.

The Process

➤ **Step 1: Changing the Tree and Ground to Red**

To start my project, I opened my photo in Photo fx | 1 |. Under the **Special FX** category, I chose the **Color Infrared 1** filter and added a layer to my photo by

| 1 |

| 2 |

| 3 |

| 4 |

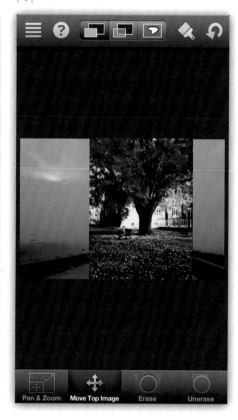

pressing the button at the bottom far right and choosing the **Add Layer** option | 2 |. This gave the tree and the leaves underneath it the red tint I was looking for. I wanted to make the red stand out more, so I chose **Enhancing**, added an **Enhancer 9** layer, and saved the image | 3 |.

➤ **Step 2: Combining Two Images and Creating a Clip Art Stamp**

After the tree and the ground were the color I wanted, it was time to create a different background. I wanted a simple, grayish backdrop, so I used Juxtaposer to open a photo I had taken on a rainy day and used that for my background. I then added my red tree photo as the top image | 4 |.

I erased the background from my photo to reveal the gray underneath | 5 |. The **Pan & Zoom** mode made it easy to get in close to the tree so I could erase all the unwanted parts of the photo. After I had the tree cut out, I saved it as a stamp in Juxtaposer for use in future projects | 6 |.

| 5 |

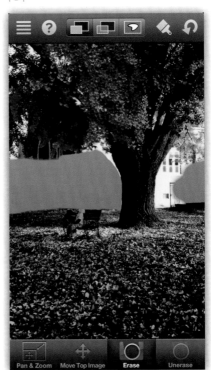

| 6 |

| 7 |

I saved the photo to my photo album, then I opened it in Photo fx, cropped it to a square format, and saved it again | 7 |.

→ **Step 3: Erasing Unwanted Portions of a Photo**
I could still see some parts of the background through the leaves, and I wanted to remove the bottom half of the bench, so I opened the cropped photo in

TouchRetouch. I used the paintbrush to mark the bench and some of the white areas between the branches to remove them | 8 |.

→ **Step 4: Using the Clone Stamp to Duplicate a Pattern**
Some of the background was still visible through the leaves, and since the bench had been removed I needed to fill that space. So I used the **Clone Stamp**

| 8 |

| 9 |

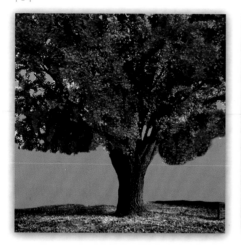

| 10 |

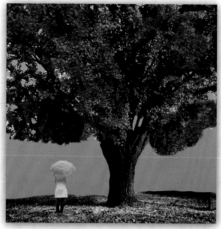

| 11 |

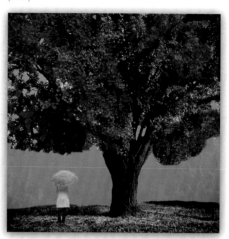

to fill in the blank space left by the erased bench and to create a more polished look for the tree.

When the **Clone Stamp** tool is selected, the source tool launches and you can take a pattern from anywhere on the photo. I placed the source icon over the ground so I could take the pattern of the solid red. Next I used the brush in **Clone Stamp** mode to fill in the space that was left from erasing the bench. Then I chose the source tool again and placed it on part of the tree to take a pattern from the leaves. I brushed over the white spots that still showed through the branches to fill it in with the pattern of red leaves and eliminated the remaining background | 9 |.

➨ **Step 5: Adding a Previously Saved Stamp**
Once again I opened the photo in Jux-taposer. For the top image, I chose **Load Stamp** to add a saved photo of myself that I had cut from a previous project. I placed the stamp in my desired location and saved the resulting image to my photo album | 10 |.

➨ **Step 6: Creating Additional Texture**
I wanted the photo to have a grungier look, so I opened the photo in Pic Grun-ger. I added the **Acid** effect at around 30 percent to give the image a worn look. I saved the result back to my photo album | 11 |.

➨ **Step 7: Adding Finishing Touches**
I opened the photo in Pixlr-o-matic and added the **Melissa** filter, a favorite of mine (maybe because we share the same name). I saved the photo and then opened it in TiltShift to add blurs at opposite corners to draw the viewer's eye toward me and my umbrella.

My Favorite App: Photo fx

My go-to app for every photo I edit is Photo fx. I use it to sharpen, adjust the contrast, apply depth of field, paint and mask, add vignettes, and much more. Photo fx is an extremely versatile app. In this tutorial I demonstrated how to change a landscape to red by using an

| 12 | | 13 | | 14 |

infrared filter in Photo fx. Sometimes this technique does not work well with a particular photo, so I developed an alternate way to add red in Photo fx by applying the **Two Strip** filter under **Film Lab**.

Figure 12 shows an original photo of Muir Woods. Figure 13 shows what the photo looks like after I added **Two Strip 6.** As you can see, the foliage and tree bark turned a different color. To offset this I added the black-and-white filter and used the mask function to erase the path and let the red show through. The black-and-white filter really makes the red pop | 14 |.

Summary

My goal for this piece was to create an image with a technique I developed to add red to a photo and celebrate my love of autumn. You learned to add red to a photo in Photo fx, combine images, create clip art stamps, erase objects from photos with TouchRetouch, and use a clone tool to refine the look of your piece and create texture.

Melissa Vincent (@misvincent)

Melissa's interest in mobile art began in April 2011 when she joined Instagram. Her interest turned into passion, and more than 140,000 people who have been inspired by her iPhone art follow her on social networks. Melissa's photographs have been featured in *National Geographic* online and on the cover of Time magazine's first annual *Wireless Issue*. Melissa's art has been exhibited at the Animazing Gallery in New York City, the LA Mobile Arts Festival 2012, the Orange County Center for Contemporary Art in California, and at the Mobile Photo Awards show at the Soho Gallery for Digital Art in February 2013. She was awarded the 2013 MPA/ArtHaus photo essay winner for her collection *The Rooms of William Faulkner*. *www.melissavincent.com*

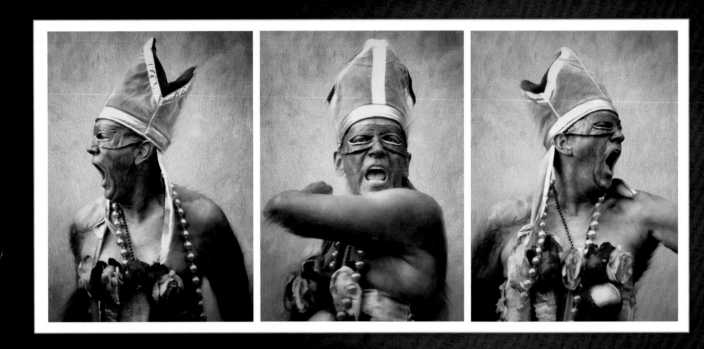

Heathen II

TUTORIAL 45

Create a triptych of a dynamic street character using editing and drawing tools

What You'll Learn

I wanted to capture the movement and energy of a lively street character. In this tutorial you will learn how to use masks to simplify a composition, how and when to upsize an image, and how to scale multiple images to matching sizes.

What You'll Need

- Flypaper Textures
- Photogene
- Snapseed
- Superimpose
- Filterstorm
- PhotoSize
- Juxtaposer
- ProCreate

Back Story

I stumbled upon this fellow as he was miming street preachers in front of St. Louis Cathedral in New Orleans during Mardi Gras. The preachers were standing behind him, broadcasting with bullhorns that just about everybody—Catholics, drunkards, educated people, environmentalists, hippie capitalists (whatever they are), sports fans, gays, and general heathens—will burn in hell. This guy, complete with green body paint, pink beads, and a corset, was miming every word and took a break only to go kiss another guy. I immediately knew I just had to get pictures of him. The movement, the energy, and the costume were simply irresistible |1|.

Ordinarily I look for three things when I am shooting: good light, a good background, and an interesting subject. In this case, however, I knew that I had to shoot the subject any way I could, even with dull light and a distracting background. I wound up shooting about 40 pictures of him, many of which were a blur from his constant motion. Figure 1 is an example from that series.

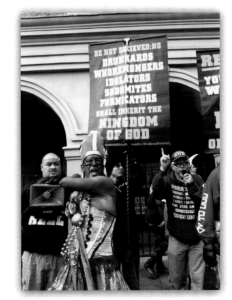

|1|

When I figure out how to edit an image, I look for something in the original that speaks to me, then I eliminate anything that distracts from my artistic vision. In this case, I wanted to juxtapose the street preachers' signs with the green guy's costume. Unfortunately the signs were so big that they overwhelmed him. I decided that the final image would be more effective if I focused on the subject's movement and energy alone. I also decided that a triptych would be an effective way to communicate that movement and energy.

I selected three images that were reasonably sharp and clear: one of the subject facing left, one facing forward, and one facing right. I then identified specific visual elements—shape, color, texture (or light and shadow patterns)—that spoke to me. In figure **1** the subject does not have any strong shadow patterns on his face, so I decided to focus on the shape and color of the figure.

Before I start editing I also look for technical challenges I am likely to face. I was not quite as close to the subject as I would have liked, so I decided to take a painterly and grungy approach because I knew I would need to upsize the images.

The Process

➤ **Step 1: Preparing the Background Texture**

The background distracted from my story about movement and energy, so I decided to eliminate it altogether and replace it with a texture. I selected one from Flypaper Textures, a set of more than 200 JPEG files that I purchased online and keep in a folder on my iPhone and iPad.

In selecting a texture, I looked for two things: the overall value or tonality, and one that would blend well with my subject. I looked for a texture with a light background to make the shape of the figure stand out, and I wanted a painterly feel to augment the mood I was looking for. I settled on **Citron Vert** from Flypaper's **Spring Painterly** set.

Keeping the textures in a separate folder outside my camera roll is great for organization, but it presents a problem for image resolution. Most apps read the files at no more than 2048 × 2048. I used Photogene to select and export the texture at full resolution | **2** |.

➤ **Step 2: Cropping, Aligning, and Sizing the Images**

First I used Snapseed to crop the center image to the size I wanted. Because of the triptych format, I decided on a vertical crop, and I constrained the crop to a graceful 3:4 proportion | **3** |.

Next I opened Superimpose to align the right and left triptych images to match the center image. First I loaded the center image from Snapseed as the background image | **4** |. I loaded one of the other images as the foreground image. I hit the **Transform** button and adjusted the transparency to about 50 percent—enough so I could see both images simultaneously | **5** |.

I pinched the foreground image to expand it until it matched the size of the background image as closely as possible. I tried to make the size of the face and the hat the same, and I attempted to position the shoulders at approximately the same height. I set the transparency to zero so that only the top image was visible, then I saved it | **6** |. I then repeated the same process for the third image in the series.

At this point I had three images that were approximately the same size. However, the resolution was not nearly what I needed to print the final piece at a reasonable size. As a general rule, if I have to upsize an image, I try to do so early in the process so I can hide some of the pixelation with textures later on. I loaded each of the images into Filterstorm and saved them with the longest side set to 2400 pixels. This would allow me to output at least a 9 × 12-inch print of each image.

| 2 |

| 3 |

| 4 |

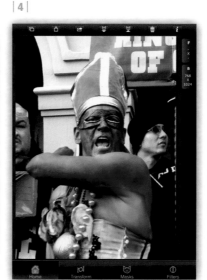

| 5 |

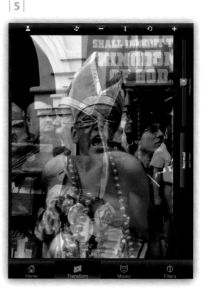

When I saved the file, I selected **Settings** under **Export Destinations** and entered the maximum size of my image | 7 |. I repeated this process for the other two images. I opened each image in PhotoSize to make sure they were the size I wanted | 8 |. It is a good idea to get in the habit of periodically checking the image size during the editing process.

Step 3: Merging the Foreground and Background

I returned to Superimpose and loaded the Flypaper Texture as the background image, and I loaded the center image for the triptych, which I had just saved in Filterstorm, as the foreground image. I expanded the image of the figure to match the height of the background | 9 |.

Then I began to mask the image. With the **Brush** tool set to its smoothest setting, I began with a rough mask and then zoomed in to work on the details until I was satisfied with the result | 10–12 |.

In case I might want to make modifications later, I saved the final image as a stamp by clicking the mask icon with the upward-pointing arrow at the top of the screen | 13 |. I also saved the image twice: once as a standard

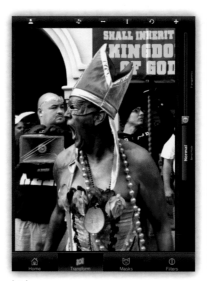

| 6 |

| 7 |

| 8 |

| 9 |

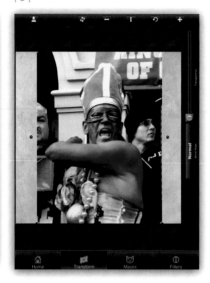

| 10 |

| 11 |

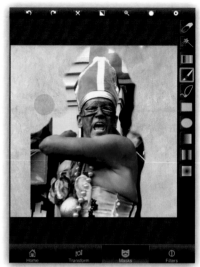

| 12 |

| 13 |

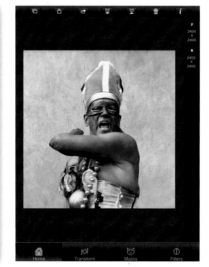

| 14 |

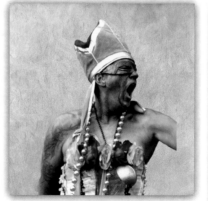

| 15 |

JPEG image to my camera roll and again as a transparent PNG file so I could import the masked image into other apps later. I repeated the masking and saving process for the other two images.

Step 4: Refining the Crop to Correct an Error

Somehow in the masking process I lost the original 3:4 proportion that I wanted for each image, so I returned to Snapseed to crop my images again. This second round of cropping also gave me an opportunity to center the images.

I recropped the right-facing image because I didn't like the way the figure's right arm was cropped off | 14 |. I cropped the image to a 3:4 proportion, just as I did in the original image | 15 |.

I returned to Superimpose and loaded my newly cropped image as the background and one of the other images as the foreground. Just as I did in step 2, I adjusted the transparency of the foreground image so I could align it over the background image | 16 |. I repeated this process for the third image.

Step 5: Refining the Edges in Juxtaposer

I now had three images that were cropped and masked. I noticed that the edges were much too hard, which gave the image a flat appearance, and also

took away from depicting the motion and energy of the figure. On the iPhone, Juxtaposer is a great app for softening edges. I loaded my original texture as the base layer and one of my masked images as the top layer into Juxtaposer. I double tapped twice to fit the top image to the base image. At the top of the screen, I selected the softest brush | 17 |.

Hard edges on both sides tend to flatten an image, so I selectively softened alternating sides of the image. I kept hard edges where I wanted to draw the viewer's attention, such as around the subject's face, and I softened the edges around the areas that were not as important to my story. For example, I made some parts of the hat fade into the background | 18 |. These subtle changes were important to the effectiveness of the final image. I also refined a few areas that I had missed in the initial mask. I repeated the softening process for the other two images.

Step 6: Smudging in ProCreate

I had softened some of the edges, but I didn't think I had fully captured the sense of motion that I wanted | 19 |.

| 16 | | 17 |

I decided to open the images in one of my favorite painting apps—ProCreate— and use some of the smudge tools to further integrate the background and foreground. Even though ProCreate's resolution is a little lower than I would have liked (the maximum resolution is a little more than 1400 × 1900), I thought it would give me the effect I wanted, even if I had to upsize the images one more time.

I created a new canvas in ProCreate then tapped the **Wrench** tool and the **Canvas** button to select my image | 20 |. I selected the **Smudge** tool at the top of the screen (it looks like a finger), then I selected the **Wet Round Brush** and set

| 18 |

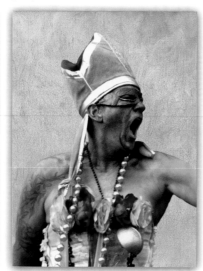

| 19 |

| 20 |

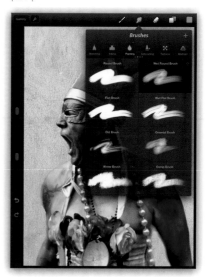

| 21 |

the size to 6 percent | 21 |. I selectively smudged a few areas—just enough to give a sense of motion. Then I saved the image as a JPEG and repeated the process for the other two images.

➤ Step 7: Upsizing One Final Time

I wanted to bring my images back up to 2400 pixels, so I imported them into Filterstorm again and saved them at the higher resolution, just as in step 2. This also prepared the images for more textures and other refinements.

➤ Step 8: Making Final Refinements

I was now approaching the final stage of the edit. I had masked my images and softened and smudged the figures, but I was still not quite satisfied | 22–24 |.

As often happens when I assemble an image from different sources, the foreground and background were not integrated as much as I would have liked. The image still looked a little cobbled together. When this happens, I apply what I call a final polish filter—most frequently in Snapseed or Photo-Copier—to unify the colors and textures. I almost always generate multiple variations of the image and project the possibilities on my Apple TV before I make a final selection.

I chose to work in Snapseed and played around with several tools. I

wanted to add some extra polish to the image, but I had to be careful not to get too carried away. I settled on using **Center Focus**. I set the center size to about 25, the inner brightness to +20, the outer brightness to −80, and the blur to +60. Finally, I added **Vintage Filter #4** with the style strength set to 0.

My Favorite App: Superimpose

I often use Superimpose to integrate textures within my images. Because of my preference for candid shots, I often end up with backgrounds that need to be replaced. I keep several folders of

| 22 | | 23 | | 24 |

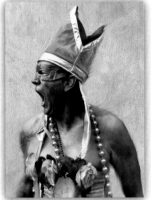 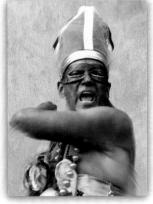 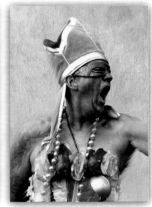

textures—some from Flypaper Textures and some of my own—on my iPhone. The Flypaper Textures are a little pricey but beautiful. If you are on a budget, you can easily make your own textures. Just open an image and adjust the brightness and contrast until the image disappears. Then use any of the grunge apps to apply one or more textures. Vintage Scene, Grungetastic, Pic Grunger, and Modern Grunge are some of my favorites.

I sort my textures by type—paint, paper, cloth, urban/industrial, antique, and nature—and I choose a texture that matches the feel I want to project in my image. For example, if I am aiming for a painterly feel, I usually pick one of the paint textures. Choosing a texture with the right feel is more important than choosing a texture with a matching color. After I bring the texture into Superimpose I can easily adjust the color and the brightness to match my image.

Summary

To create this image I relied heavily on Superimpose to mask and align the images. In addition, I used Photogene to import the background, Filterstorm to upsize the images, PhotoSize to monitor the image sizes during the editing process, Juxtaposer to refine the edges, ProCreate to smudge parts of the images, and Snapseed to crop the images and apply the final filters. I used Flypaper Textures for the background.

Marie Matthews (Kaphinga)

As a longtime mainstay of iPhoneArt.com, Marie Matthews is noted for her painterly portraits of street characters. She has been voted Artist of the Month on iPhoneArt.com and has exhibited her work at the LA Mobile Arts Festival and at Pixels at an Exhibition's Third Wave exhibition. Her images have been featured on CNET, in the Los Angeles Times and Business Insider, and on a number of well-known iPhoneography websites, including iPhoneogenic, iPhoneography.com and iPhoneographyCentral.com, and. Marie's images were selected as some of the best images of 2012 on iPhoneogenic.com and TheAppWhisperer.com. When she is not creating images with her iPhone, Marie teaches painting and figure drawing in Atlanta, Georgia.
http://www.iphoneart.com/kaphinga

APPENDIX 1: Apps Used in this Book

For complete information on these apps, please visit the book's companion website at *www.rockynook.com/iPhoneArt*. There you will also find links to each app in iTunes. The numbers in parentheses below refer to the tutorial numbers in which the app was used.

 6x6 A camera replacement app that takes square photographs like old square medium format roll film. (23, 39)

 Alien Sky Create customized skies with a collection of high-res space objects such as: bright suns, lens flares, and lens filters. (39)

 AntiCrop Extend one or more edges of an image (increase the canvas size) by duplicating edge pixels. (27, 34)

 ArtRage Painting tools that mimic a real art studio. Unlimited layers that you can scale, rotate, and position independently. (27, 29)

 ArtStudio A sketching, painting, and photo-editing tool with flexible canvas sizes. Includes tools, brushes, filters, and fonts. (23, 25, 27)

 Autopainter HD Turn photos into authentic looking paintings with four realistic impressionistic styles: Aquarelle, Benson, Cezanne, and Van Gogh. (37)

 AutoStitch Panorama Take panoramas of up to 18 MP with no visible seams. (10, 27, 35)

 Big Lens Bring DSLR-level depth-of-field control to your iDevice. (26)

 BlendCam Superimpose pictures by taking a picture with the app or use pictures from your photo album. (37)

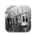 **BlurFX** Provides a variety of great selective blur effects. Blur effects include Gaussian, Median, and Normal. (24)

 Bracket Mode Exposure bracketing, otherwise known as HDRI (high dynamic range imaging). (10)

 Brushes A universal painting app that runs on your iPhone or iPad. Move paintings between devices. (1)

 Camera Awesome A camera replacement app. Includes professionally designed effects from renowned photographer Kevin Kubota. (1,14)

 Camera+ A camera replacement app that includes filter effects and basic editing tools. (1, 2, 4, 5, 9. 11, 27, 30, 33, 37, 40)

 Cameramatic A toy-camera app for iPhone and iPod touch. Take strange and beautiful photos by using filters and frames. (6, 31)

 ClearCam Eliminate blur, reduce noise, and take sharper, clearer photos with 2x megapixels (up to 18MP on iPhone 5). (25)

 Color Splash Give photos a dramatic look by converting them to black and white, while keeping chosen details in color. (25)

 ColorBlast! Create dynamic black and white photos with selected areas of color by simply brushing in the area of interest. (28)

 ColorSchemer Access over a million palettes and interact with the 750,000-member COLOURlovers community. (31)

 Diptic Combine and edit photos to create collages. Add text and borders, and customize layout.* (1, 30)

 DXP A multi-exposure blending app (two layers at a time) with 18 blend modes. (34, 35)

 Dynamic Light Get an HDR look on any mobile platform from a single image using a single dial. (10, 35)

 EasyTitler Add text to your vertical, horizontal, or square format images. (28, 30)

 FilterMania 2 Over 750 artistic and photorealistic filters constantly being updated. Layer filter-on-filter for unique creations. (18)

 Filterstorm A suite of powerful editing tools, including layers and numerous blending modes. Export high-res images up to 22MP. (1, 5, 9, 19, 20, 21, 26, 33, 35, 45)

 FlickStackr Brings Flickr photo sharing to the iPad. Browse, upload, and edit your photos' metadata in Flickr. (34)

 Flypaper Textures This is not an app, but rather are downloadable textural layers. You'll need a program that can utilize layers. Textures are sold in "Packets" and include painterly, classic, and grunge looks. (45)

 FocalLab Offers effects achieved by expensive lenses or SLR cameras. (18)

 FX Photo Studio A collection of over 190 photo effects and filters. (19, 25)

 Hipstamatic Make and share beautiful photography with Hipstamatic. Swap lenses, flashes, and films for hundreds of different effects. (1, 5, 6, 17, 18, 21, 43)

 iColorama Enhance colors and apply filters and image settings. (38)

 iDarkroom A photo-processing app. Shuffle effects with one tap. (28)

 iDesign A 2D vector drawing and design app for the iPad, iPhone, and iPod Touch. Draw accurately without your finger blocking your view. (32)

 Image Blender A simple iPhone and iPad app for blending images together. (4, 6, 10, 12, 16, 28, 31, 38, 40, 42, 43)

 iResize Allows you to quickly resize individual images or groups of photos. (34)

 Iris Photo Suite (now for iPad only. iPhone version replaced by Laminar) A set of tools to quickly add life and emotions to images with over 72 filters and textures plus lots more. (36)

 Juxtaposer Combine multiple images into photomontages. (4, 20, 22, 24, 25, 27, 42, 43, 44, 45)

 King Camera An all-in-one photo app with direct Instagram sharing. The free version is fully functional in web resolution. (42)

 Laminar (formerly Iris Photo Suite for iPhone) A complete set of tools to quickly add life and emotions to images: from filters and textures, to histograms and layers. (13, 17, 19, 22, 27, 28)

 Layers – Pro Edition (for iPad) Doodle, draw on photos, or paint a masterpiece on your iPad. The pro edition provides more brushes, layers, and advanced operations than the standard edition. (37)

 Lens+ Changes your iPhone's native camera into an analog [like] retro camera. (16)

 LensLight A portable light studio for your photos. Accentuate photos with various customizable lighting effects and textures. (25, 26, 27)

 lo-mob Brings lo-fi and experimentations to your pictures, and is like using an old analog camera. Take a picture with the app's camera or process an image from your library. (14, 22)

 Lumiè Adds 60 bokeh effects to images with predesigned filters.* (18)

 Microsoft Tag Lets you connect to a world of information and entertainment. Reads Microsoft Tag barcodes and QR Codes by scanning a 2D barcode. *(16)

 Noir Photo Lets you transform your photos with beautiful, dramatic lighting, and instant results. Convert to black-and-white and apply a tint. (34, 39, 42)

 Perfect Photo A photo editor with 28 editing tools and effects. (7)

Phonto Allows you to add text to pictures with more than 200 customizible fonts.* (31)

Photo Clip Edit photos taken by iPhone camera or by PhotoClip with the intuitive trimming operations. Crop to

square, make horizontal corrections, and change aspect ratios. (19)

 Photo Editor – Fotolr An image-processing app with many editing options.* (22)

 Photo fx Edit photos and create effects for your iPhone or iPod Touch images. Includes simulations of popular Tiffen glass filters, specialized lenses, optical lab processes, film grain, exacting color, natural light, and photographic effects, plus a paint system with a variety of brushes. (19, 22, 28, 30, 35, 44)

 Photo Power A photo-processing tool to help you edit your photos. (39)

 Photo Transfer App Move photos and videos between your iPhone, iPad, Mac, or PC using your local WiFi network.* (13)

 PhotoCopier Creates a photographic reproduction of a printed or graphic work's style and applies it to your own image; styles from popular movies and the world's master painters. (23)

 PhotoForge An editing and painting app for iPhone and iPod touch for retouching, effects, color correction, and as a painting tool. Create original artwork or edit existing photos. (13, 23, 42)

 PhotoForge2 This successor of Photo-Forge was rebuilt for full resolution editing on iOS 4.2+. Works on iPhone, iPad, or iPad. Full res image editing. (27)

 Photogene Fully featured photo-editing tool. (24, 35)

 Photogene2 This successor to Photogene
is a tool for editing your iPhone photos. Optimized for iPhone 5. (34, 45)

 PhotoSize Reveals the pixel dimensions of any image you choose from a device's photo album or Camera Roll. (45)

 PhotoToaster A photo editor for iPhone and iPad with 60 one-click effects, 80 one-click settings, plus much more. (18, 41)

 PhotoWizard-Photo Editor For editing photos on iPhone or iPod. Edit the full image or selectively apply filters with masking tools. (20, 28, 34)

 Pic Grunger Grunge effects, textures, and colors that may be applied to any picture taken from your camera or stored on your device. (32, 44)

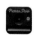 **Picfx** A square-format photography app. Layer multiple and then share to your favorite social network or save to your camera roll. (24, 28, 32)

 PictureShow Emulates various toy camera styles. Enables you to mix frames, light leaks, and noises to create an unexpected result with shuffle button. (28)

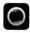 **Pix: Pixel Mixer** A photo editor to create your own professional quality photos. Features 31 filters, 24 film layers, and 16 frames.* (40)

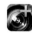 **Pixlr Express PLUS** A full-featured photo editor in an ads-free experience. Includes a large variety of effects, overlays, and borders. (15)

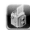 **Pixlr-o-matic** A darkroom app to add effects, overlays, and borders to get retro, grunge, clean, or stylish looks.* (14, 15, 18, 35, 37, 41, 44)

 Pro HDR Create full-resolution HDR images with a single tap for iPhone, iPad, and iPod. Automatic in-app HDR capture or manual in-app photo capture. (8)

 ProCamera Capture, edit, and share photos and videos. Turns your iPhone into a "DSLR." Anti-shake stabilizer makes photos sharp. Self-timer. Full screen, volume trigger, and more. (3, 6, 22, 26, 39)

 ProCreate Sketch and paint with 48 brushes: from sets of pencils, inks and paintbrushes, to unique digital tools. Ultra-high definition 4K and custom canvas sizes. Advanced layering system and blend modes. (45)

 Rays Add realistic-looking light ray effects. The rays are only added to highlight areas, so they have the effect of passing through objects and adding a 3D look. (15)

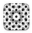 **Real Halftone** An app that generates a halftone dot. Select a dot shape and adjust screen angle of CMYK colors to make a variety of halftone dot photographs. (27)

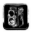 **RetroCamera** Creates the vintage look of old-school cameras. High-resolution images. (28)

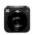 **ScratchCam FX** Create awesome vintage photos with ScratchCam's effects generator or craft your own grunge effects. (6, 11, 15, 16, 17, 18, 22, 23, 26, 28, 30, 33, 35, 37, 41, 43)

 ShockMyPic Applies a Van Gogh-like painting filter on a given image from the image gallery or the camera. (36)

 Simply B&W Turn color shots into black and white photos with 6 different colored lens filters. (35)

 SketchBook Mobile A painting and drawing app for iPhone and iPod touch with a full set of sketching tools. Digitally capture ideas as napkin sketches or produce artwork on the go. Uses the same paint engine as SketchBook Pro.* (32)

 SketchBook Pro (iPad) A professional-grade painting and drawing application for iPad that uses the same paint engine as its desktop counterpart. With a complete set of sketching and painting tools, and a full screen workspace. (14, 32)

 Slow Shutter Cam Offers three capture modes: Automatic, Manual, and Light trail. With selectable shutter speeds and exposure compensation. (35, 36, 41)

 Snapseed Enhance, transform, and share photos. Built-in Google+ capabilities to share your images. Auto Correct to adjust color and exposure or Selective Adjust to select and enhance specific areas.* (1, 3, 4, 5, 6, 8, 9, 11, 15, 16, 20, 22, 25, 26, 28, 30, 31, 37, 38, 39, 40, 43, 45)

 SpookyPic Makes common photos look spooky. Support iPhone5's 4-inch Retina display. Support iOS 6. (28)

 Squaready A free app to crop landscape and portrait format photos to square. Post entire photos on Instagram without re-cropping. (6, 21, 25, 41)

 Superimpose Layering and blending app that also includes color and saturation adjustments by layer (maximum of two at a time). (20, 21, 23, 34, 39, 41, 45)

 tadaa – HD Pro Camera A photo taking and editing app with 26 HD filters. (6)

 Thicket:Classic An audiovisual world of texture, movement, line, and tone. (43)

 Tile Wallpaper Repeats an image multiple times horizontally and vertically to create a larger tiled image. (34)

 TiltShift Simulates a tilt-shift lens that makes an image look like a photo of a miniature scene. (44)

 ToonPAINT Create cartoon-looking paintings with your photos that you can simply color-in. It's like paint-by-numbers, but using your own images.* (32)

 TouchRetouch Remove unwanted content or objects from your photos using just your finger on iPhone or iPod Touch.* (3, 4, 5, 8, 11, 14, 27, 28, 33, 35, 38, 44)

 True HDR Create full-res HDR (high dynamic range) images with your iPhone, iPad, or iPod Touch. Includes fully-automatic capture mode and semi-auto/manual mode. (10)

 Vintage Scene Make photos look old school or retro. Turn a new or recent photo into an old photo that looks like it was taken many years ago. (13, 16)

 VSCO CAM Take, process, and share images quickly with your iPhone. Take, save, and edit pictures within the app or that are in your camera roll. (32, 39)

> **Note:** The apps mentioned in this book reflect features and interfaces that were current at the time of writing. The interfaces and functionality as depicted here may have changed since this book went to press. Please consult developer specifications and functionality before purchasing the most current versions of these apps.

* Android compatible

APPENDIX 2:
Quick Guide to Techniques, Filters, and Effects Used in the Book

(Numbers in parentheses refer to chapters)

Android
• apps (Introduction, Appendix 1)
Black-and-white (1, 4, 5, 6, 11, 14, 19, 20, 26, 28, 30, 31, 32, 34, 35, 38, 39, 41, 42)
Blending (1, 4, 10, 12, 16, 17, 19, 20, 21, 22, 23, 24, 25, 26, 27, 30, 31, 34, 35, 36, 37, 38, 39, 40, 41, 42, 43, 44)
Blur (4, 6, 9, 14, 15, 16, 24, 26, 34, 35, 36, 38, 45)
Borders and frames (1, 5, 14, 17, 18, 30, 32, 40, 41)
Brushes (14, 20, 27, 29, 32)
Canvas
• texture and color options (29, 40)
• size, extending (27, 34)
Camera replacement (2, 3, 4, 6, 11, 16, 17, 18, 21, 22, 25)
Cartoonize (32)
Cloning (3, 4, 5, 6, 7, 8, 9, 10, 11, 14, 19, 22, 28, 33, 34, 44)
Close-up (11, 12, 13, 23)
Color
• adjustment (14, 25, 28, 30, 31, 33, 34, 35, 36, 37, 38, 39, 40, 41, 42, 44)
• removal (1, 4, 5, 6, 11, 12, 14, 19, 20, 28, 41, 42)
• custom RGB/hex palettes (31)
Compositing/collage (1, 4, 6, 12, 14, 16, 19, 20, 21, 22, 23, 24, 25, 26, 27, 28, 30, 31, 34, 38, 39, 40, 42, 43, 44, 45)
Contrast
• automatic (33)
• Decrease (4)
• increase (8, 30, 31, 35, 37, 38, 39, 42)
• using curves (9, 20, 27, 39)

Cropping (1, 3, 6, 11, 14, 18, 19, 20, 21, 24, 31, 33, 34, 35, 37, 38, 40, 41, 43, 45)
Curves (9, 20, 27, 39)
Drawing
• pencil (14, 27, 32)
• vector lines/shapes (31)
Effects and filters
• add drama (3, 4, 9, 11, 14, 15, 25, 26, 33, 37)
• cartoonize (32)
• clarity (2, 33, 35, 37)
• color tints (12, 14, 15, 18, 28, 35, 37, 42, 44)
• cross process (33)
• emboss (10)
• emulsion (4)
• giving images punch (6, 9, 16, 25, 33, 44)
• grain (5, 6)
• Grunge, worn (6, 14, 15, 16, 22, 23, 26, 28, 32, 33, 38, 39, 40, 41, 43, 44)
• Invert (6)
• Lighting (4, 9, 10, 14, 15, 34, 35, 37, 39, 41)
• Lomo (26, 41)
• Orton (10)
• Painterly (27, 29, 32, 34, 35, 36, 37)
• Retro (31, 40)
• sepia (2, 24, 40, 42)
• symmetry (25)
• texture (6, 14, 15, 16, 17, 18, 23, 28, 30, 31, 32, 33, 34, 35, 36, 37, 38, 39, 40, 41, 42, 43, 44, 45)
• Type/text (22, 26, 28, 30, 31)

• vintage aged (4, 13, 14, 26, 28, 32, 33, 34, 38, 42, 43, 44)
Exposure
• adjustment (2, 3, 9, 20, 25, 39)
Focus, add
• using blur (4, 6, 9, 14, 15, 16, 20, 22, 26, 39, 44, 45)
• using selective color (28, 35, 44)
• using selective light (4, 5, 8, 34, 35, 39, 45)
• using sharpening (35)
• using vignetting (3, 14, 24, 25, 34, 39, 45)
HDR (2, 4, 8, 9, 10, 13)
Layers (1, 4, 5, 6, 9, 11, 12, 13, 14, 16, 17, 18, 19, 20, 21, 22, 23, 25, 26, 27, 28, 29, 30, 31, 32, 33, 34, 35, 36, 37, 39, 43, 44, 45)
Light control/enhancement
• using available light (1, 5, 11, 13, 33)
• bokeh and contre jour (11)
• external light (2, 4)
• light box (13)
• selective lighting/brightness (25, 26, 26, 34, 35, 37, 39, 42)
Macro (11, 12, 13)
Masking (6, 9, 16, 17, 20, 22, 23, 24, 25, 26, 27, 28, 34, 37, 38, 39, 40, 42, 43, 44, 45)
Noise reduction (34)
olloclip macro lens (11, 12)
Painting (8, 29, 32, 37)
Panorama (10)
Repeat image/pattern
• Stamp tool (6, 22, 25, 34, 42, 43, 44, 45)
Resizing/upsizing images (1, 34, 45)

Retouching: removing blemishes, objects, etc. (3, 4, 5, 8, 11, 14, 20, 21, 24, 25, 27, 28, 33, 34, 35, 38, 39, 42, 43, 44, 45)
Saturation (2, 3, 8, 21, 22, 28, 30, 37, 38, 39)
Selection/selecting (6, 19, 20)
Sharpening (9, 30, 31, 35, 37)
Shapes: creating and coloring (31)
Skina macro lens attachment (11)
Slowshutter/light-trails (35, 36, 41)
Smudge tool (45)
Square format (1, 5, 6, 13, 14, 19, 20, 21, 23, 24, 30, 35, 40, 41, 43)
Stabilizer (8, 10)
Stitching images (10, 27)
Text, adding (14, 22, 26, 27, 28, 30, 31)
Texture
• sourcing/adding texture (12, 13, 23, 24, 28, 30, 32, 33, 34, 35, 36, 37, 38, 39, 40, 41, 42, 43, 44, 45)
• tiling (34)
Tiling textures (34)
Tone, adjust (1, 3, 9, 14, 20, 21, 27, 30, 33, 35, 37, 39)
Transforming
• scaling (5, 19, 25, 26, 32, 34, 41, 45)
• rotating/straighten (21, 26, 31, 34, 36, 39)
Transparent backgrounds/PNG files (31)
Type, adding (14, 22, 26, 27, 28, 30, 31)
Vignetting (1, 3, 8, 12, 24, 25, 34, 39)

ACKNOWLEDGMENTS

No book is ever truly written in isolation, and that is especially true of this book. Forty-five contributing artists (including the authors) from 12 countries have come together to put this labor of love into your hands. It represents the first and most comprehensive iPhoneography book to showcase so much talent, across so many genres of art and photography, inside the covers of a single book.

Each contributor, who we personally selected, generously shared his or her unique artistry, technique, and creative process. We selected the individual images to be featured in each tutorial, and we curated the additional pieces from each artist for presentation in the Gallery section of this book.

In addition to selecting the artists and the art to be showcased, we provided the overall vision and direction for the effort, the structure for the tutorials, and the relationship with an established photographic art publisher, Rocky Nook. And of course we enforced the deadlines; drove everyone to keep their prose clear, concise, and easy to follow; and led the charge in getting the word out about this important new resource for iPhone photographers.

But it was the invited artists who contributed the vital core of the book—and to them we owe our greatest thanks. They graciously agreed to open the curtain and reveal their techniques, endlessly rewrite and refine their tutorials, and, most importantly, describe their creative process from conception through final art. Many of the artists relate how they handled creative dead ends, how they found meaning where it may not have existed before, and how their worldview and approach to photography and art profoundly expresses their vision. This willingness to share both the excitement and frustration of the creative process ensures that readers learn not only valuable techniques, but they are also given a glimpse into what it takes to develop and refine a personal creative vision.

Because so many artists, with so many divergent creative approaches and subjects, have chosen to share what they know, you have before you the most comprehensive book on iPhone photography produced to date. The contributors collectively used over 90 apps to accomplish the work shown here. You will learn a bit about each one, and considerably more about the most important of them.

There are others we must thank for helping make this book possible. Bob wishes to thank Jacqueline Gaines for encouraging him along his creative iPhoneography journey on Flickr and for directing his attention to iPhoneArt.com. That initial thoughtfulness introduced Bob to Daria Polichetti and Nate Park, who were in the process of preparing the first LA Mobile Arts Festival.

In the days leading to the event, Bob realized that the iPhoneography community had reached a bit of an inflection point; although a number of websites offered tutorials, there was no formally published and systematically organized creative resource for aspiring mobile artists. Nicki had created iPhoneographyCentral.com as an amazing online resource for sharing iPhoneography techniques. It was only natural for Bob to ask her if she would be interested in coauthoring an iPhoneography tutorial book. Her reply was an enthusiastic yes.

We submitted our proposal to two or three publishers, and Rocky Nook publisher Gerhard Rossbach was intrigued but not ready to commit. When he visited the LA Mobile Arts Festival the

following month, he was overwhelmed by the caliber of creative work he saw on display. Gerhard boldly offered to publish the book on the spot. Only the details were left to iron out during his next visit to the United States.

Bob wishes to thank his incomparable wife and friend, Marya, and his wonderful son and future all star, Jon, for their encouragement, understanding, and support throughout the year it has taken to complete this book—and for allowing him to pursue his iPhone obsession. Bob cannot begin to thank Marya enough for the love and companionship she has shown in their life and faith journey together and the opportunity to raise a beautiful and talented family that includes their older children, Elisabeth and Nicholas, and very soon their first grandchild. Bob also extends special thanks to his mother for the creative impulse she bequeathed to her sons, and to his father for encouraging him to express his faith through this new medium.

Nicki would like to give thanks to fellow British iPhoneographer Lindsey Thompson, who was especially proactive from the outset in encouraging her and other artists on Flickr and iPhoneArt. Nicki would also like to thank all those artists who had faith in the iPhoneographyCentral website in 2011, volunteered beta testing, and uploaded the first few tutorials: included among them are Aaron Davis, Anders Uddeskog, Jaime Ferreyros, James Klees, Lindsey Thompson, and Jeff White. Their tutorials inspired others to help build a library that now exceeds 100 tutorials. Thanks also go to Marty Yawnick of LifeInLoFi.com for embracing iPhoneographyCentral from the very start. His glowing review thrust it into the iPhoneography spotlight.

Nicki thanks Alan Kastner for his steadfast and tireless support of this project, for the Japanese-to-English translations of some of the tutorials in this book, and for submitting his own brilliant tutorial.

Nicki thanks her good friend, muse, and work colleague Amy Maslin, who embodies the irreverent and passionate spirit of the iPhoneography community in her wonderful pose for the image on the front cover of this book and in Nicki's tutorial, *Flamin' Amy*.

Nicki would also like to thank the late Nacho Cordova for his generosity to the iPhone art community in its infancy. His deep thoughts, kind spirit, and exuding calm were, and still are, a welcome presence in this excitable and instantaneous world of iPhoneography. His online dialogue and images are terribly missed, but his contribution will never be forgotten.

Nicki would like to give special thanks to her beautiful son, Lewis, for always putting a smile in her heart and the all-important and treasured book-writing breaks they shared; her lovely mum for her unwavering kindness and patience, and for always allowing Nicki to be *herself*; her wonderful dad for passing on his drive, energy, and photographic interest; and of course to the unshakable love and support of her partner, Bob. Without him, she could never have done this.

Both authors extend special thanks to Joan Dixon and Matthias Rossmanith at Rocky Nook, whose ongoing confidence in us and in our project made our work so much easier; to Daria Polichetti, who, in addition to writing a superb foreword for our book, was very helpful in providing contact information for a number of iPhoneArt.com artists we wanted to include in the book; and to Dan Berman, Dan Marcolina, and Cindy Patrick for their generous praise and promotion of the book in a number of venues.

And, of course, the authors wish to acknowledge the successful division of labor that allowed us to pool our individual skills to accomplish a shared vision.